FORCE
FIELDS

FORCE FIELDS

BETWEEN INTELLECTUAL HISTORY AND CULTURAL CRITIQUE

MARTIN JAY

ROUTLEDGE · NEW YORK AND LONDON

Published in 1993 by

Routledge
An imprint of Routledge, Chapman and Hall, Inc.
29 West 35th Street
New York, NY 10001

Published in Great Britain by

Routledge
11 New Fetter Lane
London EC4P 4EE

Library of Congress Cataloging-in-Publication Data

Jay, Martin
 Force fields : between intellectual history and cultural critique
 / Martin Jay
 p. cm.
 Includes bibliographical references
 ISBN 0-415-90603-2 (HB). — ISBN 0-415-90604-0 (PB)
 1. Philosophy, Modern—20th century. 2. Intellectual life—
History—20th century. 3. Civilization, Modern—20th century.
I. Title.
B804.J39 1992
190'.9'04—dc20 92-28012
 CIP

ISBN 0-415-90603-2 hb
ISBN 0-415-90604-0 pb

In memory of
Eugene Lunn (1941–1990),
who will always be in his prime

Contents

Acknowledgments

The fingerprints of many people can be found on the following pages, for the earlier incarnations of these essays have passed through many helpful hands. Let me acknowledge with gratitude the friends who solicited, encouraged, criticized, occasionally resisted, and yet somehow always managed to improve one or more of the essays in this collection: Svetlana Alpers, Andrew Arato, Thomas Bender, Robert Boyers, Victor Brombert, John Burnheim, Richard Buxbaum, Stefan Collini, Aleš Erjavec, Ferenc Fehér, John Forrester, Hal Foster, Jonathan Friedman, Anthony Giddens, Geoffrey Galt Harpham, Paul Hernadi, Denis Hollier, Axel Honneth, Prafulla Kar, Rosalind Krauss, Martin Kreiswirth, José Lambert, Scott Lash, Charles Lemert, David Lindenfeld, David Lloyd, Slavomir Magala, J. Hillis Miller, Vincent Pecora, Mark Poster, Paul Rabinow, Michael Rosen, Michael Roth, Elaine Showalter, Peter Steiner, Mark Kline Taylor, and Richard Wolin. As always, Leo Lowenthal and my wife, Catherine Gallagher, generously unleashed their formidable critical skills on each text. And my children, Shana Gallagher, and Rebecca Jay, must be acknowledged for keeping our domestic force field crackling with energy.

Thanks must also go to William P. Germano, who has now edited a collection of my pieces for the third time, and only gets better with the practice. I also want to acknowledge the copy-editing of Laurie McGee and Veselin Scekic, who prepared the index. So too the journals where some of these essays initially appeared and the presses in whose collections others first saw the light of day deserve a word of thanks, both for publishing them and for permitting their republication: *The Cambridge Review* (Chapter 3), *Cultural Critique* (Chapter 6), *Poetics Today* (Chapter 8), *Strategies* (Chapter 12), *Filosofski Vestnik* (Chapter 11), *Journal of Contemporary Thought* (Chapter 8), *Indian Journal of American Studies* (Chapter 10), Oxford University Press (Chapter 1), Suhrkamp Verlag (Chapter 2),

M.I.T. Press (Chapter 2), Duke University Press (Chapter 8), Bay Press (Chapter 9), Sage Publications (Chapter 10), Basil Blackwell (Chapter 9), Francke Verlag (Chapter 12), Slovensko Društvo za Estetiko (Chapter 3), and the University of Michigan Press (Chapter 13).

Finally, I want to acknowledge the abiding support and encouragement over many years of the friend to whose memory this volume is dedicated, Eugene Lunn. We began our careers as European Intellectual Historians at the University of California, he at Davis and I at Berkeley, at virtually the same time. Our on-going colloquy on issues of mutual concern, prematurely ended by the cancer against which he so courageously struggled, was one of the intellectual and personal delights of my life. I hope some of his spirit is evident in these essays, and indeed in whatever work it may be my good fortune to complete in the years to come.

Introduction

"Every historical state of affairs presented dialectically," Walter Benjamin once argued, "polarizes and becomes a force field (*Kraftfeld*) in which the conflict between fore- and after-history plays itself out. It becomes that field as it is penetrated by actuality."[1] If the relation between past and present can be construed as such a field of conflictual energies, any whole-sale, empathetic surrender to the past "as it actually was" is as problematic as the indiscriminate imposition of present constructions onto a pliant and vulnerable past. For Benjamin, the past is not "there" to be discov-ered, nor is it "here" to be invented. The negotiation between them, however, is more than the harmonious "fusion of horizons" that a his-toriography inspired by, say, Hans-Georg Gadamer's hermeneutics might assume, more even than that "dialogic" interaction Dominick LaCapra has recently urged on us.[2] It requires instead a willingness to intervene destructively as well as constructively, to shatter received wisdom as well as reconfigure the debris in new and arresting ways.

Benjamin's own remarkable application of these principles, best ex-emplified in his unfinished *Passagenwerk*, defies easy imitation.[3] The re-demptive political project that he heroically, if with increasing despera-tion, embraced can no longer generate much enthusiasm. His claim that "what matters for the dialectician is having the wind of world history in his sails"[4] can, in fact, only evoke embarrassment at a moment when the wind has been knocked out of not only Marxist narratives of world history but also the very idea of master narrative itself. Benjamin's plea for shat-tering the reified continuity of history, as it is normally written, may appear to be receiving a respectful hearing at a time when the work of Foucault and other French critics of seamless narrative has become influ-

1

ential. But his accompanying call for a new, authentically "messianic" version of universal history has had far less success.

And yet, even though the redemptive impulse in the idea of historical force fields no longer inspires much confidence,[5] Benjamin's general point about the tense interaction between past and present must still command respect. So too should the suggestive use of the force field metaphor by Theodor Adorno, who frequently employed it, along with the related Benjaminian image of a constellation, to suggest a nontotalized juxta-position of changing elements, a dynamic interplay of attractions and aversions, without a generative first principle, common denominator, or inherent essence.[6] At a time when many cultural theorists and philoso-phers have grown wary of totalizing systems and foundational discourses, it is thus not surprising to find these metaphors recently acknowledged in Richard Bernstein's *The New Constellation* as "extremely fertile . . . for 'comprehending' the 'modern/postmodern' situation."[7]

Although it would be an exaggeration to claim that the idea of force fields equally pervades the essays collected in this book, its presence can be discerned in explicit or implicit forms in virtually all of them. For several years, in fact, I've called the semiannual column I write for *Sal-magundi* "Force Fields," indicating that even before this collection was conceived, the concept tacitly informed much of my work, at least as a guiding ideal. It first appeared in an essay published in 1981 on "Positive and Negative Totalities: Implicit Tensions in Critical Theory's Vision of Interdisciplinary Research,"[8] and then served as the master trope of my 1984 monograph on Adorno.

More generally, I would argue that the discipline in which I was orig-inally trained, intellectual history, can itself be fruitfully understood as a force field of different impulses. Often called a hybrid of philosophy, the history of intellectuals and their institutions, and cultural history broadly defined, intellectual history has suffered from the charge that it does none of these well. Its handling of ideas is rarely rigorous enough for the professional philosopher; its attention to context is often too superficial to satisfy sociologists of knowledge; and its persistent attention to elite culture offends the antihierarchical sensibilities of many cultural histo-rians. And even when it provides a helpful reconstruction of the origins and development of current theoretical problems, it is sometimes faulted for failing to contribute to their solutions, for bringing the pot to boil, as it were, without cooking much of anything.

And yet, it may well be a hidden strength of intellectual history that it functions at the shifting intersection of different, often conflicting dis-courses. Self-conscious about the debt of current thought to the past, it avoids the fallacy of thinking originality is always a self-evident virtue. Rather than dismissing "mere" commentary as inferior to creative in-

novation, it acknowledges the still potent impact of past ideas in new and unexpected constellations with others from different contexts. Inevitably attuned to recent intellectual trends, it distrusts historical approaches that feign indifference to current theoretical disputes. Instead, intellectual historians often feel compelled to incorporate some understanding of recent developments in their attempt to re-create the past. The checkered reception of ideas, the tangled skein of misreadings and misappropriations that characterize the afterlife of any idea or cultural creation worth studying, unavoidably includes those that dominate the historian's own era. In essence, then, intellectual history can itself be seen as the product of a force field of often conflicting impulses, pulling it in one way or another, and posing more questions than it can answer. Rather than positioned as the distanced observer of a cultural or discursive field, the intellectual historian must thus conceptualize his or her own vantage "point" as itself a field in play.[9]

In more substantive terms, the essays that follow often betray an origin at the intersection of several larger projects on whose margins they emerged. Having written a number of studies of Western Marxism, most notably of the Frankfurt School, I have inevitably absorbed some of the lessons of that much contested tradition (demonstrated, for example, by the evocation of Benjamin and Adorno above). As one of the forces insistently pulling me into its gravitational orbit, Western Marxism is most apparent in the essays that deal with the work of figures like Jürgen Habermas or Agnes Heller. But it is also manifest at various moments in other pieces, where questions of ideology and legitimation appear, or where the vexed question of the relation between politics and aesthetics is raised.

A powerful pull in another direction derives from my subsequent immersion in the recent French thought that has become so insistent a presence in the current debates in the American academy. Although less powerful in its attraction than the earlier force in my field, poststructuralism of various kinds has inevitably influenced my choice of themes and the ways in which I address them. Thus, names like Bataille, Foucault, Kristeva, de Man, and Derrida appear in many of these essays as more than the target of an indignant Habermasian critique of their putative sins. Without wanting to minimize the differences between them or claim any smooth harmony is possible, I would argue for a productive exchange between these two impulses rather than an either/or choice. The dialectical imagination, it might be said, has something to learn from what can be called the diacritical imagination, and vice versa.

An even more complicating force evident in many of the following pieces reflects the project I am now completing on the theme of vision in twentieth-century French thought. Here very different questions from

the ones raised in traditional philosophical and political discourses come to the fore, questions relating to the culture of the senses and the metaphorics of perception. Although my main concern has been with discursive considerations of what can be called "ocularcentrism," I have also been intrigued by the variety of visual practices or, to borrow Christian Metz's term, "scopic regimes." Indeed, the issue of how discourse and practice interact has inevitably demanded attention. My research in this area has impressed upon me the extent to which our current universe of discourse, heavily indebted to the pervasive suspicion of the gaze preeminent in France and elsewhere, has influenced our historical reconstruction of previous visual practices, indeed our interpretation of vision as such. Several of the essays that follow draw out the implications of this "insight," often bringing it to bear on questions of social and political theory as well.

The force fields that generate disparate essays, it should also be recognized, are adventitiously constructed by the unforeseen intersections of one's own obsessions with those of other scholars. That is, without the opportunities provided by routine professional invitations to write for conferences, special journal volumes, *Festschriften* and the like, which create what may at times seem like distractions from the "big book" but are better understood as healthy inducements to stretch beyond its confines, a volume like this would be an impossibility. It is thus not only to acknowledge with gratitude the invitations that generated many of these essays that some explanation of their provenance is warranted.

"Urban Flights: The Institute of Social Research Between Frankfurt and New York" was composed for a conference on "The University and the City" in 1986.[10] Not only did this invitation entice me to return once again to the Frankfurt School, but it also allowed me to apply the force field model of analysis, which I had already tested in my short book on Adorno, to the history of Critical Theory as a whole. "The Debate over Performative Contradiction: Habermas versus the Poststructuralists," the other essay in this collection that directly reflects my early interest in Critical Theory, arose from a request to contribute to a *Festschrift* to honor Jürgen Habermas on his sixtieth birthday in 1989.[11] Here I sought to highlight a central, but hitherto unremarked, dimension of the wide-ranging conflict between Habermas and his poststructuralist critics: the viability of a concept of contradiction, redescribed in terms of speech act theory, for social criticism.

"The Morals of Genealogy: Or Is There a Poststructuralist Ethics?" positioned Habermas and his French-oriented foes in a somewhat less antagonistic manner. This time the terrain was ethical theory, which has enjoyed a revival of interest among cultural critics at a time when the more directly political rhetoric of the sixties has become muted. Originally

intended as a modest *Salmagundi* column, the essay grew too long and required too many footnotes to serve that purpose. Instead, I was able to deliver it to the Slovenian Society of Aesthetics in Ljubljana in connection with a conference on "The Subject in Postmodernism" in 1989.[12] In it, I tried to argue for the value of poststructuralist ethical intuitions, even as I sought to marshall Habermasian arguments to compensate for their limitations.

The essay that follows, "The Reassertion of Sovereignty in a Time of Crisis: Carl Schmitt and Georges Bataille," combined two long-standing interests. I had already written on Schmitt in the context of a polemical exchange over his alleged influence on the Frankfurt School,[13] and was preparing a chapter on Bataille for my study of French attitudes toward vision.[14] Although deeply resistant to many aspects of their work, I was intrigued by the curious convergence of their preoccupation with the vexed question of sovereignty. When invited to participate in a conference on "Carl Schmitt and the Challenge to Democratic Theory" in 1990,[15] I took the opportunity to play one off against the other in the hope of showing that "sovereignty" was less a unified idea than itself an unstable force field of competing acceptations. If so, then those considerations which a strong, uniform notion of sovereignty had tried to banish from politics, notably discursive rationality as the source of legitimacy, might well command more respect than either Schmitt or Bataille, bitter opponents of parliamentary democracy, had allowed.

One of the other participants at the Schmitt conference was the Hungarian-born philosopher Agnes Heller, whose work I had been reading for some time with profit and admiration. When a group of her former colleagues in Australia asked me to contribute to a critical volume of essays on Heller's work, I seized the opportunity to explore the implications of her growing esteem for Hannah Arendt, whose ideas had both fascinated and troubled me in the past.[16] Heller's progressive disenchantment with the Marxist Humanism of her mentor, Georg Lukács, had been facilitated by her acceptance of many of the arguments that had informed Arendt's idiosyncratic defense of classical politics. Although Heller has maintained greater respect for the accomplishments of modernity than did Arendt, she came to similar conclusions about the threat of totalitarianism in the modern world. As an antidote, she was especially drawn to Arendt's stress on the faculty of judgment in politics, developed in the latter's posthumously published lectures on Kant.[17]

Heller was not alone in finding inspiration in these texts, which also informed another essay I had initially conceived as a "Force Fields" column in 1989 entitled " 'The Aesthetic Ideology' as Ideology: Or What Does It Mean to Aestheticize Politics?"[18] Here I sought to resurrect a positive notion of aestheticized politics to counter the powerful critique

of "the aesthetic ideology" tendered by a number of poststructuralist critics. Ironically, my earlier essay on Arendt had upbraided her for having countenanced a dangerous version of aestheticized politics,[19] but now having had the opportunity to read her posthumously published work on judgment, I came to somewhat different conclusions. Further support for them came from an unexpected source in the work of Jean-François Lyotard, whose appropriation of Kant was strikingly similar to that of Arendt. The result was an improbable constellation of Arendt, Lyotard, and, in a *sub rosa* way, Habermas in tension with another composed of deconstructionists like Derrida, Paul de Man, Philippe Lacoue-Labarthe, and Jean-Luc Nancy.

In certain ways, the following essay, "The Apocalyptic Imagination and the Inability to Mourn," carried on the same dispute, if in a very different context. Invited to contribute to a colloquium on "Thinking About the End: Fin-de-siécle and Apocalypse" in 1991,[20] I chose to probe the underlying sources of the puzzlingly tenacious hold of apocalyptic fantasies over the cultural imaginary of the West. Drawing on Freud's controversial conjectures about mourning and melancholy, and combining them with Kristeva's no less contested thoughts about the necessity of "matricide," I tentatively advanced an explanation in more explicitly psychoanalytic terms than I had been tempted to do in my prior work. The essay also sought to suggest an alternative to the constant repetition of the apocalyptic pattern. The latter was aimed in large measure at its post-modern version, whose surprising reinscription of traditional religious and modern scientific apocalyptic fantasies created a force field that warranted attention.

The next four essays can all be characterized as unforeseen spin-offs of my project on the French interrogation of vision. "The Rise of Hermeneutics and the Crisis of Ocularcentrism" was occasioned by a conference on Religious Texts and Social Locations.[21] It concluded with a frank acceptance of an unresolved tension between an essentially Habermasian call for at least some ocular distantiation and a poststructuralist acknowledgment, based on Christine Buci-Glucksmann's work on the baroque, of the difficulties in achieving it. "Scopic Regimes of Modernity" also invoked Buci-Glucksmann's model of baroque vision, alongside Svetlana Alpers's characterization of the Dutch "art of describing," as a counterweight to the dominant visual culture of modernity. The latter, which I called "Cartesian perspectivalism," need not be understood, I wanted to emphasize, as the sole scopic regime of the modern era. Written for a meeting on "Vision and Visuality" in 1988, it elicited insightful comments from members of the audience and the other participants, Hal Foster, Norman Bryson, Jonathan Crary, Rosalind Krauss, and Jacqueline Rose, which were included when the proceedings were published later that year

and have been retained here.[22] So too is a short postscript on its implications for urban space that was added to the talk when it was given to a conference on "The City" later that year.[23]

Insofar as "Scopic Regimes of Modernity" finished with a plea for encouraging the free play of different visual cultures, it seemed to one critic that I had succumbed to the "seductiveness of the liberal-pluralist conception of a 'synthetic' heterogeneity."[24] It was, however, precisely in the hope of resisting such a conclusion that a slightly earlier paper, "Ideology and Ocularcentrism: Is There Anything Behind the Mirror's Tain?" had been written for a conference on "Politics or Poetics" in 1987.[25] Here I sought to resist the temptation to abandon the concept of ideology because of its dependence on a discredited notion of visual mimesis (truth as the inverse of the distorted image in a *camera obscura*.) Rather than accept the implication of this discreditation that everything was equally ideological or equally valid, I argued, once again with an explicit nod to Habermas, that another standard existed by which ideological mystification might be measured: the support ideas gave to illegitimate relations of domination. The paper also gestured toward a solution to the riddle of what constitutes the "other" of ideology, a solution that drew on the varieties of visual experience and the metaphoric images they engendered.

The following essay on "Modernism and the Retreat from Form" continued the argument for the complexities of scopic regimes. A reviewer of the *Vision and Visuality* collection had querulously noted that my ideal types of modern vision left scarcely any place for more recent artistic practice: "Should one take it," he wondered, "that the modern era stopped in the later nineteenth century? No advantage is taken of the criticism of Cartesian perspectivalism offered by twentieth-century art and artists."[26] In this essay, which was prepared for a conference in 1990 on "Form in Art and Aesthetics,"[27] I tried to trace the subordinate tendency in modernist art that privileged formlessness over form. High modernism had challenged Cartesian perspectivalism in the name of a pure opticality prior to the distinction between looking subject and object on view. The countertradition of *informe*, as Bataille called it, preferred to stress the impurity of a visual experience suspended between what Lacan was to call the "eye" and the "gaze" or one that was paradoxically as much tactile as optical. Here, although the metaphor of a force field is not explicitly evoked, its presence can nonetheless be discerned, as I sought—drawing liberally on the recent work of Rosalind Krauss and Denis Hollier—to complexify the one-dimensional notion of modern art as inherently formalist and based on a search for pure opticality.

The final two essays address broader questions of method in intellectual history and the humanities. "The Textual Approach to Intellectual History" was prepared for a panel at the 1989 meeting of the American

Historical Association.[28] Lacking any sustained philological training, I
have tended more toward synoptic content analysis than careful readings
in the spirit of literary criticism, toward what LaCapra has recently called
"reading for the plot" rather than "plotting for the read."[29] But I have
also come increasingly to recognize the limitations of a method that too
effortlessly reduces texts to a pattern of inherent intelligibility, whose
genesis can then be explained by an even less problematized contextual
matrix. In this essay, however, I sought to go beyond the simple dichot-
omy of textualism and contextualism that has come to dominate many
recent polemics in intellectual history methodology. Instead, I discrimi-
nated among several possible textual approaches and found in at least
one of them an allegorical impulse that paradoxically invokes the trace
of nontextual "otherness" that goes beyond self-referential textuality.
Without explicitly invoking the concept of a force field, the essay tried to
set in motion an interplay of impulses that defy reduction to any one pole
of a putative opposition. I was pleased to discover shortly after its com-
pletion that Derrida himself had once described texts as "always a field
of forces: heterogeneous, differential, open."[30].

Finally, "Name-Dropping or Dropping Names? Modes of Legitimation
in the Humanities" probes the implications of how validity claims are
defended in disciplines that have long since lost any belief in a simple-
minded correspondence theory of truth. It was written for a conference
in 1988 on "Theory Between the Disciplines."[31] Why, I wondered, did
humanists so often tacitly rely on the legitimating authority of auratic
names rather than the force of the better argument in what Habermas
would call a communicatively rational interaction? Although I was by no
means willing to abandon the latter as an inherent premise of scholarly
work, the tenacity of name-dropping seemed to indicate it was fulfilling
some function that could not be entirely dismissed as ideological. Without
coming to any definitive conclusions, I offered several possible expla-
nations, which drew on a wide variety of discourses, including psycho-
analysis and deconstruction. Here too, as even the paper's formal struc-
ture—tacking between several opposing positions—unintentionally
reveals, the model of a force field tacitly informs the argument.

If that model's full potential is to be realized, I want to note in con-
clusion, one of its dimensions not yet highlighted must be given its due.
The conflict Benjamin evokes in the formulation cited above is not, it
should be noted, strictly speaking, between the present and the past,
although he says the force field is "penetrated by actuality." Rather it is
between "fore- and after-history," a translation of "vorgeschichte und
nachgeschichte," which can also be rendered "prehistory and posthis-
tory."[32] That is, a force field is constructed not merely of past and present
moments, but also by anticipation of the future. Conceiving that future

from the point of view of redemption may, as I mentioned previously, no longer arouse much enthusiasm, but the importance of its gravitational pull on our present conceptualization of the past cannot be ignored. Whether due to the discovery of new materials, the concoction of fresh interpretative theories or merely the working out of still unforeseeable narrative resolutions, historians inevitably operate with the expectation that the future will reconstruct a past that differs in important ways from our own version of it. The fiction of the "last historian" who gets the entire story right may be easy to dismiss, but we all operate, I think, with the assumption that "posterity" will enjoy a perspective we cannot now have.

Benjamin, to be sure, was also profoundly aware of the darker possibility of future forgetting; indeed his entire project can be profitably understood as a desperate attempt to rescue what was in danger of undeserved oblivion. Ironically,the current evocation of the concept of "posthistory" may itself indicate a sort of forgetting in its loss of faith in putative historical processes of emancipation, its resigned acceptance of the alleged failure of the "project of modernity."[33] Benjamin himself, of course, had only contempt for that project in its historicist guise, distrustful as he was of any assumption of automatic progress in human affairs. Unlike the current proponents of the claim that posthistory has already arrived, however, he firmly believed that it would be very different from what now passes for the end of the story. But only if the past were not forgotten, and its elements reconfigured instead in new force fields with the present and future, might such an outcome be reached. There is, I hope, a certain residue of that faith at least faintly palpable in the essays that follow.

1

Urban Flights: The Institute of Social Research between Frankfurt and New York

The theme of the city and the university provides a welcome opportunity to clarify an aspect of the Frankfurt School's history that has always troubled me. I refer to the vexed problem of its roots in the social and cultural conditions of its day, the link between its Critical Theory and the context that, in some sense or another, allowed it to emerge. As wary as I have always been of the sociology of knowledge in its more reductionist forms, I have never felt comfortable either with the School's reticence about exploring its own origins, an attitude best expressed in Theodor Adorno's remark that "a stroke of undeserved luck has kept the mental composition of some individuals not quite adjusted to the prevailing norms."[1] Even luck, deserved or not, seems to me worth trying to explain and perhaps in the case of the Frankfurt School, looking at its relations to the cities and universities with which it was connected may provide some help. For after all, it is not every group of intellectuals whose very name suggests both an urban and an academic link.

Even more understanding may ensue if we remember that the sobriquet "Frankfurt School" was only a late concoction of the 1960s and was never perfectly congruent with the Institute of Social Research out of which it came. The disparity between the research institute and the school of thought that emerged within its walls has in fact led some observers to call into question the coherence of the phenomenon as a whole. No less involved a figure than Jürgen Habermas has recently remarked that although the Institute continues, "there is no longer any question of a school, and that is undoubtedly a good thing."[2]

However, rather than abandoning the search for coherence because of the historical and nominal displacements of the institute and the school, it seems to me more fruitful to acknowledge the unsettled nature of a

cultural formation that nonetheless did retain a certain fluid identity over time. As I have tried to argue in my study of Adorno, that identity may best be understood as the product of a force field of untotalized and sometimes contesting impulses that defy any harmonious integration.[3] In that work, I identified several salient forces in Adorno's personal intellectual field: Hegelian Marxism, aesthetic modernism, cultural mandarinism, a certain Jewish self-awareness and, from the point of view of the reception rather than generation of his ideas, poststructuralism. If we add psychoanalysis and a nuanced appreciation of Max Weber's critique of rationalization, we can perhaps see the major forces operating to constitute the intellectual field of both the Institute and the School, at least until the time of Habermas's introduction of several new elements from linguistics, cognitive psychology, hermeneutics, and anthropology.[4] Now, to do justice to all of the constellations of these elements during the various phases of the group's history is obviously beyond the scope of this paper. Instead, what I would prefer to do is focus on only a few of them and explore the possibility that their interaction may in some way reflect the School's genesis in its specific urban and academic contexts.

To make these connections will perhaps be especially revealing because the members of the School themselves rarely, if ever, thought to make them. In fact, with the salient exception of Walter Benjamin, himself only obliquely related to the Institute, its members never directed their attention to the important role of the city in modern society.[5] Perhaps because they knew that the critique of urban life was the stock and trade of antimodernist, protofascist ideologies—a point clearly made in Leo Lowenthal's celebrated 1937 critique of Knut Hamsen[6]—they aimed their own critiques at other targets. Georg Simmel's explorations of metropolitan life or the urban sociology of the University of Chicago's Robert Park had little resonance in their work. In fact, it was not until the Institute returned to Germany after the war that it participated in an empirical community study, that of the city of Darmstadt.[7] And even then its members warned against the dangers of isolating their results from a more theoretically informed analysis of society as a whole.[8] Frankfurt itself, the environment that nurtured their own work, was never an object of systematic analysis.

No less ignored during the School's earlier history was the role of the university. Perhaps because an emphasis on education was characteristic of the Revisionist Marxism they scorned, it was not one of the members' central preoccupations. Only after their return to Frankfurt, when Horkheimer in particular was deeply involved in the reconstitution of the German higher educational system, did a Frankfurt School member seriously ponder the importance of academic issues.[9] Far more characteristic of their first Frankfurt period is the caustic remark of the young and still militant Horkheimer in his essay collection *Dämmerung* that the absorp-

tion of Marxism into the academy as a legitimate part of the curriculum was "a step towards breaking the will of the workers to fight capitalism."[10]

What makes such a charge so ironic, of course, is that the Institute itself clearly did not emerge out of the working class, but rather from a particular stratum of the urban educated bourgeoisie (the *Bildungsbürgertum*) in crisis. As such, it has been seen by some observers as the first instance of an elitist Western Marxism distanced from the real concerns of the masses.[11] Whether or not this is fair to the complexities of its members' development, it does correctly register the fact that the Institute must be understood as much in the context of what Fritz Ringer has called "the decline of the German mandarins"[12] as in that of the working-class struggle for socialism. What, however, made the Institute's unique achievement possible was the specific urban and academic situation in which its particular response to that decline was enacted. To understand that situation, we will have to pause for a moment and focus on certain features of Frankfurt am Main prior to the Institute's foundation.

The old imperial free city had been a center of international trade and finance since the Middle Ages, even if its hegemony had been challenged by the rise of Basel, Mannheim, and especially Leipzig in the eighteenth century.[13] Along with its economic prosperity went a certain political autonomy from the larger German states, which survived until its absorption into Prussia in 1866. The ill-fated parliament in the Paulskirche in 1848 reflected the city's symbolic role as a center of liberalism, as well as its earlier function as the site of the Holy Roman Emperor's election and coronation. Not surprisingly, the greatest organ of German liberalism, the *Frankfurter Zeitung*, was founded in the city by Leopold Sonnemann in 1856.

Frankfurt was also distinguished by its large and relatively thriving Jewish community, which numbered some 30,000 members during the Weimar years and was second only to Berlin's in importance. Originally protected by both the emperor and the city council, it weathered the enmity of gentile competitors and the political reverses of the post-Napoleonic era to emerge after 1848 as an integral part of the city's economic, social, and political life.[14] Although assimilation was probably as advanced as anywhere else in Germany, Frankfurt's Jews were noted for their innovative response to the challenges of modernity. Reform, conservative, and orthodox branches of Judaism were creatively developed within its walls.[15] It was, of course, in the Frankfurt of the 1920s that the famous Freie Jüdische Lehrhaus was organized around the charismatic rabbi Nehemiah Nobel, bringing together such powerful intellectuals as Franz Rosenzweig, Martin Buber, and Ernst Simon.

Although lacking its own university until 1913,[16] Frankfurt had enjoyed a long tradition of private support for scholarly institutions, stretching

back to the efforts of Dr. Johann Christian Senckenberg in the eighteenth century. When the university was founded as the amalgamation of several of these academies and institutes, it was a so-called *Stiftungsuniversität*, funded by private contributors, often from the Jewish community, rather than by the state.[17] The philanthropist Wilhelm Merton, an assimilated Jewish director of a giant metallurgical concern, was the major benefactor. Independent of the anti-Semitic and increasingly statist university system that had long since left behind the liberal intentions of its founder Wilhelm von Humboldt,[18] the new Frankfurt University offered a radical departure in German academic life on the eve of the war. Its self-consciously modern outlook was demonstrated by its being the first German university not to have a separate theology faculty and by its express willingness to open its ranks to a broader range of students and faculty.

Before the war, Merton had also funded a mercantile academy and an institute for public welfare, which have been seen as the prototype for the research institutes that were launched after 1918.[19] Included in their number was one founded in 1923 with the backing of a millionaire grain merchant, Hermann Weil, which chose the name *Institut für Sozialforschung*. This is not the place to retell the story of that founding, a task recently performed in detail by the German historian Ulrike Migdal,[20] but several points merit emphasis. First, the relative autonomy of the Institute, guaranteed by Weil's largesse, was very much in the time-honored Frankfurt tradition of private, bourgeois underwriting of scholarly enterprises. Although after the war and the inflation, the university itself had to call on state support to survive, Weil's continued generosity, combined with his aloofness from the Institute's actual work, meant that it was remarkably free from political and bureaucratic pressures. Although an attenuated link with the Prussian state was forged through an arrangement that specified the Institute's director had to be a university professor, clearly something very different from a traditional academic institution was created.

The difference was manifested in several important ways. First, unlike the many seminars and institutes that proliferated during the Wilhelmian era,[21] the Institute of Social Research was not dedicated to the goal of scientific specialization and compartmentalization. Instead, it drew on the concept of totalized, integrated knowledge then recently emphasized by Georg Lukács in his influential study *History and Class Consciousness*.[22] Although the early leadership of the Institute was by no means explicitly Hegelian Marxist, it nonetheless eschewed the fragmentation of knowledge characteristic of bourgeois *Wissenschaft*. Second, the Institute was launched solely to foster research and without any explicit pedagogical responsibilities. This privilege meant, among other things, that the traditional mandarin function of training an educated elite designed to serve

the state, a function that had become increasingly onerous during the Wilhelmian years,[23] was completely absent from the Institute's agenda. That agenda, and this is the third obvious difference from normal academic institutions, included the critique and ultimate overthrow of the capitalist order.

The irony of a millionaire businessman like Hermann Weil supporting such a venture has not been lost on subsequent observers from Bertolt Brecht on.[24] Perhaps Weil's son Felix, the disciple of Karl Korsch on whose urging the Institute was created, had sugarcoated the pill by saying that it would be devoted only to the dispassionate study of the workers' movement and anti-Semitism. Perhaps, Migdal has speculated, the senior Weil was cynically hoping for access to the Soviet grain market through the goodwill accumulated by linking his Institute to the Marx-Engels Institute in Moscow. For whatever reason, the Institute of Social Research was the first unabashedly Marxist enterprise to be connected to a university in Germany and most likely anywhere else outside of the USSR. As such, it had led to the suspicion that the proper context in which to situate its founding is neither urban nor academic, but political. One particularly wild and unsubstantiated version of this contention is Lewis Feuer's bizarre suggestion that it might well have been a Willi Münzenberg front organization that soon became a "recruiting ground . . . for the Soviet espionage service."[25]

Despite the absurdity of this particular charge, it is of course true that the Institute was not founded in a political vacuum. Several of its earliest members did, in fact, have personal links to radical parties, most notably the German Communist Party (KPD).[26] And there was a friendly interchange with David Ryazanov's Institute in Moscow, largely having to do with the preparation of the Marx-Engels Gesamtausgabe. The student nickname "Cafe Marx" was thus not unwarranted. And yet, what is no less true and ultimately of more importance is that the Institute was never institutionally linked with any faction, sect, or party on the left, nor did it hew to any single political or even theoretical line during its earliest years. In this sense, the popular notion of a "school," which was rarely applied to earlier groups of Marxist intellectuals,[27] along with that of a research institute, does capture an important truth about its status. Neither a traditional academic institution, nor a party-oriented cadre of theoreticians, the Institute members presented something radically new in the history of leftist intellectuals.

The notion of a school implies not only detachment from practical concerns, but also the presence of a guiding figure setting the program of inquiry. To the extent that such a master figure was able to emerge, and it was perhaps not until Horkheimer replaced Carl Grünberg as official director that one did,[28] the Institute's constitution made it possible.

For it gave the director explicitly "dictatorial" powers to organize research. According to the sociologist Helmut Dubiel, an elaborate interdisciplinary program was inaugurated by Horkheimer on the basis of Marx's model of dialectical *Forschung* and *Darstellung*, research and presentation, in which philosophy oriented and was in turn modified by social scientific investigation.[29] How closely the Institute actually followed this model has been debated, but it is clear that for a long time, the common approach known after Horkheimer's seminal 1937 essay as Critical Theory[30] did give the work of most Institute members a shared perspective.

To understand Critical Theory's provenance, however, we cannot stay solely within the confines of academic or political life in the Weimar Republic. For it was the cultural milieu of Frankfurt itself that also played a crucial role. Although not as stimulating an environment for nonacademic intellectual pursuits as prewar Munich or postwar Berlin,[31] Frankfurt could still boast a cultural atmosphere open to the most experimental currents of Weimar life. A rapid *tour d'horizon* reveals a variety of important innovations. Frankfurt, for example, was the locus for the great modernist workers' housing projects of Ernst May, the city's chief architect after 1925. Along with such contributions to interior design as Schütte-Lihotsky's famous "Frankfurt kitchen," these monuments to socially conscious functionalism earned Frankfurt the honor of being called "the first twentieth-century city" by one recent observer.[32]

It was also in Frankfurt that the recent invention of the radio took on a new and powerful role as an experimental cultural medium.[33] The Süddeutsche Rundfunk was the third station in Germany to be established, after Berlin and Leipzig. Rather than pandering to the lowest common denominator of taste, Radio Frankfurt, as it was popularly known, often scheduled concerts of the most challenging modern music and broadcast innovative radio plays and serious lectures on a wide variety of subjects. The so-called "wandering microphone" of reporters like Paul Lavan opened up perspectives on modern urban life that have been likened to the documentary films of William Ruttman, the director of the celebrated "Berlin: Symphony of a City."[34]

It was in Frankfurt as well that the *Frankfurter Zeitung*, then under the direction of Sonnemann's grandson Heinrich Simon, allowed writers like Siegfried Kracauer, Joseph Roth, Soma Morgenstern, and Benno Reifenberg to analyze a broad spectrum of cultural and social issues in its famous feuilleton section. The city was also the home for one of the first German psychoanalytic institutes, established in 1929 under the direction of Heinrich Meng and Karl Landauer. No less characteristically innovative was the city's decision the following year to grant its highest honor, the Goethe Prize, to the still controversial Sigmund Freud.[35] If we add to this picture the Jewish Renaissance sparked by the already mentioned Frankfurt Lehr-

haus, we have a sense of how lively and progressive nonuniversity life could be in Weimar Frankfurt.

As a result, many members of the Institute of Social Research were able to leave their academic ghetto behind and enjoy intimate contact with an experimental and often modernist urban culture. At the Cafe Laumer on the corner of the Bockenheimer Landstrasse and the Brentanostrasse, they created on off-campus outpost that attracted many nonuniversity intellectuals. Years later, the writer Ernst Erich Noth would remember the "Nachseminar" conducted there by the young Theodor Wiesengrund Adorno as far more stimulating than anything going on at the university itself.[36] Through friendships with Kracauer, closest in the cases of Lowenthal and Adorno, members of the Institute had ties to the *Frankfurter Zeitung*, which also carried the work of a later colleague, Walter Benjamin. Also by way of personal ties, especially with Ernst Schoen, several Institute figures were given access to Radio Frankfurt, where they held forth on cultural questions, including the modern music Adorno was so anxious to promote. In the early 1920s, there were also important links between the Frankfurt Lehrhaus and future Institute figures, most notably Lowenthal and Fromm.[37] Similar ties were forged with the Frankfurt psychoanalysts at the end of the decade. Not surprisingly, one Institute member, Lowenthal, played an important role in initiating the city's decision to honor the founder of psychoanalysis in 1930.[38]

Even the Institute's new building, a spare, fortresslike edifice built by Franz Röckle on the corner of the Bockenheimer Landstrasse and the Victoria Allee, bespoke a kinship with urban modernism. Posing a visual challenge to the ornately decorated villas in Frankfurt's fashionable West End, the *Neue Sachlichkeit* structure expressed the Institute's defiance of the outmoded cultural ambiance of the Wilhelmian past. Although Horkheimer was later to criticize the spirit of the *Neue Sachlichkeit* in general as too technologically rationalist and thus complicitous with reification,[39] the Institute's building was initially understood as an expression of the no-nonsense goals of a Marxist research institute dedicated to the unmasking of the illusory facades of bourgeois society.

If, however, the Frankfurt School's debt to the nonacademic modernist culture of its urban environment must be acknowledged, so too must its measured distance from it. As in the case of their relation to the university, most Institute members maintained a certain aloofness from the urban cultural scene and the intellectual milieu it fostered. If one compares their status with that of friends like Kracauer or Benjamin, who were entirely outside of the academic hierarchy,[40] it is possible to see the effects of this distance. The latter were often dependent on the demands of the cultural marketplace in ways that influenced the form and substance of their work, which tended to be less systematic and more journalistic. Not surprisingly,

Kracauer and Benjamin wrote more frequently on mass culture and urban life than Institute members, and they generally did so with a more nuanced appreciation of their implications. Here the influence of Simmel's pioneering explorations of metropolitan life was clearly discernible.[41] Moreover, as demonstrated by Kracauer's 1931 essay on the economic pressure on all writers to become journalists and Benjamin's 1934 discussion of the author as producer,[42] they were far more vulnerable to the proletarianization of intellectual life than the more privileged members of the Institute. The contrast is demonstrated by their differing responses to the worsening crisis of Weimar's political and cultural scene, which was already evident in ominous changes in the direction of the *Frankfurt Zeitung* and Radio Frankfurt in the last years of the Republic.[43] Whereas Kracauer and Benjamin had great personal and professional difficulties in the 1930s, the Institute was able to make provisions for an orderly escape from Germany in 1933 with virtually all of its resources, save its library, intact.

In short, the Institute's relations with both the official university structure and the modernist urban subculture—and one might add the radical political parties of the day as well—were always somewhat eccentric and marginal. The phenomenon that later became known as the Frankfurt School was thus never merely a direct product of its urban or academic origins, nor of any organized political movement. Rather, it emerged as the dynamic nodal point of all three, suspended in the middle of a sociocultural force field without gravitating to any of its poles. Hostage to no particular defining context, it hovered in a kind of intellectual no-man's land. This ambiguous status, as might be expected, was even more strongly exacerbated after its flight from Frankfurt via Geneva to New York in 1934. For here the distance between the Institute and American university life, as well as the urban culture of its adopted city, grew more attenuated than it had been in relation to their preexilic German counterparts. And, of course, whatever links any of its original members may have had with political praxis in Weimar were now utterly shattered.

The Institute's move to Columbia University in 1934 has recently been the occasion for a polemic launched by Lewis Feuer in the English journal *Survey*.[44] Having been a participant in the exchange that followed, I don't want to rehearse all of its unpleasantness now. I would only want to emphasize that Feuer's attempt to turn the Institute members into a bunch of fellow-traveling crypto-Communists who duped a naive Columbia administration into welcoming them to New York is incompatible with the complicated triangulated reality of their initial Frankfurt years. As we have seen, that story cannot be flattened out into an essentially political narrative of the kind that Feuer, with his penchant for conspiracy theories, imagines. In New York, the Institute's financial self-sufficiency, main-

tained at least until the end of the 1930s, meant that it could enjoy the luxury of relative withdrawal from all of its originally defining contexts, academic, urban, and political. Unlike other less fortunate émigrés, its members could generally avoid the compromises forced by the exigencies of their situation. Continuing to write almost exclusively in German, confining their teaching to the occasional course in the Columbia extension program, only rarely opening the pages of their journal to American authors,[45] they managed to keep the local academic world at arm's distance. Although ties with the Sociology Department at Columbia were slowly developed, they were as likely to be through other refugees like Paul Lazarsfeld as through native scholars like Robert Lynd or Robert MacIver. Virtually no sympathetic connections appear to have been made with the philosophers in New York. Collaborative projects with Americans did not materialize until the 1940s and then often under nonuniversity auspices, such as the American Jewish Committee, the Jewish Labor Committee or the Central European Section of the Office of Strategic Services (OSS). And although some younger American scholars, later to gain prominence, such as M. I. Finley, Alvin Gouldner, C. Wright Mills, and even Daniel Bell,[46] were influenced by their fleeting contacts with the Institute, it would be impossible to call them legitimate students of a school. In short, relatively secure behind the walls of the building at 429 West 117th Street, provided by Columbia, the Institute remained a hidden enclave of Weimar culture in exile and not in any meaningful way a part of American academic life.

If one looks at the building itself and compares it with the one the Institute left behind in Frankfurt, another difference from its German days can be noted. Rather than a visual provocation to the surrounding environment, a symbol of its inhabitants' defiant modernism and innovative Marxism, the building on 117th Street was merely one of a row of similarly innocuous brownstones, with pseudoclassical columns and balustrades flanking the entrance. As such, it unintentionally expressed the Institute's wariness about standing out in a vulnerable way in its new surroundings. Understandably anxious about their status as exiles, often reluctant to address specifically American issues out of ignorance, unsure of their own political direction, and cautious about highlighting the radicalism of their past, the Institute members remained aloof from any oppositional intellectual movement in the 1930s and early 1940s.[47] When Horkheimer and Adorno moved to southern California in 1941, they were absorbed almost entirely into the German exile community there. They seem to have had little to do with either the academic or urban intellectual culture of Los Angeles, such as it was in those days. In fact, as the wrenchingly painful aphorisms in Adorno's *Minima Moralia* demonstrate, their alienation from any nurturing context was never as great as during those years.[48] Only

the collaboration with the Berkeley Public Opinion Study Group in the late 1940s, which led to the publication of *The Authoritarian Personality*, broke this pattern. As for those Institute members who remained on the East Coast, such as Neumann, Marcuse, and Lowenthal, it was only in connection with governmental service during the war that they began sustained interactions with American intellectuals.[49]

Symptomatic of the Institute members' general isolation from the non-academic intellectual urban life of their host country is the fact that in the now rapidly proliferating histories of the most important group of American cultural figures of the 1930s and 1940s, the so-called New York intellectuals, their names are rarely to be found.[50] Although they shared many of the same leftist and modernist sympathies as writers around such journals as *The Partisan Review*, there seems to have been virtually no contact between them. Only in the debate over mass culture did Americans like Dwight MacDonald find any inspiration in Frankfurt School ideas before the war's end.[51] It was not until well after the Institute's return to Germany that an American oppositional culture, and then an oppositional political movement, began to recover the work done by the Institute during its exile.[52]

It was, of course, only during the second Frankfurt period of the Institute, begun when Horkheimer, Pollock, and Adorno returned for good in the early 1950s, that its isolation from its academic, urban, and ultimately political contexts was undone. Now for really the first time, the Frankfurt School, as it soon became known, was no longer relatively marginalized. Lured back by some of the same officials who had blithely presided over the dissolution of the Institute's unrescued property during the Nazi era,[53] its leaders were feted as honored links with the Weimar past. Horkheimer was elected rector of the University of Frankfurt in 1951 and reelected the following year. He wrote and lectured on matters of educational policy and gave frequent interviews to the press on a wide variety of timely subjects.[54] The columns of the Frankfurt newspapers and the airwaves of its radio station were open to him and Adorno, who overcame their animosity to the mass media in a self-conscious effort to influence public opinion. Even the new Institute building, to return to an indicator we have examined previously, bespoke a certain fit with postwar Frankfurt. Although it was similar to the *Neue Sachlichkeit* structure of the 1920s, it was now perfectly in accord with the International Style architecture then rising on the ruins of the bombed out inner city. Thus, while it would certainly be overstated to say that the Institute leadership had made its peace with the modern world, it was palpably less estranged from it than during either its first Frankfurt era or its exile in America.

Ironically, however, in a short time, the new public for its work become increasingly curious about the ideas formulated during those earlier pe-

riods. And much to the discomfort of Horkheimer in particular, many of his readers insisted on applying them to contemporary problems. Although this is not the place to analyze the Frankfurt School's complicated relationship to the German New Left, it should be noted that it was largely the ideas generated before that reception began that earned the School its reputation. It is thus appropriate to return in conclusion to the question, posed earlier, of the relation between Critical Theory and the Institute's academic and urban environments during its most creative and formative years, the years before it found its audience. Can we, in other words, make sense of the force field of its intellectual impulses by situating them in their generative contexts?

The most important of those forces, it bears repeating, were Hegelian Marxism, cultural mandarinism, aesthetic modernism, Jewish self-awareness, psychoanalysis, Weberian rationalization theory, and poststructuralism. The last of these, as mentioned earlier, makes sense only from the point of view of the School's reception rather than its genesis, and so cannot be meaningfully linked to the contexts we have described, even if we want to emphasize, as some commentators have recently done, the links between Jewish hermeneutic traditions and poststructuralist thought.[55] What of the others? Although a renewed interest in Hegel can be discerned in the 1920s in certain university circles,[56] Hegelian Marxism was clearly a product of the politically generated reconceptualization of Marxist theory begun by Lukács and Korsch outside the academy. During the Grünberg years, the Institute itself was not really beholden to a Hegelian Marxist methodology, even if, as we have seen, its program was aimed at overcoming the fragmentation of bourgeois *Wissenschaft*. Moreover, insofar as one of the chief implications of the recovery of the Hegelian dimension in Marxism was the unity of theory and practice, to the extent that the Institute was a nonpolitical research enterprise, its specific institutional framework was at odds with the lessons of Lukács and Korsch.

And yet in one sense, we might find a link between the Hegelian Marxist component of Critical Theory, which was especially evident in the 1930s, and the Institute's peculiar academic status. By stressing the difference between appearance and essence and splitting the empirical class consciousness of the working class from its ascribed or objective class consciousness, Hegelian Marxism opened up the possibility of a vanguard speaking for the class it claimed to represent. In the case of Leninists like Lukács and, at least for a while, Korsch, that role was played by the Communist Party. For the Institute members who were not able to accept that solution, it was perhaps possible to see small groups of intellectuals fulfilling a similar function. That is, without fooling themselves into thinking they were substitutes for the revolutionary metasubject promised by

Hegelian Marxism, they could at least consider themselves the temporary repositories of its totalistic epistemological vantage point. The insulated and protected quality of the Institute, especially acute during its American exile, might therefore have helped sustain the assumption that the Frankfurt School, unsullied by the political and commercial compromises forced on most intellectuals, was the voice of the totality. Although this was a fragile hope, for reasons that I want to explore shortly, it might at least be explicable in terms of the Institute's peculiar academic status.

Similarly, the residues of cultural mandarinism in Critical Theory, its suspicion of technological, instrumental rationality, and almost visceral distaste for mass culture, might be explained in part by its exponents' attenuated links with the *Bildungsbürgertum* and the university system. The elitism, which Frankfurt School members often accepted as a valid description of their position, was thus not merely a function of the vanguardist implications of Hegelian Marxism; it also reflected their roots in a hierarchical academic structure. Acknowledging this possibility, however, must not blind us to the complicated relationship they had to that structure mentioned earlier. As a research institute in a privately initiated university, they were able to avoid the obligation of bureaucratic service to the state or the need to train its future leaders. Thus, they were never simply mandarins conservatively resisting challenges to the hegemony of their status group. Even though they adopted much of the pathos of Weber's theory of rationalization as an iron cage limiting the prospects of modernization, they never gave up the hope for an alternative future based on the realization of substantive reason denied by the more pessimistic mandarins.

Their refusal to follow the mandarin lesson of despair was motivated not only by their Marxist inclinations, but also by their general sympathy for the creative impulses we have seen were so prevalent in their urban environment. The messianic hopes evident in the Jewish Renaissance stimulated by the Frankfurt Lehrhaus were expressed in various forms and with different degrees of intensity in the work of such Institute figures as Fromm, Lowenthal, Benjamin, and Adorno.[57] So too the introduction of psychoanalytic themes in their work was facilitated by the hospitable climate Frankfurt provided for Freud's ideas. And, finally, the aesthetic modernism of Frankfurt, "the first twentieth-century city," found a ready echo in their defense of avant-garde art, even if more of the esoteric than exoteric kind represented by the *Neue Sachlichkeit*.[58]

Their preference for esoteric rather than exoteric modernism, the art of Schoenberg, Kafka, and Beckett rather than that of, say, the surrealists, suggests one final observation about the members' relation to their urban environment. As Carl Schorske has noted,[59] the ideal of the burgher city as an ethical community had informed the neohumanism of German

Idealists like Fichte. Often serving as an antidote to the competing image of the modern industrial city as an inhuman locus of alienation and vice, this model emphasized the possibility of reconstituting the civic virtue of the ancient polis or Renaissance city state. Now, although the Frankfurt of the early twentieth century may have approached this ideal in some modest respects, in the context of a national culture and polity as fragmented as that of Weimar Germany, it was clear that no genuinely ethical community could arise on an urban level alone. The Institute's members, with their penchant for totalistic explanations of social problems, never entertained the possibility that a renovated city life alone would make much difference. In addition, it might be speculated that the Hellenic ideal of the virtuous polis held little attraction for them because of their attenuated debt to a Hebraic tradition, whose nostalgia, as George Steiner has recently reminded us,[60] was more for a garden than a city. Reconciliation with nature was, in fact, one of their most ardently held goals, even if they were suspicious of attempts by *völkisch* and, one might add, Zionist thinkers to realize it without radical social change. Still, reinforced by the traditional Marxist expectation that communism would mean the overcoming of the very distinction between urban and rural,[61] they never speculated on the renewal of civic virtue as an end in itself.

When the Institute fled to New York, this dream must have seemed even more remote from reality. Not only were they foreigners precariously situated in an alien environment, that environment itself was even further removed from the ethical community ideal than Frankfurt had been. For as Thomas Bender has argued,[62] American cities like New York had long since ceased to support a vibrant metropolitan culture, and anything approaching a common intellectual life had been replaced by one-sided professional elites incapable of talking to each other about larger problems outside of their fields of knowledge. An interdisciplinary school of thinkers, whose institute was founded precisely to combat the specialization of apparently incommensurable discourses, could therefore only withdraw into itself under these circumstances. As a result, their holistic inclinations, already called into question by the failure of a universal class to appear, were further damaged by the lack of a true public during their years of exile. Not surprisingly, their very faith in the concept of totality itself was severely shaken by the time they returned to Germany after the war. As I have tried to demonstrate elsewhere,[63] their disillusionment was a central episode in the general loss of confidence in totality evident in the history of Western Marxism as a whole.

Even when they returned to a Frankfurt now anxious to listen to them, they were far too chastened by their American experience to hold out any hope for the dream of a city of virtue. Thus, as mentioned earlier, when they did engage in a community analysis, it was always with the

warning that the proper unit of analysis could not be merely urban, for the manipulation of popular consciousness by a national and even international culture industry precluded any purely urban renaissance of civic virtue. Although Jürgen Habermas later introduced the notion of a resurrected public sphere as a possible antidote to the totally manipulated consciousness of one-dimensional society, he did so with a definite awareness of the limits of the older model. "The question that is brought to mind," he recently argued, in an essay on "Modern and Postmodern Architecture,"

> is whether the actual *notion* of the city has not itself been superseded. As a comprehensible habitat, the city could at one time be architecturally designed and mentally represented. The social functions of urban life, political and economic, private and public, the assignments of cultural and religious representation, of work, habitation, recreation, and celebration could be *translated* into use-purposes, into functions of temporarily regulated use of designed spaces. However, by the nineteenth century at the latest, the city became the intersection point of a *different kind* of functional relationship. It was embedded in abstract systems, which could no longer be captured aesthetically in an intelligible presence. . . . The urban agglomerations have outgrown the old concept of the city that people so cherish.[64]

What lessons, if any, can be gleaned from this overview of the Frankfurt School's relations to the universities and cities with which it was associated during its history? First, it is evident that no straightforward, reductive contextual analysis can provide a satisfactory key to explain the content of the School's ideas. There were simply too many overlapping contexts—academic, urban, political, and we might have added personal and intellectual as well—to allow us to ground Critical Theory or the Institute's work in any one master context. Dominick LaCapra's contention in his powerful critique of just such an attempt, Janik and Toulmin's *Wittgenstein's Vienna*, is thus borne out by our analysis: no single-minded contextual account can arrogate to itself the power to saturate texts or constellations of ideas with one essential meaning.[65] Indeed, if the point made earlier with reference to the importance of the post-structuralist reception of Critical Theory is taken seriously, no generative contextualism, however open to multiple dimensions, can exhaust the meaning of a cultural phenomenon for us. Its force field necessarily includes both generative and receptive moments, and it is an illusion to think we can completely bracket out the latter in the hope of merely recapturing the former.

But some limited explanatory power must nonetheless be granted contextual analysis, if we remember the need to respect the untotalizability

of multiple contexts. In the case of the Frankfurt School, it is precisely the dynamic intersection and overlapping of discrete contexts that provided the stimulus to their work. Their constellation of tensely interrelated ideas, themselves never achieving a perfectly harmonious synthesis, was thus enabled by the irreducibly plural and often conflicting contexts of their lives. Without pretending that a perfect correspondence can be established between specific stars in their intellectual constellation and specific contexts out of which they emerged, I hope it has been demonstrated that some attention to their academic and urban situations helps demystify the claim of "a stroke of undeserved luck" as an explanation for their critical acumen.

One final observation is in order. It is a staple of intellectual history to credit social or cultural marginality with stimulating heterodox or innovative ideas. In the case we have been examining, it would be more accurate to speak of multiple marginalities, most notably those we have identified in relation to their academic, urban, and political contexts, and conceptualize the School and the Institute as nodal points (close, but not precisely identical) of their intersection. Or rather in the manner of a Venn diagram, we can see them occupying the overlapping area where three eccentric circles come together. The Frankfurt School's favorite phrase "*nicht mitmachen*," not playing along , thus comes to mean more than just a defiance of conventionality and political camp-following; it defines instead the very conditions of their intellectual productivity, and perhaps not theirs alone.

2

The Debate over Performative Contradiction: Habermas versus the Poststructuralists

Of the many laudable aspects of Jürgen Habermas's remarkable career, none is perhaps as striking as his consistent willingness to engage in constructive debate with a wide variety of critical interlocutors. There can, indeed, be few thinkers whose theoretical development has been so powerfully marked by public encounters with opponents over a lifetime of intense intellectual interaction. From his earliest debates with the German student movement in the 1960s and his participation in the "positivism dispute" with the followers of Karl Popper, through his exchanges with Hans-Georg Gadamer over hermeneutics and Niklas Luhmann over systems theory, up until his spirited involvement in the current controversies over postmodernism and the "normalization" of the German past, Habermas has been a courageous and responsible "public intellectual" of the kind rarely found in contemporary Western culture. He has, moreover, been patiently willing to learn from others involved in the collective project he has done so much to launch.[1] Although anyone who knows firsthand the passionate intensity with which he argues would hesitate before calling him a cold-blooded "saint of rationalism," as Gladstone once did John Stuart Mill,[2] Habermas is certainly one of the most cogent examples of the power of the communicative rationality he so fervently espouses.

This fit between Habermas's ideas and his actions is particularly important, for it draws our attention to an issue that is itself at the heart of his theory. I refer to the value of performative consistency, which is one of the reigning regulative ideals of his universal pragmatics. There can, in fact, be few more withering rebukes in his vocabulary than the charge of "performative contradiction," which he uses again and again to challenge the validity of his opponents' positions.

There is, however, to my knowledge, no sustained examination of the implications of this concept in his work, despite its central importance. Attempting such task is especially urgent, because the very same issue has been explicitly raised in much poststructuralist thought, but with radically different conclusions. Without hoping to arrive at a definitive resolution of a long-standing philosophical dispute, I want to use this opportunity to explore the multiple implications of the theme of performative consistency and contradiction. For in so doing, a central dimension of Habermas's achievement may become clearer.

A useful point of entry into the issue is the traditional dialectical notion of contradiction, which was still powerfully present in the work of Habermas's mentors in the Frankfurt School. Hegel's critique of Aristotelian logic as too formal and ahistorical has, of course, always had a strong, if at times controversial impact on Marxist thought.[3] Although dividing over the question of whether contradictions exist in nature and society or merely in society—Engels exemplified the former position, Lukács the latter—most Marxists have insisted that contradiction is an ontological reality, not merely a logical one. Thus, for example, Herbert Marcuse contended in *One-Dimensional Man* that "if dialectical logic understands contradiction as 'necessity' belonging to the very 'nature of thought' . . . , it does so because contradiction belongs to the very nature of the *object* of thought, to reality, where Reason is still Unreason and the irrational still the rational."[4] Similarly, Theodor Adorno claimed that "the dialectical contradiction expresses the real antagonisms which do not become visible within the logical-scientific system of thought."[5] Rejecting the charge that suspending the logic of noncontradiction leads inevitably to irrationalism, classically leveled by Karl Popper in his "What Is Dialectic?"[6], he insisted that "if one contaminates by association dialectics and irrationalism then one blinds oneself to the fact that criticism of the logic of non-contradiction does not suspend the latter but rather reflects on it."[7]

In subtle ways, however, Adorno distanced himself from the more straightforward Hegelian Marxist position represented by Marcuse. He did so by problematizing the normative alternative presupposed by the critique of contradiction: a perfectly positive dialectical sublation. Rather than embracing such a normative vantage point, Adorno came to see it as itself an expression of a potentially oppressive identity theory. Thus, in *Negative Dialectics*, he warned against the hypostatization of noncontradictoriness as the complete overcoming of all tensions and differences in a grand synthesis: "It is precisely the insatiable identity principle that perpetuates antagonism by suppressing contradiction. What tolerates nothing that is not like itself thwarts the reconciliation for which it mistakes itself. The violence of equality-mongering reproduces the contradiction it eliminates."[8] Reconciliation, for Adorno, thus paradoxically in-

cludes a moment of preserved contradiction, which is not merely an evil to be overcome. "The task of dialectical cognition is not, as its adversaries like to charge, to construe contradictions from above and to progress by resolving them—although Hegel's logic, now and again, proceeds in this fashion. Instead, it is up to dialectical cognition to pursue the inadequacy of thought and thing, to experience it in the thing."[9]

Whether or not Adorno was correct in his critique of Hegel,[10] the significance of his position is clear. By arguing against the goal of a perfectly noncontradictory world, in which logical and ontological categories would be seamlessly united, he opened the door for a more modest notion of contradiction, which would be meaningful for only certain aspects of social reality. As we will see shortly, Habermas was to walk through that door.

In another respect, however, Adorno defended a notion—or rather a practice—of contradiction that Habermas would tacitly reject. Continuing to use the tools of critical reason, Adorno nonetheless denounced the tyranny of the Enlightenment because of its totalitarian imposition of reason on a recalcitrant world. According to Habermas, "Adorno was quite aware of this performative contradiction inherent in totalized critique. Adorno's *Negative Dialectics* reads like a continuing explanation of why we have to circle about within this *performative contradiction* and indeed even remain there"[11] Unlike those who seek to escape the paradox of a rational critique of totalizing reason by denouncing reason *tout court*, Adorno, Habermas claims "wishes to endure in the performative contradiction of a negative dialectics, which directs the unavoidable medium of identifying and objectifying thought against itself. Through the exercise of endurance, he believes himself to be remaining most nearly faithful to a lost, non-instrumental reason."[12]

However much Habermas admired Adorno for refusing to force his way out of this dilemma or seek false consolations, however much he shared Adorno's reluctance to posit on ultimate unity of concept and reality, he nonetheless has sought to shift the terms of the argument about contradiction in a new direction, which would lead out of the aporias of the dialectic of enlightenment in its classical Frankfurt School formulation. Whereas Adorno remained terrified of the imposition of logical consistency on a world that should be nonidentical to its concept, insisting that conceptual representations can never be fully adequate to their objects, Habermas focused instead on the relations among subjects. The most extensive exposition of this change appeared in a passage from *Legitimation Crisis*, which bears quoting in its entirety:

> The concept of contradiction has undergone such attrition that it is often used synonymously with "antagonism," "opposition," or "conflict." Ac-

cording to Hegel and Marx, however, "conflicts" are only the form of appearance, the empirical side of a fundamentally logical contradiction. Conflicts can be comprehended only with reference to the operatively effective rules according to which incompatible claims or intentions are produced within an action system. But "contradictions" cannot exist be-tween claims or intentions in the same sense as they can between state-ments: the system of rules according to which utterances—that is, the opinions and actions in which intentions are incorporated—are produced is obviously different in kind from the system of rules according to which we form statements and transform them without affecting their truth value. In other words, the deep structures of a society are not logical structures in a narrow sense. Propositional contents, on the other hand, are always used in utterances. The logic that could justify speaking of "social contradictions" would therefore have to be a logic of the em-ployment of propositional contents in speech and in action. It would have to extend to communicative relations between subjects capable of speaking and acting; it would have to be a universal pragmatics rather than logic.[13]

For Habermas, in other words, contradictions exist less on the level of social *ontology*, as they did for Hegelian Marxists like Marcuse, than on that of intersubjective *communication*. Class societies have fundamental contradictions, he claims, only because "their organizational principle necessitates that individuals and groups repeatedly confront one another with claims and intentions that are, in the long run, incompatible."[14] *Legitimation Crisis* is devoted to explaining how such fundamental class contradictions can be displaced from the economic to other levels of social interaction. The plausibility of its argument is less important for us here than the link Habermas forges between contradiction and communication. He does, to be sure, also acknowledge that contradictions can be mean-ingfully applied to incompatibilities in the system maintenance mecha-nisms of societies, but he clearly prefers using the term to indicate com-peting claims to the truth by actors in the society, claims whose validity can be discursively weighed.

Despite his adherence in *Legitimation Crisis* to the notion of "dialectical contradiction," it may seem that Habermas has quietly returned to a more conventional Aristotelian alternative. Thus, for example, in his recent critique of deconstructionist ideas about contradiction, he claims, "there can only be talk about 'contradiction' in the light of consistency require-ments, which lose their authority or are at least subordinated to other demands—of an aesthetic nature, for example—if logic loses its conven-tional primacy over rhetoric."[15] What, however, takes this argument be-yond being a mere restatement of traditional logic is its emphasis on the performative dimension of language, the *use* of arguments in commu-nicative interaction rather than the consistency of statements or propo-

sitions per se. A performative contradiction does not arise when two antithetical propositions (A and not A) are simultaneously asserted as true, but rather when whatever is being claimed is at odds with the presuppositions or implications of the act of claiming it. To use the terminology of J. L. Austin and John Searle, to which Habermas is indebted, it occurs when the locutionary dimension of a speech act is in conflict with its illocutionary force, when what is said is undercut by how it is said. For instance, according to Habermas, the communicative use of language harbors an immanent obligation to justify validity claims, if need be. When the claims one makes on a locutionary level deny the very possibility of such a justification, then a performative contradiction is committed.

A particularly strong version of this argument, going somewhat beyond Habermas's more cautious formulations, can be found in the work of Karl-Otto Apel, who has claimed that like it or not, humans are necessarily socialized into a transcendental-pragmatic language game from which they withdraw at the peril of autistic isolation or even suicide. One cannot make a "decision" to join or abstain from participating in this language game, he contends, "since any choice that could be understood as meaningful already presupposes the transcendental language game as its condition of possibility. Only under the rational presupposition of intersubjective rules can deciding in the presence of alternatives be understood as meaningful behavior."[16]

Although uncomfortable with the transcendental basis of Apel's position, which entails a foundationalism he feels is untenable, Habermas often adopts a similar strategy against certain of his opponents. Those whose ideas derive from Nietzsche are especially inviting targets, for their illocutionary practice seems most radically in tension with their locutionary assertions. That is, they employ methods of argumentation that tacitly entail intersubjective validity testing to defend a position that denies communicative rationality its legitimacy. As Habermas puts it with reference to Adorno's negative dialectics and Derrida's deconstruction, "the totalizing self-critique of reason gets caught in a performative contradiction since subject-centered reason can be convicted of being authoritarian in nature only by having recourse to its own tools."[17]

Other examples of Habermas's reliance on the critical leverage of the performative contradiction argument might be given, but by now its importance for his position should be clear. He uses it, first, to criticize inconsistencies in his opponents' argumentative practice and, second, to provide a standard by which social contradictions can be judged now that the older Hegelian Marxist model of ontological contradiction is no longer viable. How successful, we now must ask, has he been in defending its effectiveness for these purposes? How, in particular, has his defense func-

tioned as an antidote to the poststructuralist critique of communicative rationality? To answer these questions requires giving that critique a careful reading. Although there are several possible versions from which to choose, let me focus on three in particular, those offered by Michel Foucault, Rodolphe Gasché, and Paul de Man.[18]

Foucault's critique appeared in his 1966 encomium to the critic and novelist Maurice Blanchot, "The Thought from Outside."[19] Its opening section is devoted to the theme "I speak, I lie." Foucault begins by evoking the ancient Greek "liar's paradox," Epimenides the Cretan's self-contradictory assertion that "all Cretans are liars." In condensed form, it is the statement "I lie," which Foucault contrasts with the apparently self-consistent statement "I speak." But surprisingly, he contends that the latter is more problematical than the former. That is, the liar's paradox can be solved if we recognize that a distinction can be made between two propositions, one of which is the object of the other.[20] For there is no logical contradiction between the Cretan saying something about a class of people of which he is a member, if the two propositions are on different levels.

The "I speak," which at first glance seems to be lacking even a superficial paradoxical tension, in fact raises more fundamental problems, according to Foucault. ' "I speak' refers to a supporting discourse that provides it with an object. That discourse, however, is missing; the sovereignty of 'I speak' can only reside in the absence of any other language"[21] Such an absence seems to grant the speaking subject an enormous originary power, but, so Foucault claims, it is really the opposite that is true. For the supposed void surrounding the "I speak" is really "an absolute opening through which language endlessly spreads forth, while the subject—the 'I' who speaks—fragments, disperses, scatters, disappearing into that naked space In short, it is no longer discourse and the communication of meaning, but a spreading forth of language in its raw state, an unfolding of pure exteriority."[22] It is precisely modern literature, such as that of Blanchot, which best registers this exteriority of language to the speaking subject.

The challenge Foucault presents to the cogency of performative contradiction thus arises from his positing of the exemplary character of a literary language that is wholly exterior to the intentionality of a speaking subject. If in this use of language, there is no meaningful actor responsible for the speech acts whose locutionary and illocutionary dimensions can be consistent or contradictory, then it makes little sense to employ performative criteria to judge the value of arguments or to characterize social tensions.

Moreover, what if the very idea of contradiction is a misnomer when applied to all varieties of linguistic interaction? This is the troubling ques-

tion asked by the second poststructuralist critic I want to introduce whose work bears on the question at hand, Rodolphe Gasché. Whereas Foucault posits a linguistic level exterior to pragmatic interaction, but doesn't really flesh out its implications,[23] Gasché develops Derrida's richly articulated analysis of the aporetic workings of language on all its levels. In *The Tain of the Mirror*, he argues that deconstruction "starts with a systematic elucidation of contradictions, paradoxes, inconsistencies, and aporias constitutive of conceptuality, argumentation, and the discursiveness of philosophy. Yet these discrepancies are not logical contradictions, the only discrepancies for which the philosophical discourse can account. Eluded by the logic of identity, they are consequently not contradictions properly speaking."[24] If they are not to be understood as logical contradictions, then what are they? Gasché answers that "deconstruction attempts to 'account' for these 'contradictions' by 'grounding' them in 'infrastructures' discovered by analyzing the specific organization of these 'contradictions'."[25] These basic infrastructures are what Derrida variously calls archetraces, *différance*, supplementarity, iterability, re-marking, dissemination, and so on. Whatever one makes of these terms, they are not to be understood as equivalent to contradictions. For they can never be resolved in a dialectical way through some kind of higher synthesis. They always subtend any more logical use of language, which can never efface their disruptive effects. Even as a regulative ideal, a noncontradictory sublation would entail the restitution of what Gasché claims was the traditional philosophy of speculative reflection, what Adorno would have called identity theory.

According to Gasché, Austin's attempt to transcend a mentalist philosophy of reflection by turning to speech acts "amounts to nothing more or less than the surreptitious reintroduction of the problem of reflection in order to solve the problems left in the wake of logical positivism. His revolution consisted of hinging the entire representational function of language, with which Russell and Whitehead were exclusively concerned, on a constituting self-reflexivity of the linguistic act."[26] Insofar as Habermas has adopted an Austinian notion of performance, he too falls prey to a philosophy of identitarian reflection, despite his repudiation of the mentalist fallacy.[27] If we abandon reflection philosophy, Gasché concludes, we must also cease trying to apply logical categories like contradiction to linguistic performance, which can never be disentangled from the heterological infrastructures "beneath" or "behind" the level of pragmatic utterances.

Still another way to conceptualize this noise in the logical system entails accepting the existence of something called contradictions, but denying the possibility of ever overcoming them. One of the most influential versions of this strategy appears in Paul de Man's analysis of Nietzsche in

Allegories of Reading.[28] Here de Man defends in Nietzsche precisely what Habermas criticizes: his willing embrace of performative contradiction, which resulted from his appreciation of the undecidable dimensions of linguistic performance. "Already in *The Birth of Tragedy,*" he claims, "Nietzsche advocates the use of epistemologically rigorous methods as the only possible means to reflect on the limitations of these methods. One cannot hold against him the apparent contradiction of using a rational mode of discourse—which he, in fact, never abandoned—in order to prove the inadequacy of this discourse."[29] Why can't one hold it against him, as Habermas clearly does? De Man begins his answer by approvingly citing Nietzsche's own observation, showing his debt to Kant (filtered through Schopenhauer), that "great men, capable of truly general insight, were able to use the devices of science itself in order to reveal the limits and relativity of all knowledge, thus decisively putting into question the scientific claim to universal validity and purpose."[30] In other words, there is nothing problematic in using the scientific method to show the limits of scientific knowledge. Here, however, one might reply that what is being challenged is only an overinflated claim to knowledge, which was never a necessary implication of the scientific method properly understood.

De Man's second answer is more substantial. It entails a careful reading of the tension between the thematic and rhetorical implications of *The Birth of Tragedy.* As might be expected, he finds the work divided against itself: "For all its genetic continuity, the movement of *The Birth of Tragedy,* as a whole as well as in its component parts, is curiously ambivalent with regard to the main figures of its own discourse: the category of representation that underlies the narrative mode and the category of the subject that supports the all-pervading hortatory voice."[31] These and other ambivalences in Nietzsche's work are not, however, to be taken as signs of weakness, as Habermas would probably contend. "Have we merely been saying that *The Birth of Tragedy* is self-contradictory and that it hides its contradictions by means of a 'bad' rhetoric?" de Man asks. "By no means; first of all, the 'deconstruction' of the Dionysian authority finds its arguments within the text itself, which can then no longer be called simply blind or mystified. Moreover, the deconstruction does not occur between statements, as in a logical refutation or in a dialectic, but happens instead between, on the one hand, metalinguistic statements about the rhetorical nature of language and, on the other hand, a rhetorical praxis that puts these statements into a question."[32] In short, for Nietzsche and de Man, there is an inevitable disparity between the content of an assertion and the rhetoric of its expression.

This conclusion is at odds with the tradition of defining and then decrying contradictions in two ways. First, against the older Aristotelian tradition, it rejects the imposition of logical categories onto the world. De

Man endorses Nietzsche's contention that our reluctance to affirm and deny one and the same thing "is a subjective empirical law, not the expression of any 'necessity' *but only of an inability.*"[33] That is, the apparent truth of logical propositions is only the result of an arbitrary human fiat. "In fact," Nietzsche continues, "*logic* (like geometry and arithmetic) applies only to *fictitious truths [fingierte Wahrheiten] that we have created.*"[34] Like Adorno with his anxiety about the domination of nature by concepts, de Man follows Nietzsche in rejecting the belief that the world can be made commensurate with logical categories.

De Man's second target is the more performative notion of contradiction we have seen Habermas defend. Now that we know logic is a subjective imposition, he asks, can we then assume that "all language is a speech act that has to be performed in an imperative mode?"[35] Nietzsche's text appears to make precisely this argument, at least on a locutionary level. But the text "acts" in a different way; it "does not simultaneously affirm and deny identity but it denies affirmation. This is not the same thing as to assert and to deny identity at the same time. The text deconstructs the authority of the principle of contradiction by showing that this principle is an act, but when it acts out this act, it fails to perform the deed to which the text owed its status as act."[36] That is, Nietzsche may think he is rejecting the unequivocal affirmation of identity that is at the basis of the logic of noncontradiction, but his text does only one thing, deny that affirmation. To be performatively consistent, it would have to both deny and affirm simultaneously. De Man claims that this dilemma is not peculiar to Nietzsche for "the deconstruction states the fallacy of reference in a necessarily referential mode. There is no escape from this, for the text also establishes that deconstruction is not something we can decide to do or not to do at will."[37]

For de Man, therefore, the lesson is no less universal than Apel's, though its content is quite different: The tension between the constative and performative modes of language is permanent and irreducible. Indeed, "the differentiation between performative and constative language (which Nietzsche anticipates) is undecidable; the deconstruction leading from the one model to the other is irreversible but it always remains suspended, regardless of how often it is repeated."[38] It makes no sense, therefore, to charge someone with performative contradiction, when such a crime is the original sin of all language.

This permanent condition is itself an expression of another undecidable aspect of language, which de Man attributes to rhetoric itself. Rhetoric can either apply to the skills of persuasion, which involve intersubjective interaction, or to the figural tropes, which are best located on that infrastructural level noted by Gasché. For de Man, "rhetoric is a *text* in that it allows for two incompatible, mutually self-destructive points of view,

and therefore, puts an insurmountable obstacle in the way of any reading or understanding. The aporia between performative and constative language is merely a version of the aporia between trope and persuasion that both generates and paralyzes rhetoric and thus gives it the appearance of a history."[39]

These, then, are some of the main challenges presented by poststructuralism to Habermas's reliance on the concept of performative contradiction as a cornerstone of his universal pragmatics. Foucault locates language entirely outside of a sovereign subject, who can be held responsible for its effects. Gasché describes that "outside" in terms of infrastructures that are irreducibly heterological and thus never equal to logical contradictions that can be overcome. De Man endorses Nietzsche's contention that consistency and contradiction are merely subjective projections onto a world whose complexity humans are unable to fathom. And he further argues that while Nietzsche's constative assertion of this very argument is at odds with the performative effects of his text, this tension is emblematic of the always undecidable status of rhetoric, at once a technique of conscious persuasion and an expression of what might be called the linguistic unconscious of tropes and figures.

How might Habermas respond to these arguments? Or rather, what have his responses been to those he has already tried to meet? Against Foucault's emphasis on the exteriority of language, which was of course a standard structuralist assumption of the 1960s, he has maintained the possibility of a reconstructive science applicable to the level of communicative utterance. In "What Is Universal Pragmatics?" he admitted "this abstraction of *language* from the use of language in *speech* (*langue* versus *parole*), which is made in both the logical and the structuralist analysis of language, is meaningful. Nevertheless, this methodological step is not sufficient reason for the view that the pragmatic dimension of language from which one abstracts is beyond formal analysis."[40] This argument is directed against the classical structuralist binary opposition, which privileges *langue* over *parole*. But it is important to note that Habermas did not quarrel with the opposition, urging us to efface the boundary in poststructuralist fashion, but rather simply reversed the hierarchy.

The issue between Habermas and the poststructuralists, then, is the extent to which one level can be analytically distinguished from the other in order to map out its workings. It is always easy to demonstrate that such a procedure does violence to the inevitably mixed quality of linguistic phenomena. But so does virtually every human effort to understand the infinitely complex reality we call the world. Although it certainly is worthwhile being aware of the inevitably partial quality of our results when we choose to isolate one dimension of a phenomenon for analysis, refusing to analyze at all leads to cognitive and practical paralysis. While

it may well be the case that performative utterances are always made against the backdrop—or better put, through the medium—of a language that is at once *langue* and *parole*, Habermas's development of a universal pragmatics, however one may judge all of its implications, demonstrates the power of choosing to isolate the one from the other. Essentially reducing language to only its "deepest" level, bracketing the other as insignificant, is as impoverished as assuming no meaningful distinction can be made between levels at all.

This impoverishment is especially evident, if we emphasize with Gasché the domination of the deepest level by heterological infrastructures. Although useful as a reminder that not every linguistically embodied opposition or tension can be reduced to logical contradictions, Gasché's argument seems too quickly to assume that none can. Nor is it necessarily the case that every attempt to defend consistency is an expression of a discredited philosophy of reflection, in which difference is reduced to sameness. Habermas, in fact, has been very careful to emphasize that intersubjective communication is necessary when the parties involved are *not* identical. Consensus or consistency does not mean perfect unity, merely an always provisional willingness to agree on the basis of a process of validity testing that can be revised later. On the level of individual speech acts, performative consistency does not completely obliterate the distinction between locutionary meaning and illocutionary force. To rule nonreflective consistency out of court on a priori grounds is thus to impose a foundationalist transcendentalism of the most blatant kind.

De Man's Nietzschean emphasis on the self-limiting status of scientific inquiry, which acknowledges its own insufficiency, need not, as we have seen, pose a problem for anything but the most extravagant versions of science. Habermas with his strongly hermeneutic understanding of science needs no reminder of its limits. For by shifting the argument from the insufficiency of a monologic scientific grasp of the world (the Nietzschean and indeed Kantian premise of de Man's critique) to the intersubjective validity testing of arguments about the world, he has made it possible to restore a meaningful dimension to the charge of contradiction, which no longer refers to the gap between concepts and objects. Instead, it has been recast in the performative mode, pitting locutionary and illocutionary dimensions of interaction against each other.

De Man's second argument is, of course, directed against this move. By contending that we can never unravel the constative from the performative dimensions of speech acts, that the two are in fact always in conflict, and finally, that rhetoric means both techniques of persuasion and language's tropic unconscious, he wants to deny the possibility of any noncontradictory consistency. Habermas's reply has been to claim that this argument levels the genre distinction between literature, dom-

inated by rhetoric in the second sense, and philosophy, beholden to it in the first. His basic point is that the latter is grounded in a normal use of language in which "all participants stick to the reference point of possibly achieving a mutual understanding in which the *same* utterances are assigned the same meaning."[41] More generally, he chastizes deconstructionists for failing to register the distinction between the "world-disclosing" functions of literature and the "problem-solving" functions of theoretical discourse that have been differentiated out in modern societies.

Rejoinders to these arguments doubtless exist, but I will allow others less drawn to Habermas's position than I to contrive them. Let me, however, finish with a few questions of my own, which concern the relation between the individual and the social dimensions of his argument. It is one thing to accuse Nietzsche, Adorno, Derrida, and so on of getting caught in performative contradictions that undercut the power of their arguments. It is another to redescribe, as we've seen Habermas do in *Legitimation Crisis*, social contradictions in terms of a public clash of incompatible claims and intentions.

First, this argument may put too much weight on those aspects of language that Habermas has concentrated his energies on exploring: the pragmatic rather than the structural (or infrastructural) level, and "normal" understanding-oriented speech rather than world-disclosing speech. What we usually see as social conflicts are just as likely to be generated by the clash between these levels or modes as by a tension only within the former. Although it may be possible for some of these conflicts to be translated into discursively adjudicable claims, it is by no means clear that all or even most can. Habermas perhaps tacitly concurs with this insight when he allows the term contradiction to be used for dysfunctional system maintenance mechanisms as well as utterances. In a way, this concession implies that contradictions can exist on the nonpragmatic level of language too. If so, Habermas needs to explore their implications more carefully than he has hitherto done; in particular he needs to articulate the linkages between the two types of contradiction more explicitly.

Second, Habermas's strong rejection of "consciousness philosophy," that equation of thought with the interiority of a sovereign subject we have also seen Foucault criticize, raises the question of the location of the responsible speaker who is able to perform consistently. How can Habermas, for example, accuse Nietzsche, Derrida, or Adorno of performing contradictions, unless he attributes to them the ability to decide whether or not they will?[42] What is perhaps needed is a more explicit differentiation between what we might call the "subject" and the "agent," which does not abandon the responsibility of the latter even as it robs the former of its putative sovereignty.[43]

Third, the model of performative contradiction may be inadequate to explain the clash between different social groups who may be communicating perfectly, doing all they can to reach an understanding, but in fact have different, perhaps even irreconcilable, interests. Here it might not be the procedural level that is generating contradictions, but rather the substantive level of what is being discussed. Habermas, to be sure, argues that "conflicts that are described independently of communications theory or systems theory are empirical phenomena without relation to truth. Only when we conceive of such oppositions within communications theory or systems theory do they take on an immanent relation to logical categories."[44] But such empirical phenomena are often far more powerful motors of political and social practice than those immediately accessible to discursive adjudication. Are they not to be construed as having any relation to truth and logic until they are made available for such theoretical consideration?

Finally, the lesson of Adorno's reluctant willingness to endure the state of performative contradiction may be worth pondering. His decision is perhaps defensible as a recognition that the current social reality (but not something called "language") renders abnormal the state of performative consistency Habermas wants to instantiate. What speech act theorists like to call the "happy" or "felicitous" outcome of illocutionary acts may be hard to come by in a world not conducive to fulfilling other kinds of happiness. And a fortiori, the intersubjective overcoming of contradiction is even less likely to occur.

Still, the incontrovertible examples that we do have in everyday life of such happy outcomes may perhaps be seen as the prefigural traces of the more utopian possibility Habermas, despite all his reservations about redemptive utopias, has never fully abandoned. Our dogged tendency to see tensions, conflicts, and aporias as contradictions amenable to resolution, rather than mere epiphenomena of an externally exterior linguistic system of heterological infrastructures or tropic displacements, bears witness to the irradicability of this hope. In fact, it may be one of the central lessons of Habermas's remarkable oeuvre that only when conflicts become performative contradictions can their resolution be possible at all.

3

The Morals of Genealogy: Or Is There a Poststructuralist Ethics?

Of all the aspects of the loose and heterogeneous body of thought that has come to be called poststructuralism, none seems to engender as much unease and resistance in its critics as its assumed debunking of ethics. The charge of nihilism, so often leveled against its supposed epistemological implications, is no less frequently directed at its moral ones as well.[1] A variety of lineages has been adduced to account for poststructuralism's putative moral deficit: its freely acknowledged debt to Nietzsche's attempt to go "beyond good and evil," its fascination for scenarios of violence, mutilation, and sacrifice from de Sade to Bataille, its attraction to politically tainted figures like Heidegger and the early Blanchot (a weakness only magnified by the de Man scandal), and its inheritance of the aesthetic modernist willingness to forget the victim so long as the gesture is beautiful.

As a result of such influences, poststructuralist thinkers are said to have abandoned the ethical impulse of the Western humanist tradition for the aesthetic play of linguistic signifiers without flesh and blood referents. The poststructuralist disdain for the centered epistemological subject and a strong psychological ego is seen as no less an attack on the responsible moral agent. Even if the existence of such an agent can still be admitted, the poststructuralist belief in the undecidability of interpretations has been taken to imply the impossibility of any informed ethical decisions. So too, the poststructuralist critique of coherent and unified narratives has been understood as a barrier to any conceptualization of an individual life as a moral tale, a meaningful story of struggle over time with good and evil whose telos is a virtuous character. Finally, the poststructuralist dismissal of intersubjectively generated communities and its hostility to humanist pieties about solidarity has suggested the absence of any hope for that

shared ethical life Hegel called *Sittlichkeit*, rooted in common ethical *Sitte* or customs, as well as the universal moral imperatives praised by Kant. Instead, poststructuralism is often taken to mean a valorization of impulse, desire, and transgression, which sanctions an ethical "anything goes." Accordingly, two of the most important recent discussions of ethics in the Anglo-American world, Alasdair MacIntyre's *After Virtue* and Bernard Williams's *Ethics and the Limits of Philosophy* felt no apparent obligation to consider any poststructuralist thinkers.[2]

The actual status of ethical discourse among poststructuralists themselves may, therefore, come as somewhat of a surprise. For despite the conventional wisdom concerning their alleged nihilism, a closer familiarity with their work will in fact reveal an intense and abiding fascination with moral issues. Although the values defended may not jibe with those of our dominant traditions, poststructuralist thinkers have raised fundamental questions about ethics, which need to be addressed rather than ignored.

Let me begin with a *tour d'horizon* to establish the validity of the claim that poststructuralism is far from indifferent to ethical issues. The last writings of Michel Foucault, to start with the most explicit case, emphasized less language and power than the constitution of sexual ethics, or more precisely the classical Greeks' ethical "care of the self."[3] Jean-François Lyotard devoted a book-length dialogue with Jean-Loup Thébaud, called *Just Gaming* in the inspired title of the English translation, to questions of justice, ethics, and politics.[4] Jacques Lacan's most extended consideration of ethical issues came in his *Éthique de la psychanalyse*, a seminar conducted in 1959–60 and published in 1986.[5] The feminist psychoanalyst Luce Irigaray pondered the ethical postures of a range of philosophers from Plato to Levinas in her *Éthique de la différance sexuelle*.[6] Jacques Derrida's ethical ruminations have been scattered throughout his corpus but are perhaps nowhere as evident as in his "Violence and Metaphysics: An Essay on the Thought of Emmanuel Levinas" in *Writing and Difference*.[7] One of his major American disciples, J. Hillis Miller, has recently published an account of *The Ethics of Reading*.[8] Even Georges Bataille, according to his friend Maurice Blanchot, was on an "ethical quest" because he was haunted by "the demand for a morality."[9]

In the burgeoning literature on poststructuralism, these ethical concerns have not gone entirely unremarked. Commentators like Michel de Certeau, John Rajchman, James Bernauer, Arnold Davidson, Christopher Norris, Richard Shusterman, and Tobin Siebers have all explored different aspects of poststructuralist ethics, with various degrees of enthusiasm.[10] But no global account has yet been attempted, and probably for a good reason. Not only do the separate considerations of ethical issues by poststructuralists fail to cohere into a systematic moral discourse, but it is also

one of their few shared assumptions that such a positive theory of ethics is both untenable and dangerous.

If one had to single out the most common aspect of this dispersed body of thought, the likeliest candidate would be its shared resistance to defining the ethical in terms of a system of norms, rules, laws, or values, which can be codified in a rigorous way. With apologies to Max Weber, we might call theirs the "ethics of ending ultimates," rather than that of "ultimate ends." Thus, for example, Foucault remarked on the Greek disjunction between ethics and any social or institutional system and wondered "if our problem nowadays is not, in a way, similar to this one, since most of us no longer believe that ethics is founded in religion, nor do we want a legal system to intervene in our moral, personal, private life. Recent liberation movements suffer from the fact that they cannot find any principle on which to base the elaboration of a new ethics."[11] Although reluctant to hold up the Greek solution to this dilemma as an ahistorical norm, he clearly admired their linkage of liberty and morality. "Liberty is the ontological condition of ethics," he told interviewers in 1984, "But ethics is the deliberate form assumed by liberty."[12] And when asked by an earlier interlocutor about his own moral stance, he replied, "I am a moralist, insofar as I believe that one of the tasks, one of the meanings of human existence—the source of human freedom—is never to accept anything as definitive, untouchable, obvious, or immobile," and he defined his moral values as "refusal, curiosity, innovation."[13] It is for these reasons that Rajchman can claim that Foucault upheld a specifically modernist ethics of subjectivity: "not the ethic of transgression, but the ethic of constant disengagement from constituted forms of experience, of freeing oneself for the invention of new forms of life an ethic that is a matter of choice of life rather than abstract obligation."[14]

Similarly, Lyotard's defense of the radical incommensurability of prescriptive and descriptive language games in *Just Gaming* leads him to the further claim that no a priori, categorical criteria exist to determine how we should make moral judgments. There is no *sensus communis* telling us how to act; "we are in the position of Aristotle's prudent individual, who makes judgments about the just and the unjust without the least criterion."[15] Accepting this situation is the mark of "pagan" ethics, which refuses to provide any external command system to follow. Rather than being entirely Greek in origin, Lyotard's ethics also acknowledges a strong debt to the Jewish thinker whose impact on Derrida and other poststructuralists has been considerable: Emmanuel Levinas. Levinas provides a nonpositivist rationale for the belief that ontological musings about what is can never be the ground of ethical thought about what should be. There exists no theoretical justification of ethical commands, which always come

from outside. We must judge without being able to provide criteria for our ethical decisions.

Lacan's insistence that "that status of the unconscious, which is so fragile on the ontic plane, is ethical"[16] may also be interpreted in a similar way. For his defense of desire as a perpetual and insatiable lack can be seen as a resistance to achieving the wholeness of a system, a resistance with a certain moral pathos. Thus his celebrated hostility to ego psychology can be understood as a refusal to accept the violent closure of the self, the creation of a fully formed character that would stop short the linguistically generated flow of desire. De Certeau correctly calls this stance an "ethical anarchy" because it challenges that "sacrifice of desire for the benefit of the city,"[17] which was the moral imperative of Creon in the Antigone legend as well as that of Machiavelli's raison d'état. It is also an "ethics of speech," because it valorizes the ongoing and interminable logorrhea of the symbolic, rather than the perceptual totalization of the imaginary. As Siebers puts it, "the ethical act comes to represent the play of purposeful incompleteness, what Lacan calls blablabla, in its refusal to convince, to name, to stop."[18] What it also refuses is the altruistic reciprocity that characterizes most traditional ethical teachings. For Lacan, this means an "ethics of celibacy"[19] in which the possibility of human intersubjectivity is denied.

A common theme emerges in all of these cases: ethics is understood as resistance to a positive system of moral commands, a normative order that can be theoretically justified. We might call this the motif of "negative autonomy" in poststructuralist thought, which accords well with its general defense of heterogeneity, difference, marginality, and nonidentity against the coercive power of totalization and closure. The precise nature of the entity or impulse that gives itself the law (which is, of course, the literal definition of autonomy) is not, to be sure, always clear, because poststructuralism abandons the concept of a coherent agent. This is the reason its belief in autonomy can only be called negative, analogizing from the idea of a negative theology, which can never name God. But the ethically charged resistance of something (or some non-thing) to externally imposed codes is a persistent topos of poststructuralist thought nonetheless.

As such, it repeats, in a more linguistically and often psychoanalytically inflected register, that earlier ethical discourse normally called existentialist. For example, Lacan's emphasis on lack as the constituent dimension of desire and his distaste for its violent overcoming recalls similar gestures in Sartre.[20] So too, the poststructuralist hostility to universalist normative systems echoes in part Kierkegaard's celebrated "teleological suspension of the ethical," in which he identified ethics solely with the universal, disinterested, rational Idealism of Hegel. Although Kierkegaard's justifi-

cation of this suspension by a leap of faith, an either/or decision based on a call from the divine, seems hard to square with the poststructuralists' Nietzschean recognition of God's demise,[21] they both share a clear distrust of a morality grounded in an external theory.

Paradoxically, poststructuralist ethics, at least in certain of its guises, and Kierkegaard's fideistic existentialism share another trait, which is in tension with their defense of a weakly autonomous agent able to resist authority. Here the influence of Levinas on Lyotard and other poststructuralists comes into play. For Levinas, the origin of the moral command has always been external; it has come from an "Other" with whom the listener has a nonreciprocal relationship of obedience.[22] The one who receives the ethical imperative can never assume the role of the one who speaks, which makes a purely humanist ethics impossible. Does it also mean the valorization of heteronomy rather than autonomy? Lyotard, tacitly distancing himself from Foucault, tries to avoid this question: "in such a case the question of autonomy or heteronomy does not arise. . . . It is not servitude at all, because this is prior to the question of freedom. It is what Levinas calls *passivity* . . . [23] There is, moreover, a difference between the Jewish source of Levinas's ethics and Lyotard's paganism. The former is explicitly transcendental in its belief that divine ethical commands partake of the truth; the latter lacks the confidence to say who is sending the prescriptions and therefore cannot judge their truth content. "The position of the sender, as authority that obligates, is left vacant," Lyotard admits; "that is, the prescriptive utterance comes from nothing: its pragmatic virtue of obligation results from neither its content nor its utterer."[24]

Although J. Hillis Miller's *Ethics of Reading* is more consistently deconstructionist than Lyotard's *Just Gaming* in its questioning the incommensurability of prescriptive and descriptive language games, it comes to similar conclusions concerning the limits of human autonomy. Contrary to the conventional wisdom that deconstructive interpretation means the sovereign arbitrariness of the critic, he contends that the act of reading is always a response to an imperative from the text. He links that imperative to the pragmatic implications of narrative itself, which introduces a temporal deferral of the fulfillment of some lawlike injunction. "Such a narrative," he writes, "leaves its readers at the end as dissatisfied as ever, still in expectation of the fulfillment of the promise which was the whole reason for being of the story. What the good reader confronts in the end is not the moral law brought into the open at last in a clear example, but the unreadability of the text."[25] The ethics of reading is therefore the imperative *not* to decide in a definitive way what the correct interpretation is, the command to thwart the epistemological desire "to get the text right."

Drawing explicitly on de Man's theory of reading, Miller claims that ethical judgments are a necessary dimension of all language: its allegorical, supplementary resistance of closure and determinate meaning. Thus reading is not something we can decide to do or not to do, for language always compels us to be undecided, to defer final interpretations. "Far from being 'indeterminate' or 'nihilistic,' however, or a matter of wanton free play or arbitrary choice," Miller reassures us, "each reading is, strictly speaking, ethical, in the sense that it *has* to take place, by an implacable necessity, as the response to a categorical demand, and in the sense that the reader *must* take responsibility for it and for its consequences in the personal, social, and political worlds."[26]

The stakes of this claim are very high, for Miller follows de Man in inflating the concept of Reading (which he capitalizes) into "not just reading as such, certainly not just the act of reading works of literature, but sensation, perception, and therefore every human act whatsoever."[27] But if this were the case, if everything were a version of Reading, and if furthermore, we were always compelled by Reading not to decide, it is difficult to know what the ethical choices for which we must take responsibility really are. Miller, however, wants to maintain that Reading has a critical edge. Its ethical force, he claims, is linguistic and cannot "be accounted for by the social and historical forces that impinge upon it. In fact the ethical moment contests these forces or is subversive of them."[28] Once again we have the characteristic poststructrualist gesture of identifying ethics with resistance to external social order, in this case the resistance produced by textuality rather than the negative autonomy discussed above.

But how does this resistance operate, according to Miller? In his discussion of George Eliot, he addresses the question of language's performative function, its ability to make something happen in the world. He concludes that "even if it can be decided that performatives do make something happen, it can never be decided exactly what that something is and whether that something is good or bad. . . . Language used performatively makes something happen all right, but the link between knowing and doing can never be predicted exactly or understood perspicuously after the fact."[29] Elsewhere, in his consideration of the moral implications of reading Trollope, he reaches the complementary conclusion: "all Trollope's novels hover around the impossibility, in the end, of distinguishing between apparently solidly grounded moral choice[s]."[30]

Thus the implication seems to be that since we cannot judge how our actions, all of which are to be understood as a version of Reading, will have an impact on the world in moral terms, nor can we ever know the grounds of our decisions, but are nonetheless compelled to act morally, the only laudable choice is to submit to the infinite undecidability of

language itself and suspend judgment indefinitely. Not surprisingly, this version of poststructuralist ethics has seemed problematic to critics like Siebers, who complains, "Linguistic undecidability really amounts to a Romantic strategy designed to confront what is perceived to be the differentiating capacity of literature and language. It tries to turn a dangerous element into one that is self-reflexive and self-destructive in the hope that what is violent and threatening in language will defuse itself without any effort on our part. That language is *necessarily* ethical merely because it does not permit judgments (that it defers differences) is an idea whose absurdity will become increasingly apparent as time goes by."[31]

Whether or not Siebers's prediction will come true may be itself undecidable, but it does raise an important question about the implications of an ethical theory that counterposes Reading, as a necessarily moral act, to social and political forces that are always in need of subversion. For it focuses our attention on the implicit image of society assumed by poststructuralism in its various guises. If, as MacIntyre has contended, every moral philosophy "characteristically presupposes a sociology,"[32] what, we may ask, are the versions assumed, tacitly or otherwise, by the authors in the poststructuralist camp?

It is perhaps easier to describe them in negative than positive terms. Clearly, they are equivalent to neither the Kantian kingdom of ends nor the Aristotelian republic of virtue. They are also a far cry from the positive ethical form of life Hegel called *Sittlichkeit*. Indeed, it is precisely the effort to attain such holistic communities that the poststructuralists fear leads to coercion and repression. The ethical, we have seen, means for many of them resistance to systematic moral codes and integrated forms of life. Concomitantly, ethics means remaining suspicious of a utopian image of an entirely self-generating society, the product of self-conscious, reflective, autonomous humanism. Lyotard's pagan call for passive obedience to commands from an unknown other, Lacan's distrust of an imaginary agent controlling desire, Miller's emphasis on the obligation to honor the text's undecidability, all of these undercut any notion of a deliberate and collective social self-determination.

Similarly, poststructuralist ethics is based on a rejection of a society of egalitarian mutuality and reciprocity. Foucault's stress on the necessarily asymmetrical quality of Greek sexual ethics,[33] Lyotard's acceptance of Levinas's critique of reducing the other to a version of the self, and Lacan's stern rejection of compassion, sympathy, or the reciprocal caring of lovers all suggest that equality implies for them little more than the leveling of qualitative differences through the quantitative reduction of the exchange principle. Ethics, once again, means resistance to such a coercive reduction.

The positive alternatives to these discredited social models are not easy to discern. In certain moods, the poststructuralists seem to be advocating a radically individualist anarchy in which modes of interaction are ruled by considerations that may seem more properly called aesthetic than ethical. The work of Foucault, in particular, lends itself to this interpretation, because he has explicitly adopted Nietzsche's advocacy of aesthetic self-fashioning as an ideal.[34] Rather than being true to the allegedly "authentic" self advocated by existentialists like Sartre, he insists, "we have to create ourselves as a work of art."[35] The result might well resemble the elite and narcissistic world of the nineteenth-century dandy, who deliberately rejected the telos of a natural self in favor of a life of contrived artifice, and did so with minimal regard for its impact on others.[36] Lacan's ethical agenda has also been interpreted as an "ethopoetics," producing "a sort of constant cultural resistance to the tyranny of the very idea of an objectively good human arrangement."[37]

If, however, poststructuralist ethics seems to privilege art over morality, or at least to blur the distinction between the two in the name of a "paraesthetic" distrust of the very attempt to differentiate them,[38] it is necessary to ask what its model of "the aesthetic" or the "work of art" actually is. To provide a proper answer to this question would require too extensive a digression,[39] but at least some clarification may be helpful. Rather than praising the work of art as an organic, beautiful whole, an autotelic structure providing a sensuous manifestation of an Idea, a boundaried object following its own immanent laws, the poststructuralists embrace instead the modernist (or in certain cases, postmodernist) work "in crisis." That is, art is seen as more open to intrusions from without than utterly self-sufficient, more a complicated mixture of representation and presence than either purely one or the other, more what Walter Benjamin would have called allegorical than symbolic.

To base an ethics on such a view of the aesthetic has certain consequences. Translated into individual terms, it suggests an unstable, dispersed, protean (or more benignly put, nonrigid, risk-taking, self-questioning) "self" that refuses to congeal into a totalized character. In a more communal sense, it means a type of society that is much harder to depict in positive terms than that predicated on the ideal of an organic work of art. Thus Lyotard's much-discussed preference for the sublime over the beautiful is a mark of the poststructuralist penchant for the unpresentable, not only as an aesthetic phenomenon, but as a social one as well. The clearest depiction of this social order (or rather, disorder) is Bataille's account of an ecstatic community of expenditure, in which the exchange principle is overcome and individuals sacrifice their boundaried egos in an orgy of self-immolation. Blanchot has recently called this the "unavowable community" because of its unrepresentability and permanent

virtuality.[40] Jean-Luc Nancy has referred to it as a *"communauté désoeu-
vrée"* because it is not the product of conscious work or production but
comes from elsewhere.[41] Here the splendid isolation of the dandy is over-
come and self-fashioning turns into a kind of unfashioning of even the
contrived self. The violent dismembering of that self is considered ethical
because it undoes the worse violence that constituted it in the first place.[42]

To those unattracted to the ecstatic, unavowable, unworkable com-
munity that tacitly underlies poststructuralist ethics, it may seem un-
worthy of serious consideration. But in certain respects, it jibes with some
of the conclusions reached by widely respected ethical theorists like Alas-
dair MacIntyre and Bernard Williams, whose sober analyses of the issues
betray little trace of giddy ecstasy. MacIntyre, for example, is no less
hostile than the poststructuralists to the Kantian belief in a universal moral
command system that can be rationally justified.[43] His emphasis on the
power of tradition is also compatible with Lyotard's pagan ethics of lis-
tening to commands that come from an external source. And his critique
of what he calls ethical "emotivism," the contention that morality merely
expresses personal feelings or attitudes, comes close to their rejection of
the putatively "authentic" self whose individual realization is the highest
ethical goal. MacIntyre, to be sure, is nostalgic for the restitution of an
Aristotelian virtuous community of the type poststructuralism finds re-
pressive, but their targets are remarkably similar.

The same might be said of Williams, and perhaps a fortiori because of
his disdain for MacIntyre's nostalgia. His critique of ethical theory, as an
inappropriate attempt to construct a universally valid system of moral
commands, is one point in common. Another is his distrust of the strong
notion of ethical decision that is denied in the poststructuralist stress on
passive listening. Indeed, he specifically states that "ethical conviction,
like any other form of *being convinced*, must have some aspect of passivity
to it, must in some sense come to you."[44] And finally, he shares with
them a distaste for moral purism, the reduction of ethics to a set of rig-
orously consistent obligations rather than constructive practices, some of
which may prove in conflict with others. "Our major problem now," he
writes, "is actually that we have not too many [ethical ideas] but too few,
and we need to cherish as many as we can."[45] Where he parts company
with the poststructuralists, however, is in his continued advocacy of a
strong notion of humanism, which they find solely an impediment to
ethical thought and action.

In conclusion, we might then say that for all its alleged nihilism, post-
structuralism shows itself to be grappling with ethical issues in interesting
and significant ways. However one may feel about its various and often
conflicting ethical investments, it compels us to reflect on the costs of
moral absolutism, the violence latent in trying to construct fully realized

ethical forms of life. It alerts us as well to the dangers of a totally self-generated ethical code, which fails to acknowledge the passive moment in our feeling the compulsion of prescriptive commands. And it forces us to question the implications of a normative order that purports to be a positive ethical community, which may be as much the expression of an imaginary phantasm as the restoration, *pace* MacIntyre, of a lost world before the "catastrophe" of modernity.

What poststructuralism, however, does not provide is any help with the thorny question of how to adjudicate in the present different, often conflicting ethical claims. Infinite deferral in Miller's sense is a luxury not afforded us in most circumstances. When poststructuralists, according to de Certeau's reading of Lacan, side with ethical anarchism against the coercive morality of Creon's state, they fail to see, as Hegel among others recognized, that the conflict in the Antigone legend was between two legitimate ethical demands, not between raison d'état and moral conscience. In the even more fractured ethical world of the present, we are often caught between conflicting ethical imperatives, each with its own power, each demanding a choice. The painful controversy over abortion is an obvious example; the decision to end a pregnancy or bring it to term is not, *pace* Miller, like reading a book.

Although we may despair of ever grounding the different claims in theoretical ways, we can still try to adjudicate them through a kind of intersubjective rational discourse. What Jürgen Habermas has called "discourse ethics" provides a minimalist framework for an ethics that is more than the arbitrary acceptance of commands from without.[46] Here the criterion of reciprocity in weighing the arguments for each position comes into play in a way that challenges the poststructuralist suspicion of any version of mutuality or symmetry. Although Habermas's position, which is too complicated to explore here, is not without its problems,[47] at least it highlights the critical procedural issue of how we persuade others of the force of the imperatives we feel. Without communicative discourse, we are left with little beyond assertions and evocative rhetoric.[48] Why, for example, should we give priority to protecting difference and heterogeneity over their obliteration? Why is an aesthetic self-fashioning preferable to an ascetic self-denial in the service of another ideal?[49] Why is the undisciplined body with its impulsive desires and unfulfillable yearnings worth defending against the violence of the disciplining ego or Lacan's imaginary? Why is an ecstatic community ethically superior to the totalized form of life Hegel called *Sittlichkeit*? A case can doubtless be made for both sides of these and other like disputes. But unless arguments are marshalled to make them, unless intersubjective discourse weighs their merits and understands their multiple implications, unless we adopt something of what Max Weber used to call the "ethics of responsibility,"

we risk the sterile skepticism about ethics in general, which the post-structuralists, despite their commonplace reputation, have themselves been at such pains to repudiate.

4

The Reassertion of Sovereignty in a Time of Crisis: Carl Schmitt and Georges Bataille

In 1937, Georges Bataille, the French novelist, critic, and cultural theorist, published a defense of Nietzsche, whose putative links to Nazism he sought to debunk. "National Socialism," he wrote, "is less romantic and more Maurrassian than is sometimes imagined, and one must not forget that Rosenberg is its ideological expression closest to Nietzsche; the jurist Carl Schmidt [sic], who incarnates it just as much as does Rosenberg, is very close to Charles Maurras and, with a Catholic background, has always been alien to the influence of Nietzsche."[1]

Although still an interesting issue, the relationship between Nietzsche and Nazism is not the reason I have cited this passage. Nor do I want to broach the no less controversial subject of Schmitt's political theory and its preparation for his role as Nazi "crown jurist" in the early years of the Third Reich. I have introduced Bataille's remarks instead to suggest the possibility of a hitherto unremarked parallel between two of the most fascinating and disturbing figures in twentieth-century intellectual history, Carl Schmitt and Georges Bataille himself.

Except for short discussion of Schmitt's *Political Theology* in Rita Bischoff's magisterial account of Bataille, *Souveränität und Subversion* and an even briefer consideration in Habermas's *Philosophical Discourse of Modernity*, there have been few comparisons in the previous literature.[2] The reasons for this relative neglect are not difficult to discern. As far as I can tell, this is the only reference to Schmitt in Bataille's work, and the extent of his familiarity is in some doubt to judge from the fact that he misspelled Schmitt's name. Schmitt, for his part, may well have been only dimly aware of Bataille, whose work did not reach a European-wide audience until after his death in 1962, by which time Schmitt was approaching extreme old age.[3]

And yet, by uttering these two names in the same breath, we can, I think, begin to get a purchase on one of the most interesting intellectual phenomena of their era, the revalorization of the concept of sovereignty, a goal that was sought with equal fervor in both of their seemingly very different cases. Differences, to be sure, did exist, but before examining them, it will be useful to establish certain similarities. Approximately of the same generation—Schmitt was born in 1888, Bataille in 1897—each experienced the trauma of the first world war and the continuing crisis of the interwar era with special intensity. Thus, they came to question the very basis of political order by reopening the fundamental issue of sovereignty.[4] Both were convinced that the liberal, parliamentary interpretation of the limits of sovereignty, based as it was on a faith they did not share in the power of discursive rationality, was bankrupt. And both were willing as a result to entertain drastic solutions to the political dilemmas of their day.

Their concepts of sovereignty, to be sure, appear very different, at least on the surface. But as I hope to show, they were in certain respects complementary, each betraying a strong debt to a residual counter-Enlightenment notion of secularized religion. Here the Catholicism of their youth may well have had a subtle effect, if in very disparate ways. Together Schmitt and Bataille present a remarkable, if ultimately problematic, challenge to liberal thinking on sovereignty, which to be sure itself lacked answers to all the trenchant questions they raised. It is perhaps easier to begin with Schmitt's notion of sovereignty than Bataille's, because it was more squarely situated in the mainstream of thinking about the subject that goes back to Hobbes and Bodin. Most explicitly spelled out in his 1922 study, *Political Theology*,[5] Schmitt's concept of sovereignty remained, as far as I can ascertain, virtually constant throughout his entire career. More than a merely theoretical issue, sovereignty for Schmitt functioned as well as a cornerstone of his thinking about concrete political problems during the Weimar period and after. His influential studies of the varieties of dictatorship, legality and legitimacy, and the existential political conflict between friend and foe, were all intimately tied to his specific policy suggestions concerning, for example, the role of the president in the Weimar constitution and the legality of Hitler's Enabling Act.[6] In all these cases, the ultimate importance of his revalorization of a strong concept of sovereignty can easily be discerned.

Schmitt's notion of sovereignty, to strip it down to its essentials, was based on five principles: (1) sovereignty means the capacity to make ultimate political decisions; (2) the context in which that capacity is revealed is "the state of exception" (*Ausnahmezustand*),[7] when the normal workings of the constitutional order are suspended; (3) the decision that is made in such circumstances cannot be bound by a set of general norms

but is instead made without criteria; (4) the power that assumes the func-
tion of the sovereign is indivisible; (5) its acts derive solely from its will
and not according to any transcendental principles of rationality or natural
law. *Voluntas*, in other words, is prior to *ratio*.

A major target of these claims was the contention of liberal *Rechtstaat*
theorists such as Hans Kelsen that the impersonal law was itself the
sovereign and that binding juridical norms could be adduced that con-
strained its representatives' will.[8] Another was the argument of corporatist
theorists such as Otto von Gierke and Hugo Preuss, syndicalists such as
Léon Deguit and G. D. H. Cole, or pluralists such as Harold Laski that
state sovereignty was itself a derivative function of social associations
prior, both logically and chronologically, to the political realm. A third
was the assumption that liberal parliamentarism, with its faith in rational
decision making, was compatible with democracy, which Schmitt iden-
tified with a unified General will. Popular sovereignty, he argued, meant
the identity or identification of rulers and ruled, an isonomic homogeneity
that expressed itself in an indivisible power, perhaps most clearly em-
bodied in a plebiscitarian dictator.[9]

Although he harked back to early modern theorists of sovereignty such
as Hobbes, Bodin, and Pufendorf, the ultimately religious underpinnings
of Schmitt's arguments are transparently clear. "All significant concepts
of the modern theory of the state," he famously asserted, "are secularized
theological concepts not only because of their historical development—
in which they were transferred from theology to the theory of the state,
whereby, for example, the omnipotent God became the omnipotent
lawgiver—but also because of their systematic structure, the recognition
of which is necessary for a sociological consideration of these concepts."[10]
That is, the political sovereign is modeled on the Christian notion of God,
the ultimate authority whose decisions are not bound even by the natural
or moral laws which He promulgates.[11] The states of exception in which
this pattern is revealed thus function like miracles in theology; they serve
to show that the sovereign like God can suspend his laws if he so chooses.

The modern state, to be sure, emerged in a climate in which God's
capacity to intervene capriciously in the world was, Schmitt contended,
gradually forgotten; Enlightenment Deism, for example, turned Him into
a spectator of the mechanism He had created and Kant made Him sub-
servient to the moral law. Modern state theory since the time of Locke
reflected this repression of divine omnipotence, marginalizing anything
that conflicted with its faith in juridical and constitutional self-referen-
tiality. But political states of exception demonstrated, Schmitt insisted,
that like the God who could still make miracles, the sovereign could
suspend whatever rules he had laid down or reverse whatever commands

he had made previously.[12] His will, like the divinity's, was in no way constrained by logic, reason, nature, or any other authority.

Such a notion of sovereignty was not Schmitt's invention. He admitted its pedigree in the counterrevolutionary theory of de Maistre, Bonald, and Donoso Cortés, and he saw certain parallels in the Leninist notion of the dictatorship of the proletariat. In all of these cases, sovereign decision was understood to suspend the criterion of discursive will-formation through rational deliberation. The legitimacy of a decision was thus prior to its legality, the latter being merely a system of rules whose origins in the sovereign's inaugurating act had been forgotten. Legality, in other words, was not the cause of legitimacy, but rather its formal expression.[13]

Schmitt's secularization thesis may not be fully persuasive, as Hans Blumenberg has contended,[14] but it clearly reveals the assumptions at work in his political theory. Striving to show that liberal notions of rationality are not the ultimate ground of decisions, but anxious to avoid a crisis of authority, he sought an absolute ground instead in the irresponsible lawgiver, conceptualized as a metasubject with an undivided capacity to will. In the name of a nonnormative realism, which would be the inspiration for later political realists like Hans Morgenthau,[15] he sought to demonstrate the ultimate dependence of one of the most fundamental concepts in politics on a covertly theological notion of the divine.

In so doing, Schmitt repersonalized the concept of sovereignty, even though he posited the state as the ultimate decision-maker.[16] That is, as F. H. Hinsley has shown in his important study of the concept's history, only when the conflict between ruler and popular sovereignty was settled in favor a third concept, that of state sovereignty separate from both, was the modern concept of sovereignty really launched.[17] Neither the king nor the community was thus truly sovereign, but the political fiction called the state instead. There was thus a certain nonidentity between the sovereign state and its embodiments in the Ruler or the Ruled.

Schmitt recognized the importance of that third sphere, but insisted on repersonalizing it in the form of a secularized version of God. His state was thus cast in terms of a metasubject with the capacity to will and the ability to decide as its prime characteristics. It was also for this reason that its political interactions could be understood in the deeply personalist terms of friend and foe. Schmitt's monologic notion of the sovereign prevented him from taking seriously anything prior to such a personalized metasubject, a possibility he dismissed as an inappropriate intrusion of the social realm into that of the political.[18] Schmitt's hostility to corporatist theory meant that he had to posit the personalized state as its own ground, as a self-generating subject on the model of God as a prime mover.

It is precisely at this point that Georges Bataille's theory of sovereignty provides an interesting comparison. As in the case of Schmitt, Bataille was fascinated with sovereignty from virtually the beginning of his career until its end. The theme is foreshadowed in his 1933 essay on *dépense* (expenditure or waste), became explicit in his subsequent work on fascism, and remained a preoccupation up until the study entitled *Souveraineté* left uncompleted at his death.[19] Bataille's ruminations on the theme were, to be sure, indebted to a very different set of sources from Schmitt's. Instead of Hobbes and Bodin, de Maistre and Donoso Cortés, he learned from Mauss and Kojève, Nietzsche and Lautréamont. His discourse of sovereignty was thus less juridical and constitutional than anthropological and literary. It was also carried out in the service of a politics that came closer to anarchism than to that conservative search for order in Schmitt he damned as Maurrasian.

But in certain respects, it paralleled that of Schmitt's. Both thinkers were intent on showing that behind or beneath the facade of liberal laws and their rational justifications lay a more primary realm of sovereignty. Both questioned the claim that the sovereign was bound by normative constraints or universal rules. Both were convinced that decisions were existential and made without criteria.[20] And both agreed that the religious origins of sovereignty could not be extirpated, even in the most seemingly secular world of modernity.

But perhaps most important of all, both Schmitt and Bataille invoked sovereignty as an antidote to the endless circulation and exchange of commodities and ideas that constituted for them the essence of the modern world. As the Italian political theorist Giacamo Marramao has argued,[21] the main target of Schmitt's ire in the 1920s was a contractual theory of politics premised on the exchange of promises or goods by equals. His decisionism, Marramao writes, has the merit of highlighting "the divergence, the non-parallelism, the asynchronicity of productive-economic *ratio* and political-institutional order Sovereignty is nothing other than sovereign indifference to the system of needs, the interests and the power relations that emerge from the crisis of liberal states."[22] The abstract formalism of Kelsen's normative theory was thus for Schmitt another version of the abstract exchange principle at the root of bourgeois economics. The free market of commodities based on the universal solvent, money, was similar to the free market of ideas in the liberal public sphere; both failed to register the unexchangeable power of the sovereign to decide in a state of exception.

The sovereign is therefore like God in yet another way: in his absolute incommensurability, qualitative uniqueness, and irreducibility to a neutral counter in a process of infinite exchange. Schmitt's celebrated critique of political romanticism,[23] whose penchant for endless, action-deferring dis-

cussion he would attribute to liberal parliamentarism as well, can thus be construed as impatience with the occlusion of political decision making by the interminable process of debate. Whether in the form of commodity exchange, contractual reciprocity, or the discursive exchange of opinions, the enemy of sovereignty was the same: the reduction of the unique to the fungible, the qualitatively different to the quantitatively same.

Only a politics that would preserve the distinction between friend and foe could escape this fate. That is, only when a sovereign decision-maker represented a homogeneous community construed as a collective friend opposed to an external or internal foe could its irreducible uniqueness be preserved. Such a community could not tolerate for very long the exchange of opinions and contractual compromising of interests in a pluralist polity. Nor could it accept the limitations on its qualitative incommensurability posed by its incorporation in an international system of norms or laws inhibiting its ability to decide for itself.

In the case of Bataille, sovereignty served no less explicitly as a counterweight to bourgeois notions of exchange and liberal concepts of the rule of law. As Annette Michelson has noted, his critical sociology was "an assault upon discursive reason as the foundation of the social order of capitalism."[24] Perhaps his first extensive discussion of sovereignty came in his 1933/4 essay on "The Psychological Structure of Fascism."[25] Noting that the word was derived from the Latin adjective *superaneus*, which meant "superior," he linked it with a Nietzschean sense of noble mastery[26] evident in the unchecked power of an absolute king. Such a ruler, Bataille wrote, "wholly maintains the separate power of divine supremacy. He is exempt from the specific principal of homogeneity, the compensation of rights and duties constituting the formal law of the State: the king's rights are unconditional."[27]

Such a formulation echoes Schmitt's defense of a sovereign above the law and modeled on the divine lawgiver. Or rather it does, except for one crucial difference: Bataille's insistence that sovereignty means exemption from the principle of homogeneity, a principle that was, it will be recalled, one of the cornerstones of Schmitt's antiliberal theory of democracy. Instead, Bataille contends that sovereignty is "the imperative form of heterogenous existence."[28] Heterogeneity, as all readers of Bataille will immediately acknowledge, is one of his most revered terms. It signifies everything that cannot be assimilated to what he called a "restricted economy" of production and exchange, referring instead to a "general economy" of waste, expenditure, excess, and overflow. Expressed in the potlatch ceremonies of northwestern American Indians investigated by Marcel Mauss, with their conspicuous sacrifice of wealth, heterogeneity was apparent as well in a variety of normally denigrated human phenomena: excrement, bodily fluids, madness, intoxication, obscenity, trash,

perverse sexuality, and so on, everything that subverted the spiritual, moral, and intellectual hierarchy of civilization.

For Bataille, heterogeneity was ultimately tied to a concept of the sacred that had long been suppressed in our disenchanted world. Insofar as sovereignty was based on such a concept of the sacred, it shared a certain religious underpinning with Schmitt's version of the term. But whereas Schmitt's sovereign was the political instantiation of a theological concept of God, whose powerful will was the source of his decisions, Bataille's emerged from what might be called the atheological religious experience of ecstatic heterogeneity.[29] "The supreme being of theologians and philosophers," he insisted, "represents the most profound introjection of the structure characteristic of *homogeneity* into *heterogeneous* experience: in his theological aspect, God preeminently fulfills the sovereign form. However, the counterpart to this possibility is implied by the fictitious character of divine existence, whose *heterogeneous* nature, lacking the limitative value of reality, can be overlooked in a philosophical conception (reduced to a formal affirmation that is in no way lived)."[30]

The heterogeneous nature of the lived rather than theologized God was best shown, Bataille claimed, in His function as sacrificial victim of communal violence. Just as the sovereign's power and authority was above the law, so too his superiority is shown by his role in the Dionysian dismemberment that creates the community's cohesion. The "death of God" thus signifies much more than the atheist's fantasy of transcending superstition; it means instead the sacrifice of the sovereign's individual integrity in order for the community to live. The result is what Bataille called an acephalic community, one without a head.[31] In the later terminology of his friend Maurice Blanchot, it was an "unavowable" or "unworked" (*désoeuvrée*) community, because it was neither the expression of a positive subjective avowal, as social contract theory would warrant, nor the product of collective work.[32]

Sovereignty in Bataille's lexicon was thus close to Schmitt in certain ways, but very different in others. Insofar as its target was a politics of rational discussion or juridical normativity, it was similar to Schmitt's. The two were also united in their hostility to a politics reduced to an epiphenomenon of the bourgeois marketplace. But insofar as what Bataille put in its place was not a politics of decision making based on an undivided will, the two concepts were very different. Indeed, they were so different that Bataille's notion of sovereignty could be taken by Jacques Derrida as an antidote to the Western metaphysical tradition of privileging voluntarism and the strong subject, indeed as an antidote to any foundationalist philosophy whatsoever. "A nonprinciple and a nonfoundation," Derrida argued, "it definitively eludes an expectation of a reassuring *archia*, a condition of possibility or transcendental of discourse."[33]

That is, Bataille's notion of sovereignty challenges the expectation that any positive foundation or *archia* can be found in the nonrational will of an undivided sovereign.[34] Whereas Schmitt, anxious to maintain order in a world without transcendental guarantees, sought to stop the regression of authority after he had shown that laws are always legitimated by men, Bataille, eager to explode order, allowed the regression to proceed ad infinitum. Rather than posting a creator-God as the *ur*form of the sovereign, he made it the dismembered God instead.[35] Or more precisely, he posited a notion of the sacred that was the *un*formed matrix of sovereign power.[36]

It is for this reason that the term sovereignty could reappear elsewhere in his work in nonpolitical contexts, both literary and erotic. For example, in *Literature and Evil*, written in 1957, Bataille claimed that "literary expression always raises the problem of *communication*, and is indeed poetry or nothing. . . . There is no difference between this powerful communication and what I call sovereignty."[37] Such communication, to be sure, is not the discursive rationality favored by philosophers like Habermas; it is instead the potlatch of signs and the explosion of meaning that constitutes the unavowable community.[38] Here the value of words is not their instrumental exchangeability for others, but rather their sheer disclosure of an almost Heideggerian notion of nonrepresentational Being.[39] Along with poetic sovereignty, Bataille also celebrated its erotic equivalent, which was linked with nonreproductive violence, death, evil, and the transgression of the law.[40] The sovereign sexual self was ecstatically dissolved, its body's boundaries transgressed and violated, the ego nowhere in control of its impulses or those of its partner.

How literal this celebration of sexual violence and self-mutilation was meant to be taken has been a matter of some conjecture, which cannot concern us now. More pertinent to our general theme are the linkages between Bataille's theory of sovereignty and his analysis of the political violence that was fascism. Written in solidarity with the left, "The Psychological Structure of Fascism" nonetheless shows a clear attraction to certain radical impulses on the far right.[41] As in the case of the Marxist theorist, Ernst Bloch, whose *Erbschaft dieser Zeit* was written around the same time,[42] Bataille was anxious to redeem the transgressive, genuinely antibourgeois moments in fascism for a radicalized left. In particular, he admired the explosive expressions of heterogeneity he detected in fascist politics, its critique of both capitalist and orthodox socialist versions of materialism in the name of a more subversive celebration of the mutilated and ecstatic body.

Fascist power, he contended, was composed of both military and religious dimensions. It simultaneously expressed the qualities of each: "qualities derived from the introjected *homogeneity*, such as duty, disci-

pline, and obedience; and qualities derived from the essential *heterogeneity*, imperative violence, and the position of the chief as the transcendent object of collective affectivity. But the religious value of the chief is really the fundamental (if not formal) value of fascism, giving the activity of the militiamen its characteristic affective tonality, distinct from the soldier in general."[43]

Although the capitalist interests supporting fascism were on the side of homogeneity, Bataille contended that the effervescence of subversive heterogeneity was less atrophied there than in bourgeois, democratic societies. As a result, whereas he expressed only the bleakest pessimism about the chances for a revolutionary movement in the democracies, he was cautiously optimistic about the promise of fascism. "The fact of fascism," he concluded, " . . . clearly demonstrates what can be expected from a timely recourse to reawakened affective forces. . . . An organized understanding of the movements in society, of attraction and repulsion, starkly presents itself as a weapon—at this moment when a vast convulsion opposes, not so much fascism to communism, but radical imperative forms to the deep subversion that continues to pursue the emancipation of human lives."[44]

Thus, both Schmitt and Bataille could interpret and even welcome, if with differing degrees of enthusiasm and with different estimations of its full implications, the rise of fascism as a reassertion of the power of sovereignty. Both could celebrate that reassertion for undermining the liberal illusion that rational norms or abstract processes of equal exchange could found a polity. And both could ultimately learn that their enthusiasm was misplaced, as fascism in power turned out to be something very different from what they expected—in Schmitt's case, not the Hobbesian restoration of order in a unified state, in Bataille's, not the liberating subversion of that order in the name of a sacred community of ecstatic *dépense.*

If their hopes were not realized, how valid nonetheless are their complementary concepts of sovereignty? How persuasive is their shared contention that sovereignty means the opposite of discursive rationality and contractual exchange? One way to begin answering these questions is to take seriously their argument that the concept of sovereignty cannot be fully appreciated without reference to its prefiguration in either theology or religious experience. For in so doing, we are forced to breach the frontier between the political and nonpolitical realms that Schmitt in other contexts was so anxious to police. That is, we have to recognize that the autonomy of the political, which was aggressively asserted by a number of twentieth-century thinkers hostile to the nineteenth-century's tendency to reduce it to epiphenomenal status, cannot be so easily maintained after all, at least in its strongest form.

Another way to express this insight is to recognize that implicit in both their concepts of political sovereignty are covert anthropological premises about the way humans interact. These are more explicit in the case of Bataille, whose interest in Durkheim and Mauss we have already encountered, but they can be discerned as well in Schmitt. To grasp the anthropological underpinnings of their complementary theories of sovereignty, I would like to turn briefly to the work of Victor Turner, in particular his well-known book on the Ndembu tribe of northwestern Zambia, *The Ritual Process*.[45]

According to Turner's generalizations from his research, there is an oscillation between two main social forms in many societies, one that he identifies with hierarchical status structures, the other with the disruption of those structures through what he calls the liminal experience of communitas. With a certain amount of readjustment,[46] these can be mapped on to the two versions of sovereignty espoused by Schmitt and Bataille. That is, hierarchical status means that the ultimate decision-making power of the society is gathered at the top of the pyramid, where the Schmittian sovereign can rule unchecked by normative constraints. Or when such norms do exist, the chief is often in the position of deciding when to apply them. Although hierarchical status structures are normal rather than exceptional states in Schmitt's sense, they at least contain the potential for a strong, voluntarist sovereign to emerge.

Turner's communitas is even closer to the second notion of sovereignty we have identified with Bataille. In Turner's words, "communitas breaks in through the interstices of structure, in liminality, at the edges of structure, in marginality; and from beneath structure, in inferiority. It is almost everywhere held to be sacred or 'holy,' possibly because it transgresses or dissolves the norms that govern structured and institutionalized relationships and is accompanied by experiences of unprecedented potency."[47] Examples of liminality are found in rites of passage, carnivalesque reversals of normal status, and monastic religious communities outside of the structure of the church. Significantly, Bataille himself evoked saturnalias of inversion and the festivals of madmen as examples of the sovereign communication he so admired.[48] And his transgressive mingling of the sacred and the obscene, the most holy and the most debased, express precisely what Turner's liminality does to the normal hierarchical structures of society.

Turner further distinguishes communitas from structure in another way, which is pertinent to the distinction between our two concepts of sovereignty. Whereas the boundaries of the ideal communitas are coterminous with the entire human race, structure follows Durkheim's notion of social solidarity, "the force of which depends upon an in-group/out group contrast."[49] That is, the politics founded on hierarchical structure maintain

the friend/foe distinction that Schmitt claimed was the existential essence of the political. Bataille's sovereignty, in contrast, grows out of an ecstatic, unboundaried, open community without the need to define itself in opposition to a hostile other.

According to Turner, the social process as a whole requires a perpetual oscillation between these two moments. "What is certain," he claims, "is that no society can function adequately without this dialectic. Exaggeration of structure may well lead to pathological manifestations of communitas outside or against 'the law.' Exaggeration of communitas, in certain religious or political movements of the leveling type, may be speedily followed by despotism, overbureaucratization, or other modes of structural rigidification."[50] If this is true, then the full complementarity of Schmitt and Bataille's notions of sovereignty can be appreciated. Just as religion has its theological moment and its experiential one, just as God can be conceptualized as a unified Subject with the will to decide and a dismembered sacrificial victim whose death founds the community, so too the sovereign cannot be reduced to either version. Even in a state of exception, the oscillation can continue, perhaps the recent events in Romania being an interesting example of the ambiguities that can result.

But if the concept of the sovereign can itself be shown to have an internally contested dynamic, one final observation may be in order. Once sovereignty is shown to be less absolute, final, and self-grounded than either Schmitt or Bataille seemed to think it is, once, that is, we recognize it as split from within and undecidably one thing or another, we might wonder as well about the solidity of its external boundaries. Even if we concede to Schmitt that sovereignty should be confined to a realm that is strictly speaking political rather than dependent on social, economic, or other allegedly prior processes, the political itself can be understood as a more contested terrain. Sovereignty rather than being the ground of the political, its ultimate truth revealed in exceptional circumstances, would have to share a place with other no less political factors.

One way to conceptualize the political other of sovereignty would be to follow Michel Foucault's widely discussed contention that micropolitical processes of domination have emerged in the modern world that are outside the power of the state. "This new type of power, which can no longer be formulated in terms of sovereignty," he writes, "is, I believe, one of the great inventions of bourgeois society. . . . This non-sovereign power, which lies outside the form of sovereignty, is disciplinary power."[51] Here the limit of decisionist sovereignty in Schmitt's sense is not Bataille's ecstatic sovereign community, but rather a welter of political practices and apparatuses that escape any conscious control.

Another way to think about the political other of sovereignty, however, would be to reintroduce precisely those considerations that both Schmitt

and Bataille so ardently sought to banish. That is, rather than claiming that discursive rationality and normative criteria are parasitic on a prior sovereign, understood either as a creator God or an ecstatic sacred community, we might acknowledge their equal status in a political realm that can never be fully grounded at all. At a time when liberalism and parliamentarism seemed bankrupt, reducing them to epiphenomena might have been a tempting choice. Today, when the profound problems in all the alternatives are no less evident, it may be wise to reexamine their power. For in an age that likes to think itself postmodern and thus willing to live without ultimate foundations, the priority of the decisionist or ecstatic sovereign to the norms that confront him or her is no more plausible to maintain than the priority of those norms to the decisionistic or ecstatic sovereign. If we are forced to give up one, how can we hold on to the other? Once we understand the instability in the very concept of sovereignty, which this comparison of Schmitt and Bataille has sought to highlight, are we not, in short, compelled to acknowledge that the concept of the political includes rather than excludes discussion and reasoned argument? For who really exists to decide otherwise?

5

Women in Dark Times: Agnes Heller and Hannah Arendt

Few academic honors have been more strikingly appropriate than the selection in 1986 of Agnes Heller as the New School's Hannah Arendt Professor of Philosophy. For the holder of the chair and the thinker after whom it was named are inextricably linked in a myriad of important ways. Although the two never actually met,[1] it is scarcely an exaggeration to say that Arendt has been Heller's *sub rosa* intellectual companion for at least the past two decades. In ways that I will explore shortly, Heller's work can be construed as a subtle response to Arendt's, often in the form of a meditation on the same themes in the changing context of a later day.

But even beyond their intellectual affinities, Arendt and Heller are linked by similar biographical destinies.[2] Born a generation apart—Arendt in Königsberg in 1906 and Heller in Budapest in 1929—both were the products of that remarkably creative, if often restlessly tormented cultural configuration known as Central European Jewry.[3] Although thoroughly assimilated and religiously nonobservant, they came to know the status of pariah Bernard Lazare had identified with the Jew who refuses the alternative option of parvenu, whose emancipation is merely social.[4] Touched personally by their people's melancholy fate, they both lost relatives and close friends during the Holocaust and were compelled to wrestle with its horrible lessons, as well as those of totalitarianism in general. Neither was able to remain in the country of her origin, both ultimately migrating to New York after temporary exiles elsewhere, Arendt for eight years in Paris and Heller for nine in Melbourne.

No less significant was their homologous intellectual formation under the tutelage of two of the most imposing and problematic thinkers of the century, Martin Heidegger in Arendt's case, Georg Lukács in Heller's.[5]

Although at different ends of the political spectrum, Heidegger and Lukács shared a radical rejection of capitalist modernization and bourgeois values, which led them to embrace politically questionable alternatives. Thus, both Arendt and Heller ultimately had to struggle to distance themselves from certain aspects of their mentors' work, without at the same time repudiating their obvious debt.[6] In the effort to define themselves as independent thinkers, each was supported by gifted husbands, who were intellectual as well as emotional collaborators secure enough not to begrudge them the limelight.[7]

Both also found similar role models to emulate. Perhaps most notable among them was Rosa Luxemburg, whom they cherished as much for her remarkable courage and personal integrity as for her ideas.[8] What they did find especially admirable in Luxemburg's theory was her resistance to the dictatorial implications of Lenin's version of the vanguard party, which went along with her admiration for the role of workers councils. Neither Arendt nor Heller, it should also be noted, was troubled by Luxemburg's indifference to the issue of gender, which they themselves rarely foregrounded in their own work.[9]

No less attractive to both Arendt and Heller was the figure of Gotthold Ephraim Lessing, whose defiantly independent *Selbstdenken* the former explicitly and the latter implicitly chose to emulate.[10] Appropriately, each was awarded the city of Hamburg's Lessing Prize, Arendt in 1959, Heller in 1981. In their respective acceptance speeches,[11] they celebrated Lessing's rejection of absolute truth in the name of multiple truths (or in Arendt's reading, opinions) and his critique of fundamentalist moralism. They also praised his insight into the importance of concrete friendship in the public realm as opposed to abstract notions of equality or the communal ties of fraternity. And both spoke movingly of the importance of his *Nathan the Wise*, with its celebrated parable of the three rings, for their own sense of themselves as Jews.[12] But perhaps most of all it was Lessing's realization that philosophy is an affair of the world, not the individual mind, that won their approbation. For both Arendt and Heller, even in the darkest of times, philosophy must not lose its world-affirming link to the intersubjective realm of human interaction, the public arenas of politics and culture.

But precisely what that link can or ought to be proved a source of a certain tension between their two positions. In what follows, I would like to pursue a bit more closely Heller's imaginary dialogue with Arendt (who never, alas, had the opportunity of a rejoinder) in the hope of clarifying the issues that separated them. Beginning with Heller's response to Arendt on specifically political themes, I will then consider her more general appreciation and critique of Arendt's philosophy as a whole.

In the Budapest of the 1950s, Arendt's work was virtually unknown; *The Origins of Totalitarianism* could not have been, after all, required reading in Lukács's seminar at the time when Heller became one of its members. Arendt for her part seems to have had little interest in or sustained knowledge of Lukács or indeed of Western Marxism as a whole. One will look in vain for a reference to *History and Class Consciousness* in her work, which tended in a very non-Lukácsian way to conflate Marx and the dialectical materialism stemming from Engels.[13] Nor did she have any patience with the revival of Hegel, whose philosophy of history she deemed one of the major obstacles to the recovery of political life.

The first opportunity for a potential convergence between Arendt and Lukács's star student came in 1958, when an epilogue to *The Origins of Totalitarianism* pondered the lessons of the Hungarian Revolution. For Arendt, 1956 was the closest thing in history to Luxemburg's "spontaneous revolution"[14] in which no one deliberately "made" an uprising against the state. Even more importantly, it showed the vitality of the council model, which represented a "true upsurge of democracy against dictatorship, of freedom against tyranny."[15] Lukács had been a celebrant of the councils himself for a short while after his conversion to Communism in 1918, although they were no longer very evident in the work he did following his self-abnegating reconciliation with the party. Still, his critical instincts and utopian hopes remained sufficiently intact to allow him to become a significant presence, intellectually and politically, in the Imre Nagy regime. His students in what was later called the "Budapest School" shared his enthusiasm for the revolution, despite the political and professional trouble it created for him (and soon for them as well).

Thus, it is not surprising to see Heller and Fehér many years later discover a certain kinship with Arendt in their own reassessment of the events of 1956.[16] Not only did they agree with her contention that the revolution was not consciously made, they also shared to an extent her sense of the importance of the councils, for embodying the principle that "one participates only if one wishes to participate."[17] Even though they took issue with her historical analysis of the progressive credentials of federalist as opposed to centralizing tendencies in Hungary, they accepted Arendt's contention that federalism was indeed on the agenda of what she had called the "new republic" in 1956.

The first explicit contact with Arendt's work, as Heller remembers it, had come, however, not with the 1958 epilogue, but with the publication of *The Human Condition* in the same year. Arendt's critique of Marx for reducing all making to labor, grounded in an image of man as *animal laborans* rather than *homo faber*, could not have pleased Heller, nor could Arendt's defense of the necessity and virtues of reification or her reading of Marx as obsessed with the social question.[18] And she never accepted

Arendt's contention that Marx had marginalized the value of freedom.[19] But other dimensions of Arendt's argument slowly found their way into Heller's work in later years. The idea itself of a "human condition" as opposed to a "human nature" surfaced in Heller's *General Ethics*,[20] and she would come to disdain a "philosophy of history," with all of its pseudoscientific pretensions to know how the future will or should unfold, in favor of a more modest "theory of history."[21]

What especially seems to have intrigued Heller, however, was Arendt's appropriation of the pluralist *vita activa* tradition dating back to Aristotle. In particular she appreciated Arendt's resuscitation of the value of political activity in the public realm as an essential component of the good life. But rather than claiming that Marx had failed to understand this lesson, as had Arendt, Heller contended that he had fully anticipated Arendt's own position. As she told an interviewer with some irony in 1985, "Hannah Arendt, otherwise a critic, showed herself to be a good student of Marx when she emphasized that the victory of the bourgeois (the egoistic private person) over the citizen was the greatest single catastrophe that prepared the ground for the 'rightist' and 'leftist' totalitarian systems that were to come."[22]

Although Heller found Arendt's categorical distinctions among labor, work, and action suggestive, she resisted the absoluteness of the boundaries separating them, as well as the hierarchical order in which Arendt had placed them. *Praxis* and *poesis* were not as incommensurable as Arendt had assumed. Insisting that a third category called the sphere of objectification was needed to supplement those of work and production,[23] Heller balked at the assumption that human freedom was solely a function of action in a distinctly political realm, however much politics was its precondition. "The good life," she insisted, "is the life of the good person, not of the good citizen."[24]

Unlike Arendt, Heller also more positively evaluated the importance of what Aristotle had called *techné*, which included speech and reflection just as much as did the realm of public affairs.[25] Commensurate with her long-standing interest in the value of everyday life, she likewise rejected Arendt's denigration of the social as merely an inflated version of the ancient household, the *oikos*, in which great deeds were impossible to perform because of the constraints of need satisfaction. "The politicization of social justice," she argued, "is by no means tantamount to giving priority to the so-called 'social question,' as Hannah Arendt once believed. . . . In politicizing social issues, the priority of the political (of liberties and liberal-democratic rights) is reconfirmed rather than negated."[26] Or as Fehér would put it in an essay he contributed to their jointly published *The Postmodern Political Condition*: "to divide the world into acts pertaining to freedom while rejecting the all too material de-

mands of needs, and into other acts which satisfy needs and hence which pertain only to the realm of necessity, is a *false spiritualization of liberty*."²⁷

The same sentiment in fact even appeared in the talk Heller gave when she was inaugurated in the Hannah Arendt chair at the New School, entitled "The Concept of the Political Revisited."²⁸ Arguing as well against that other seminal defender of the autonomy of the political, Carl Schmitt, she criticized the exclusivity of a political sphere that categorically restricted its scope to nonsocial and noneconomic issues. Contending that Arendt was alone among defenders of this position in not turning it in a dangerously radical direction, Heller nonetheless criticized her dream of reviving an elite political class comparable to the citizens of the Greek polis. "It is not the resolute one-sidedness of Arendt's political vision that I question here," she concluded, "I rather take issue with her self-created dilemma, namely being committed to democracy while at the same time excluding a wide variety of issues men and women perceive as political affairs of the greatest urgency in their daily lives."²⁹

And yet, while chastising Arendt for her overly rigid segregation of the political from socioeconomic concerns, Heller came more and more to appreciate her value as an opponent of the opposite temptation: the sublation of the distinction in an allegedly higher form of "human emancipation." This hope, which was the dream of Marxist Humanism ever since Marx's essay "On the Jewish Question" and which continued to inspire Lukács throughout his career, Heller came explicitly to repudiate. Against its contemporary defenders such as Cornelius Castoriadis,³⁰ with whom on many other issues she concurred, Heller evoked Arendt as a critic of what she and Fehér called the "redemptive paradigm" in politics.³¹ Even Arendt's controversial argument about the banality of evil from *Eichmann in Jerusalem*, a work Heller generally disliked, could be understood as a warning against granting politics any sublime (or conversely demonic) function.

If Arendt was a utopian, Heller came to argue, it was only in the mold of what could be called the Great Republic tradition, a "utopia of the least possible degree."³² In this context, Arendt's distinction between the social and the political might be understood as not so pernicious, after all, because it transcended the liberal dichotomy of private and public: "Her insistence on the 'insertion' of a 'social sphere' between the political and the private, the cause of so many misunderstandings on the Western Left (which has always believed that she was 'conservative') was a recurrent theme within the tradition of the Great Republic. It is small wonder then that Arendt was enthusiastic about the institutions which mushroomed during the 'ten free days' of the Hungarian Revolution in 1956, and that she discovered a sisterly spirit in Rosa Luxemburg, whose intentions she understood so well."³³

The full implications of the republican tradition were drawn out in "The Pariah and the Citizen (On Arendt's Political Theory)," an essay by Fehér included in *The Postmodern Political Condition*. Here Arendt's invidious comparison between the French and the American Revolutions in *On Revolution* became the basis of a veritable distinction between democracy and republicanism.[34] Whereas the former was based on the fiction of popular sovereignty legitimated by a homogeneous general will and producing complete consensus,[35] the latter recognized the plurality of opinions and reached compromises only through the formal mechanism of majority decision. It also understood the wisdom of separating authority, in the form of constitutional laws, from immediate political power. Thus, republics maintained minority rights, whereas democracies threatened to extirpate them.[36] Although Arendt's version of American history was flawed because of her failure to acknowledge its own belief in popular sovereignty, her contrast between these two types of government—or more precisely, her belief in the republic as the regulative ideal of actually existing democracies—was "remarkably insightful."[37]

If Arendt's weak utopian hopes could be accommodated to Heller's antiredemptive politics of radical (republican) democracy, so too could her dystopian vision of radical tyranny as its negative pole. In an "Imaginary Preface to the 1984 Edition of Hannah Arendt's *The Origins of Totalitarianism*,"[38] Heller endorsed with only minor modifications Arendt's reconstruction of its origins and workings. Opposing those who claimed Arendt's ideal type was now obsolete, Heller stubbornly insisted that not only did the contemporary Soviet Union still live in the shadow of Stalinism, but also that totalitarianism was on the rise in the Third World. Distinguishing between fascist or satellite Communist countries, where political totalization was unmatched by social totalization, with the Soviet Union, where both had taken place, she gloomily concluded that there were no realistic chances of a transformation in a fully totalitarian society. Contending that Arendt's cautious optimism of the mid-1960s had thus been misplaced, she nonetheless added "I hope that some of my own prognoses will equally prove wrong."[39]

If Arendt became a more vital presence in Heller's political theorizing as the influence of Lukács over her began to wane, she also became increasingly evident, both as a stimulus and a target of criticism, in Heller's more general philosophical speculations. Perhaps nowhere was this impact more evident than in Heller's interest in the theme of judgment. "It was," she acknowledged, "Hannah Arendt's great deed to return to the problem of judgment."[40] Although Arendt never finished the third volume of her trilogy on *The Life of the Mind*, which was to be devoted to judgment, her posthumously published *Lectures on Kant's Political Philosophy* indicate the likely direction of her thought. The importance of judgment

was its relevance for moral and political, as well as aesthetic issues and its distinction from both cognitive and volitional modes of thinking.

In a remarkable essay devoted to Arendt's final work,[41] Heller examined the implications of her resurrection of the faculty of judgment, especially as it related to the issue of morality. Noting that the late Arendt focused on the *"vita contemplativa"* more than the *"vita activa"* and saw thinking as a fully disinterested phenomenon, Heller acknowledged that the implication of this argument was a withdrawal from the world. She also noted that Arendt had associated judgment with the role of a spectator outside of the realm of direct political action. The life of the mind was, in fact, absolute autonomy for Arendt, a form of complete *Selbstdenken* that was even purer than the autotelic *praxis* celebrated in *The Human Condition.*

And yet, judgment also provided a way back to the world, mediating between the *"vita contemplativa"* and the *"vita activa."* For "although judgments are passed *by spectators*, they are passed *on actors.* The faculty of judgment judges political actions."[42] Moreover, judging, unlike cognition, was a quest for meaning rather than truth, or more accurately, meanings in the plural. And furthermore, Heller contended, "meaning constituted by judging, albeit pluralistic, can be shared, contrary to the meanings constituted by the process of thinking and willing. This is why judging, as the faculty of the contemplative life, corresponds to political action in the 'vita activa.' In the final analysis then, the political dimension gains the upper hand even in *bios theoreticus.*"[43]

Arendt had been wrong, however, in several ways, according to Heller. First, the radical separation of meaning from truth was a function of her reductive equation of truth with its positivist version as scientific knowledge. In her own philosophizing, truth claims of another kind were implicitly raised, which contradicted her contention that thinking was indifferent to truth. Like her rigidly categorical distinction between the political and the social in her earlier work, Arendt's segregation of meaning from truth, opinions from cognition, went too far. It was also questionable to claim, as Arendt did, that thinking knows no progress, for following her own analysis, judgment was not thematically investigated until the time of Kant, much later than thinking in general and willing. If this were the case, then some sort of progress had indeed taken place.

Finally, Arendt's contention that the moral issues of good and evil concerned thinking alone, without any cognition, was fallacious.[44] Her claim in the book on Eichmann that his committing evil was solely a function of his not thinking failed to understand that some prior knowledge of the criteria of good and evil must be assumed before any judgment was possible. Therefore, "thinking on matters of good and evil cannot be 'pure' in her own definition of pure thinking for it cannot be completely

autonomous."[45] Indeed, "even the faculty of judging cannot be conceived as absolutely autonomous in matters of moral taste. Here too we need to be *compelled* by true and good norms. Knowledge, and also the quest for knowledge are prerequisites for the proper use of the faculty of judging."[46]

Moral autonomy, therefore, must be understood as relative rather than absolute, an argument Heller would pursue at greater length elsewhere.[47] The source of prescriptive commands can be found in the representative stories a society tells itself, stories that Heller calls its culture. Although Arendt may not have explicitly drawn this same conclusion, her work leads to it nonetheless. "All philosophies, diverse as they are among themselves," Heller contended, "immortalize what is good in us. Thus Arendt's work on the life of the mind conveys to us the norm that reads as follows: do not let political actions pass into oblivion!"[48] For in remembering such actions, we have paradigmatic knowledge that allows moral judgments, examples of concrete instantiations of good and evil rather than mere abstract rules. And it is, of course, precisely those judgments that Kant in the third *Critique* called reflective rather than determinant that discriminate on the basis of such paradigms. Here the fruitful convergence of aesthetic taste and political ethics can be discerned, as Arendt understood.[49]

Such have been Heller's responses to Arendt, whose important role in the evolution of the younger theorist's ideas should by now be evident. In retrospect, Heller's reception of Arendt can be seen to have followed an interesting pattern. Although never accepting Arendt's tendentious dismissal of Marx, Heller has found many of her arguments congenial in her own gradual move away from the strong version of the Marxist Humanism she absorbed from Lukács.[50] In particular, Arendt has provided welcome ammunition in the campaign against what Heller and Fehér call "redemptive politics," the belief that human emancipation requires the radical overcoming of all antinomies in a perfectly realized community of justice, freedom, and equality. Not only has her critique of the totalitarian version of that dream had its impact on Heller, so too has Arendt's discrimination among categories such as thinking and knowing, the political and the social, the *vita activa* and the *vita contemplativa*. Thus, in one of their most recent works, Heller and Fehér could explicitly state, "the controversy between 'the revolutionary' and the 'reformist' positions have faded from our vision seeming to lack relevance. At the same time, somewhat neglected political theories, for example Hannah Arendt's analyses of 'the republic,' 'the citizen,' 'the act of foundation as *constitutio libertatis*' have gained in significance for us."[51]

Heller, however, has found fault with Arendt's penchant for absolutizing her distinctions into incommensurable antitheses. Although politics

cannot fully solve social or economic questions, neither can it ignore them. Thinking may involve questions of meaning, while cognition is concerned with the truth, but the two cannot be so completely separated. Morality may be more a function of judgment than applying abstract rules, but it does involve knowing what one's culture deems good and evil and is thus not wholly autonomous. The republican tradition may be irreducible to radical democratic notions of popular sovereignty and the general will, but it would be a mistake to abolish all notions of consensus from political will-formation. Judgment may be a secondary activity performed largely by the post facto spectator, but it is not without its links to political action or its roots in a kind of participatory cognition of a culture's ethical norms. Citizenship is a necessary, but not sufficient foundation for the good life.

Perhaps the most fundamental reservation Heller seems to harbor about the incommensurability of Arendt's categories concerns the basic distinction between modernity and the classical polity, whose genius only reappears in isolated and ephemeral moments in the present. If, as one commentator has put it, Arendt's "thought is a radical form of anti-modernism,"[52] Heller's can be accounted a nuanced defense of modernity. Rather than claiming that once modernity introduced the social question, totalitarianism was virtually inevitable, she has contended that it was more an accidental outcome of a process that has also had different and more attractive potentials.[53]

Although repudiating a Hegelian or Marxist philosophy of history as an untenable metanarrative, Heller has nonetheless held on to the more modest notion that modernization reveals a set of interdependent logics, which tendentially seem to be leading in a certain direction. Morality cannot be cumulatively increased, but there are ethical and political learning processes that can tentatively be called progressive. One of the most fundamental lessons that seems to have been widely learned is that universalism requires the maintenance rather than destruction of pluralism and otherness. "European universalism, the absolutist scenario, proved to be a realistic project, for every nation of the world was included by it into a modernizing universe. And similarly, relativism also became a realistic attitude because it transpired that concrete cultural traditions may remain unaffected by the modern project, and that the latter can go together with any culture whatsoever."[54]

Now that Heller's excessively bleak prognosis of the future of Soviet and East European totalitarianism has been happily confuted, the cautious optimism in her defense of modernity seems even more justified. Perhaps the greatest difference between the two remarkable thinkers we have been discussing in this chapter is that the second may no longer be said to live in truly dark times. The problematic yearning for redemptive politics that

is so often the reverse side of hopelessness may as a result also be waning. Heller's subtle and imaginative appropriation of Arendt has perhaps given us a glimpse of what may lie on the other side.

6

"The Aesthetic Ideology" as Ideology: Or What Does It Mean to Aestheticize Politics?

In 1930, Walter Benjamin reviewed a collection of essays edited by the conservative revolutionary Ernst Jünger entitled *War and Warrior*.[1] Noting its contributors' avid romanticization of the technology of death and the total mobilization of the masses, Benjamin warned that it was "nothing other than an uninhibited translation of the principles of *l'art pour l'art* to war itself."[2] Six years later, in the concluding reflections of his celebrated essay "The Work of Art in the Era of Mechanical Reproduction," Benjamin widened the scope of his analysis beyond war to politics in general. Fascism, he charged, meant the aestheticization of politics, the deadly consummation of *l'art pour l'art*'s credo "*Fiat ars-pereat mundus*."[3]

Like much else in Benjamin's remarkable corpus, the reception and dissemination of these ideas was delayed for a generation or so after his suicide in 1940. By then his remedy—the politicization of art by Communism in the 1936 piece,[4] the transformation of war into a civil war between classes in the earlier review—was forgotten by all but his most militant Marxist interpreters. But the fateful link between aesthetics and politics was eagerly seized on in many quarters as an invaluable explanation for the seductive fascination of fascism.

In such works as Bill Kinser and Neil Kleinman's *The Dream That Was No More a Dream*, Nazism was explained by the fact that "German consciousness treated its own reality—developed and lived its history—as though it were a work of art. It was a culture committed to its aesthetic imagination."[5] Hitler's personal history as an artist *manqué* was recalled by commentators like J. P. Stern, who saw the legacy of Nietzsche's conflation of artistic form-giving and political will in Nazism.[6] The confusion between reality and fantasy in films like Leni Riefensthal's *Triumph of the Will* was taken as emblematic of the illusory spectacle at the heart

of fascist politics by critics like Susan Sontag.[7] Similar inclinations were
discerned in French fascism by Alice Yaeger Kaplan, who successfully
solicited the admission from one of her subjects, the film historian Maurice
Bardèche, "there is, if you like, a link between aestheticism and fascism.
We were probably mistaken to connect aesthetics and politics, which are
not the same thing."[8] Even the contemporary representation of the fascist
past has been accused of being overly aestheticized, albeit in the sense
of kitsch art, by Saul Friedländer.[9]

As a result of these and similar analyses, the connection between "the
aestheticization of politics" and fascism has become firmly established.
It has become such a commonplace that some of its affective power has
wandered from the historians' treatment of the issue into a related, but
not identical, discussion carried on mainly by literary critics over what is
called "the aesthetic ideology." The term was coined by Paul de Man,
whose interest in ideology critique seems to have been increasing shortly
before his death in 1983.[10] The concept has been taken up by his defenders
in the controversy that followed the disclosures of his wartime journalism,
for reasons to be examined shortly.[11] And it has also appeared in the
recent writings of the Marxist critics David Lloyd and Terry Eagleton,
whose agenda is very different from that of most of de Man's supporters.[12]

The displacement of the discussion from historical to literary critical
circles has involved, however, a significant, but not always acknowledged
reevaluation of the aesthetics whose imposition on the political is damned
as pernicious. The change has also meant a concomitant reattribution of
the original culprits allegedly responsible for the crime. In what follows,
I want to explore the implications of the shift and ask if the critique of
"the aesthetic ideology" in certain of its guises may itself rest on mys-
tifications, which allow us to call it ideological in its turn.

Any discussion of the aestheticization of politics must begin by iden-
tifying the normative notion of the aesthetic it presupposes. For unless
we specify what is meant by this notoriously ambiguous term, it is im-
possible to understand why its extension to the realm of the political is
seen as problematic. Although a thorough review of the different uses in
the literature is beyond the scope of this chapter, certain significant al-
ternatives can be singled out for scrutiny.

As Benjamin's own remarks demonstrate, one salient use derives from
the l'art pour l'art tradition of differentiating a realm called art from those
of other human pursuits, cognitive, religious, ethical, economic, or what-
ever. Here the content of that realm apart—often, but not always iden-
tified, with something known as beauty—is less important than its claim
to absolute autonomous and autotelic self-referentiality. For the obverse
of this claim is the exclusion of ethical, instrumental, religious, and other
considerations from the realm of art.

A politics aestheticized in this sense will be equally indifferent to such extra-artistic claims, having as its only criterion of value aesthetic worth. Moreover, the definition of that worth implied by such a rigid differentiation usually suppresses those aspects of the aesthetic, such as sensuous enjoyment and bodily pleasure, which link art and mundane existence; instead, formal considerations outweigh "sentimental" ones. On a visit to Paris in 1891, Oscar Wilde was reported to have said that "When Benvenuto Cellini crucified a living man to study the play of muscles in his death agony, a pope was right to grant him absolution. What is the death of a vague individual if it enables an immortal work to blossom and to create, in Keats's words, an eternal source of ecstasy."[13] Another classical expression of this attitude appeared in the notorious response of the Symbolist poet Laurent Tailhade to a deadly anarchist bomb thrown into the French Chamber of Deputies in 1893: "What do the victims matter if the gesture is beautiful?"[14] Not long after, F. T. Marinetti's *Futurist Manifesto* echoed the same sentiments in glorifying, along with militarism, anarchistic destruction, and contempt for women, "the beautiful ideas which kill."[15] Moving beyond the Futurists' flatulent rhetoric, Mussolini's son-in-law and foreign minister Ciano would confirm the practical results of its implementation when he famously compared the bombs exploding among fleeing Ethiopians in 1936 to flowers bursting into bloom.

The aestheticization of politics in these cases repels not merely because of the grotesque impropriety of applying criteria of beauty to the deaths of human beings, but also because of the chilling way in which non-aesthetic criteria are deliberately and provocatively excluded from consideration. When restricted to a rigorously differentiated realm of art, such anti-affective, formalist coldness may have its justifications; indeed, a great deal of modern art would be hard to appreciate without it. But when then extended to politics through a gesture of imperial dedifferentiation, the results are highly problematic. For the disinterestedness that is normally associated with the aesthetic seems precisely what is so radically inappropriate in the case of that most basic of human interests, the preservation of life. Benjamin's bitter observation that humankind's "self-alienation has reached such a degree that it can experience its own destruction as an aesthetic pleasure of the first order"[16] vividly expresses the disgust aroused by this callous apotheosis of art over life.

A related but somewhat different use of the term aesthetic derives from the elitist implications of the artist who expresses his or, far more rarely, her will through the shaping of unformed matter. A characteristic expression of this use appeared in Nietzsche's claim in *The Genealogy of Morals* that the first politicians were born rulers "whose work is an instinctive imposing of forms. They are the most spontaneous, most unconscious artists that exist. . . . [T]hese men know nothing of guilt, responsibility,

consideration. They are actuated by the terrible egotism of the artist . . .''[17] The fascist adoption of this stance is plainly evident in Mussolini's boast that "when the masses are like wax in my hands, or when I mingle with them and am almost crushed by them, I feel myself to be a part of them. All the same there persists in me a certain feeling of aversion, like that which the modeler feels for the clay he is molding. Does not the sculptor sometimes smash his block of marble into fragments because he cannot shape it into the vision he has conceived?"[18] What makes this version of aestheticized politics so objectionable is its reduction of an active public to the passive "masses," which are then turned into pliable material for the triumph of the artist/politician's will.

Still another use draws on the perennial battle between the image and the word. Insofar as the aesthetic is identified with the seductive power of images, whose appeal to mute sensual pleasure seems to undercut rational deliberation, the aestheticization of politics in this sense means the victory of the spectacle over the public sphere. Russell Berman, in his foreword to Alice Yaeger Kaplan, faults the fascist critics Robert Brasillach and Maurice Bardèche for praising silent films over talkies and compares their celebration of the cinema with Benjamin's: "The fascist film theoreticians contrast the organic—and organizing!—homogeneity of the silent image with the introduction of speech that dissolves the nation through individuation and criticism. . . . Bardèche and Brasillach value the pure image, popularized aestheticism, in order to produce the fascist folk, while the iconoclast Benjamin applauds the shattering of the image in montage in order to call the masses (for him at this point the communist masses) to language."[19] Taking seriously the religious underpinnings of the taboo on images, he further claims that "Benjamin's account of an aestheticization of politics consequently appears as a civilizational regression to graven images of the deity, as in Riefenstahl's representation of Hitler's descent from the clouds in *Triumph of the Will*."[20] In short, politics has to be saved from its reduction to spellbinding spectacle and phantasmagoric illusion to allow a more rational discourse to fill the public space now threatened with extinction by images and simulacra of reality.

In this cluster of uses, the aesthetic is variously identified with irrationality, illusion, fantasy, myth, sensual seduction, the imposition of will, and inhumane indifference to ethical, religious, or cognitive considerations. If any pedigree is assumed, it is found in the writings of Nietzsche in certain of his moods and aesthetic modernists like Tailhade or Marinetti. Scarcely beneath the surface is an appreciation of the links between decadence, aestheticism, and elitism, which suggest that the seedbed of fascism was fin-de-siècle bourgeois culture in crisis. We are, in other words, very much in the world whose decline was so powerfully chartered

by Thomas Mann from *Death in Venice* through "Mario the Magician" to *Doctor Faustus*.

In the case of the "aesthetic ideology" criticized by de Man, Eagleton, and other contemporary literary critics, the target is constructed, however, very differently. The aesthetic in question is not understood as the opposite of reason, but rather as its completion, not as the expression of an irrational will, but as the sensual version of a higher, more comprehensive notion of rationality, not as the wordless spectacle of images, but as the realization of a literary absolute. In short, it is an aesthetic that is understood to be the culmination of Idealist philosophy, or perhaps even Western metaphysics as a whole, and not its abstract negation. Bourgeois culture at its height rather than at its moment of seeming decay is thus taken as the point of departure for aestheticized politics.

An early version of this argument appeared in *The Literary Absolute* by French theorists Philippe Lacoue-Labarthe and Jean-Luc Nancy, published in 1978 and translated into English a decade later.[21] Discussing the Jena Romantics' redemptive notion of art, they claim that it represents the displacement of Platonic eidetics, the search for essential forms, into a new realm, which they call "eidaesthetics." This quasi-religious metaphysics of art is responsible for an absolute notion of literature, whose task is the overcoming of differences, contradictions, and disharmonies. Although implicitly challenged by a counterimpulse they call "romantic equivocity," the telos of eidaesthetics is the closure of a complete work produced by an omnipotent subject, who realizes the Idea in sensual form. Jena Romanticism's desire for poetic perfection is thus derived from an ultimately metaphysical project, which has political implications as well. The Romantic fascination with the fragment, they contend, is premised on the possibility of an "ideal politics . . . an organic politics."[22] As Europe's first self-conscious intellectual avant-garde, the Jena Romantics thus set the agenda for the conflation of art and politics pursued by so many later intellectuals.

What we might call the "eidaestheticization of politics" is even more explicit in one of the main instigators of the aesthetic ideology as de Man describes it, Friedrich Schiller. According to de Man, "the aesthetic, as is clear from Schiller's formulation [from a passage in *Letters on the Aesthetic Education of Mankind*], is primarily a social and political model, ethically grounded in an assumedly Kantian notion of freedom."[23] Its effects on writers like Heinrich von Kleist, whose *Über das Marionettentheater* de Man reads with alarm, was pernicious. The dance of Kleist's puppets, so often admired as a utopian state of grace in which purposiveness without purpose is brilliantly realized, turns out to have a very different implication. "The point is not that the dance fails and that Schiller's idyllic description of a graceful but confined freedom is aberrant," de Man darkly

warns. "Aesthetic education by no means fails; it succeeds all too well, to the point of hiding the violence that makes it possible."[24] That violence is directed against all the cultural impulses, especially those in language, which resist coerced totalization and closure.

In a later piece on "Kant and Schiller,"[25] de Man teased out the implications of this argument for fascism. Although in many ways appreciative of Kant's resistance to metaphysical closure and epistemological overreaching, he nonetheless identified in him the potential to sanction, however unintentionally, a sinister tradition. Citing a passage from Goebbels's novel *Michael*, which includes the claim that "politics are the plastic art of the state," he concedes that "it is a grievous misreading of Schiller's aesthetic state."[26] But he then adds, "the principle of this misreading does not essentially differ from the misreading which Schiller inflicted on his predecessor, namely Kant." In other words, for all their emancipatory intentions, Kant and even more so Schiller spawned a tradition that contained the potential to be transformed into a justification for fascism.

Lest the specific antifascist purposes of de Man's critique of the aesthetic ideology be missed, Jonathan Culler spells them out in his defense of de Man in the controversy over the wartime journalism. "Walter Benjamin called fascism the introduction of aesthetics into politics," Culler writes. "De Man's critique of the aesthetic ideology now resonates also as a critique of the fascist tendencies he had known."[27] That critique was carried out in the name of a notion of literature very different from that Lacoue-Labarthe and Nancy saw as complicitous with eidaesthetics. For de Man, it was precisely literary language's resistance to closure, transparency, harmony, and perfection that could be pitted against the aesthetic ideology. According to Culler, de Man's realization of this opposition demonstrates his rejection of his earlier collaborationist position: "The fact that de Man's wartime juvenilia had themselves on occasion exhibited an inclination to idealize the emergence of the German nation in aesthetic terms gives special pertinence to his demonstration that the most insightful literary and philosophical texts of the tradition expose the unwarranted violence required to fuse form and idea, cognition and performance."[28]

Whether or not this apology is fully convincing, it nonetheless clearly expresses one way the concept of the aesthetic ideology functions for deconstruction. Another concerns the sensual dimension of aesthetic pleasure, which we've also seen evident in the critique of images in the name of words made by Kaplan and Berman. In a telling passage in his essay on Hans Robert Jauss's "reception aesthetics," de Man claims that "the aesthetic is, by definition, a seductive notion that appeals to the pleasure principle, a eudamonic judgment that can displace and conceal values of truth and falsehood likely to be more resilient to desire than values of

pleasure and pain."[29] Ironically, here aesthetics is attacked not because it is formally cold and antihumane, but rather because it is human-all-too-human.

De Man's ascetic resistance to eudamonism and desire fits well with his frequent insistence that language is irreducible to perception and provides none of its easy pleasures. It also jibes nicely with his hostility to natural metaphors of organic wholeness, which, as Christopher Norris correctly notes, he saw as a major source of the aesthetic idealogy.[30] By implication, an aestheticized politics would thus be seductively promising sensual pleasures, such as oneness with an alienated nature, it could never deliver (or at least so the resolutely anti-utopian and austerely self-abnegating de Man thought).[31]

A similar, but less one-dimensionally negative analysis of this very dimension of the aesthetic ideology has recently been advanced by Terry Eagleton. He begins by noting the importance of the body and materiality in aesthetic discourse beginning with Alexander Baumgarten in the eighteenth century. It is not so much the realization of the Idea that is crucial as its concrete manifestation in the "feminine" register of sensuous form. Aesthetics thus expresses the need to leave behind the lofty realm of logical and ethical rigor for the rich, if confusing, realm of particular experience.

But despite what may seem to be progress in the detranscendentalization and demasculinization of reason, Eagleton reads the political implications of the ideology of the aesthetic with no less suspicion than de Man. It marks, he claims, "an historic shift from what we might now, in Gramscian terms, call coercion to hegemony, ruling and informing our sensuous life from within while allowing it to thrive in all its relative autonomy."[32] Once again the culprit is Schiller, who was "shrewd enough to see that Kant's stark imperatives are by no means the best way of subjugating a recalcitrant material world. . . . What is needed instead is what Schiller called the 'aesthetic modulation of the psyche,' which is to say a full-blooded project of fundamental ideological construction."[33] The modern subject is thus more aesthetic than cognitive or ethical; he is the site of an internalized, but illusory, reconciliation of conflicting demands, which remain frustratingly in conflict in the social world. As such, the aesthetic functions as a compensatory ideology to mask real suffering, reinforcing what the Frankfurt School used to call "the affirmative character of culture."[34]

Eagleton remains, to be sure, enough of a Marxist to interpret the aesthetic dialectically, and thus acknowledges its subversive potential. "Aesthetics are not only incipiently materialist," he writes, "they also provide, at the very heart of the Enlightenment, the most powerful available critique of bourgeois possessive individualism and appetitive egoism. . . .

The aesthetic may be the language of political hegemony and an imaginary consolation for a bourgeoisie bereft of a home but it is also, in however idealist a vein, the discourse of utopian critique of the bourgeois social order."[35] Eschewing the deconstructionist assumption that all dreams of autonomous and autotelic life are recipes for totalitarianism, he lyrically concludes that Marx himself was an aesthetician: "For what the aesthetic imitates in its very glorious futility, in its pointless self-referentiality, in all its full-blooded formalism, is nothing less than human existence itself, which needs no rationale beyond its own self-delight, which is an end in itself and which will stoop to no external determination."[36]

Although Eagleton's recuperation of the aesthetic moment in Marxism may seem excessively starry-eyed, and indeed is rejected by more uncompromising Marxist critics of the aesthetic ideology like David Lloyd,[37] it nonetheless reopens the question of how unequivocally evil the link between aesthetics and politics must be. Fortunately, a new and magisterial history of the problem has just appeared, which provides ample evidence for a more nuanced judgment: Josef Chytry's *The Aesthetic State*.[38] Although he acknowledges the usefulness of Benjamin's interpretation of fascism, Chytry is at pains to disentangle the earlier advocates of aesthetic politics from their alleged fascist progeny. Rather than positing an essentially unified narrative of fateful misreadings from Schiller and Kleist up to Goebbels, as did de Man, he stresses discontinuities instead, going so far as to argue that even Richard Wagner's version of the aesthetic state should not be confused with that of twentieth-century totalitarians. Having read Benjamin's essay on the Jünger collection, he knows how important the experience of the first world war was in giving an irrationalist aesthetic gloss to mass mobilization and the violence of the new technologies. There is a difference, he implicitly suggests, between the brutality committed by Kleist's dancing marionettes and that celebrated in Jünger's "storm of steel."

After a learned prologue on Greek, Renaissance, and other antecedents, Chytry's overview of the German tradition of the aesthetic state begins with Winckelmann's mid-eighteenth century recovery of the myth of an aesthetic Hellenic polis. He painstakingly traces its fortunes through the Weimar Humanists, Schiller, Hölderlin, Hegel, Schelling, Marx, Wagner, Nietzsche, Heidegger, and Marcuse. His account ends with an appreciation of Walter Spies, the German modernist artist who escaped in the 1920s to Bali, where he found—or helped create—a stunning realization of the "magic realism" that had been his artistic credo. Clifford Geertz's celebrated discussion of the Balinese theater state derived from ancient Hindu-Buddhist religion serves Chytry as scholarly support for the plausibility of Spies's vision.[39]

However idealized Spies's interpretation of Bali may seem, it is clear that Balinese aesthetic politics is a far cry from Riefenstahl's *Triumph of the Will* or Ciano's callous reduction of bombed humans to blossoming flowers. Nor is it reducible to the nightmare of seductive sensuality that appears to have kept de Man restlessly tossing and turning in his bed of linguistic austerity. Chytry's book, moreover, has another lesson worth heeding by those who want to avoid hastily turning all aesthetic politics into a prolegomenon to tyranny. In his discussion of Schiller's *Letters on the Aesthetic Education of Mankind,* he tacitly contests the critical reading we have seen in de Man. Schiller, he writes, "does not identify the moral with the aesthetic. Schiller fully recognizes the dangers of untrammeled aestheticism, but he interprets these pitfalls as resulting from an *inadequate* experience of beauty. The free play of faculties characteristic of aesthetic awareness ought to lead to awareness of the power of reason and the notion of a moral law, and any equation of this free play with the moral law itself reflects a serious misunderstanding of the experience."[40] In other words, rather than yearning to create a fully aestheticized form of life in which all differentiations were collapsed, Schiller was cognizant of the need to maintain certain distinctions. Rather than seek a complete totalization based on the eidaesthetic fiat of a dominating artist/politician, Schiller was sensitive to the value of preserving the nonidentical and the heterogeneous.

Another dimension of Schiller, as Chytry reads him, concerns the universalizing impulse in his notion of the aesthetic, which he connects to Winckelmann's emphasis on the Greek polis's democratic character. The aesthetic state in this sense is profoundly anti-Platonic and thus less the outcome of eidaesthetics than of the alternative Greek notion of *phronesis* or practical wisdom. "Against 'the most perfect Platonic republic' [Schiller] gives precedence to consent, and against what will be the German romantics' staple argument of individual sacrifice on behalf of the greater whole based on the metaphor of the formal artwork, he points out the basic categorical fallacy behind such arguments."[41] According to Schiller, the lesson of learning to appreciate natural beauty is transferable to intersubjective relations; in both cases, individuals come to respect the otherness of different objects and subjects, rather than dominating them. Even if at the end of the *Letters* Schiller withdrew into a pessimistic acknowledgment of the likely realization of his ideal by only a small elite,[42] his legacy was flexible enough to sanction a variety of aesthetic states, some more sympathetic than others.

Another way to express the more benign implications of aestheticizing politics in certain of its guises concerns the thorny issue of judgment, which takes us away from producing works of art (or their political correlates) to the problem of how we appreciate and evaluate them.[43] It was,

of course, in Kant's Third Critique that the link between judgment and aesthetic taste was classically forged. Aesthetic (or what he also called reflective) judgment is not cognitive (or determinant) because it does not subsume the particular under the general. Rather, it judges particulars without presupposing universal rules or a priori principles, relying instead on the ability to convince others of the rightness of the evaluation. When, for example, I call a painting beautiful, I assume my taste is more than a personal quirk, but somehow expresses a judgment warranting universal assent. I imaginatively assume the point of view of the others, who would presumably share my evaluation. Aesthetic judgment thus cannot be legitimated by being brought under a concept or derived from a universal imperative; it requires instead a kind of uncoerced consensus building that implies a communicative model of rationality as warranted assertability.

Kant's critique of judgment has been itself criticized by those hostile to the aesthetic ideology. In *The Truth in Painting*, for example, Jacques Derrida claims that its dependence on the principle of analogy (as opposed to induction and deduction) means it tacitly privileges an anthropocentric lawgiver, who relentlessly reduces difference to sameness.[44] Like de Man, he sees the aesthetic as thus complicitous with violence. He also claims that the very attempt to restrict aesthetic judgment to autotelic works of art necessarily fails because the boundary between the work (*ergon*) and the frame (*parergon*) is always permeable, so that it is impossible to distinguish one form of judgment from another so categorically.

This last argument, however, can be turned against the critics of the aestheticization of politics, who want to maintain a rigid demarcation between the two allegedly separate spheres. If the boundary is always to be breached (although not completely effaced), what will the results look like? The negative answers have already been spelled out above. Are there more attractive alternatives? Three come to mind. The first draws on but doesn't fully accept the absoluteness of the distinction between the aesthetic and the literary in de Man; whereas the former tends toward closure, mastery, control, and the deceptive hiding of violence, the latter means heightened sensitivity to everything in language that resists such an outcome. De Man himself drew political consequences from this contrast in one of his last essays, in which he invoked no less an authority than Marx as a model for his own work: "more than any other mode of inquiry, including economics, the linguistics of literariness is a powerful and indispensable tool in the unmasking of ideological aberrations, as well as a determining factor in accounting for their occurrence. Those who reproach literary theory for being oblivious to social and historical (that is to say ideological) reality are merely stating their fear at having their own ideological mystifications exposed by the tool they are trying

to discredit. They are, in short, very poor readers of Marx's *German Ideology*."[45] The implication of this argument is that a politics informed by the skills of reading literature deconstructively will be less prone to tyranny than one that is not. Although the target is the aesthetic ideology, the remedy is thus a kind of extension of certain tools of aesthetic analysis into the realm of politics. How, of course, anything beyond ideology critique, anything constructive, will emerge is not very clear.

Two more promising defenses of a benign version of the link between aesthetics and politics have drawn on the lessons of Kant's Third Critique, which critics like de Man dismissively assimilate to the totalizing, analogizing impulse they so dislike. The first of these can be found in the political musing of Jean-François Lyotard, most notably his dialogue with Jean-Loup Thébaud, *Just Gaming*.[46] For Lyotard, both politics and art, or at least postmodern art, are realms of "pagan" experimentation in which no general rule governs the resolution of conflicts. Kant's exposure of the dangers of grounding politics in transcendental illusions, of falsely believing that norms, concepts, or cognition can provide a guide to action, is for Lyotard a valuable corrective to the terroristic potential in revolutionary politics in particular. The recognition that we must choose case by case without such criteria, that the conflicts Lyotard calls *differends* cannot be brought under a single rule, means that political, like aesthetic, practice is prevented from becoming subservient to totalizing theory. Rightly understood, it also prevents us from embracing a more problematic version of aestheticized politics, which draws on the mistaken belief that the political community can be fashioned or fabricated like a work of art.[47]

For Lyotard, the result is a politics that can be called aestheticized in the sense of an aesthetics of the sublime. That is, insofar as the sublime acknowledges the unpresentability of what it tries to present, it stops short of attempting to realize theoretically inspired blueprints for political utopias. Rather than trying to instantiate Ideas of Reason or the Moral Law, it follows aesthetic judgment in arguing from analogies, which preserve differences even as they search for common ground. As David Carroll, one of Lyotard's admirers puts it, "the sublime serves to push philosophy and politics into a reflexive, critical mode, to defer indefinitely the imposition of an end on the historical-political process."[48]

There are, to be sure, potential problems in this version of an aesthetic politics. Not all political problems, after all, allow the luxury of an indefinitely deferred solution. The sublime may be useful as a warning against violently submitting incommensurable *differends* to the discipline of a homogenizing theory, but it doesn't offer much in the way of positive help with the choices that have to be made. Lyotard's anxiety about introducing any criteria whatsoever into political judgment opens the

door, as Eagleton has noted, for a politics of raw intuition, which fails to register the inevitable generalizing function of all language.[49]

A more promising version of the claim that aesthetic judgment can be a model of a politics that avoids the imposition of rational norms from without can be found in the work of Hannah Arendt.[50] Aesthetics in her sense is also not the imposition of an artist's arrogant will on a pliable matter but the building of a *sensus communis* through using persuasive skills comparable to those employed in validating judgments of taste. Here the recognition that politics necessitates a choice among a limited number of imperfect alternatives, which are conditioned by history, replaces the foolhardy belief that the politician, like the creative artist, can begin with a clean canvas or a blank sheet of paper. It also means, however, acknowledging the intersubjective basis of judgment, which Lyotard's strong hostility to communication tends to obscure.[51]

As Arendt put it, "that the capacity to judge is a specifically political ability in exactly the sense denoted by Kant, namely, the ability to see things not only from one's own point of view but in the perspective of all those who happen to be present; even that judgment may be one of the fundamental abilities of man as a political being insofar as it enables him to orient himself in the public realm, in the common world—these are insights that are virtually as old as articulated political experience."[52] Because judgment operates by invoking paradigmatic examples rather than general concepts, it avoids reducing all particulars to instantiations of the same principle. Instead, it involves the faculty of imagination, which allows participants in the process to put themselves in the place of others without reducing the others to versions of themselves. The "enlarged mentality," as Kant called it, that results from imagination produces a kind of intersubjective impartiality that is different from the alleged God's eye view of the sovereign subject above the fray.[53] Although not transcendental, it is nonetheless more than the validation of infinite heterogeneity and the paradoxical sublime representation of the unpresentable; it mediates the general and the particular rather than pitting one against the other, as Lyotard would prefer.

Arendt's exploration of judgment is, to be sure, more suggestive than fully worked out. Even friendly commentators like Richard Bernstein have faulted her for failing to resolve the implicit tension between her stress on the virtues of action, on the one hand, and her praise of the spectatorial role of judging, on the other.[54] And her problematic segregation of a putatively political realm from its socioeconomic other, which has troubled many of her critics, is not resolved by her desegregating the political and the aesthetic.

But whatever their inadequacies, both Lyotard's and Arendt's thoughts on the potentially benign links between aesthetic judgment and politics

serve as useful reminders that not every variant of the aestheticization of politics must lead to the same dismal end.[55] The wholesale critique of "the aesthetic ideology," to return to our initial question, can thus be itself deemed ideological if it fails to register the divergent implications of the application of the aesthetic to politics. For ironically, when it does so, it falls prey to the same homogenizing, totalizing, covertly violent tendencies it too rapidly attributes to "the aesthetic" itself.

7

The Apocalyptic Imagination and the Inability to Mourn

> Let us remember. Repetition: nonreligious repetition, nei-
> ther mournful nor nostalgic, the undesired return. Rep-
> etition: the ultimate over and over, general collapse, de-
> struction of the present.
>
> Maurice Blanchot[1]

There can be do doubt; it is happening again. Another century is ap-
proaching its end; another century is about to begin. Indeed, we are at
the hinge of a millennial shift, the like of which hasn't been experienced,
it can be safely assumed, for a thousand years. And with the inevitable
countdown to the new millennium has come a flood, even more copious
than usual, of all of those overheated fantasies of destruction and rebirth
that somehow seem to attach themselves to decisive turns of the calendar
page.

These fantasies derive a great deal of their energy, imagery, and rhetoric
from another, even more powerful tradition with which they have often
been associated.[2] Known since the second century B.C. Book of Daniel as
apocalypse, from the Greek translation of the Hebrew *gala* or unveiling,
it was given an especially ominous twist by the lurid imagination of John
of Patmos.[3] Here too an explosive mixture of anxiety and expectation is
expressed in prophetic images of violent ends and new beginnings. Here
too what Hillel Schwartz, the author of a recent cultural history of *fin de
siècles*, has called a "janiform"[3] logic—"janiform" from the two faces of
Janus—has yoked together benign images of revelation and malign ones
of obliteration.

Even before the palpable *fin* of our *siècle* is upon us, apocalyptic think-
ing has returned with a vengeance. Indeed, it may well seem that all
manner of rough beasts have been slouching unimpeded in every direc-
tion throughout the entire twentieth century. Only now, with the added
impetus of centurial—or better, millennial—mysticism, they seem to have
picked up added speed.[5] As Schwartz puts it, our century's end "has
become—as it was fated to be—a Now or Never time. Living through it,

we will feel all middle ground slipping away toward one or another pole of apocalypse, toward a glory revealed or a globe laid waste."[6]

Prognosticating whether or not the center will indeed still be holding in a decade's time, and these drastic alternatives remain unrealized, is not my concern now. Nor do I wish to provide yet another learned survey of the past expressions of the apocalyptic imagination; of these enough are already in print.[7] I want to focus instead on one of the most curious aspects of the apocalyptic tradition, which is especially evident when it is mixed with centurial or millennial fantasies. That is, I want to try to make some sense of the paradoxical fact that a body of thought so obsessed with radical ends and new beginnings somehow seems to recur with tiresome regularity.[8] Why, I want to ask, is the only sure thing we can reasonably predict in connection with the apocalypse the fact that its four horsemen will continue to come around the track again and again? Why, to put it another way, does the apocalyptic "marriage," which M. H. Abrams has identified as its culminating image, inevitably end in divorce and renewed courtship?[9]

To begin to answer so speculative a question will require taking seriously the multiple levels of apocalyptic thought that are discernible in our own time. For if we can see similarities amidst their differences, then perhaps a pattern will emerge that will suggest a common source. In an essay of 1983, the political scientist Michael Barkun wrote of "divided apocalypse" in contemporary America, by which he meant the existence of two separate traditions of religious and scientific thinking that believed history might well be near its end.[10] The former could be traced back to biblical times and the later chiliastic sects of the type Norman Cohn famously described in *The Pursuit of the Millennium*.[11] Based on the assumption that the world is a moral order providentially designed, it read historical and/or natural disasters as portentous signs of God's wrath for humankind's sins. Only a remnant of the saved would survive the final holocaust.

Reinvigorated by the creation of the state of Israel in 1948, which emerged from the ashes of a penultimate holocaust, strengthened by the spread of Christian fundamentalism from the Bible Belt to new, often urban settings, emboldened by its successful entry into the political mainstream with the rise of the New Right, religious apocalypticism has continued to grow in importance. Ronald Reagan's notorious evocation of Armageddon in one of his debates with Walter Mondale struck a chord among millions of Americans, who apparently took it as more than a mere metaphor.[12] Significantly, the most successful nonfiction, English-language best-seller of the 1970s was the millenarian evangelist Hal Lindsey's *The Late Great Planet Earth*, which sold more than 7,500,000 copies.[13]

In the wake of the Gulf War, comparable books like Charles H. Dyer's *The Rise of Babylon* are bidding fair to be its 1990s successor.[14]

Although few intellectuals are likely to be among the purchasers of such works—Barkun claims that as a group they never recovered from the so-called "Great Disappointment" following William Miller's notorious failed prediction of the Second Coming back in 1843–44—they too have had their own apocalyptic tradition to support. We often associate the scientific spirit with a certain optimism about the progressive amelioration of the human condition, but there has always been an undercurrent of anxiety about the unintended consequences of dominating nature and brutally revealing her secrets. In the 1960s and 1970s, these gained a new hearing with the rise of environmental concerns, renewed Malthusian alarm about overpopulation, feminist critiques of the gendered underpinnings of science, and the heightened awareness of the implications of nuclear war. Such writers as Barry Commoner, Robert Heilbronner, and Jonathan Schell made scenarios of global destruction and the termination of life, perhaps only cockroaches aside, plausible to an educated audience often contemptuous of explicitly religious fantasies of the last days.[15]

Ironically, as religious prophets turned more and more to political signs of the coming end and disregarded natural portents, their secular counterparts began to read the natural world for indications of impending disaster. Scientific apocalypticism also differed from its religious *Doppelgänger* in its preference for statistical extrapolations over symbolic signs of God's wrath. And it spoke the language of identifiable causality rather than one trusting in the mysterious workings of an ineffable deity.

But the two apocalyptic discourses have often shared a strong moral tone. For the scientific doomsayers, humans were still in large measure responsible for the ills that might befall them, even if it were now possible for those same humans to hold off doomsday by acting in time. Similarities between the two variants of apocalypticism have been especially manifest in the confused reaction to the onset of AIDS, which easily evoked fantasies of punishment by plague for excessive sexual license. As Elaine Showalter has noted in her recent study of gender and culture at the *fin de siècle*, "sexual epidemics are the apocalyptic form of sexual anarchy, and syphilis and AIDS have occupied similar positions at the ends of the nineteenth and twentieth centuries as diseases that seem to be the result of moral transgression and that have generated moral panic."[16] Although such panic has perhaps been most explicit among religious apocalyptic believers, it has not been entirely absent in the ranks of their secular counterparts, who often seem unable to overcome anxieties about the costs of the so-called sexual revolution.

Although Barkun reassures his readers that the two traditions are not likely to come together, he nonetheless acknowledges that "the disquieting possibility remains . . . that if both strands of apocalyptic thought should agree on the reading of events, then the potential for one grand self-fulfilling prophecy is greatly increased, and panic may produce the effects once assigned to supernatural agents."[17] This dark prophecy is perhaps given even more weight if we acknowledge the existence of yet a third strain in contemporary apocalyptic thinking, unmentioned by Barkun, which we might call its postmodernist version.

For in the cultural ruminations of such figures as Jean Baudrillard, Jacques Derrida, and Jean-François Lyotard, explicit evocations of apocalyptic imagery and ideas can also be found.[18] These are often linked, and not for the first time,[19] with an aesthetics of the sublime, in which terror is mingled with intimations of unrepresentable glory. A common source for many of their ideas can be found in Heidegger's dark prophecies of the tragic fate of the West, destroyed by its fetish of technology and humanist hypersubjectivism. As a result, theirs often seems, to borrow the title of one of Maurice Blanchot's works, "the writing of the disaster."

In the tradition of aesthetic modernism, to be sure, similar preoccupations abounded, as Frank Kermode has shown in the cases of figures like Lawrence, Yeats, and Conrad.[20] In the visual arts, Yve-Alain Bois has also noted, "the whole enterprise of modernism, especially of abstract painting, which can be taken as its emblem, could not have functioned without an apocalyptic myth."[21] What makes the postmodern version somewhat different is its suppression of one of the traditional faces of the janiform visage of apocalypse. That is, whereas modernism still held out hope for the redemptive epilogue after the millennial last days—Yeats's "second coming" or Lawrence's "epoch of the Comforter"—postmodernism has focused only on the permanence of the destruction.

It the terms of the German critic Klaus Scherpe, postmodern versions of the apocalypse have thus "de-dramatized" the tradition, leaving behind any hope of rebirth or renewal. "By dismissing apocalyptic metaphysics and insisting on a pure and self-sufficient logic of catastrophe," Scherpe writes, "postmodern thought frees itself from the necessity of expecting an event that will alter or end history."[22] Instead, it promotes an emotionally distant attitude of aesthetic indifference, which abandons traditional notions of dramatic or narrative resolution in favor of an unquenchable fascination with being on the verge of an end that never comes. As Lyotard has repeatedly stressed, the "post" in postmodern doesn't mean "after" in any chronological sense; it is always already present in the interstices of modernity. The postmodernist rejection of redemptive hope, which reflects its often proclaimed belief that we live

in an age of *posthistoire*,[23] produces a result that, Scherpe suggests, is not simply apocalypse now, but apocalypse forever.

A salient example of this attitude can be found in one of the most direct expressions of the postmodern concern for the problem, Derrida's contribution to the 1980 Cerisy-la-Salle conference on his early essay "The Ends of Man," entitled "Of an Apocalyptic Tone Recently Adopted in Philosophy."[24] Derrida's stress is not so much on the content of apocalyptic fantasies as on the prophetic tone of dread and hysteria accompanying them. He takes his cue from Kant's 1796 essay "Of a Condescending Tone Recently Adopted in Philosophy,"[25] in which the great champion of the *Aufklärung* warns against the danger an exalted, visionary tone presents to the sober work of genuine philosophical inquiry. Kant, Derrida points out, anxiously worries that nothing less than the life or death of philosophy is at issue when mystagogues pretend to have revelatory powers, able to *know* what is only *thinkable*.[26] The remedy for Kant is a kind of thought police comparable to the universal tribunal he had suggested in his *Conflict of the Faculties* to arbitrate disputes between disciplines.

But for Derrida, Kant himself unwittingly unleashed a certain kind of apocalyptic thinking when he claimed that he was putting an end to outmoded metaphysics. For in so doing, he was adopting the very model of eschatological prediction that characterizes such thinking. "If Kant denounces those who proclaim that philosophy is at an end for two thousand years, he has himself, in marking a limit, indeed the end of a certain type of metaphysics, freed another wave of eschatological discourses about philosophy."[27] That is, all subsequent proclamations of the end of something or other echo Kant's unintended apocalypticism. All of the one-upmanship, all of the "going-one-better in eschatological eloquence . . . the end of history, the end of the class struggle, the end of philosophy, the death of God, the end of religions, the end of Christianity and morals . . . the end of the subject, the end of man, the end of the West, the end of Oedipus, the end of the earth, *Apocalypse now*,"[28] all give evidence of the failure of Kant's project to banish the apocalyptic tone from philosophy.

Furthermore, Derrida suggests, the apocalyptic tone is most evident when the explicit identity of the writer is uncertain, when the voice seems to come from nowhere. The implications of this claim are profound. For if, as deconstruction has always tried to demonstrate, authorial presence is a fiction that can be dissolved, then isn't there an apocalyptic moment in all writing? Derrida unsurprisingly contends there is: "Wouldn't the apocalyptic be a transcendental condition of all discourse, of all experience itself, of every mark or every trace? And the genre of writings called 'apocalyptic' in the strict sense, then, would be only an example, an

exemplary revelation of this transcendental structure."[29] Thus, even the
contemporary "enlightened" critics of apocalypse denounce the tradition
in tacitly apocalyptic terms. "The end approaches," Derrida wryly con-
cludes, "but the apocalypse is long-lived."[30]

But if apocalypse is both everywhere and interminable, perpetually
defeating the attempt by Kant's thought police to banish it, its implications
for Derrida are not precisely the same as its earlier defenders had thought,
especially in the religious tradition. For there is a subtle shift in Derrida's
interpretation of the term, which expresses the typically postmodernist
suppression of one of its janiform faces. In an extended analysis of the
command "Come" in the Apocalypse of John, he draws on Blanchot's
and Levinas's radical separation of prescriptive and descriptive state-
ments.[31] The injunction to come, he claims, can never be transformed
into a meaningful statement about the world. Ethics and ontology are not
the same, the performative function of the former is incommensurable
with the constative one of the latter. Thus the command to come "could
not become an object, a theme, a representation, or even a citation in the
current sense, and subsumable under a category, whether that of the
coming or of the event."[32] It is beyond being, beyond visible appearance,
beyond the unveiling promised by revelation.

As a result, the apocalyptic *tone* does not really prefigure an apocalyptic
event in the sense of an ultimate illumination following the catastrophe.
According to Derrida, "here, precisely, is announced—as promise or as
threat—an apocalypse without apocalypse, an apocalypse without vision,
without truth, without revelation . . . of addresses without message and
without destination, without sender and without decidable addressee,
without last judgment, without any other eschatology than the tone of
the 'Come' itself, its very difference, an apocalypse beyond good and
evil."[33] And if no event can terminate the constant sense of waiting in
dread for the climactic conclusion, then the true catastrophe is "a closure
without end, an end without end."[34]

In a recent gloss on this essay, John P. Leavy, Jr., has argued that
Derrida's strategy is to introduce just enough of the apocalyptic to act as
a kind of immunization against its full realization.[35] It thus serves as a
kind of apotropaic device, warding off evil like images of genitals and
circumcision rites designed to prevent castration or painted eyes to keep
away the evil eye. Combining the two terms in a tongue-twisting neo-
logism, he comes up with "apotropocalyptics" to indicate the mixed qual-
ity of the results. We are, in other words, on that familiar Derridean
territory where *pharmakon* mean both poison and cure. Leavy then further
connects apotropocalyptics to another Derridean coinage, "destinerr-
ance," which suggests the impossibility of messages ever reaching their
assigned destinations.

From the point of view of deconstruction, such an outcome is a source of apparent comfort, because it forestalls final totalization. But in the larger context of postmodern apocalyptic fantasizing, the emotional effect it produces is closer to saturnine resignation, what one observer has called its pervasive "rhetoric of bereavement."[36] Thus, for example, Baudrillard has described the current mood in the following terms:

> It is no longer spleen or fin-de-siècle wistfulness. It is not nihilism either, which aims in some way to normalize everything by destruction—the passion of ressentiment. No, melancholy is the fundamental tonality of functional systems, of the present system of simulation, programing and information. Melancholy is the quality inherent in the mode of disappearance of meaning, in the mode of volatilization of meaning in operational systems. And we are all melancholic.[37]

Lyotard, when pressed to describe the affective tone produced by his 1985 postmodern exhibition at the Centre Pompidou "Les Immatériaux," replied, "a kind of grieving or melancholy with respect to the ideas of the modern era, a sense of disarray."[38] It was, moreover, a melancholy laced with a certain degree of free-floating manic hysteria, which commentators were quick to notice.[39]

Such admissions provide us with an important clue to the apocalyptic imaginary as a whole, and not merely its postmodern variant. That is, melancholy may well be the best term to describe the underlying mental condition accompanying fantasies of termination, while mania captures the mood engendered by belief in a rebirth or redemptive unveiling after the catastrophe. Although I am not usually prone to psychologizing cultural phenomena, the fit between the apocalyptic mentality and these pathologies is too striking to ignore.[40] They become even more explicit if we turn to the classic psychoanalytic text on the theme, Freud's 1917 essay on "Mourning and Melancholia."[41]

For Freud, normal mourning follows the loss of a loved person or an abstract surrogate, such as fatherland or liberty. Never considered pathological or warranting treatment, it runs its course when reality testing demonstrates the objective disappearance of the loved one. This realization allows the slow and painful withdrawal of the libido cathected to it, which restores the subject's mental equilibrium. Once the work of mourning (*Trauerarbeit*) is done, Freud claims, "the ego becomes free and uninhibited again,"[42] able to cathect with new love objects.

Melancholia apes many of the characteristics found in normal grief, such as profound dejection and loss of interest in the outside world, but it adds one that is all its own: "a lowering of the self-regarding feelings to a degree that finds utterance in self-reproaches and self-revilings and

culminates in a delusional expectation of punishment."[43] The remarkable fall in self-esteem experienced in melancholia, but not in mourning, expresses, so Freud conjectures, a split in the ego, in which one part is set against another. The punishing part he identifies with the conscience because "in the clinical picture of melancholia dissatisfaction with the self on moral grounds is far the most outstanding feature."[44]

The target of the punishment is somewhat more difficult to identify than the source, for if one listens carefully to the patient, his reproaches are not really directed against himself. Instead, they seem aimed at the lost loved object with whom the melancholic now unconsciously identifies. As Freud famously put it, "thus the shadow of the object fell upon the ego, so that the latter could henceforth be criticized by a special mental faculty like an object, like the forsaken object."[45] The result is a regression into narcissism, where the love object may no longer be around, but the love-relation with its internalized surrogate can remain. That is, part of the subject's erotic cathexis of the object regresses to identification with it, while another part sadistically punishes it for its alleged failings, sometimes even leading to suicidal fantasies and deeds. What the melancholic subject can't do is separate him- or herself sufficiently from the lost object to be able to give it up when it is objectively gone.

Freud also notes another feature frequently accompanying the melancholic syndrome, which is relevant to our general analysis: its frequent, although not universal, transformation into manic elation. "The most remarkable peculiarity of melancholia," he writes, "and one most in need of explanation, is the tendency it displays to turn into mania accompanied by a completely opposite symptomology."[46] Superficially similar to the working through of grief in normal mourning because it seems to show the lost object is no longer the object of a libidinal cathexis, mania actually continues to manifest some of the same traits evident in melancholia. In particular, it discharges a surplus of energy freed by a sudden rupture in a long-sustained condition of habitual psychic expenditure. Mania is like melancholia, Freud hypothesizes, because it also derives from the regression of the libido into a narcissistic state of self-identification.

In *Group Psychology and the Analysis of the Ego*, he would return to the relationship between melancholy and mania.[47] Here he admitted that he lacked a fully satisfactory explanation of how they were linked but argued that they expressed two sides of the same coin. In melancholia, the ego was attacked by what he now called the ego ideal, whereas in mania, the two were fused together. In both cases, the working through based on the ego's ability to test reality is now thwarted. And the periodic oscillation between the two states, producing the psychotic syndrome of manic-depression, could lead to a perpetual failure to deal with the world in

rational terms, meaning among other things the acknowledgment of the separateness of self and other.

Although Freud's explorations of mourning, melancholy, and mania were tentative and have continued to invite further refinement by analysts like Melanie Klein,[48] they can still help us to make sense of the apocalyptic imaginary. For there can be little doubt that the symptoms of melancholy, as Freud describes them, approximate very closely those of apocalyptic thinking: deep and painful dejection, withdrawal of interest in the everyday world, diminished capacity to love, paralysis of the will, and, most important of all, radical lowering of self-esteem accompanied by fantasies of punishment for assumed moral transgressions. The cycle of depression and mania is furthermore repeated in the oscillation between the two faces of the janiform syndrome we have seen intensified when apocalypse and centurial or millennial mysticism coincide.

These similarities are perhaps most evident in the religious version of apocalypse, where divine retribution for sins fits well with Freud's description of a split ego, one side sadistically punishing the other for its alleged failings. These failings are consciously understood as sin, but unconsciously, if Freud is right, express the melancholic's self-blame for the loss of the love object, a loss he unconsciously thinks he desired. The source of the blame is then projected outward and returns as an attack on the battered ego of the sufferer. Although there are reality checks that happen whenever concrete predictions of the end of the world are disappointed, the feelings of doom can be triggered again by traumatic events—wars, earthquakes, plagues, other "signs" from heaven—that reignite the process of splitting and self-punishment.

In the case of scientific apocalyptic thinking, it is harder to defend a one-dimensionally psychopathological interpretation, because there is always enough evidence of the kind secular, "enlightened" minds take seriously to support dire extrapolations and projections. And no one but the most Pollyannaish believer in the myths of progress could discount such evidence out of hand. But insofar as virtually every prediction, as far as I know, has been contested by at least some other scientists who read the data differently, the preference for the worst possible scenario, which leads to apocalyptic fantasies, may in part be explained by some of the same mechanisms that determine religious anxieties about the end of the world. That is, they may well be overdetermined in a way that suggests no single explanation will suffice to make sense of their persistent power.

Although the language of sin and redemption is no longer very fashionable among such thinkers, fantasies of retributive destruction for our aggressive domination of nature still are. However much secular critics protest against the identification of nuclear war with a meaningful Judg-

ment Day, they nonetheless often employ other metaphors that suggest similar anxieties to those haunting religious doomsayers.[49] It is also important to remember that the critique of technological hubris was easily appropriated by earlier thinkers like Ernst Jünger and Martin Heidegger, who had no trouble infusing their critiques with irrationalist, mythic energies.[50]

As for the more cynical and antiredemptive postmodernist voices in the apocalyptic chorus, they too, as we have already noted, often explicitly stress the melancholic tone of their fantasies. Even more obvious is the manic component in much of their theorizing, which is expressed in Lyotard's fascination with libidinal intensities, Derrida's valorization of infinite, unconstrained linguistic play, and Baudrillard's celebration of the hyperreal world of simulacral overload. The postmodern whirl often seems so breathlessly speeded up that there is rarely even time for the occasional testing of reality that slows down the apocalyptic fantasizing of traditional religious adherents. The result is that grim exaltation of "apocalypse forever" noted by Scherpe as typical of the dedramatized postmodernist version of the syndrome.

Mentioning the refusal to test reality refers us back to Freud's distinction between mourning and melancholy, for it is precisely the ability to do so that distinguishes the former from the latter. Insofar as apocalyptic thought remains caught in the cycle of depressive anxiety and manic release, it can thus justly be called the inability to mourn. The work of mourning, it bears repeating, has two distinguishing characteristics that set it apart from melancholy: it is conscious of the love-object that it has lost, whereas melancholy is not, and it is able to learn from reality testing about the actual disappearance of the object and thus slowly and painfully withdraw its libido from it. The love-object remains in memory, it is not obliterated, but is no longer the target of the same type of emotional investment as before.

Melancholy, in contrast, seems to follow the logic of what Freud calls elsewhere disavowal or foreclosure (*Verwerfung*), in which inassimilable material seems to be cast out of the psyche and reappears in the realm of a hallucinatory "real." Unlike neurotic repression, in which such material remains in the psyche and can be worked through via transferential reenactments, foreclosure throws it out (*ver-werfen*'s literal meaning) so that it can't be successfully symbolized and integrated. Instead of being able to reincorporate the lost object in memory, the melancholic is neither able consciously to identify what actually has been lost nor work through his or her libidinal attachment to it. Instead, he or she remains caught in a perpetually unsublated dialectic of self-punishing fear and manic denial. "The complex of melancholia," Freud tells us, "behaves like an open

wound, drawing to itself cathectic energy from all sides . . . and draining the ego until it is utterly depleted."[51]

The questions that such reflections raise are obvious: what is the object (or objects) whose loss cannot be confronted by apocalyptic thinking and why does it (or they) remain so resolutely disavowed, so resistant to conscious working through? Here the honest analyst must falter, for we are dealing with cultural phenomena of such complexity and with so long a history that no simple answer can be confidently advanced. Unlike other cases in which the inability to mourn has been adduced to interpret collective phenomena, such as the German reaction to the loss of Hitler,[52] it is difficult to locate a specific historical trauma that resists the mourning process. Still, some speculation may be warranted, if only to suggest possible ways to deal with the problem.

In a recent essay comparing archetypes of apocalypse in dreams, psychotic fantasies, and religious scripture, the psychoanalyst Mortimer Ostow has contended that all share a common premise: "the messianic rescue brings the individual into a paradise, usually recognizable as a representation of the interior of the mother's body. The trip to mother-paradise is often obstructed and made hazardous by dangerous and ferocious creatures, representing father, siblings, or both."[53] If as is often argued, monotheistic religions like Judaism and Christianity sought to replace their mother-goddess predecessors with a stern patriarchal deity, then perhaps the lost object can be understood as in some sense maternal. The pervasive marriage imagery in apocalyptic literature emphasized by M. H. Abrams would thus have a more precise and more fraught meaning than merely "God's reconciliation with His people and with the land."[54] Mourning would mean working through the loss produced by the archaic mother's disappearance. An inability to renounce the regressive desire to reunite with the mother in a fantasy of recaptured plenitude, when accompanied by the unconscious self-reproach that her death was covertly desired, would result in melancholia instead.

These psychodynamics have often been applied to religious phenomena by commentators like Jean-Joseph Goux, who ties the prohibition on incest with the mother to other taboos, such as that on images so important to Judaism and certain ascetic strains of Christianity.[55] Lyotard has also treated the same theme in an essay entitled "Figure Foreclosed," which explicitly links Freud's analysis of melancholia with the Jewish taboo on sight and the refusal of the mother.[56] A further connection, he suggests, is with the inability to provide positive symbolic representation of what has been lost, which ties this entire complex to the characteristic domination of the sublime over the beautiful in postmodernism.

But perhaps the most elaborate attempt to explain melancholy in terms of the inability to mourn the death of the mother has been made by Julia

Kristeva in her recent meditation on depression entitled *Black Sun*.[57] Going beyond Freud, she claims that it doesn't involve an actual object, such as a real mother, but rather what she calls the "Thing," which is more fundamental and more elusive. She defines it as "the real that does not lend itself to signification, the center of attraction and repulsion, seat of the sexuality from which the object of desire will become separated."[58] Gerard de Nerval's metaphor of a "black sun" from his 1854 poem "El Desdichado" captures its unrepresentable absence: "[T]he Thing is an imagined sun, bright and black at the same time."[59] The melancholic is mesmerized by the "Thing," which he mourns without respite, like a disinherited wanderer who doesn't know where his home was. Resisting symbolic representation, the Thing remains encrypted in the psyche, walled up without any ability to be expressed linguistically and worked through. Instead, melancholy produces a feeling tone of despair—perhaps like that apocalyptic tone attacked by Kant and defended by Derrida?—which is literally at a loss for words.

For Kristeva, the alternative to melancholy requires negotiating two stages in which a relation with an object is substituted for one with the ineffable Thing. First, the individual, of whatever gender, must actually "kill"—or more precisely, separate from—the mother to achieve psychic maturity. "For man and for woman the loss of the mother is a biological and psychic necessity, the first step on the way to becoming autonomous," she writes. "Matricide is our vital necessity, the sina-qua-non of our individuation."[60] When such a break does not take place and the subject narcissistically identifies with the mother instead of "killing" it through separation, then the results are pathological: "[T]he maternal object having been introjected, the depressive or melancholic putting to death of the self is what follows, instead of matricide."[61]

The second step involves a working through of the guilt produced by the matricidal act, which Kristeva claims involves linguistic identification with the father. Reminiscent of Lacan's controversial notion of the "name (no)-of-the-father," this argument subtly departs from it on one point: "[T]he supporting father of such a symbolic triumph is not the oedipal father," Kristeva claims, "but truly that 'imaginary father,' 'father in prehistory' according to Freud, who guarantees primary identification."[62] But in both cases, the ability to identify with the father's prohibition on narcissistic identification with the mother is the source of psychic health. Whereas the melancholic disavows negation, denies the signifier and seeks impossible union with the lost Thing, the successful mourner of matricidal separation is able to find a symbolic way to work through the fateful deed. Certain types of art in particular, Kristeva contends, are able to provide such an avenue of escape, especially if they avoid the silent

hypertrophy of images, which she explicitly identifies with the apocalyptic imaginary.[63]

Whether or not such arguments are a retreat from her earlier distinction between a maternal semiotic and paternal symbolic language I will leave to serious students of Kristeva's oeuvre, who also may want to debate her suggestion in *Black Sun* that a return to Christian symbolization can provide an antidote to the melancholy of postmodernism. What is important for our purposes is the link she forges between melancholy and "an unfulfilled mourning for the maternal object."[64] For what she helps us to understand is the often fiercely misogynist tone of much apocalyptic thought. That is, narcissistic identification with the mother, whose necessary "death" has not been mourned, results in that reversal Freud has argued is characteristic of melancholy in general. Cast out of the psyche rather than symbolically integrated, the identified-with mother returns, as it were, as the avenging "whore of babylon" and "mother of harlots" so ferociously reviled by John of Patmos and his progeny.[65]

That such associations may be more than adventitious is suggested by evidence from previous episodes in the history of the apocalyptic imaginary. During the last *fin de siècle*, apocalyptic fantasies were often explicitly tied to anxieties about the erosion in what was assumed to be women's primary role as a mother. As Bram Dijkstra has demonstrated in *Idols of Perversity*, once the ideal of the "household nun" was undermined and women's sexuality unleashed, many artists and intellectuals projected images of sadistic fury onto women, who were figured as viragos, gynanders, vampires, and other instruments of doom.[66] The German artist Erich Erler's 1915 etching "The Beast of the Apocalypse," in which a blood-soaked nude wreaks her vengeance, exemplifies the melancholic inability to integrate the anxieties generated by unconscious ambivalence about the mother's loss.

Although the scientific version of the apocalyptic imagination is harder to reduce to such speculations about disavowed lost mothers, the time-honored personifications of mother earth and mother nature suggest that even here something comparable may be at work. Feminist historians of science like Evelyn Fox Keller and Susan Bordo have demonstrated the extent to which the modern scientific enterprise drew on violent images of separation from the mother to legitimate itself.[67] It is thus tempting to interpret the apocalyptic moment in the critique of technological and scientific hubris as a convoluted expression of distress at the matricidal underpinnings of the modernist project, indeed of the entire human attempt to uproot itself from its origins in something we might call mother nature.

If we succumb to this temptation and agree that the lost love object disavowed by the apocalyptically prone melancholic is in some, rather

ill-defined way, the mother, then the next question is why has it been so hard to mourn her loss? Why have apocalyptic fantasies continued to thrive even in the ostensibly postreligious imaginaries we have called scientific and postmodernist? Here we are on even shakier ground than before, as collective psychological speculations of this magnitude can only be offered in the most tentative way. Still, two potential answers come to mind.

The first concerns the continued presence in what we might call the real world of the object whose apparent loss we cannot mourn. That is, whereas in the case of an individual's working through his or her loss of an actual parent, the passage of time is enough to allow the realization of genuine absence to achieve its work of consolation, in the case of the collective "loss" of mother surrogates such as the earth, no such solution is possible. For the earth, however wounded by our depredations, is still around to nurture us. There is no reality testing that permits us to let go of the libidinal investment we seem to have in an object that has not fully disappeared. Thus, the guilt at secretly wanting to do in what we love can never be fully worked through because the crime is always freshly enacted and always regretted anew.

The second explanation operates on a different plane. Taking a cue from Derrida's contention that the apocalyptic tone can never be abolished from philosophy, it suggests that mourning as a complete working through of lost material is itself a utopian myth. That is, the hope of finding a means to transcend the repetition and displacement character-istic of apocalyptic melancholia is necessarily doomed to failure. For it is, *pace* Kristeva, as impossible to reincorporate all disavowed material into the cultural unconscious and then work it through as it would be to achieve perfect mental equilibrium on the individual level. Nor may it always be healthy to strive for a perfectly worked through mourning in which none of the unrelieved grief associated with melancholy is re-tained.[68] To believe otherwise is to fall victim to the dialectical fantasies of perfect sublation that poststructuralist theory has so vigorously dis-puted. Melancholia is thus less an illness to be overcome than a permanent dimension of the human condition, and perhaps so too are the apocalyptic fantasies that can be marshalled so easily by a myriad of different stimuli.

This might be an appropriate place to end this chapter on the repetition of endings, but I want to postpone the inevitable with one final thought. It is less perhaps a bang than a whimper, a whimper of protest, that is, against the too ready acceptance of the gloomy implications of these last arguments. For although the task of undoing the domination of mother nature may be far more difficult than some well-intentioned ecofeminists suggest, there are degrees of mastery and modes of alternative relations that provide some source of genuine hope. If there has been real progress

in gender relations in the last century, and I think by many meaningful indicators there has been, it may well be the case that we have also learned something about the costs of violating mother earth. Although I don't want to be too sanguine, there may be some warrant for hope concerning the future of the collective melancholy that fuels apocalyptic fantasies.

Likewise, for all the well-justified poststructuralist skepticism about fully redemptive scenarios of reconciliation, it is important to distinguish between regressive nostalgia and the mourning process per se. Whereas in the former, the lost object remains a source of continuing libidinal investment, in the latter, it has been replaced by a thought object in memory, one which no longer commands the same amount of fruitless yearning. Kristeva, I think, is persuasive in contending that symbolic acceptance of a necessary matricide can replace endless mourning for an encrypted or disavowed Thing that resists representation. The suppurating wound of melancholia can finally heal, even though a scar remains to remind us of what has been sacrificed. Mourning need not mean complete dialectical sublation but a willingness to tolerate its impossibility. Only if the ability to mourn allows us to work through what we have lost can we get beyond the saturnine disavowal on which apocalyptic fantasies so hungrily feed. Only then will the end of a century or even a millennium no longer be an occasion for sublime terror and become instead merely an arbitrary moment in an artificial chronology that we have deliberately created and know as such. No revelations lurk on the other side of the apocalypse, just the banal, but still valuable, project of enlightenment whose horsepower may not be as powerful as that of its opponent, but which may in the long run have more stamina to stay the course.

8

The Rise of Hermeneutics and the Crisis of Ocularcentrism

In one of the most recent of his many jeremiads, the French theologian Jacques Ellul unleashes his considerable wrath on what he claims is perhaps the major failing of our time: the humiliation of the Word.[1] The culprit, as might be expected, is the privileging of vision, which Ellul traces as far back as the fourteenth-century Church's desperate resort to idolatry in order to maintain the faithful in a period of extreme crisis. Through subsequent advances in the technological means for reproducing and disseminating images—Ellul's animus against technology is well-known—the overturning of the traditional primacy of the Word has been solidified to the point of virtual irreversibility. The result, he concludes, is that we now live in an era of the "debauchery of images"[2] in which a virulent hostility toward the Word prevents us from accepting the truth of divine annunciation.

Ellul's contrast between idolatrous images and God's word is, of course, a time-honored one in the history of Western religion. Ellul himself traces it to such texts as the First Epistle of John with its condemnation of the "lust of the eyes."[3] And he explicitly affirms what he calls "the contradiction between word and image in the Bible, contrary to the present-day tendency to meld them into one."[4] Whereas some commentators contrast the Jewish taboo on graven images or seeing the face of God with the Christian toleration for the Word made flesh in the Incarnation, a toleration that supports the visible sacraments and the mimetic *imitatio Dei*,[5] Ellul staunchly asserts the iconoclastic impulse in both faiths. Not for him is the contention that Christianity contains both Hellenic and Hebraic impulses. Instead, he insists that like Judaism, it worships an invisible, nontheophanus God, a God who speaks to humans who only listen. Anything else, he insistently maintains, is an idolatry that culmi-

nates in what he calls, following the unlikely lead of the Situationist Guy Debord, our secularized "society of the spectacle."[6]

Whether or not Ellul is fair to the complexities of the Christian attitude toward these issues I will leave to those better versed in its history and theology than I. How defensible his account of the fall into idolatry during the fourteenth century may be I must also permit others to decide, although it may be worth mentioning that recent readings of the balance between textuality and figurality in late medieval art have come to very different conclusions.[7] Nor do I want to pause to consider the implications of Ellul's rigid distinction between the illusory "reality" presented to the eyes and a deeper "truth" known only through language, a dichotomy whose plausibility depends on a faith in divine annunciation I cannot claim to share.

What I would prefer to emphasize instead is the paradoxical typicality of Ellul's self-described cry in the wilderness and its implications for the recent upsurge of interest in hermeneutics. For despite Ellul's apparent isolation, his diatribe against vision is itself merely an instance, perhaps more blatant and apocalyptic than some others, of a now very widespread excoriation of what can be called the sins of ocularcentrism. Although Ellul does occasionally make a grudging reference to other contemporary critics of the primacy of sight, such as Paul Ricoeur, Michel Foucault, and Jean-Joseph Goux,[8] he never acknowledges how widespread his own attitude now is, especially in France.

As I have argued elsewhere with special attention to the case of Foucault,[9] there has been a remarkably pervasive and increasingly vocal hostility to visual primacy in France ever since the time of Bergson. Whether in the philosophy of a Sartre or a Lyotard, the film criticism of a Metz or a Baudry, the feminism of an Irigaray or a Kofman, the theology of a Levinas or a Jabès, the literary criticism of a Bataille or a Blanchot, the literature of a Robbe-Grillet or a Bonnefoy, one can find a deep-seated distrust of the privileging of sight. It is even evident in the last place one might imagine, the visual arts themselves, if the explicitly "antiretinal"[10] art of Duchamp is any indication. Perhaps because of the long-standing domination of Cartesian philosophy and the no less powerful role played by spectacle and surveillance in the maintenance of centralized political power in France,[11] the reaction against ocularcentrism has taken a particularly strong turn there.

But it is evident elsewhere as well. In fact, German thinkers like Wagner, Nietzsche, and Heidegger must be accounted important voices in the chorus of iconoclasts. There can be few more influential contributions to the critique of ocularcentrism than Heidegger's widely discussed essay on "The Age of the World Picture."[12] Through the writings of such contemporary philosophers as Richard Rorty, this hostility to visual primacy

has also spread to the English-speaking world.[13] As a result, the ground has been widely prepared for the reception of hermeneutics. For if we pose the good hermeneutical question, "to what question is hermeneutics the answer?"[14] a plausible candidate would be: on what sense can we rely, if vision is no longer the noblest of the senses? No less an authority than Hans-Georg Gadamer has answered: "[T]he primacy of hearing is the basis of the hermeneutical phenomenon."[15] In other words, our increasing interest in the truths of interpretation rather than the methods of observation bespeaks a renewed respect for the ear over the eye as the organ of greatest value.

If Ellul's argument is therefore far less unusual than he implies, it is nonetheless useful to dwell on it as an exaggerated expression of many of the charges made against vision. Although, as we will see momentarily, *The Humiliation of the Word* does not exhaust the list of those complaints, it does provide a remarkably extensive compendium of them. Visual images, Ellul tells us, echoing without acknowledgment Bergson, are instantaneous snapshots of external reality without any duration. The visual world is pointillist, producing an external presence without any meaningful continuity between past and future. The visual image produces an object outside of the self solely there for our manipulation. "Sight," he asserts, "is the organ of efficiency."[16] Images can give us nothing but external appearances and behavior, never inward meaning. Claiming to represent the truth, vision actually operates on the level of deceptive artifice. What is seen, moreover, can produce unease and disquietude, but never genuine mystery. "Sight," Ellul charges, "introduces us to an unbearable shock. Reality when seen inspires horror. Terror is always visual."[17]

Vision is also problematic, he continues, because its synchronic gaze produces an instantaneous totality, which forecloses the open-ended search for truth through language with its successive temporality. If we accept the evidence of our senses, most notably sight, we are lost, for "evidence is absolute evil. We must accept nothing based on evidence, contrary to Descartes' recommendation."[18] Vision and the fall are thus coterminous for Ellul. The contemporary version of our fallen condition is exemplified, he claims, in our worship of "Money, State and Technique—the new spiritual trinity that manifests itself in quite *visible* idols, belonging exclusively to the *visible* sphere."[19]

Other examples of Ellul's critique of ocularcentrism can be adduced, but by now its overdetermined status should be obvious. So too should some of its problematic implications. It is worth pausing with them for a moment before passing on to what I think are some of the deeper sources of the antivisual discourse that has prepared the way for the popularity of hermeneutics today. To begin with the charge mentioned last, claiming

that money or technique are inherently visible idols is remarkably an-
achronistic, for if anything it is their growing immateriality in the age of
computers and data banks that should be stressed instead.[20] Indeed, as
Goux has noted, it was the decision to go off the gold standard earlier
this century that robbed money of whatever actual visible referent it might
have in the world, making it more abstract and empty than ever.[21] Sim-
ilarly, if Foucault's argument about the Panopticon is correct, we might
say the same thing about the state. For surveillance is based on the in-
visibility of the all-seeing eye that normalizes and disciplines through the
power of its assumed gaze. Here it is the experience of being seen (or
believing that one is looked at) rather than the images one sees that
maintain the power of the political order. This modern version of the old
superstition of the evil eye,[22] whose roots are perhaps in the belief in an
omniscient God, means that sight may indeed be complicitous with
power, but not in the way Ellul contends.

Ellul's contention about the inherently synchronic, pointillist, antihis-
torical implications of vision, made of course by many before him,[23] is
no less problematical. For vision is not reducible merely to the Medusan
gaze freezing everything on which it fixates into deathlike stillness. Kinesis
is by no means foreign to ocular experience. The antithesis of the gaze
is the fleeting and ephemeral glance, darting restlessly from one image
to another.[24] Although it may well be true that the Western cultural tra-
dition often privileged the violent act of seizing one moment in the visual
process and eternalizing it, the alternative potential in vision has never
been entirely suppressed. Indeed, as we have known since the work of
the French scientist Javal in 1878, the eye is always in constant flux,
moving in a series of little jumps or flicks from one short-lived fixation
to another.[25] These saccadic eye movements, as they are called from the
French *par saccades*, suggest that the notion of a frozen gaze is not a
biological constant, but merely one potential visual practice among others.
Based implicitly on a questionable fiction of the disembodied eye gazing
from afar, it fails to register what philosophers like Merleau-Ponty and
others have stressed instead: the incarnated reality of vision in the cor-
poreal and social context out of which it emerges.[26]

Also speaking against the static, ahistorical implications of vision at-
tributed to it by Ellul is the counterevidence he himself supplies by citing
the Epistle of Saint John mentioned earlier concerning the "lust of the
eyes." A frequent source of hostility to vision has, of course, been the
anxiety unleased by what Augustine called "ocular desire"[27] in the more
ascetic, antihedonist critics of idolatry. What they have recognized is that
desire is a source of restless dissatisfaction, preventing humans from con-
tentment with their lot. As such, it provides a stimulus to living in an
imagined future or perhaps returning to a lamented past. That is, it has

a deeply temporalizing function. However we may conceptualize the multiple sources of desire—ontologically, psychologically, socially, mimetically, or whatever—the recognition that vision plays a key role in generating and sustaining it means that sight, contra Ellul, must be understood as far more than an ahistorical valorization of presence. In fact, the current society of the spectacle is based on the stimulation of visual desire without true fulfillment in ways that suggest the complicity of sight and absence. Put in more positive terms, we might say that the metaphor of farsightedness, which we use to indicate a capacity to plan for the future, also suggests a potentially temporal dimension of vision forgotten by those who emphasize only the gaze of Medusa.

Ellul's hostility to vision, like that of many others in the antivisual discourse, rests, as we have seen, on a concomitant encomium to hearing. Whereas images are like dead objects before us, hearing, they claim, engenders an intersubjective dialogue. Whereas sight encourages the hubris of a subject who can direct his or her gaze wherever he or she chooses, hearing entails a healthy receptivity to outside influences, in particular to the voice of God, which cannot be blocked by shutting the ears in the way we can close our eyes. Hearing calls for a response to clarify the mystery of the interlocutor. As such, it has an ethical import absent from the subject-object manipulation fostered by vision.[28] True religion, Ellul concludes borrowing a dichotomy of Ricoeur's, is therefore derived from proclamation rather than manifestation.[29]

Here too questions about these characterizations of the essential nature of our senses might be asked. As Hans Blumenberg has suggested, the modern reevaluation of intellectual curiosity as more than merely an idle vice was due in large measure to our liberation from "blind obedience" to voices from the past.[30] Only when men and women were allowed the freedom to see for themselves could the modern project of emancipation from illegitimate authority begin. Only with the explicit valorization of our upright posture with its favoring of the far-seeing eyes over senses like smell or touch could human dignity be assured.[31]

Ellul, to be sure, is certainly no friend of the modern project, and thus would not find Blumenberg's defense of it compelling. But even if we turn to his argument about the superior ethical implications of hearing over sight, complications arise. For as a host of commentators have noted, there is also a potential for mutuality and intersubjectivity in visual interaction, however much it may also lead on occasion objectifying the other.[32] The reciprocal glance of lovers, contrary to the description of the reifying "look" in the antivisual discourse of critics like Sartre,[33] need not always produce a sadomasochistic interplay of power. There is a strong potential for the opposite outcome in the exchange of visual tenderness, a potential well captured in the dual meaning of the word "regard."

In short, despite Ellul's rigid dichotomy, the implications of privileging one sense over another are not so straightforward. Rather than essentializing sight, hearing, or any other sense, it is far more fruitful to tease out their multiple, even contradictory potentials and recognize that different cultures at different moments have stressed some over others. At present, if the recent popularity of hermeneutics is any indication,[34] we may well be entering a new period of distrusting vision, an era reminiscent of the other great iconoclastic moments in Western culture. Before we allow the pendulum to swing too far in the new antivisual direction, however, it may well be worth pondering the contradictory implications of the humiliation of the eyes. Some of these have been touched on in our discussion of Ellul's extreme version of ocularphobia. In the remainder of this essay, I would like to focus on three others, which have particular resonance in the development of hermeneutics.

The first concerns the ancient distinction between two models of light, known as *lux* and *lumen,* a distinction ultimately abandoned because of its problematic implications. The second refers to the tradition of what can be called specularity, which is associated with Hellenic and idealist theories of mimesis. The third touches on what a recent writer has termed "baroque vision" or *la folie du voir* (the madness of vision).[35] In each case, a crisis in certain assumptions about vision has helped turn attention to other senses and to language. The rise of hermeneutics has been aided by this shift. But in each case, a kind of revenge has also been enacted against the overprivileging of the nonvisual, so that sight has reemerged within the hermeneutic realm itself. To borrow a phrase of the literary critic Mary Ann Caws, we can now discern a return of "the eye in the text."[36]

As Vasco Ronchi and others have pointed out,[37] ancient theories of light, revived by medieval writers like Robert Grosseteste and modern ones like Descartes, distinguished between visible *lux* and invisible *lumen.* The former normally meant the phenomenon of light experienced by the human eye, light, that is, with color and shadow. The latter signified the physical movement of light waves or corpuscles through transparent bodies that occurred whether perceived or not. Here the science of optics was developed to study the laws by which such movement necessarily took place. In the hands of a religious thinker like Grosseteste, lux was understood as the profane, natural illumination in the eyes of mere mortals, whereas lumen was the primal light produced by divine radiation. In the hands of more secular thinkers like Descartes, lux was conceived as both the movement or action in the luminous body and the experience of colored illumination in the eye of the beholder, while lumen was the corpuscular movement through the transparent medium.[38] Lumen for

Descartes was the proper subject of those geometric laws of catoptrics and dioptrics, reflection and refraction, which he claimed could be studied deductively because they corresponded to the natural geometry of the mind.

However the dichotomy was construed—and its confusions finally led to its replacement by one word *luce* meaning light per se—it generally entailed some sort of hierarchical relationship between lux and lumen. Echoes of the old Platonic distinction between eternal forms or ideas and their imperfect resemblances in the world of human perception can be heard in the privileging of divine radiation or natural optics in the mind of the viewer over mere perception. In religious terms, the dichotomy was sometimes expressed as a distinction between a higher mirror of the soul reflecting lumen and a lower mirror of the mind showing only lux, the latter allowing man to see only through a glass (by way of a mirror) darkly.[39] In more secular terms, it suggested the dichotomy between rational speculation with the mind's eye and the empirical observation of the actual two human eyes. There was even an aesthetic version of the contrast in the visual arts with painters like Poussin and Lebrun expounding a Cartesian denigration of color in favor of distinct and clear form, while others like Rubens favored the restoration of color and shadow over pure form.[40]

One of the most powerful sources of ocularcentrism in the West, it might be conjectured, was precisely this conception of the dual nature of light. For if one of its models was discredited, it was always possible to fall back on the other as a ground of certainty. Thus, for example, the Platonic denigration of the senses could draw on the power of internal vision with "the third eye," as it were, as a way to the truth. Here lumen was understood as superior to lux. And concomitantly, the empiricist critique of deductive reason and innate ideas could invoke the validity of scientifically controlled observation of lux with the actual eyes as the ground of secure knowledge. In both cases, the monologic vision of a subject contemplating an external object and reflecting on its reality was paramount, although there were more residues of a participatory involvement between subject and object in Platonism than in empiricism.[41]

The crisis of ocularcentrism comes when it is no longer acceptable to oscillate between these two models or to assume a necessary hierarchy between them. In religious terms, the shift involves an abandonment of the metaphysics of divine radiation. Ellul expresses this turn in his interpretation of the famous prologue to the Gospel of John, where it is written, "In the Beginning was the Word. The Word was the light of the world."[42] He reads this passage to mean that light is merely an effect of God's word. "Nowhere is it said that God *is* the light, and even less that the light is God."[43] Nor is it correct, he continues, to rely on the direct

observation of Jesus as a historical figure, because that reduces him to a mere image of reality not an expression of truth. Only in the book of Revelation, Ellul concedes, is there an indication of the ultimate reconciliation of word and image but, until the apocalypse comes, it is necessary to ward off the deceptive lures of sight.

For more secular critics of the priority of lux over lumen or vice versa, one source of skepticism has been the very attempt to posit a hierarchy, making one notion of light essential and primary and the other apparent and secondary. For such commentators as Maurice Merleau-Ponty, it is rather their irreducible interpenetration in a chiasmic interaction that characterizes light and our experience of it.[44] If such an undecidability exists in relation to illumination, then the power of the visual model, in either its speculative or its empirical guise, must be questioned as the ground of epistemological certainty. The implication is that visual perception is a problematic tool in the search for meaning or truth. Language, it is also argued, is always already intertwined with perception of whatever kind, which then opens the door for a new appreciation of its importance. One result is the increased interest in hermeneutic interpretation, which can— although by no means must—seek truth in a recollected word, rather than a visual form.[45]

A second spur to the new focus on hermeneutics emerged from the crisis in mimetic representation occasioned by the collapse of what might be called specularity as a model of knowledge. By specularity, I mean the operation of reflection in a mirror reproducing the observing subject. Rodolphe Gasché describes its importance in his recent study, *The Tain of the Mirror*, in the following terms:

> reflection signifies the process that takes place between a figure or object and its image on a polished surface. As a consequence of this optic metaphoricity, reflection, when designating the mode and operation by which the mind has knowledge of itself and its operations, becomes analogous to the process whereby physical light is thrown back on a reflecting surface. From the beginning, self-consciousness as constituted by self-reflection has been conceptualized in terms of this optic operation. . . . [R]eflection is the structure and the process of an operation that, in addition to designating the action of a mirror reproducing an object, implies that mirror's mirroring itself, by which process the mirror is made to see itself.[46]

The source of this specular notion of reflection has been traced back to the Greeks by commentators like Thorlieff Boman and Susan Handelman, who pit it against the Hebraic critique of vision.[47] Speculation, they note, is, along with contemplation, the Latin translation of the Greek *theoria*; it is rooted in the word "specio," to look or behold. In more

modern philosophy, the primary example of specularity can be found in the Idealist philosophers of identity, most obviously Hegel. Here the ultimate dialectical unity of Subject and Object is rooted in the *speculum* of the Absolute Spirit. As Gadamer has noted, "the mirror image is essentially connected, through the medium of the observer, with the proper vision of the thing. It has no being of its own, it is like an 'appearance' that is not itself and yet causes the proper vision to appear as a mirror image. It is like a duplication that is still only one thing."[48] Thus, in specular thought, vision is understood not in terms of an eye seeing an object exterior to itself but of the eye seeing itself in an infinite reflection. Speculation is closely identified with, although need not be considered perfectly equivalent to, dialectical thought, for it both acknowledges the difference between subject and image and sublates it into a grand unity, an identity of identity and nonidentity.

The problematic implications of specularity have been no less evident to critics of ocularcentrism than those of the lux/lumen hierarchy. On one level, it evokes all of the dangers of narcissism, with its solipsistic outcome. Excessive self-absorption in personal terms has always seemed problematic, even if recent psychologists like Heinz Kohut have made a case for at least one form of a beneficent narcissism.[49] Overly frequent mirror-gazing, medieval moralists warned, led to the deadly sin of Superbia or pride, which was a perversion of the prudential injunction to know oneself.[50] On a more philosophical level, absolute reflection suggested the danger of assuming the metaphysical unity and homogeneity of the universe. Gasché, from his Derridean vantage point, is especially sensitive to this potential, defending as an antidote the irreducible otherness that escapes specular identity:

> The alterity that splits reflection from itself and thus makes it able to fold itself into itself—to reflect itself—is also what makes it, for structural reasons, incapable of closing upon itself. The very possibility of reflexivity is also the subversion of its own source. . . . [T]he generalization of reflexivity becomes at the same time the end of reflection and speculation. It opens itself to the thought of an alterity, a difference that remains unaccounted for by the polar opposition of source and reflection, principle and what is derived from it, the one and the Other.[51]

Other recent theorists outside of the deconstructionist camp have also been critical of identity theory; Adorno's negative dialectics is an obvious example. So it will come as no surprise to learn that advocates of hermeneutics have recognized the dangers of specularity. Thus, Paul Ricoeur has defended the idea of metaphor as a nonpictorial resemblance that preserves difference, even as it suggests similarity.[52] Gadamer has also noted that "the arguments of reflective philosophy cannot ultimately con-

ceal the fact that there is some truth in the critique of speculative thought based on the standpoint of finite human consciousness."[53] Although, as we will see shortly, there may well be a moment of specularity in certain variants of hermeneutics, the undermining of specular, idealist identity theory must be accounted one of the stimulants to its recent popularity.

A final instance of the crisis of ocularcentrism concerns what might be called the heterodox tradition of baroque vision. Here the recent work of the French philosopher Christine Buci-Glucksmann, *La raison baroque* of 1984 and *La folie du voir* of 1986, has been instrumental in illuminating its implications.[54] Illuminate, to be sure, may not be the right word, for baroque vision entails a fascination for obscurity, shadow, and the oscillation of form and formlessness. The notion of *la folie du voir* (the madness of vision) Buci-Glucksmann takes from Merleau-Ponty to signify the imbrication of viewer and viewed in a nonsublatable dialectic of imperfect specularity.[55] Here the mirror that reflects is anamorphosistic, either concave or convex, manifesting only distortion or disorientation.[56] It produces a schizoid fracture between the eye and the look, which resists recuperation into a perfect reciprocity.

Baroque vision is also deeply antiplatonic, hostile to the ordered regularities of geometrical optics. As such, it opposes both Cartesian philosophy and perspective in painting. The space it inhabits is more haptic or tactile than purely visual, more plural than unified. It presents a bewildering surplus of images, an overloading of the visual apparatus. Resistant to any panoptic God's eye view, any *survol global*,[57] baroque vision is the triumph of color over line, of opaque surface over penetrated depth. It strives for the representation of the unrepresentable and, necessarily failing to achieve it, resonates a deep melancholy, evident in the baroque fascination with the intertwining of death and desire explored by Walter Benjamin.[58]

Buci-Glucksmann, writing from a tacitly postmodernist perspective, is a celebrant of baroque vision, which she lyrically extols as a stimulant to ecstasy. But if we bracket her positive evaluation of its implications, it is possible to discern yet another source of hostility toward ocularcentrism. For the visual experience she describes can easily engender anxiety, uncertainty, and dyspepsia in less ecstatic souls. One can easily imagine the response of an Ellul to her self-consciously pagan paean to visual madness. If the eye is so deceptive and the visual scene so replete with dazzling flashes of brilliance casting light only on opaque, impenetrable surfaces, recourse to another sense for security may appear an obvious antidote to its dizzying effects.

Hermeneutics, then, can be said to have flourished in the wake of an overdetermined crisis of visual primacy that has been fed by three stimuli in particular: (1) a loss of faith in the objectivist epistemology that searches

for a geometrical lumen beneath the surface of experienced lux (or that claims scientific observation of lux alone can be the source of sense certainty); (2) a suspicion of the narcissistic and solipsistic lures of specularity and the identitarian philosophies to which it gives rise; and (3) an anxiety produced by the temptations of baroque vision with its theatricalized interplay of disorienting illusions. Because of these and other influences too numerous to mention, we have increasingly come in the twentieth century to distrust perception in general and vision in particular as the ground of knowledge, often turning instead to language in all of its various guises as an alternative. Although, therefore, Ellul may be correct on one level to say we live in a culture dominated by images rather than words, on another, he is mistaken. For one might just as easily speak of the humiliation of the eye as of the word in our increasingly iconoclastic discursive climate.[59]

If the rise of hermeneutics to its current place of honor can be traced, at least in part to this denigration of vision, it would, however, be erroneous to conclude that the age-old battle between sight and sound has been definitively resolved in favor of the latter. As W. J. T. Mitchell has recently observed,

> the history of culture is in part the story of a protracted struggle for dominance between pictorial and linguistic signs, each claiming for itself certain proprietary rights on a "nature" to which only it has access. . . . Among the most interesting and complex versions of this struggle is what might be called the relationship of subversion, in which language or imagery looks into its own heart and finds lurking there its opposite number.[60]

Hermeneutics is in no way exempt from this pattern, as the eye reasserts itself in the text and the gaze or glance interrupts the voice.

This reassertion is evident even in the vocabulary employed by the major hermeneutic theorists. Thus, for example, for all of Heidegger's hostility to the technological world picture and his frequent use of aural metaphors,[61] he nonetheless supports an alternative notion of circumspect vision called *Umsicht* as a way to describe *Dasein*'s situatedness in the world.[62] And despite his celebrated emphasis on language as the "house of Being," he uses such visual metaphors as a *Lichtung* (clearing) to indicate the way in which Being manifests itself, rather than is merely proclaimed.

As for Gadamer, his emphasis on the historical fusion of horizons shows how indebted he remains to the intertwining of sight and sound. "The horizon," he acknowledges, "is the range of vision that includes everything that can be seen from a particular vantage point. . . . A person who

has no horizon is a man who does not see far enough and hence means not to be limited to what is nearest, but to be able to see beyond it."[63] Key hermeneutic concepts like *Bildung* (self-cultivation), Gadamer recognizes, derive in part from the ancient, mystical tradition of the imitation of God's image. *Bild*, he notes, means both *Nachbild* or copy and *Vorbild* or model.[64]

In addition to these obvious visual residues in the terminology of hermeneutics, which might be attributed more to the pervasiveness of ocular metaphors in Western languages than to any deep-seated affinity between vision and interpretation, there are more fundamental ways in which the word and the image are intertwined in certain variants of contemporary hermeneutics. If, for example, we take the critical hermeneutics developed by Jürgen Habermas in his fraternal debate with Gadamer,[65] the continuing importance of what might be called the objectifying, distantiating implications of the lumen/lux tradition might be discerned. For in his analysis of the interplay between explanation and understanding in critical social theory, Habermas defends the necessity of some monologic, subject-object method in making sense of the ways in which contemporary society acts as if it were a "second nature."[66] That is, because we live in a society without the immediacy, transparency, and communicative rationality of perfect intersubjectivity, the tools of explanatory distantiation typical of natural science cannot be given up in exchange for a method wholly dependent on empathetic understanding. If society operates at least in part like a reified second nature, then it is wrong to wish this reality away in the name of a hermeneutic community always already in place. Indeed, without the tension between explanation and interpretation—sight and hearing, if you will—there can be no genuine critique of the mixed quality of our society. Each is a necessary check to the totalizing pretensions of the other.

As for specularity in hermeneutics, Gadamer himself admits that it remains an inevitable impulse in language. After a long consideration of Hegel's conflation of speculation and dialectics, which he condemns for its indebtedness to the Greek philosophy of logos, he nonetheless acknowledges that

> language itself, however, has something speculative about it in quite a different sense—not only in that sense intended by Hegel of the instinctive preformation of the reflexive relationship of logic—but, rather, as the realization of the meaning, as the event of speech, of communication, of understanding. Such a realization is speculative, in that the finite possibilities of the word are oriented towards the sense intended, as towards the infinite. . . . Even in the most everyday speech there appears an element of speculative reflection, namely the intangibility of that which is still purest reproduction of meaning.[67]

If I understand Gadamer correctly, his communicative rather than lo-gocentric notion of specularity emphasizes the always, already linguistic quality of thought, which prevents a gap between an idea in the mind and its verbal expression. "To be expressed in language," he notes, "does not mean that a second being is acquired. The way in which a thing presents itself is, rather, part of its own being. Thus everything that is language has a speculative unity: it contains a distinction between its being and the way in which it presents itself, but this is a distinction that is really not a distinction at all."[68]

In addition to the speculative dimension of language as the realization of meaning in the mirrored reproduction of word and idea, at least as a teleological impulse, there is another, more productive dimension, which Kathleen Wright highlights in her subtle discussion of the speculative structure of language in Gadamer. "That one and the same text can be different and mean more," she notes, "is because language in the inter-pretative conversation, like the mirror image, reflects back into the text and brings more of its meaning and truth into being."[69] In other words, in a true dialogue, the mirroring effect of question and answer, or give and take, produces a richer and more developed truth than was there before. Contrary to the model of the divine word spoken to the passive listener defended by Ellul,[70] Gadamer's more specular notion of language allows for a less authoritarian, less past-oriented hermeneutics, which recognizes the moment of what he calls application as an essential di-mension of the production of truth. Here the nonlogocentric, non-He-gelian specularity he finds in language is a source of its strength, not its weakness.

If we combine this claim for a modified specular moment in herme-neutics with the Habermasian argument developed a few moments ago, an argument stressing the usefulness of at least some objectifying visual distantiation in explanation, the following conclusion can be drawn. Within linguistic interaction, there may be an implicit teleology toward specular hermeneutic consensus in which transparent intersubjective communication is achieved, but in our current world of distorted and impeded communicative exchange, it is necessary to assume, in an "as if" manner, the possibility of a monological, objectifying gaze in order to examine the blockages. Systematic social obstacles to the realization of linguistic specularity in Gadamer's sense of the term can only be observed from an assumed position of exteriority, even if their removal may well entail action produced by intersubjective consensus and the fusion of horizons. Although it may be impossible ever to achieve such a perfectly objective, synoptic perspective and leave behind our embeddedness in the flesh of the world, the strategy of seeking it may be necessary to

realize more adequately the condition of nonlogocentric specularity Gadamer, perhaps too quickly, posits of language as such.

If, however, combining these two perspectives leaves us with this essentially Habermasian conclusion, turning instead to the implications of our third ocular model, that of baroque vision in Buci-Glucksmann's sense, will suggest how difficult its achievement may be. For although she too is interested in the eye in the text, her attitude toward its proper place is very different from those of the more optimistic hermeneuticians. Her exploration of baroque culture not only focuses on its visual aspect but also includes an arresting discussion of its linguistic dimension, which she identifies with its interest in rhetoric. "Baroque rhetoric," she writes, "inverts, overturns, the traditional schemas and hierarchies between image and concept. The figure no longer 'represents' the concept because the 'concept'—*le concetto*—is itself only a knot of words and images, a figured expression."[71] This knot, she insists, always resists unravelling to reveal a transparent meaning. It operates instead chiasmically to defeat any specular sublation or mirroring of differences. Like Gasché, she recognizes the materiality of the mirror, its "tain" or silver backing, which pure specularity always forgets.

Explicitly taking issue with Merleau-Ponty's optimistic hermeneutic belief in the saturation of the world with meaning, Buci-Glucksmann understands the implications of baroque rhetoric to be the maintenance of opacity and superficiality. Defying the search for hidden meanings and deep structures, the rhetoric of the baroque is like its visual madness: anamorphosistic, undecidable, and resistant to any plenitude. Allegory rather than symbolism is its essential mode because, as Benjamin knew well, allegory expresses the impossibility of a perfect unity between image and concept. The specular moment in language emphasized by Gadamer is thus called into question by the allegorical rhetoric and visual theatricality of the baroque. What is left instead, Buci-Glucksmann concludes, are "palimpsests of the unseeable (*irregardable*)."[72]

Her celebration of this heterodox tradition of baroque vision and rhetoric culminates in its extension into the modern era, beginning with Baudelaire, where it competes with the alternative visual modernisms of Cartesian subject-object perspectivalism and Hegelian logocentric specularity. It might be more accurate to identify it with the postmodern or at least the poststructuralist movement out of which Buci-Glucksmann clearly emerges. However we construe it, this third model of the eye in the text provides ample evidence that the crisis of ocularcentrism is by no means resolved, even in our seemingly iconoclastic era of hermeneutic suspicion of the primacy of the image. Ellul to the contrary notwithstanding, the age-old battle between the eye and the ear is far from being decided one way or the other. And perhaps more important, it would be

unwise to wish, as Ellul seems to do, for a clear-cut victory of either side. For it is in the remarkably fluid and complex interaction of the two that one of the great motors of human culture can be discerned. Humbling the image is no antidote to humiliating the word. It is far healthier to nurture in both what is best called a mutual regard.

9

Scopic Regimes of Modernity

The modern era, it is often alleged,[1] has been dominated by the sense of sight in a way that set it apart from its premodern predecessors and possibly its postmodern successor. Beginning with the Renaissance and the scientific revolution, modernity has been normally considered resolutely ocularcentric. The invention of printing, according to the familiar argument of McLuhan and Ong,[2] reinforced the privileging of the visual abetted by such inventions as the telescope and the microscope. "The perceptual field thus constituted," concludes a typical account, "was fundamentally nonreflexive, visual and quantitative."[3]

Although the implied characterization of different eras in this generalization as more favorably inclined to other senses should not be taken at face value,[4] it is difficult to deny that the visual has been dominant in modern Western culture in a wide variety of ways. Whether we focus on "the mirror of nature" metaphor in philosophy with Richard Rorty or emphasize the prevalence of surveillance with Michel Foucault or bemoan the society of the spectacle with Guy Debord,[5] we confront again and again the ubiquity of vision as the master sense of the modern era.

But what precisely constitutes the visual culture of this era is not so readily apparent. Indeed, we might well ask, borrowing Christian Metz's term, is there one unified "scopic regime"[6] of the modern or are there several, perhaps competing ones? For, as Jacqueline Rose has recently reminded us, "our previous history is not the petrified block of a single visual space since, looked at obliquely, it can always be seen to contain its moment of unease."[7] In fact, may there possibly be several such moments, which can be discerned, if often in repressed form, in the modern era? If so, the scopic regime of modernity may best be understood as a contested terrain, rather than a harmoniously integrated complex of visual

114

theories and practices. It may, in fact, be characterized by a differentiation of visual subcultures, whose separation has allowed us to understand the multiple implications of sight in ways that are now only beginning to be appreciated. That new understanding, I want to suggest, may well be the product of a radical reversal in the hierarchy of visual subcultures in the modern scopic regime.

Before spelling out the competing ocular fields in the modern era as I understand them, I want to make clear that I am presenting only very crude ideal typical characterizations, which can easily be faulted for their obvious distance from the complex realities they seek to approximate. I am also not suggesting that the three main visual subcultures I single out for special attention exhaust all those that might be discerned in the lengthy and loosely defined epoch we call modernity. But, as will soon become apparent, it will be challenging enough to try to do justice in the limited space I have to those I do want to highlight as most significant.

Let me begin by turning to what is normally claimed to be the dominant, even totally hegemonic, visual model of the modern era, that which we can identify with Renaissance notions of perspective in the visual arts and Cartesian ideas of subjective rationality in philosophy. For convenience, it can be called Cartesian perspectivalism. That it is often assumed to be equivalent to the modern scopic regime per se is illustrated by two remarks from prominent commentators. The first is the claim made by the art historian William Ivins, Jr., in his *Art and Geometry* of 1946 that "the history of art during the five hundred years that have elapsed since Alberti wrote has been little more than the story of the slow diffusion of his ideas through the artists and peoples of Europe."[8] The second is from Richard Rorty's widely discussed *Philosophy and the Mirror of Nature*, published in 1979: "in the Cartesian model the intellect *inspects* entities modeled on retinal images. . . . In Descartes' conception—the one that became the basis for 'modern' epistemology—it is *representations* which are in the 'mind'."[9] The assumption expressed in these citations that Cartesian perspectivalism is *the* reigning visual model of modernity is often tied to the further contention that it succeeded in becoming so because it best expressed the "natural" experience of sight valorized by the scientific worldview. When the assumed equivalence between scientific observation and the natural world was disputed, so too was the domination of this visual subculture, a salient instance being Erwin Panofsky's celebrated critique of perspective as merely a conventional symbolic form.[10]

But for a very long time, Cartesian perspectivalism was identified with the modern scopic regime *tout court*. With full awareness of the schematic nature of what follows, let me try to establish its most important characteristics. There is, of course, an immense literature on the discovery,

rediscovery, or invention of perspective—all three terms are used depending on the writer's interpretation of ancient visual knowledge—in the Italian Quattrocento. Brunelleschi is traditionally accorded the honor of being its practical inventor or discoverer, while Alberti is almost universally acknowledged as its first theoretical interpreter. From Ivins, Panofsky, and Krautheimer to Edgerton, White, and Kubovy,[11] scholars have investigated virtually every aspect of the perspectivalist revolution—technical, aesthetic, psychological, religious, even economic and political.

Despite many still disputed points, a rough consensus seems to have emerged around the following points. Growing out of the late medieval fascination with the metaphysical implications of light, light as divine *lumen* rather than perceived *lux*, linear perspective came to symbolize a harmony between the mathematical regularities in optics and God's will. Even after the religious underpinnings of this equation were eroded, the favorable connotations surrounding the allegedly objective optical order remained powerfully in place. These positive associations had been displaced from the objects, often religious in content, depicted in earlier painting to the spatial relations of the perspectival canvas themselves. This new concept of space was geometrically isotropic, rectilinear, abstract, and uniform. The *velo* or veil of threads Alberti used to depict it conventionalized that space in a way that anticipated the grids so characteristic of twentieth-century art, although as Rosalind Krauss has reminded us, Alberti's veil was assumed to correspond to external reality in a way that its modernist successor did not.[12]

The three-dimensional, rationalized space of perspectival vision could be rendered on a two-dimensional surface by following all of the transformational rules spelled out in Alberti's *De Pittura* and later treatises by Viator, Dürer, and others. The basic device was the idea of symmetrical visual pyramids or cones with one of their apexes the receding vanishing or centric point in the painting, the other the eye of the painter or the beholder. The transparent window that was the canvas, in Alberti's famous metaphor, could also be understood as a flat mirror reflecting the geometricalized space of the scene depicted back onto the no less geometricalized space radiating out from the viewing eye.

Significantly, that eye was singular, rather than the two eyes of normal binocular vision. It was conceived in the manner of a lone eye looking through a peephole at the scene in front of it. Such an eye was, moreover, understood to be static, unblinking and fixated, rather than dynamic, moving with what later scientists would call "saccadic" jumps from one focal point to another. In Norman Bryson's terms, it followed the logic of the Gaze rather than the Glance, thus producing a visual take that was eternalized, reduced to one "point of view" and disembodied. In what

Bryson calls the "Founding Perception" of the Cartesian perspectivalist tradition,

> the gaze of the painter arrests the flux of phenomena, contemplates the visual field from a vantage-point outside the mobility of duration, in an eternal moment of disclosed presence; while in the moment of viewing, the viewing subject unites his gaze with the Founding Perception, in a moment of perfect recreation of that first epiphany.[13]

A number of implications followed from the adoption of this visual order. The abstract coldness of the perspectival gaze meant the withdrawal of the painter's emotional entanglement with the objects depicted in geometricalized space. The participatory involvement of more absorptive visual modes was diminished, if not entirely suppressed, as the gap between spectator and spectacle widened. The moment of erotic projection in vision—what St. Augustine had anxiously condemned as "ocular desire"[14]—was lost, as the bodies of the painter and viewer were forgotten in the name of an allegedly disincarnated, absolute eye. Although such a gaze could, of course, still fall on objects of desire—think, for example, of the female nude in Dürer's famous print of a draftsman drawing her through a screen of perspectival threads[15]—it did so largely in the service of a reifying male look that turned its targets into stone. The marmoreal nude drained of its capacity to arouse desire was at least tendentially the outcome of this development. Despite the occasional exception, such as Caravaggio's seductive boys, the nudes themselves fail to look out at the viewer, radiating no erotic energy in the other direction. Only much later in the history of Western art, with the brazenly shocking nudes in Manet's *Dejeuner sur l'herbe* and *Olympia*, did the crossing of the viewer's gaze with that of the subject finally occur. By then the rationalized visual order of Cartesian perspectivalism was already coming under attack in other ways as well.

In addition to its de-eroticizing of the visual order, it had also fostered what might be called denarrativization or detextualization. That is, as abstract, quantitatively conceptualized space became more interesting to the artist than the qualitatively differentiated subjects painted within it, the rendering of the scene became an end in itself. Alberti, to be sure, had emphasized the use of perspective to depict *istoria*, ennobling stories, but in time, they seemed less important than the visual skill shown in depicting them. Thus, the abstraction of artistic form from any substantive content, which is part of the clichéd history of twentieth-century modernism, was already prepared by the perspectival revolution five centuries earlier. What Bryson in another of his books, *Word and Image*, calls the diminution of the discursive function of painting, its telling a story to the

unlettered masses, in favor of its figural function,[16] meant the increasing autonomy of the image from any extrinsic purpose, religious or otherwise. The effect of realism was consequently enhanced as canvases were filled with more and more information that seemed unrelated to any narrative or textual function. Cartesian perspectivalism was thus in league with a scientific worldview that no longer hermeneutically read the world as a divine text but saw it as situated in a mathematically regular spatiotemporal order filled with natural objects that could only be observed from without by the dispassionate eye of the neutral researcher.

It was also complicitous, so many commentators have claimed, with the fundamentally bourgeois ethic of the modern world. According to Edgerton, Florentine businessmen with their newly invented technique of double-entry book-keeping may have been "more and more disposed to a visual order that would accord with the tidy principles of mathematical order that they applied to their bank ledgers."[17] John Berger goes so far as to claim that more appropriate than the Albertian metaphor of the window on the world is that of "a safe let into a wall, a safe in which the visible has been deposited."[18] It was, he contends, no accident that the invention (or rediscovery) of perspective virtually coincided with the emergence of the oil painting detached from its context and available for buying and selling. Separate from the painter and the viewer, the visual field depicted on the other side of the canvas could become a portable commodity able to enter the circulation of capitalist exchange. At the same time, if philosophers like Martin Heidegger are correct, the natural world was transformed through the technological worldview into a "standing reserve" for the surveillance and manipulation of a dominating subject.[19]

Cartesian perspectivalism has, in fact, been the target of a widespread philosophical critique, which has denounced its privileging of an ahistorical, disinterested, disembodied subject entirely outside of the world it claims to know only from afar. The questionable assumption of a transcendental subjectivity characteristic of universalist humanism, which ignores our embeddedness in what Maurice Merleau-Ponty liked to call the flesh of the world, is thus tied to the "high altitude" thinking characteristic of this scopic regime. In many accounts, this tradition as a whole has thus been subjected to wholesale condemnation as both false and pernicious.

Looked at more closely, however, it is possible to discern internal tensions in Cartesian perspectivalism itself that suggest it was not quite as uniformly coercive as is sometimes assumed. Thus, for example, John White distinguishes between what he terms "artificial perspective," in which the mirror held up to nature is flat, and "synthetic perspective," in which that mirror is presumed to be concave, thus producing a curved rather than planar space on the canvas. Here, according to White, Paolo

Uccello and Leonardo da Vinci were the major innovators, offering a "spherical space which is homogeneous, but by no means simple, and which possesses some of the qualities of Einstein's finite infinity."[20] Although artificial perspective was the dominant model, its competitor was never entirely forgotten.

Michael Kubovy has recently added the observation that what he calls the "robustness of perspective"[21] meant that Renaissance canvases could be successfully viewed from more than the imagined apex of the beholder's visual pyramid. He criticizes those who naively identify the rules of perspective established by its theoretical champions with the actual practice of the artists themselves. Rather than a procrustean bed, it was practically subordinated to the exigencies of perception, which means that denunciations of its failings are often directed at a straw man (or at least his straw eye).

Equally problematic is the subject position in the Cartesian perspectivalist epistemology. For the monocular eye at the apex of beholder's pyramid could be construed as transcendental and universal—that is, exactly the same for any human viewer occupying the same point in time and space—or contingent—solely dependent on the particular, individual vision of distinct beholders, with their own concrete relations to the scene in front of them. When the former was explicitly transformed into the latter, the relativistic implications of perspectivalism could be easily drawn. Even in the seventeenth century, this potential was apparent to thinkers like Leibniz, although he generally sought to escape its more troubling implications. These were not explicitly stressed and then praised until the late nineteenth century by such thinkers as Nietzsche. If everyone had his or her own camera obscura with a distinctly different peephole, he gleefully concluded, then no transcendental worldview was possible.[22]

Finally, the Cartesian perspectivalist tradition contained a potential for internal contestation in the possible uncoupling of the painter's view of the scene from that of the presumed beholder. Interestingly, Bryson identifies this development with Vermeer, who represents for him a second state of perspectivalism even more disincarnated than that of Alberti. "The bond with the viewer's physique is broken and the viewing subject," he writes, "is now proposed and assumed as a notional point, a non-empirical Gaze."[23]

What makes this last observation so suggestive is the opening it provides for a consideration of an alternative scopic regime that may be understood as more than a subvariant of Cartesian perspectivalism. Although I cannot pretend to be a serious student of Vermeer able to quarrel with Bryson's interpretation of his work, it might be useful to situate the painter in a different context from the one we have been discussing. That

is, we might include him, and the Dutch seventeenth-century art of which he was so great an exemplar, in a visual culture very different from that we associate with Renaissance perspective, one which Svetlana Alpers has recently called *The Art of Describing*.[24]

According to Alpers, the hegemonic role of Italian painting in art history has occluded an appreciation of a second tradition, which flourished in the seventeenth-century Low Countries. Borrowing Georg Lukács's distinction between narration and description, which he used to contrast realist and naturalist fiction, Alpers argues that Italian Renaissance art, for all its fascination with the techniques of perspective, still held fast to the storytelling function for which these techniques were used. In the Renaissance, the world on the other side of Alberti's window, she writes, "was a stage in which human figures performed significant actions based on the texts of the poets. It is a narrative art."[25] Northern art, in contrast, suppresses narrative and textual reference in favor of description and visual surface. Rejecting the privileged, constitutive role of the monocular subject, it emphasizes instead the prior existence of a world of objects depicted on the flat canvas, a world indifferent to the beholder's position in front of it. This world, moreover, is not contained entirely within the frame of the Albertian window, but seems instead to extend beyond it. Frames do exist around Dutch pictures, but they are arbitrary and without the totalizing function they serve in Southern art. If there is a model for Dutch art, it is the map with its unapologetically flat surface and its willingness to include words as well as objects in its visual space. Summarizing the difference between the art of describing and Cartesian perspectivalism, Alpers posits the following oppositions: "attention to many small things versus a few large ones, light reflected off objects versus objects modeled by light and shadow; the surface of objects, their colors and textures, dealt with rather than their placement in a legible space; an unframed image versus one that is clearly framed; one with no clearly situated viewer compared to one with such a viewer. The distinction follows a hierarchical model of distinguishing between phenomena commonly referred to as primary and secondary: objects and space versus the surfaces, forms versus the textures of the world."[26]

If there is a philosophical correlate to Northern art, it is not Cartesianism with its faith in a geometricalized, rationalized, essentially intellectual concept of space but the more empirical visual experience of observationally oriented Baconian empiricism. In the Dutch context Alpers identifies it with Constantin Huygens. The nonmathematical impulse of this tradition accords well with the indifference to hierarchy, proportion, and analogical resemblances characteristic of Cartesian perspectivalism. Instead, it casts its attentive eye on the fragmentary, detailed, and richly articulated surface of a world it is content to describe rather than explain.

Like the microscopist of the seventeenth century—Leeuwenhoeck is Alpers's prime example—Dutch art savors the discrete particularity of visual experience and resists the temptation to allegorize or typologize what it sees, a temptation to which she claims Southern art readily succumbed.

In two significant ways, the art of describing can be said to have anticipated later visual models, however much it was subordinated to its Cartesian perspectivalist rival. As we have already noted, a direct filiation between Alberti's *velo* and the grids of modernist art is problematic because, as Rosalind Krauss has argued, the former assumed a three-dimensional world out there in nature, whereas the latter did not. A more likely predecessor can thus be located in the Dutch art based on the mapping impulse. As Alpers notes,

> Although the grid that Ptolemy proposed, and those that Mercator later imposed, share the mathematical uniformity of the Renaissance perspective grid, they do not share the positioned viewer, the frame, and the definition of the picture as a window through which an external viewer looks. On these accounts the Ptolemaic grid, indeed cartographic grids in general, must be distinguished from, not confused with, the perspectival grid. The projection is, one might say, viewed from nowhere. Nor is it to be looked through. It assumes a flat working surface.[27]

Second, the art of describing also anticipates the visual experience produced by the nineteenth-century invention of photography. Both share a number of salient features: "fragmentariness, arbitrary frames, the immediacy that the first practitioners expressed by claiming that the photograph gave Nature the power to reproduce herself directly unaided by man."[28] The parallel frequently drawn between photography and the antiperspectivalism of impressionist art, made for example by Aaron Scharf in his discussion of Degas,[29] should thus be extended to include the Dutch art of the seventeenth century. And if Peter Galassi is correct in *Before Photography*, there was also a tradition of topographical painting—landscape sketches of a fragment of reality—that resisted Cartesian perspectivalism and thus prepared the way both for photography and the Impressionist return to two-dimensional canvases.[30] How widespread or self-consciously oppositional such a tradition was I will leave to experts in art history to decide. What is important for our purposes is simply to register the existence of an alternative scopic regime even during the heyday of the dominant tradition.

Alpers's attempt to characterize it is, of course, open to possible criticisms. The strong opposition between narration and description she posits may seem less firm if we recall the denarrativizing impulse in perspectival art itself mentioned previously. And if we can detect a certain fit between the exchange principle of capitalism and the abstract relational space of

perspective, we might also discern a complementary fit between the valorization of material surfaces in Dutch art and the fetishism of commodities no less characteristic of a market economy. In this sense, both scopic regimes can be said to reveal different aspects of a complex, but unified, phenomenon, just as Cartesian and Baconian philosophies can be said to be consonant, if in different ways, with the scientific worldview.

If, however, we turn to a third model of vision, or what can be called the second moment of unease in the dominant model, the possibilities for an even more radical alternative can be discerned. This third model is perhaps best identified with the baroque. At least as early as 1888 and Heinrich Wölfflin's epochal study, *Renaissance and Baroque*, art historians have been tempted to postulate a perennial oscillation between two styles in both painting and architecture.[31] In opposition to the lucid, linear, solid, fixed, planimetric, closed form of the Renaissance, or as Wölfflin later called it, the classical style, the baroque was painterly, recessional, soft-focused, multiple, and open. Derived, at least according to one standard etymology, from the Portuguese word for an irregular, oddly shaped pearl, the baroque connoted the bizarre and peculiar, traits that were normally disdained by champions of clarity and transparency of form.

Although it may be prudent to confine the baroque solely to the seventeenth century and link it with the Catholic Counter-Reformation or the manipulation of popular culture by the newly ascendant absolutist state—as has, for example, the Spanish historian José Antonio Maravall[32]—it may also be possible to see it as a permanent, if often repressed, visual possibility throughout the entire modern era. In the recent work of the French philosopher Christine Buci-Glucksmann, *La raison baroque* of 1984 and *La folie du voir* of 1986,[33] it is precisely the explosive power of baroque vision that is seen as the most significant alternative to the hegemonic visual style we have called Cartesian perspectivalism. Celebrating the dazzling, disorienting, ecstatic surplus of images in baroque visual experience, she emphasizes its rejection of the monocular geometricalization of the Cartesian tradition, with its illusion of homogeneous three-dimensional space seen with a God's eye view from afar. She also tacitly contrasts the Dutch art of describing, with its belief in legible surfaces and faith in the material solidity of the world its paintings map, with the baroque fascination for opacity, unreadability, and the undecipherability of the reality it depicts.

For Buci-Glucksmann, the baroque self-consciously revels in the contradictions between surface and depth, disregarding as a result any attempt to reduce the multiplicity of visual spaces into any one coherent essence. Significantly, the mirror that it holds up to nature is not the flat reflecting glass that commentators like Edgerton and White see as vital in the development of rationalized or "analytic" perspective, but rather

the anamorphosistic mirror, either concave or convex, that distorts the visual image—or more precisely, reveals the conventional, rather than natural quality of "normal" specularity by showing its dependence on the materiality of the medium of reflection. In fact, because of its greater awareness of that materiality—what a recent commentator, Rodolphe Gasché, has drawn attention to as the "tain of the mirror"[34]—baroque visual experience has a strongly tactile or haptic quality, which prevents it from turning into the absolute ocularcentrism of its Cartesian perspectivalist rival.

In philosophical terms, although no one system can be seen as its correlate, Leibniz's pluralism of monadic viewpoints,[35] Pascal's meditations on paradox, and the Counter-Reformation mystics' submission to vertiginous experiences of rapture might all be seen as related to baroque vision. Moreover, the philosophy it favored self-consciously eschewed the model of intellectual clarity expressed in a literal language purified of ambiguity. Instead, it recognized the inextricability of rhetoric and vision, which meant that images were signs and that concepts always contained an irreducibly imagistic component.

Baroque vision, Buci-Glucksmann also suggests, sought to represent the unrepresentable and, necessarily failing, produced the melancholy that Walter Benjamin in particular saw as characteristic of the baroque sensibility. As such, it was closer to what a long tradition of aesthetics called the sublime, in contrast to the beautiful, because of its yearning for a presence that can never be fulfilled. Indeed, desire, in its erotic as well as metaphysical forms, courses through the baroque scopic regime. The body returns to dethrone the disinterested gaze of the disincarnated Cartesian spectator. But unlike the return of the body celebrated in such twentieth-century philosophies of vision as Merleau-Ponty's, with its dream of a meaning-laden imbrication of the viewer and the viewed in the flesh of the world, here it generates only allegories of obscurity and opacity. Thus, it truly produces one of those "moments of unease" which Jacqueline Rose sees challenging the petrification of the dominant visual order (the art of describing seeming in fact far more at ease in the world).

A great deal more might be said about these three ideal typical visual cultures, but let me conclude by offering a few speculations, if I can use so visual a term, on their current status. First, it seems undeniable that we have witnessed in the twentieth century a remarkable challenge to the hierarchical order of the three regimes. Although it would be foolish to claim that Cartesian perspectivalism has been driven from the field, the extent to which it has been denaturalized and vigorously contested, in philosophy as well as in the visual arts, is truly remarkable. The rise of hermeneutics, the return of pragmatism, the profusion of linguistically oriented structuralist and poststructuralist modes of thought have all put

the epistemological tradition derived largely from Descartes very much on the defensive. And of course, the alternative of Baconian observation, which periodically resurfaces in variants of positivist thought, has been no less vulnerable to attack, although one might argue that the visual practice with which it had an elective affinity has shown remarkable resilience with the growing status of photography as a nonperspectival art form (or if you prefer, counter-art form). There are as well contemporary artists like the German Jewish, now Israeli, painter Joshua Neustein, whose fascination with the flat materiality of maps has recently earned a comparison with Alpers's seventeenth-century Dutchmen.[36]

Still, if one had to single out the scopic regime that has finally come into its own in our time, it would be the "madness of vision" Buci-Glucksmann identifies with the baroque. Even photography, if Rosalind Krauss's recent work on the Surrealists is any indication,[37] can lend itself to purposes more in line with this visual impulse than the art of mere describing. In the postmodern discourse that elevates the sublime to a position of superiority over the beautiful, it is surely the "palimpsests of the unseeable,"[38] as Buci-Glucksmann calls baroque vision, that seem most compelling. And if we add the current imperative to restore rhetoric to its rightful place and accept the irreducible linguistic moment in vision and the equally insistent visual moment in language, the timeliness of the baroque alternative once again seems obvious.

In fact, if I may conclude on a somewhat perverse note, the radical dethroning of Cartesian perspectivalism may have gone a bit too far. In our haste to denaturalize it and debunk its claims to represent vision per se, we may be tempted to forget that the other scopic regimes I have quickly sketched are themselves no more natural or closer to a "true" vision. Glancing is not somehow innately superior to gazing, vision hostage to desire is not necessarily always better than casting a cold eye, a sight from the situated context of a body in the world may not always see things that are visible to a "high-altitude" or "God's eye" view. However we may regret the excesses of scientism, the Western scientific tradition may have only been made possible by Cartesian perspectivalism or its complement, the Baconian art of describing. There may well have been some link between the absence of such scopic regimes in Eastern cultures, especially the former, and their general lack of indigenous scientific revolutions. In our scramble to scrap the rationalization of sight as a pernicious reification of visual fluidity, we need to ask what the costs of too uncritical an embrace of its alternatives may be. In the case of the art of describing, we might see another reification at work, that which makes a fetish of the material surface instead of the three-dimensional depths. Lukács's critique of naturalist description in literature, unmentioned by Alpers, might be applied to painting as well. In that of baroque

vision, we might wonder about the celebration of ocular madness, which may produce ecstasy in some, but bewilderment and confusion in others. As historians like Maravall have darkly warned, the phantasmagoria of baroque spectacle was easily used to manipulate those who were subjected to it. The current version of "the culture industry," to use the term Maravell borrows from Horkheimer and Adorno in his account of the seventeenth century, does not seem very threatened by postmodernist visual experiments in "la folie du voir." In fact, the opposite may well be the case.

Rather than erect another hierarchy, it may therefore be more useful to acknowledge the plurality of scopic regimes now available to us. Rather than demonize one or another, it may be less dangerous to explore the implications, both positive and negative of each. In so doing, we won't lose entirely the sense of unease that has so long haunted the visual culture of the West, but we may learn to see the virtues of differentiated ocular experiences. We may learn to wean ourselves from the fiction of a "true" vision and revel instead in the possibilities opened up by the scopic regimes we have already invented and the ones, now so hard to envision, that are doubtless to come.

After the initial presentation of this paper,[39] I became increasingly aware of the more practical ways in which the three scopic regimes it discusses have been realized. In particular, an invitation to refashion the paper for a conference on the modern city at the Institute of Contemporary Arts in London led me to speculate on the possible correlations between each regime and different styles of urban life. Georg Simmel's contention that visual experience is paramount in the modern metropolis has been widely repeated, but precisely what that experience has been is often unduly homogenized. Applying the three scopic regimes to different urban visual cultures may provide a useful way to discriminate among the varieties that are often conflated into one version of "the modern city."[40]

Cartesian perspectivalism best corresponds to the model of the rationally planned city, whose origins go as far back as Rome. Here the ideal of a geometric, isotropic, rectilinear, abstract, and uniform space meant the imposition of regular patterns, usually grids or radical concentric circles, on the more casual meanderings of earlier human settlements. The rationalization of urban space was generally suspended during the Middle Ages, but was revived during the Renaissance. Popes like Sixtus V (1585–90) sought to rebuild Rome along radial lines and recapture its earlier glory. During the reign of Louis XIV, the town of Richelieu, built as a double rectangle alongside the chateau of the Cardinal, demonstrated the link between the monocular, perspectivalist subject and the power of the sovereign's gaze.[41] Later palace-cities like Versailles, Karlsruhe,

urban planning

Mannheim, even l'Enfant's Washington showed the fit between state power and urban space built according to the visual principles of the dominant scopic regime of the modern era.

During the Enlightenment, utopian architects like Jean-Jacques Lequeu, Étienne-Louis Bouillée, and Claude-Nicolas Ledeux produced even more grandiose plans for rigorously geometric cities in the service of Reason, plans that were never directly realized. Only in the nineteenth century with Baron Haussmann's Paris, the grids of American cities like New York and Philadelphia, and Ildefonso Cerda's "Extension" of Barcelona was urban space remade in Cartesian perspectivalist terms. The twentieth-century dreams of Le Corbusier and other technologically inspired International Style architects represent perhaps the purest expressions of the dominant visual order of modernity. The much maligned Brasilia planned by Lucio Costa in the 1950s was the culmination of their project.

For those who do the maligning, an appealing alternative has often appeared in the urban space more closely approximating our second scopic regime, that associated with the Dutch art of describing. Delft, Haarlem, and of course Amsterdam itself represent cities spared the imposition of geometricalized grids or intimidating monumental vistas. Perspectivalist effects are self-consciously absent, as streets and canals provide informal curved views that defy a central vanishing point. The textures of building materials and the interplay of stone, brick, and water create as much a haptic as purely visual experience; clear form is less important than atmosphere. As a result, such cities seem less like visual incarnations of the disciplining state bent on controlling its citizenry through surveillance and more like comfortable sites of an active civil society.

The celebrated interiors so often painted by Vermeer, de Hooch, and other masters of the art of describing suggest an urban life spent with great gratification in the private space created by bourgeois prosperity. Dutch cities rarely contain the monumental squares or rectilinear boulevards that create the backdrop for a more public life, either political or cultural. And as Alpers notes,[42] the views of their cities by Ruisdael, Cuyp, and Vermeer reveal a close continuity between urban and rural life very different from the rupture between "culture" and "nature" evident in Cartesian perspectivalist urban space. Although rarely duplicated by design and destined to be surpassed by other urban models, such cities remain as reminders of highly attractive alternatives to the dominant scopic/urban regime.

A third possibility, of course, is the more frequently realized baroque city, which came into its own in the seventeenth century with such planners as Bernini in Rome. Abandoning the rectilinear perspectivalism of Pope Sixtus, he sought to subvert the rational neoclassicism of the Ren-

aissance. As Germain Bazin has noted, "spectacular surprise effects are the very essence of the baroque. . . . Baroque planning . . . was addressed not to reason but to the senses. The baroque architect endeavoured to turn the meanest spaces to advantage by the fragmentation of planes, by the elasticity of curves. He had no desire to bring uniformity to the facades of different houses and buildings; these should charm the spectator by their variety."[43] Baroque cities had large public squares, but unlike their Cartesian perspectivalist counterparts, they were secret enclaves (like the Plaza Major in Madrid or the Piazza Navona in Rome) unconnected to the arteries of commercial traffic. Such spaces were often the theatrical arenas for everything from religious festivals to auto-da-fés.

More could obviously be said to flesh out the linkages between the scopic regimes of modernity and its urban styles. But as earlier, I want to conclude with a plea for the creative nurturance of all of them rather than the erection of a new hierarchy. For each has tended to a certain extent to generate the others, at least as a minor accompaniment. Thus, for example, the geometricalized regularities of French classicism at the height of the *ancien regime* were sometimes softened by baroque effects. Haussmann's monumental boulevards with their houses of equal height and vistas culminating in monuments became the locus for that evanescent phantasmagoria of modern Parisian street life celebrated by Baudelaire and many since. Cerda's grids were soon enlivened by brilliantly decorated art nouveau facades on the chamfered corners where his streets intersected.

Similarly, the Dutch cityscape has been interpreted as covertly baroque because of the individuality of the houses lining its canals.[44] And of course, for all its giddy disorientation of the senses, the baroque itself could not do away entirely with the classical underpinnings of the buildings in which it placed its trompe l'oeil interiors and on which it hung its extravagant facades. If postmodernism can be said to have resurrected the baroque impulses celebrated by Buci-Glucksmann, it too has retained the modernist shells of Cartesian perspectivalism. In short, just as there is no "natural" vision prior to cultural mediation and therefore no intrinsically superior scopic regime, there is no one urban style that can satisfy by itself the human yearning for ocular stimulation and visual delight.

Discussion

From *Vision and Visuality*, ed. Hal Foster (Seattle, Bay
View Press, 1988)

Jacqueline Rose I want to ask a question about your idea of "the plu-
rality of scopic regimes." I take your point that this spectacular plurality
can be used as an oppressive device. But the critique of Cartesian per-
spective has always been tied to a specific conception of the political and
to a particular notion of the bourgeois subject. And I wonder what hap-
pens to that political critique if one reformulates it as you have.

Martin Jay It would be fascinating to map out the political implications
of scopic regimes, but it can't be done too reductively. The perspectivalist
regime is not necessarily complicitous only with politically oppressive
practices. Under certain circumstances it may be emancipatory; it really
depends on how it is used. And the same is arguable about any alter-
natives that are presented.

The perspectivalist regime may be complicitous with a certain notion
of an isolated bourgeois subject, a subject that fails to recognize its cor-
poreality, its intersubjectivity, its embeddedness in the flesh of the world.
Of course, this subject is now very much under attack, and I don't want
to reconstitute it naively. Nevertheless, Cartesian perspectivalism also
functions in the service of types of political self-understanding that de-
pend on distanciation—explanatory social-scientific models, for example,
which argue against the hermeneutic immersion of the self in the world
and create at least the fiction of an objective distance from it. Here I think
of the combination that Jürgen Habermas has introduced in his discussion
of the logic of the social sciences—a combination of explanatory and her-
meneutic understanding based largely on a perspectivalist fiction of being
outside the object of inquiry. This fiction is easy to debunk because we
are always embedded in the world; it is also easy to criticize its relation
to scientism. But before we move too quickly to a counterscientific po-
sition, we should recognize that Western science depended on this prac-
tically useful fiction of a distanciating vision. I don't want in any way to
underplay the dangers here—gender dangers, class dangers, and so forth.
Nonetheless, one can sometimes disentangle the political from the visual;
it is not always entailed.

Norman Bryson I have a question about Dutch art, your second scopic
regime. It's true that, unlike Mediterranean art, Dutch art does seem typ-

ically to get rid of the frame: the framing of the image seems arbitrary—
a random cut—and composition doesn't appear as the set of repercussions
within the image of its frame. Nevertheless, one could also say that Dutch
art is, so to speak, hyperreal compared to Mediterranean art: it is even
more realist precisely because it is not limited by structures of the frame.
And although Northern painting follows another perspectival system—
spherical rather than flat—its commitment to perspective is not funda-
mentally different from that in the south. In short, I wonder whether
there really is such a difference between Dutch art and Mediterranean
art, and whether a real point of difference between Cartesian perspecti-
valism and other modes has to do instead with the performative—the idea
of performance and the insertion of embodiment into the optical field. I
am thinking here of baroque art, but also of nineteenth-century art forms
in which there is a considerable intervention of the bodily into the frame—
in the visibility of pigment and gesture, in the rise of the sketch, and in
bravura styles such as that of Delacroix or of Daumier. The significant
break with Cartesian perspectivalism might be found in this fracturing of
visual space upon the entry of the body.

Jay In a way I was trying to make the same point: that Dutch art is not
as radical a break with perspectivalism as baroque art. But here I should
clarify what I mean by realism. One might, as Svetlana Alpers does, draw
on the familiar Lukácsian distinction between realism and naturalism
(which should be taken with a grain of salt). As Lukács describes it, realism
deals with typological, essential depths—not with surfaces. Narration pro-
duces a typological sense of meaningfulness which goes beyond the scat-
tered and untotalizable facts of a literary text (or perhaps a painting). With
its stress on the three-dimensional space rather than the two-dimensional
surface of the canvas, Cartesian perspectivalism is realist in this sense.
Naturalism, on the other hand, is interested solely in surface—in describ-
ing its varieties of forms without reducing them to any symbolically mean-
ingful visual depth. It rests content with the visual experience of light on
our eyes.

Now these modes of realism and naturalism might well be seen as
complementary. Both create a reality-effect, the one by our belief that
reality is depth, the other by simply showing surfaces. Both modes are
also complicitous with a certain kind of scientific thought; indeed, science
has gone back and forth between such Cartesian and Baconian notions
of where reality lies. But I think you are right: the third alternative calls
both of them into question through a performative critique of the reality-
effect itself. In painting I suppose this is produced by the painter or the
beholder entering the picture in some metaphorical way; this makes it
impossible to see the painting as a scene out there viewed with either

the realist or the naturalist eye. It would be interesting to see what the history of that more radical alternative might be. Certainly, as I argued at the end of my paper, it seems to entrance many of us now.

Hal Foster Could you say a little more about how, in your way of thinking, Cartesian perspectivalism de-eroticizes?

Jay The argument is that perspectivalism creates such a distance between the disincarnated eye and the depicted scene that the painting lacks the immediacy associated with desire. But this is often called into question by various aesthetic practices; I mentioned Caravaggio as an example. One crucial thing here is the crossing of gazes; in most nudes the figure does not look back at us, but rather is objectified in such a way that our gaze meets no intersubjective return look. In Manet, however, there is such a *frisson* of reciprocity, which was lost in the Cartesian perspectivalist construction, and the result was de-eroticization.

Foster In your model, then, de-eroticization is somehow opposed to fetishization?

Jay That's an interesting issue. A fetish can be seen as erotic, or as producing a kind of closed entity which lacks erotic reciprocity. Maybe there are two types of erotic relationship, the one fetishistic, the other not. Certainly fetishism occurs more in Dutch art in terms of the objects on the canvas. If there is a fetishism in Cartesian perspectivalism, it is a fetishism of the space itself. But it would be interesting to pursue an idea of different modes of erotic interaction rather than the simple opposition of the erotic versus the de-eroticized.

Audience (Bernard Flynn) I have a question for Martin Jay. I was somewhat surprised that you see Descartes as the initiator of a regime of the visual. It seems to me that his texts could be read just as well in a radically, militantly antivisual sense. Think of what becomes of the piece of wax in the *Meditation:* all the information that one gets through the senses is false, is never reinstated. And even in the *Optics*, in his theory of perspective (as Merleau-Ponty reads it in "The Eye and the Mind"), one doesn't see anything at all, one judges. The mind may survey the brain and then generate a perspective-effect—but not really by sight so much as by mathematical judgment. In fact, Descartes even uses the metaphor of the text: that one reads the brain.

Martin Jay This is an excellent question; it gives me an opportunity to clarify the dimension of the visual in Descartes. One could say the same

thing about Plato: that he too was hostile to the illusions of the senses and was anxious to defend the alternative of the mind's eye. Cartesianism contains this dualism as well, for Descartes also gives us a critique of the illusions of observation. But in its place he provides a notion of the mind as visually constituted. For Descartes the mind contains "clear" and "distinct" ideas, and clarity and distinctness are essentially visual terms. Moreover, the mind perceives natural geometry, which is commensurate with the geometry that underlies our actual empirical sight. Descartes believes in the commensurability of these two realms (which I could also characterize in terms of two notions of light, luminous rays or *lumen* and perceived *lux*); it enables him to argue that inventions like the telescope are valuable because they show us visual experience which is commensurate with that of natural geometry.

Now the issue of judgment, the issue of the text, is also very interesting. It relates to the point I made earlier regarding the semantic dimension of vision. You are right: Descartes uses rhetorical and linguistic explanations that take us away from a purely imagistic notion of the mind's eye or of actual eyes. But it is almost always done in the service of a strong notion of mental representation where one sees (as he puts it) "with a clear mental gaze." So what is at issue is neither actual empirical observation (which Merleau-Ponty, with his emphasis on the body and binocular vision, wants to restore), nor is it an entirely rhetorical, semantic, judgmental, or linguistic alternative. It is a third model, which again I think is parallel to the Platonic tradition of mental representation—of the mind's eye, of the purity of an optics which is outside actual experience.

Audience (John Rajchman) I have a question for both Jonathan [Crary] and Martin. I was impressed by your remarks, Jonathan, and I was especially interested in the influence of Foucault upon them. Your use of Foucault is very different from one which presents him as a denigrator of vision, as Martin has in another context ["In the Empire of the Gaze: Foucault and the Denigration of Vision in Twentieth-Century French Thought," in *Foucault: A Critical Reader*, ed. David Hoy]. It is a Foucault who is more concerned with "events" of the visual.

Foucault argued, of course, that abnormality or deviation is a central category in our modern period, especially when it comes to madness. (As Jonathan has mentioned—and Georges Canguilhem talks about this too— Fechner and Helmholtz conceived vision in terms of the normal and the abnormal, and of course they were read by Freud. In fact, in *Beyond the Pleasure Principle*, I believe there are references to both Fechner and Helmholtz.) For Foucault there is a great difference between this modern conception of madness as abnormal and the Renaissance conception of madness as a marvel or a monstrosity from another world. So when Martin

talks about "the madness of seeing" (*la folie du voir*) and suggests, à la Christine Buci-Glucksmann, that this is a reactualization of a baroque vision, I am not sure I agree. The baroque did not possess our category of the abnormal, and our visual irrationality (influenced by the paradigm that Jonathan sketched) is a different sort of thing. So perhaps it is not a reactualization so much as a rethinking of "the madness of seeing" in terms of our own rationality of the abnormal. (To see it in this way, incidentally, would give us a different perspective from the kind of phobia about irrationality that comes from Jürgen Habermas.) Isn't there some kind of clash between these sorts of history?

Jay Your point that Buci-Glucksmann constructs a baroque vision for her own purposes is a valid one, but I think she has also recovered an attitude which is more positive about "madness." Obviously her interpretation is deeply imbued with contemporary concerns—one hears Lyotard, Lacan, and other recent thinkers on every page—so it is not simply an historical account.

Now as for the two registers of madness: *la folie du voir* is a term that has been around for a while (Michel de Certeau also wrote about it). In this sense madness is seen as ecstatic, connected to *jouissance*, as not constraining. My Habermasian note at the end was to suggest that "madness" is neither good nor bad but is a category we need to problematize. This may require a return to a notion that Foucault would find problematic, but it seems to me that he also teaches us to be wary of any return to the body. For Foucault, of course, the body is constituted culturally and historically; therefore we are forced once again to think about its implications rather than accept it as a solid ground or as some antidote to the false decorporealization of vision.

Krauss I have a question for Martin, one that relates to John Rajchman's. I am not sure that seventeenth-century visual regimes can be mapped quite so directly onto late nineteenth- and early twentieth-century practices. Are these weak homologies, or just totally different phenomena? Take your example of the modernist grid and the map presented by Svetlana Alpers as a model for seventeenth-century Dutch painting. The modernist grid is tremendously different from this cartologic grid, for the modernist grid is reflexive: it maps the surface onto which it is projected; its content is that surface itself. A map is not doing that: its content comes from elsewhere; it has nothing to do with the reflexive model.

Another instance is the anamorphic image. Now the opacity that is figured in anamorphosis is a matter of point of view: one can see the image correctly if one can get to the correct position. Whereas the invisibility that arises within modernism is not so obviously physical: it is

tinged or affected by the unconscious, and in this unconscious invisibility there isn't any correct perspective or other vantage point. It can only be reconstructed in the modality of a different form like language. I think that's a weak metaphoric use of the idea of anamorphosis. You seem to accept this Buci-Glucksmann hypothesis; I would think that as an historian you would not.

Jay I share the willingness to problematize these linkages; let me see what this might mean in these two cases. First with the grid. What Alpers tells us is that whereas the perspectival grid is wholly different from the modernist grid, the cartographic grid (which is also present in seventeenth-century Dutch art) is a way-station to the modernist one. It is halfway because it insists not on an illusory reproduction of an external reality but rather on a sign-ordered transfiguration of it. So already there is a kind of conventionality to this grid, an awareness of the necessity of a mode that is not simply mimetic. And to that extent maybe it does point the way to a fully nonmimetic twentieth-century grid.

As for anamorphosis, a satisfactory response would require going into some detail. In his discussion of sight in *The Four Fundamental Concepts of Psycho-analysis*, Lacan is fascinated by the idea of anamorphic vision, as is Lyotard in *Discours, Figure* (significantly, both use the Holbein painting *The Ambassadors*, with its anamorphic skull, on their title pages). In Lacan's discussion of vision one gets a sense of crossed visual experiences, which is what anamorphic vision, if seen in tension with straightforward vision, gives us. So to that extent it helps us understand the complexities of a visual register which is not planimetric but which has all these complicated scenes that are not reducible to any one coherent space.

Finally, as to the Buci-Glucksmann argument: I would agree that one has to take it with a grain of salt; it is written from the perspective of the 1980s, it is not purely an historical exercise. But I think it helps us to see a potential for another vision already there in the Western tradition, even during the heyday of Cartesian perspectivalism. It allows us to see what Jacqueline Rose calls "the moment of unease" which is latent but now perhaps rediscovered in that tradition—even if we have partly concocted it as well.

10

Ideology and Ocularcentrism: Is There Anything Behind the Mirror's Tain?

In what is surely one of the most widely remarked metaphors in all of his work, Marx compared ideology to a *camera obscura*, that "dark room" in which a pinhole in one wall projects an inverted image of an external scene onto its opposite. The famous passage from *The German Ideology* reads as follows: "If in all ideology men and their circumstances appear upside-down as in a *camera obscura*, this phenomenon arises just as much from their historical life-process as the inversion of objects on the retina does from their physical life-process."[1]

Marx's selection of a visual metaphor to distinguish upright from distorted knowledge is by no means surprising or unusual, for Western thought has long privileged sight as the sense most capable of apprising us of the truth of external reality. Whether in the guise of Platonic Ideas in the "mind's eye," Cartesian "clear and distinct" ideas available to a "steadfast mental gaze," or Baconian observations empirically grounded in "the faith of the eyes,"[2] our most influential epistemologies have been resolutely ocularcentric. Accordingly, as Hans Blumenberg has demonstrated,[3] light has been the privileged metaphor for truth and enlightenment the metaphor for its acquisition.

But if vision has enjoyed a special status as the noblest of the senses, its capacity to deceive has also been a source of frequent concern. Trusting in the mind's eye, what Carlyle once called "spiritual optics,"[4] has sometimes led to a distrust of the actual perception of the two physical eyes. Both the Platonic and the Cartesian traditions have been deeply suspicious of the imperfections of what might be called "material vision" and have sought to distance themselves from the eye as concretely embedded in the human body.[5] Religious thinkers, believing more in the Word of God and the hermeneutic project of interpreting it than in divine manifestation,

have often echoed this suspicion. In its more extreme forms, hostility to pagan idolatry has produced a full-fledged iconoclasm. One of its stimulants has been the fear that the eye is responsible for exciting restless yearnings—what Augustine called "ocular desire"[6]—whereas the ear is credited with the ability to listen patiently for an authoritative voice from above.

For all these reasons and many more that we do not have time to adduce, vision has served both as the model for truth and a source for falsehood, an ambiguity cleverly exploited in Marx's metaphor of ideology as a *camera obscura*. Here the contrast is between a false vision that is reversed and inverted and a true one that is straightforwardly adequate to the object it sees. The darkness and obscurity of the closed box is also implicitly set against the transparent clarity of a *camera lucida*, in which ideology is banished in the glare of enlightenment. Although the analogy between retinal vision and ideological misprision is not really precise— the mind, after all, has no problem setting its images straight,[7] whereas ideology's inversions are not so easily dispelled—Marx's choice of a visual metaphor was a rhetorically powerful ploy at a time when ocularcentrism still reigned supreme.

In our own century, however, the premises of that assumption have come increasingly under attack. Indeed, a great deal of recent intellectual energy has been directed, as I have tried to demonstrate elsewhere,[8] at dismantling the traditional hierarchy of the senses, which placed vision at the summit. As a result, it has been dethroned in many quarters as the allegedly most noble of the senses. With its departure has gone the assumption that the alternative to a distorted, ideological sight, inverted and reversed, obscure and opaque, is a clear and distinct vision of the truth as it actually is.

In fact, if anything, confidence in the truth-telling capacity of vision in any of its various guises has become itself a widely reproached mark of ideological mystification. This reversal is evident, for example, in the recent proliferation of attacks on the idea of the totalizing gaze from above, the God's eye view of the world, and the practices of surveillance and discipline to which it contributes. Foucault is, of course, an obvious example here, but another would be someone who comes from a very different tradition, the phenomenology that Foucault always criticized: Claude Lefort. Drawing on Merleau-Ponty's attack on "high-altitude thinking," Lefort has specifically linked the belief in a God's eye view with a mistaken concept of ideology:

> We cannot . . . undertake to delimit ideology with reference to a reality whose features would be derived from positive knowledge, without thereby losing a sense of the operation of the constitution of reality and

without placing ourselves in the illusory position of claiming to have an overview of Being. . . . If we were to regard as ideology the discourse which confronts the impossibility of its self-genesis, this would mean that we would be converting this impossibility into a positive fact, we would believe in the possibility of mastering it; we would once again be placing ourselves in the illusory position of looking down at every discourse in order to "see" the division from which it emerges, whereas discourse can only reveal this in itself.[9]

Another manifestation of the new distrust of the visual can be discerned in the frequent appearance of attacks on specularity and speculation, mirroring and the metaphysics of reflection. In the Marxist tradition, this critique was most vigorously elaborated by Louis Althusser. Borrowing Lacan's categories of the mirror stage and the imaginary, Althusser insisted that ideology is "a representation of the imaginary relationship of individuals to their real conditions of existence."[10] Such imaginary relationships are not equivalent to false consciousness, however, because they are permanent and inevitable elements of all social systems, no matter how emancipated. The most fundamental mechanism through which ideology constitutes these imaginary relationships is what he calls the interpellation of individuals as subjects, a process that, despite the verbal hailing also implied, is essentially specular. The individual subject is but a reduced mirror image of the metasubject that is an abstraction generated by the contradictions of the system to occlude their operations. Whether it be called God, the Absolute Spirit, the State, or even Humanity, this metasubject is fundamentally the same phenomenon. The little "I" of the ideological subject is thus based on the metasubject's specular "eye" that duplicates only itself in a process of reflective narcissism.

Althusser's critique of the ocularcentric basis of ideology was, to be sure, based on a contrasting notion of Marxist science, which somehow escaped mystification. Although not identified with "true consciousness" in the traditional sense of clear and distinct ideas or representations of an external reality, it nonetheless presupposed the possibility of access to a more fundamental level of structural relations that ideology worked to veil. Insofar as Althusser remained beholden to the structuralism that he always protested he had surpassed, his version of science was itself hostage to an ocular notion of penetrating vision, which could see the outlines of the deep structures transparent through the seemingly opaque surface of ideology. Althusser's confusing and ambiguous concept of scientificity has been the target of a number of devastating critiques and there can be few, if any, adherents left who hold to it with any confidence. But his critique of specularity, shared as we have seen by Lacan, remains very powerful in non-Marxist as well as Marxist circles.

In feminist thought, for example, it has been most extensively articulated in the work of Luce Irigaray.[11] The flat reflecting mirror of Western metaphysics, she has contended, has been complicitous with the phallocentric privileging of male subjectivity. Here the visibility of the male genitalia is invidiously contrasted with the apparent *"rien à voir"* of the female. The classical psychoanalytic account of castration anxiety with all its sexist implications is also indebted to the privileging of visibility over the invisible. For feminists like Irigaray—and one could adduce evidence from others like Cixous or Kristeva—it is ideological, at least from a woman's vantage point, to assume sight is nobler than other senses like touch and smell.

Even more radical critiques of ocularcentrism have come from deconstructionists like Sarah Kofman, who are less willing than Irigaray to affirm another sensual hierarchy. In her 1973 study *Camera Obscura—de l'idéologie*, she explicitly confronts the implications of Marx's visual metaphor in *The German Ideology*.[12] Noting its continued importance in Freud as well, she argues that it mistakenly reproduces the traditional binary, metaphysical oppositions of clarity/obscurity, transparency/opacity, rationality/irrationality, and truth/falsehood. By merely hoping to reverse the illusory image of ideology, Marx and Freud betray their nostalgia for a hierarchical and binary order of their own. Although Marx does not simply posit scientific consciousness as the antidote to false consciousness—a mistaken characterization of his position that ignores his stress on the need for a practical resolution of the contradictions in the world that necessitates ideological mystification—his ideal, Kofman claims, "remains that of a perfect eye, a pure retina."[13]

Only Nietzsche, Kofman concludes, transcends the inadequate use of the *camera obscura* metaphor. He does so by recognizing its metaphoricity, embracing an artistic rather than scientific notion of truth, and multiplying the perspectival implications of the device itself. Everyone, Nietzsche realizes, has his own *camera obscura*, so that no collective or intersubjective vision of reality is possible. "The *camera obscura*," she writes approvingly, "is never a *camera lucida* and in the usage Nietzsche makes of such metaphors, there is no nostalgia for clarity. Nietzsche strategically repeats this classical metaphor precisely to denounce the illusion of transparency."[14]

In his recent defense of the philosophical legitimacy of deconstruction, *The Tain of the Mirror*, Rodolphe Gasché extends this argument even further. Claiming that the mainstream of Western philosophy has been a metaphysics of specularity, he argues that it came to a head in the absolute reflection of German Idealism, most notably Hegel. In his thought, all otherness, difference, and heterogeneity are recuperated in a grand gesture of perfect mirroring, in which the metasubject sees only

itself. What is lost in the process is the unseeable silver backing of the mirror, the material tain in the title of Gasché's book. It is on this reverse side of the mirror, according to deconstruction, that dissemination writes itself. But the result is not total blindness, Gasché insists:

> At first the mirror that Derrida's philosophy holds up seems to show us only its tain; yet this opaque tain is also transparent. Through it one can observe the play of reflection and speculation as it takes place in the mirror's mirroring itself. Seen from the inside this play gives an illusion of perfection, but observed through the tain, it appears limited by the infrastructural agencies written on its invisible side, without which it could not even begin to occur.[15]

There is, therefore, a certain place for sight in deconstruction, but all it can show is the limits of specularity and the interference of the mirror's tain in its functioning.

Lacking a positive notion of clear truth, unmediated objectivity, and transparent vision, all of these antiocular arguments might well appear to have abandoned any critical notion of ideology as well. Althusser's denial that ideology can be overcome, which is even more troubling once the poverty of his scientific alternative is exposed, may serve as the telos of virtually all of these writers. For if we live only in a world of individual perspectives, as Kofman contends, if we are forever trapped in a network of imaginary relationships based on the specular interpellation of the subject, as Althusser argues, if we cannot fully break through the looking glass of phallogocentrism because of our sexual divisions, as Irigaray implies, and if the gaze through the mirror's tain shows us only the limits of pure specularity, as Gasché argues, it is difficult to discern what the antidote to ideology can be. To put it in slightly different terms, once the "other" of ideology is jettisoned as a contrasting concept, the term loses its critical edge and becomes purely descriptive, as in certain mainstream sociological uses of it.[16]

How, we must ask, is it then possible to defend the practice of ideology critique in a nonocularcentric age? If we cannot see the fully visible truth, naked, pure and upright—a phallocularcentric image, if there ever was one—can we establish another standard by which we can measure ideological distortion? If, to play on Lacan's famous distinction between "le petit objet a" and "le grand objet A," we must give up a visual "other" of ideology with a capital "O," can we at least find nonvisual ones with a small "o" instead?

For those who have distrusted the illusions of our senses and sight in particular, a frequent alternative has been sought in the realm of language. The religious tradition that in the broadest sense we can call Hebraic (as

opposed to the more visually oriented Hellenic) has always trusted more in the divine word than in imagistic idols. Not surprisingly, many more secular critics of ocularcentrism have also turned to language as a way to preserve a critical notion of ideology. But here, of course, there is no simple community of opinion about what language is or how it operates to mystify or tell the truth.

Of all the possible tendencies that one might choose to discuss, let me for the sake of brevity stress an opposition between two, which we can roughly call deconstructionist and critical hermeneutic. Both are suspicious of a monologic, scientific vision, which claims to see the truth beneath the surface of a mystified level of appearances. Both abandon the assumption of what Richard Rorty calls the mind as a "glassy essence"[17] mirroring objects external to it. Both reject the ocularcentric implications of Marx's *camera obscura* metaphor. But in offering an alternative, each foregrounds a different dimension of language.

At first, deconstruction—if indeed we can homogenize it into such a coherent entity—may appear hostile to any concept of ideology. This would certainly be the implication one can draw from Sarah Kofman's radically Nietzschean perspectivalism. And it is also symptomatic that the index to Gasché's book carries no reference to ideology at all. But, if we turn to the work of another major champion of deconstruction, the late Paul de Man, we can see that at least one of its spokespeople did still argue for its importance. In the opening essay of his collection *The Resistance to Theory*, de Man writes:

> What we call ideology is precisely the confusion of linguistic with natural reality, of reference with phenomenalism. It follows that, more than any other mode of inquiry, including economics, the linguistics of literariness is a powerful and indispensable tool in the unmasking of ideological aberrations, as well as a determining factor in accounting for their occurrence. Those who reproach literary theory for being oblivious to social and historical (that is to say ideological) reality are merely stating their fear at having their own ideological mystifications exposed by the tool they are trying to discredit. They are, in short, very poor readers of Marx's *German Ideology*.[18]

How then does literary theory in the deconstructive mode better read *The German Ideology* without regressing to the ocularcentric notion of setting right reversed and inverted images? De Man answers:

> It upsets rooted ideologies by revealing the mechanics of their workings; it goes against a powerful philosophical tradition of which aesthetics is a prominent part; it upsets the established canon of literary works and blurs the boundaries between literary and non-literary discourse. By implication, it may also reveal the links between ideology and philosophy.[19]

The implications of de Man's own position are not difficult to discern. For deconstruction, the major mystifying ideologies of Western culture are the occlusion of the rhetorical moment in philosophy and science, the mistaken conflation of linguistic reference with the reality of an external object, the hypostatization of such categories as the Aesthetic or the Literary, the smoothing over of the mechanics of literariness in every text, the confinement of textuality itself to what appears between the covers of a book, and so on. All of these questionable practices are indeed worth challenging as possible sources of obfuscation, and we are certainly in debt to deconstruction for exploring their implications.

And yet, we may well feel uneasy with the contradictions lurking behind de Man's attempt to salvage a critical concept of ideology. Looking closely at his own rhetoric gives cause for alarm. Who, for example, is the "we" in his first sentence? If the Nietzschean perspectivalism of Kofman is taken to its individualist conclusions, where is there room for a collective subject in deconstruction, a subject able to get outside of its own *camera obscura* long enough to share a common view of the nature of ideology? Furthermore, de Man tells us that ideology is the confusion of linguistic with natural reality, reference with phenomenalism. The "other" of ideology in this sense—other with small "o"—would be presumably the overcoming of that confusion. But this achievement would not mean that we could tell when we are talking about linguistic "reality" and when we are not. For one of the main lessons of deconstruction is surely that we can never make a sharp distinction between two such putative approaches to the world. Our knowledge of nature, or anything else for that matter, is always already linguistic in the strong sense of the term. All that we can overcome, therefore, is the false belief that we can bracket our rhetorical mediations and see the world straight. Thus, we must remain agnostic about any external reality against which we can measure our understanding and find it appropriate or not. To know that we have hitherto been confused in our attempt to disentangle reference from phenomenalism may be an advance over blithely thinking we are not, but it is not much of a step beyond ideology as an inevitable and irremediable dimension of the human condition. For along with the deconstruction of the boundary between rhetoric and the perception of nature goes the sober realization of its inevitable restoration in our everyday practice. There is no radical cure, no revolutionary therapeutic benefit, to be derived from the acknowledgment of our false belief, for it is important to prevent our lapsing back into error. Deconstruction, like poetry in Auden's celebrated line, makes nothing happen.

De Man, however, does contend that "the linguistics of literariness is an indispensable tool in the unmasking of ideological aberrations." But if there are aberrations, there must be a norm by which they are measured,

a state presumably free of ideology itself or else closely approximating it. But it is precisely such a state of full presence, immediacy, and transparence that deconstruction has been at such pains to refute. If there is a normative *point d'appui* beyond the deceptions of ideology, it is only the Nietzschean rejection of the whole problematic of true and false consciousness based on a discredited subject/object metaphysics of adequation between idea and its referent. But here we are faced with the time-honored problem of how to judge such an assertion as itself true or false, when the whole basis for distinguishing between the two is denied. To say we are somehow beyond that dilemma because we have learned that language cannot be reduced to its constative, predicative function and therefore measured against a putative object outside it may be satisfying to some, but it provides very little basis for a workable concept of ideology.

Finally, de Man tells us that deconstruction will upset "rooted ideologies by revealing the mechanics of their working." This contention is, of course, the old formalist program of baring the device, which in the hands of Brecht and his followers found its way into Marxist aesthetics as well. Although it is certainly an indispensable tool in exposing the illusions of authorial genius or the organic integrity of the work of art, it too is unfortunately very problematic as a basis for ideology critique. First, the goal of revealing hidden mechanisms is itself tacitly grounded in an essence/appearance model, which deconstruction is normally at pains to discredit. Although he himself questions the surface/depth distinction, de Man's rhetoric of revelation suggests otherwise. For it entails that very ocularcentric premise of being able to see through an apparently opaque surface to reveal the hidden depths beneath, which the antiocular turn of much twentieth-century thought has called into question. The Derridean metaphor of a bottomless chessboard suggests that once we reach a putative hidden mechanism, it too will be subject to further deconstruction ad infinitum, so that no ultimate, essential level of explanation can ever be reached.

Second, there is precious little evidence to show that baring literary devices really changes anything outside of the practice of literary criticism. It was, moreover, already anticipated by modernist art, among whose central strategies were the foregrounding of its own artifice, the revelation of the materiality of its media, and the problematizing of its authorial voice. This deaestheticization of art, as Adorno would have called it, was useful in debunking certain earlier notions of the aesthetic, but it was the founding moment of a new aesthetics of a different kind, which we call modernism.[20] Whether or not it in its turn may be ideological in some respects can also be debated, and, of course, has been by critics from Lukács to Jameson. De Man himself contributes to the suspicion that it may be by his tendency to call it the essential quality of all literature,

self-consciously modernist or not. For in so doing, the historical specificity of different literary practices is lost.

Finally, as Brecht knew, but his less politically committed followers have sometimes forgotten, ideology is not really weakened by the exposure of its workings alone, but only when the larger constellation of forces making it necessary are themselves changed. De Man, to be sure, acknowledges the importance of this insight in passing, when he says that the linguistics of literariness is "*a* determining factor" in accounting for the occurrence of ideology, but he never offers any real analysis of the linkages between it and the other unnamed determining factors. Instead, we have to take on faith the contention that subverting the mystifications deconstruction is most concerned with challenging—those I listed previously—will work in common cause with subverting the others, whatever they may be. But in fact the links between them are not very easy to establish, especially as deconstruction can be turned itself against many of the values that oppressed groups have, perhaps in their benighted way, thought they were fighting for, values like solidarity, community, universality, popular sovereignty, self-determination, agency, and the like. In the absence of a more developed notion of what is not an ideological aberration, the suspicion will remain that deconstruction can be corrosive not only of mystifications but also of any possible positive alternative to them.

For all its determined undermining of many of the most fundamental assumptions of Western thought, for all its soliciting—in Derrida's sense of shaking, but leaving still standing—the traditional hierarchies of that thought, for all its self-proclaimed subversiveness, it is hard to avoid the conclusion that the deconstructive alternative to a discredited ocularcentric version of ideology critique is by itself insufficient. For it provides little guidance in suggesting the other of ideology, either with a small or large "O," outside of suggesting that its own Sisyphean labors are it.

What then of the alternative I have for shorthand purposes designated critical hermeneutics? Here the major spokesperson is Jürgen Habermas, although the contributions of other thinkers like Paul Ricoeur and Karl-Otto Apel should also be acknowledged. This is not the place to spell out Habermas's introduction of a linguistic turn into the Frankfurt School's Critical Theory or to examine the mountain of commentary devoted to it. Let me make only a few remarks that bear on the question of ideology. Although Habermas's work does contain discussions of various substantive ideologies that he considers particularly important today—the fetish of science and technology, for example[21]—the main contribution he has made to ideology critique concerns its formal underpinnings. Based on a pragmatic rather than structural linguistics, composed of insights from a variety of traditions, his argument has emphasized the process of com-

municative interaction through intersubjective discourse. He posits as a counterfactual telos of language the assumption of an undistorted speech situation in which the power of the better argument rather than prejudice, manipulation, or coercion creates a consensus of opinion about both cognitive and normative matters. What defines "better" is not congruence with an external reality but its ability to persuade after a process of rational deliberation is carried out, a process always open to later revision. Such a state of affairs is, of course, a regulative ideal, which can be approached only asymptotically. The main advantage of this argument over hermeneutic theories that assume meaningful communication always already exists or can be realized through interpretive effort alone—what makes it a critical rather than pure hermeneutics—is its linkage of language to power. For it argues that the undistorted speech situation can only be approximated when social conditions are themselves free of hierarchical domination. A conflict of interpretations can be rationally adjudicated only when a formal structure of rules and procedures is in place, which permits the unconstrained interchange of views leading to the ultimate triumph of the better argument. This condition does not mean the naive suspension of power, as some of Habermas's critics have charged, but the challenging of systematically asymmetrical relations of power. The power that remains is not in the service of domination, which is the *raison d'etre* of ideology, but in that of acting in concert to overcome illegitimate authority. Such an overcoming can only be achieved by an intersubjective effort that goes beyond the radical individualism of Sarah Kofman's Nietzschean perspectivism and the anti-individualism of such theories as Althusser's with its claim that the subject is only an effect of specular ideology.

By squarely facing the thorny problem of how to distinguish between a consensus based on manipulation, prejudice, and mystification and one grounded, at least tendentionally, in rational discourse supported by symmetrical power relations, Habermas helps us to establish a vantage point from which ideology can be called an aberration. As John Thompson puts it in his recent *Studies in the Theory of Ideology*, "to study ideology . . . is *to study the ways in which meaning (or signification) serves to sustain relations of domination.*"[22] That is, ideology is not a function of occluded vision; it is a distortion in the process of communicative rationality in the service of blocking the achievement of symmetrical power relations. Ideology critique, in other words, is meaningful only when it goes beyond baring the device and subverting received wisdom to challenge the conditions that necessitate ideology in the first place. For ideology is not merely a mistaken understanding of reality; it is an element in the exploitation and domination of human beings.

Habermas's project therefore is in the service of emancipation through social change, not merely textual reinterpretation. Because he is willing to defend in a nuanced way the values of the enlightenment tradition, it is not surprising to discover that he is somewhat less virulently hostile to vision than some of the other figures discussed previously. In fact, the process of ideology critique as he understands it contains a certain role for the objectivist epistemology that is so closely tied to the privileging of vision. Not only is it an indispensable tool in our intercourse with nature, but it also helps us make sense of those aspects of a reified social order that act as if they were a "second nature," to use the familiar Hegelian Marxist concept. That is, insofar as hierarchical, asymmetrical relations of domination permeate our society, it is necessary to investigate them from without, even as we try to undermine them from within. Although the point of view of total outsiderness is, of course, a fiction, embedded as we are in the flesh of the world and possessed of only a limited horizon from which to look about, it is nonetheless a useful "as if" concept in our attempt to grasp the larger structural constraints that limit our communicative interaction. Deconstructionists like de Man tacitly acknowledge this necessity in their assumption that we can reveal the mechanism of ideology's workings. We cannot entirely relinquish the cold eye of dispassionate analysis, losing the advantage given by gaining some perspective on a problem, in order to listen to each other for the purpose of coming to a rational consensus about our potentially common interests. As Ricoeur has also often stressed, we need a moment of distantiation, a more synoptic overview, as one positive condition of all historical understanding.

Obviously, a great deal can be said about the implications of all this, many of which may well seem problematic without further development, but let me close by taking a different tack, which will lead us toward a certain cautious rapprochement between the two linguistically informed alternatives to an ocularcentric concept of ideology. Neither of them alone provides a sufficiently powerful basis for an ideology critique that will survive the charge of arbitrariness hurled by those who deny the escapability of ideology. The deconstructive position tends to an ahistorical preoccupation with language and textuality per se. As a result, its exponents often lean toward a certain homogenization of the metaphysical tradition of Western thought as a whole, which is characterized as logocentric, specular, and so on. Symptomatically, when Derrida was asked at a recent conference to explain the rise of deconstruction itself during the last generation, he brushed the question aside by asserting that language always calls itself into question.[23] This type of hostility to historical change is, needless to say, fatal for any critical theory of ideology that

wants to go beyond the crippling assumption that mystification is a universal constant of the human condition.

Still, by challenging a whole host of received truths, deconstruction has opened up an enormously stimulating series of issues for ideology critique to consider. The point, however, is to foster the conditions under which such a debate might be carried out with the hope of working through their implications. Here only a theory that takes seriously the linkages between linguistic manipulations and social domination in particular historical circumstances can help us. There is no guarantee, to be sure, that a perfectly symmetrical speech situation, if it is indeed more than a counterfactual, regulative ideal, can provide anything like the certainty of the old ocularcentric notion of true consciousness as congruence between idea and its object. But it does at least give us some procedural standard by which our fragile capacity to reason may lead us beyond ideological illusions and the domination they abet. Without such a criterion, we may well fall back into a resigned acceptance of the coercive power of institutionalized authority, which cannot be challenged by anything outside it (e.g., Stanley Fish). For such a position, the "other" of ideology is an utterly meaningless concept.

One final word on the relationship between ideology and the visual is in order. In the ocularphobic context of much twentieth-century thought, it often seems as if the old religious hostility to idolatry has been resurrected to thwart any positive appreciation of the visual. One of the sources of the religious distrust of sight, as we have noted, was the anxiety unleashed by ocular desire. In our more secular context, this emotion sometimes appears to have been transformed into a deep distrust of what Guy Debord made famous as "the spectacle" of modern consumer capitalism.[24] Alongside of surveillance, the spectacle is attacked as one of the visual mainstays of the current order, one that operates by stimulating yearnings that are never really satisfied in a positive and fulfilling way.

It would be foolish to reject this insight into the way wants are generated in our society, at least in part by the seductions of sight. But it has also been noted by writers like Castoriadis and Ricoeur that what can be called the "social imaginary" contains elements that cannot be reduced to mere ideological mystifications.[25] For in addition to illusory phantasms, it also projects utopian images of another possible social order. From an Augustinian point of departure, ocular desire is to be condemned because it distracts us from listening to the divine word in Scripture, but for those of us no longer so certain of the power of that word, it may have a more laudable function. As a stimulant to dissatisfaction, however open to manipulation it may be, it is also a source of yearning for something better. The critique of ideology can exist only when such yearnings are still accounted viable. The old metaphor of a *camera obscura* showing ideology

as a reversed and inverted image of a truly existing world may, as we have remarked, be difficult to sustain in our antiocular age, but another link between ideology and the visual may not. That is, what we are looking *for* when we criticize the distortions of ideology may be present in what we are looking *at* in certain manifestations of ideology itself.[26] The images of specular reciprocity, transparent meaning, standing in the light of the truth, and so on, may all be easy to deconstruct as chimeras, but they are perhaps also ciphers of that unattainable "Other" of ideology—this time with a capital "O"—on which all critique must ultimately rest.

11

Modernism and the Retreat
from Form

The history of aesthetic modernism has often been written as the triumph
of form over content, the apotheosis of self-referentiality over the rep-
resentation or expression of anything external to the artwork.[1] The critical
discourse accompanying modernism has likewise been preoccupied with
formal issues, whether approvingly, as in the case of writers like Roger
Fry, Clive Bell, and the Russian Formalists, or not, as in that of most
Marxist critics. For the latter, the very term "formalist" became, as we
know all too well, a convenient term of abuse, with opponents like Georg
Lukács and Bertolt Brecht ingeniously concocting ways to pin the label
on each other.[2] No less heated has been the discussion, extending at least
as far back as Simmel, of the putative links between the formal abstraction
of modern life as a whole and its aesthetic counterpart. Modernity, in
short, has sometimes seemed coterminous with the very differentiation
of form from content, indeed even the fetishization of self-sufficient form
as the privileged locus of meaning and value.

In what follows, I want less to overturn this conventional wisdom than
problematize it, by pursuing the trail of what can be called a subordinate
tendency in aesthetic modernism, which challenged the apotheosis and
purification of form. That is, I want to explore what might be called a
powerfully antiformalist impulse in modern art, which can be most con-
veniently identified with Georges Bataille's spirited defense of *informe*.[3]
In so doing, I also hope to provide some insights into the complicated
relations between modernism, the contest over the hegemony of form,
and what I have elsewhere called the crisis of ocularcentrism, the deni-
gration of vision especially virulent in twentieth-century French thought.[4]

Before entering the obscure and labyrinthine territory of the *informe*,
let me pause a moment with the concept, or rather concepts, of form to

147

which it was deliberately counterposed. Although this is not the place to hazard a full-scale investigation of the multiple meanings adhering to that term, it will be useful to recall five different senses that have had a powerful impact in the history of aesthetics.[5] First, form has been identified with the composite arrangement or order of distinct parts or elements, for example the disposition of shapes in a painting or notes in a melody. Good form has in this sense generally meant proportion, harmony, and measure among the component parts. Second, form has meant what is given directly to the senses as opposed to the content conveyed by it, how, for instance, a poem sounds rather than what it substantively means. Formal value in this sense has meant sensual pleasure as opposed to a paraphrasable core of significance. Third, form has signified the contour or shape of an object, as opposed to its weight, texture, or color. In this sense, clarity and grace are normally accorded highest honors. Fourth, form has been synonymous with what Plato called Ideas and Aristotle entelechies, that is, with the most substantial essence of a thing rather than its mere appearance. Here formal value has carried with it a metaphysical charge, suggesting the revelation of a higher truth than is normally evident in everyday perception. Fifth and finally, form has meant the constitutive capacity of the mind to impose structure on the world of sense experience. Kant's first Critique is the *locus classicus* of this notion of form, with its attribution of a priori cognitive categories to the human intellect. Although Kant himself did not attribute comparable transcendental categories to aesthetic judgment, later critics like Konrad Fiedler, Alois Riegl, and Heinrich Wölfflin did seek universal formal regularities governing aesthetic as well as epistemological experience.

The modernist apotheosis of form has at one time or another drawn on all of these meanings. Thus, for example, the denigration of ornament in the architecture of Adolf Loos, Le Corbusier, or the Bauhaus meant the holistic elevation of structural proportion and measure over the isolated fetish of component parts. Similarly, the stress on the musical sonority of poetry, typically expressed in Verlaine's famous injunction to wring the neck of eloquence, indicated the apotheosis of form as sensual immediacy over mediated content. The autonomization of line and figure in the abstract paintings of a Mondrian or Malevitch likewise indicated the triumph of contour over texture or color, as well, of course, as over mimetic, narrative, or anecdotal reference. In the case of a painter like Kandinsky, the liberation of abstract form was defended in the name of a religious essentialism that evoked Platonic and Aristotelian metaphysical notions of substantial form. And finally, there has been no shortage of modernist artists who characterize their work as the willful imposition of form on the chaos outside them, and perhaps inside as well.

If, however, much of modernism can be interpreted as the hypertrophy of form in many or all of its senses, there has been from the beginning a counterimpulse within modern art that has resisted it, a refusal to countenance the differentiation and purification characteristic of modernist aesthetics in general. It is important to note, however, that this resistance has not taken place in the name of one of form's typical antonyms, such as content, subject matter, or element. It has not provided the materialist antidote to self-referentiality that a Marxist like Lukács so fervently craved. Rather, it has preferred to define itself, if it deigned to submit itself to definition at all, in negative terms, as deformation or, more radically still, as formlessness. Instead of privileging ideal formal beauty, it has sought to valorize baseness and ignobility. In the place of purity and clarity, it has favored impurity and obscurity.

Here, of course, there have been precedents, as the history of the grotesque as an aesthetic concept demonstrates.[6] But what gives the modernist turn against form its special power is its linkage with the widespread critique of visual primacy, of the ocularcentric bias of the Western tradition in its most Hellenic moods. The link between form and vision has, of course, often been emphasized, ever since it was recognized that the Latin word *forma* translated both the visually derived Greek words *morphe* and *eidos*. Thus, for example, Jacques Derrida has observed in this critique of form and meaning in Husserl that "the metaphysical domination of the concept of form is bound to occasion some submission to sight. This submission always would be a submission of *sense* to sight, of sense to the sense-of-vision, since sense in general is the very concept of every phenomenological field."[7] Even linguistic notions of form carry with them a certain privileging of vision. According to the American deconstructionist David Carroll, the structuralism of Jean Ricardou and the Russian Formalists "stresses the *visibility* of linguistic operations in the determination of the form of the novel. Form is constituted by the visible operations of language at work in the novel—the frame of all frames."[8]

The link between form and the primacy of vision is most obvious when the term signifies clarity of outline or luminous appearance, but it also lurks behind certain of the other meanings mentioned above. Thus, for example, the identification of form with the proportion among discrete elements often draws on the visual experience of symmetrical commensurability. So too, the belief that form signifies essential truths draws on the Platonic contention that Ideas exist in the "eye of the mind." Although it is of course true that form can be applied to aural, temporal phenomena, such as sonatas and symphonies, the capacity of the eye to register from a distance a static and simultaneous field of ordered regularity means that it is the primary source of our experience of form.[9]

If this is the case, it might be expected that an aesthetic modernism that privileged formalism would also be favorably inclined toward the hegemony of the eye. And as the influential school of criticism identified with the American art critic Clement Greenberg demonstrates, this expectation was not disappointed. For Greenberg spoke glowingly of the "purity" of the optical as the defining characteristic of the modernist visual arts, even sculpture.[10] In literary terms, the same impulse may be discerned in Joseph Frank's celebrated defense of the idea of spatial form in modern literature, which sought to undo Lessing's distinction between the atemporal and temporal arts.[11] And it should also be remembered that one of the cherished hopes of Russian Formalist criticism was precisely, as Jameson has noted, "the renewal of perception, the seeing of the world suddenly in a new light, in a new and unforeseen way."[12]

However valid these characterizations of the dominant tendencies may be, and they were never entirely uncontroversial, they fail to do justice to the subaltern tradition of formlessness that also must be accorded its place in the story of modernism. One avenue of entry into this alternative impulse can be found in the role of so-called primitive art in the early development of modernist aesthetics. In most accounts, it is recognition of the abstractly formal properties of that art which is given pride of place.[13] Indeed, it was precisely the discovery in primitive artifacts of a universal "will-to-form" in Riegl's sense by critics like Wilhelm Worringer, Roger Fry, and Leo Frobenius that allowed their elevation into the realm of the aesthetically valuable.

The accompanying cost of this gesture, however, was the decontextualization of these works, which robbed them of any ethnographical value as objects of cultural practice. Generally forgotten as well was their ideological appropriation in the later context of Western imperialism.[14] Instead, their purely formal qualities were differentiated out from the entanglements of both their contexts or origin and reception, and then elevated into instances of a putatively universal aesthetic. As such, they could then provide inspiration for a modernist formalism, which was equally indifferent to its contextual impurities.

Although only recently have critics made us all so aware of the ambiguous role of primitivism in the origins of modern art, their critique was already anticipated in the countercurrent that we have called modernist formlessness. In particular, it was implicit in the very different appropriation of the exotic by the French Surrealists, who never forgot the ethnographic dimension of the objects that could also be valued for their aesthetic significance.[15] The circle around the journal *Documents* retained the emphasis on the sacred, ritual, and mythic function of the artifacts, which they had imbibed from their readings in Durkheim and Mauss and their contact with fieldworkers like Alfred Métraux.

Foremost among them was Georges Bataille, who combined his interest in the sacred aspects of primitive culture with an appreciation of Dionysian frenzy and violent sexuality, derived from Nietzsche and Sade, into a full-blown defense of the virtues of transgression, heterogeneity, excess, and waste. Among the most explicit values to be transgressed, according to Bataille, was the fetish of form in virtually all of its guises. In his 1929 entry on *Informe* in the *Documents "dictionnaire critique,"* he claimed that dictionaries really begin when they stop giving fixed meaning to words and merely suggest their open-ended tasks instead. "Thus," he continued, *"formless* is not only an adjective having a given meaning, but a term that serves to bring things down in the world, generally requiring that each thing have its form. What it designates has no rights in any sense and gets squashed everywhere, like a spider or an earthworm."[16] Whereas conventional philosophers always try to place the world into categorical straitjackets, assigning everything a proper form, what they tended to forget is the conflict between constative meaning and performative function. "Affirming that the universe resembles nothing and is only *formless,"* Bataille concluded, "amounts to saying that the universe is something like a spider or spit."[17] The "saying" of something so outrageous is not a truth claim in its own right but an assault on all claims to reduce the world to formal truths.

For Bataille, the problematic hegemony of conceptual and aesthetic form was explicitly linked to the ocularcentric bias of Western metaphysics.[18] Distinguishing between two traditions of solar illumination, he identified the first with the elevating Platonic sun of reason and order, which cast light on essential truths, and the second with the dazzling and blinding sun which destroyed vision when looked at too directly. The myth of Icarus, he contended, expressed this duality with uncommon power: "it clearly splits the sun in two—the one that was shining at the moment of Icarus's elevation, and the one that melted the wax, causing failure and a screaming fall when Icarus was too close."[19] Whereas traditional painting reflected the Platonic search for ideal form, modern painting, most explicitly that of Picasso and Van Gogh, had a very different goal: "academic painting more or less corresponded to an elevation—without excess—of the spirit. In contemporary painting, however, the search for that which most ruptures elevation, and for a blinding brilliance, has a share in the elaboration or decomposition of forms."[20]

Bataille's plea for the decomposition of form was expressed as well in his valorization of materialism, albeit one very different from that posited by traditional metaphysics or by Marxist dialectics.[21] Rather than a materialism of the object, his was a materialism of the abject. As Rosalind Krauss has noted, *"Informe* denotes what alteration produces, the reduction of meaning or value, not by contradiction—which would be dialec-

tical—but by putrefaction: the puncturing of the limits around the term, the reduction to sameness of the cadaver—which is transgressive."[22] Refusing to turn matter into a positive surrogate for spirit or mind, Bataille linked it instead to the principle of degradation, which he saw operative in the Gnostic valorization of primal darkness.[23] As a result, it was impossible to mediate between matter and form, as, say, Schiller had hoped with his "play drive," to produce a higher synthesis. The materialism of *informe* resisted any such elevating impulse.

The baseness of matter as opposed to the nobility of form was tied as well by Bataille to the recovery of the body, which had been suppressed by the exaltation of the cold, spiritual eye. It was, however, a grotesque, mutilated, headless body, a body whose boundaries were violated and porous, that he most valued. For Bataille, the waste products of the body, normally hidden and devalued as dirty or obscene, were closest to the experience of sacred excess and ecstatic expenditure realized in primitive religion. Here no measured proportion among elements, no sensual pleasure unsullied by violent pain, no sharply defined outlines, no revelation of essential ideas shone forth. Instead, formal beauty was consumed in the flames of a symbolic conflagration like that of the potlatch ceremonies of the American Indians, whose conspicuous consumption of wealth he so admired.[24]

So too, form in the Kantian sense as the imposition of structure by a constitutive subject on the chaos of the world was utterly absent in Bataille's theory. His idiosyncratic concept of sovereignty meant the loss of willed control by a homogeneous agent and submission instead to the heterogeneous forces that exploded its integrity.[25] The "acephalic" (headless) community he sought was based on the ecstatic sacrifice of subjectivity, individual and collective, not an act of conscious choice.[26] It was also the opposite of merely formal democracy, which produced only a sterile and lifeless simulacrum of political freedom.

Bataille's own writing can also be read as instantiating a principled resistance to the subjective imposition of form. Thus, Denis Hollier has claimed that "perhaps Bataille's work gets its greatest strength in this refusal of the temptation of form. This refusal is the interdiction making it impossible in advance for his works ever to be 'complete,' impossible for his books to be only books and impossible for his death to shut his words up. The transgression is transgression of form . . . the temptation of discourse to arrest itself, to fix on itself, to finish itself off by producing and appropriating its own end. Bataille's writing is antidiscursive (endlessly deforms and disguises itself, endlessly rids itself of form)."[27]

It would be easy to offer other examples of Bataille's critique of form and link them with his no less severe attack on the ocularcentric bias of Western culture. What is of more importance, however, is to establish the

existence of a similar inclination among other significant modernist fig-
ures. Armed with an appreciation of Bataille's defense of *informe*, several
recent critics have provided us with the means to do so. For example, in
her 1988 study of Rimbaud and the Paris Commune, Kristin Ross has
examined the nature of class in his poetry and linked it to his celebrated
call for the derangement of the senses with its explicit spurning of the
Parnassian poets' dependence on the mimetic eye. In Rimbaud, as she
reads him, "grotesque, hyperbolic, extraordinary, superhuman perception
is advocated in opposition to what capitalist development is at that mo-
ment defining (in the sense of setting the limits) *as* human, as *ordinary*
perception."[28] The space that is prefigured in his poetry is not geomet-
rically ordered or transparently lucid, a space peopled by formal groupings
like parties or bureaucracies. It is instead a more tactile than visual space,
an irregular field through which flows of energy and force pass without
coalescing into visibly recognizable structures.[29]

The word Ross chooses to describe Rimbaud's notion of class is
"swarm," which she compares positively to more traditional notions of
a disciplined proletariat expressing its allegedly mature class conscious-
ness by following the leadership of a vanguard party. "If 'mature' class
consciousness partakes of the serial groupings like the party or state,"
she writes, "then the movement of Rimbaud's swarm is much more that
of the *informe* ('it has no form he give it no form'): the spontaneous,
fermenting element of the group."[30] For all his celebrated elevation of the
poet into the role of *voyant*, Rimbaud's own work insisted on the im-
portance of the erotic body as opposed to the spiritual eye and resisted
the differentiation of poetic form from everyday life. Just as he refused
to be socialized through bourgeois formation, Rimbaud rejected the al-
ternative art-for-art sake's socialization into aesthetic form. His notorious
decision to give up poetry entirely in favor of living dangerously was
thus already anticipated in the poetry itself, which Ross interprets as the
antithesis of the life-denying aestheticism expressed in Mallarmé's fetish
of the pure word.

No less exemplary of the modernist turn against formal purity was the
remarkable experiments in photography carried out by the Surrealists in
the interwar era, which have recently been interpreted in Bataille's terms
by Rosalind Krauss. Examining photographers like Jacques-André Boif-
fard, Brassaï, and Man Ray, she detected the trace of his, rather than
André Breton's ideas on their work. "The surrealist photographers were
masters of the *informe*," she writes, "which could be produced, as Man
Ray had seen, by a simple rotation and consequent disorientation of the
body."[31] Even surrealist painters like Masson and Dali, she argued, were
in his debt: "It is to Bataille, not to Breton, that Dali owed the word
informe with the particular, anamorphic spin."[32]

According to Krauss, the dominant modernist defense of photography's aesthetic credentials in strictly formalist terms, exemplified by champions of what is called "Straight Photography" like Edward Weston and John Szarkowski, was challenged by the surrealist introduction of textual and temporal interruptions into the pure image. "The nature of the authority that Weston and Straight Photography claim," she writes, "is grounded in the sharply focused image, its resolution a figure of the unity of what the spectator sees, a wholeness which in turn founds the spectator himself as a unified subject. That subject, armed with a vision that plunges deep into reality and, through the agency of the photograph, given the illusion of mastery over it, seems to find unbearable a photography that effaces categories and in their place erects the fetish, the *informe*, the uncanny."[33]

Still another instance of the alternative modernist tradition of debunking pure, visible form can be discerned in its receptivity to the aesthetics of the sublime. Although the sublime is often more closely identified with Romanticism or Postmodernism than with High Modernism, no less a celebrant of its importance than Jean-François Lyotard has claimed that "it is in the aesthetic of the sublime that modern art (including literature) finds its impetus and the logic of avant-gardes finds its axioms."[34] Painters from Malevitch to Barnett Newman, he claims, instantiate what Burke, Kant, and other theorists of the sublime meant when they stressed its striving to present the unpresentable, its fidelity to the Hebraic injunction against graven images.[35] "To make visible that there is something which can be conceived and which can neither be seen nor made visible" Lyotard writes, "this is what is at stake in modern painting. But how to make visible that there is something which cannot be seen? Kant himself shows the way when he names 'formlessness, the absence of form,' as a possible index to the unpresentable."[36] Although modernism, as opposed to the postmodernism he prefers, is still nostalgic for the solace of presentable form, it nonetheless exemplifies for Lyotard the ways in which art can disrupt the clarity and purity of formal beauty. In so doing, it reveals the workings of inchoate, libidinal desire, which explodes through the deceptively calm surface of both figural and discursive representation.

One final instance of the modernist retreat from form can be found in music, where Schoenberg's bold experiments in atonality and *Sprechstimme* were not the only challenge to traditional values. Perhaps even more extreme examples of what might be called musical *informe* can be discerned in Futurist composers like Luigi Russolo, one of the founders of *bruitismo*.[37] Here noise, often that of the jarring world of modern technology, was explicitly privileged over tone. Acoustical phenomena without any discernable pitch replaced those which could be translated into visible notation on a traditional scale. Although Futurist composition was relatively modest in achievement, the increasing incorporation of noise

into modern music is evident in works like Igor Stravinsky's *L'Histoire du Soldat* (1918) and Edgard Varèse's *Ionisation* (1931). Here timbre and color usurped the role normally given to pitch, as they also did in the so-called *Klangfarben* of Schoenberg and Berg. The new importance of color, however metaphorical that term may be in the lexicon of music, demonstrates a certain congruence with the other phenomena we have been discussing, for it has normally been counterposed to visual form.

Other examples of the retrospective critical appreciation of *informe* in modernist art might be given, as the conventional wisdom identified with Bell, Fry, and Greenberg has come under increasing attack.[38] But it is now time to explore more closely the implications of this new appreciation. What are the stakes involved when we go from identifying modernism with the abstraction of form in all of its guises from content, matter, and so on to identifying instead it with a contested field in which the opposite impulse is also at play? What has been gained by acknowledging the importance of formlessness as at least a significant countercurrent within modernist art?

First, what has to be made clear is that *informe* does not mean the simple negation of form, its wholesale replacement by chaos or the void. As Bataille contends, *informe* is not a positive definition, but a working term that functions by disruption and disorder. That is, it needs the prior existence of form, which it can then transgress, to be meaningful. Just as the grotesque operates by the disharmonious juxtaposition or integration of apparent formal opposites,[39] just as the sublime keeps the tension between presentation and unpresentability, so too the *informe* needs its opposite to work its magic. If not for the powerful formalist impulse that so many critics have rightfully seen in modernism, the *informe* would not be so insistently summoned up to undermine it.

There are several possible ways to conceptualize and explain the tension between form and formlessness that we have been tracing. One is to assimilate it to a more timeless struggle between structure and energy, stasis and movement, the immutable and the ephemeral. Here we reenter the territory perhaps classically traversed by Lukács in his pre-Marxist work *Soul and Form*.[40] But whereas Lukács called form "the highest judge of life"[41] and agonized over the inability of life, with all its chaotic energy, to measure up to that stringent tribunal, the tradition we have been examining in this paper has had the opposite reaction. For the celebrants of the *informe*, it is precisely the failure of life to remain frozen in formal patterns, with its material impurities purged and its baser impulses expelled, that warrants praise.

From a psychoanalytic perspective more in tune with this inclination, it would be fruitful to consider Lacan's celebrated analysis of the chiasmic intertwining of the eye and the gaze in *The Four Fundamental Concepts of*

Psycho-analysis.[42] Here he provides a complicated explanation of the ways in which the subject is situated in a visual field split between an eye, which looks out on a geometrically ordered space before it, and a gaze, in which objects "look back" at the body of the eye that is looking. Although modernist formalism sought to transcend the perspectivalist scopic regime identified with the eye in its most Cartesian version, it substituted a pure opticality in which the tension between eye and gaze was suppressed.[43] The modernist formalism celebrated by critics like Greenberg thus forgot what those critics sensitive to the *informe* remembered: that the visual field was a contested terrain in which pure form was always disrupted by its other. That other might be interpreted in linguistic terms, as the interference of the symbolic with the imaginary, or as a conflict within the realm of vision itself, but however it be ultimately understood, it meant that modernism, indeed any art, could not be reduced to the triumph of pure form.

That Lacan's own analysis emerged out of the same matrix as Bataille's,[44] that he himself was fascinated with the sublime, as Slavoj Žižek has recently reminded us,[45] that he was deeply aware of the challenge to pure opticality raised by the recovery of anamorphosis by critics like Jurgis Baltrušaitis,[46] means that his ideas themselves were indebted to the revaluation of formlessness that we are now trying to explain. One commentator, Joan Copjec, has gone so far as to claim that "contrary to the idealist position that makes *form* the cause of being, Lacan locates the cause of being in the *informe*: the unformed (that which has no signified, no significant shape in the visual field); the inquiry (the question posed to representation's presumed reticence)."[47] It may, therefore, be problematic to rely on Lacan entirely for an explanation of the specific dialectic of form and formlessness in modernism. For his analysis of the eye and the gaze was aimed at uncovering the workings of vision in all contexts and for all time.

A more historically specific approach might usefully draw on Peter Bürger's well-known distinction between modernism and the avant-garde.[48] Whereas modernism remained within the institution of art, seeking to explore the limits of aesthetic self-referentiality, the avant-garde sought to reunite art with life, thus allowing the emancipatory energies of the former to revitalize the latter. The high modernist apotheosis of pure form, it might be argued, fits well into the first of these categories; the differentiation of the visible from the other senses, which we have noted as one of the central impulses behind formalism, corresponds to the differentiation of the institution of art from the lifeworld. The counterimpulse we have identified with the *informe*, on the other hand, is perhaps better understood as part of the avant-garde's project, in Bürger's sense of the term. That is, it calls into question the purity of the aesthetic

realm, undermines the distinction between high art and base existence, and reunites vision with the other senses. Not surprisingly, Bataille and other defenders of *informe* would often argue for its political value as a way to realize the revolutionary potential of the unformed masses. Kristin Ross's celebration of Rimbaud's notion of class as a swarm is an instance of this impulse, which seeks to protect the proletariat from its form-giving representatives in the vanguard party.

All of these explanations help us make sense of the struggle between form and formlessness in aesthetic modernism, but the context in which I think it might most suggestively be placed is, as I have argued above, the crisis of ocularcentrism in Western culture. That is, with the dethroning of the eye as the noblest of the senses, with the revalorization of the "acephalic" body whose boundaries are permeable to the world, with the celebration of noise and force over clarity and contour, the "will-to-form" that critics like Riegl saw as the ground of aesthetics has been supplanted or at least powerfully supplemented by a contrary "will-to-formlessness."

From one perspective, all of these changes might be damned as complicitous with a dangerous counterenlightenment irrationalism and libidinal politics. And in certain respects the charge may be valid, at least if the complicated dialectic of form and formlessness is forgotten and a simple-minded antiformalism is put in its place. But from another point of view, there may be less cause for alarm. For it may perhaps be a mark of a kind of cultural maturity that we no longer tremble, as did Simmel or Lukács, at the "tragic" possibility that life and form cannot be harmoniously united.

May we, in fact, conclude that the modernist standoff between form and *informe* has left us with a willingness to tolerate a mixture of intelligibility and unintelligibility, boundaried integrity and transgressive force, spiritualized ocularity and the messiness of the rest of our bodies, that betokens a less anxious age? Have we learned to accept limits on the form-giving constitutive subject, abandoned the search for timeless essences amidst the plethora of ephemeral appearances, and realized that the distinction between ergon and parergon, text and context, is not as fixed as it appeared? If so, the performative power of saying the "universe is something like a spider or spit" may have actually done some of its work, and the hope of harnessing the emancipatory (but not redemptive) energies of modernist—or in Bürger's terms, avant-garde—art for life may not be so vain after all.

12

The Textual Approach to
Intellectual History

With a mixture of trepidation and excitement, intellectual historians have found themselves drawn more and more steadily into the maelstrom of theoretical disputation that now characterizes the humanities as a whole. Always vulnerable to seduction by the ideas we study and no less prone to transferential identification with the intellectuals who generate them, we find ourselves compelled to reflect on the premises of our discourse with unwonted self-consciousness. The theoretical struggles that began to rend other humanist disciplines in the 1960s and 1970s have thus come to be replayed in our own homely idiom in the last decade. Now even the pages of *The American Historical Review* resound with the clash of arguments audible a short while ago only in journals like *Glyph, Diacritics,* or *Critical Inquiry.*

If there is any debate in particular that typifies the intellectual historical reenactment of these battles, it is the one that broadly speaking pits those who stress textual interpretation against those who emphasize contextualist explanation. Here intellectual historians like Dominick LaCapra, Hans Kellner, Robert F. Berkhofer, Jr., and David Harlan find themselves opposed by others like John Toews, David Hollinger, Anthony Pagden, and James Kloppenberg.[1] Whereas the former eagerly endorse the linguistic turn imported from philosophy and literary criticism, the latter hold fast to a version of the social history of ideas promulgated by the previous generation of intellectual historians, now sometimes defended in terms of a pragmatic hermeneutics of experience.

As a stalwart of neither camp and disinclined in any case to prescribe a single approach as normative for the field as a whole, I am loath to use this opportunity to fire yet another shot in the polemical war that now rages in our little corner of the discipline. Instead, I want to clarify the

implications of only one of the approaches, that which has been called textualist, and address some of the evident anxieties it has aroused. In so doing, I hope to show that intellectual history is strongest when it resists dreaming of a master methodology that totalizes all of its disparate approaches into one extorted reconciliation.

It may be useful to begin by recalling that this is not the first time that the textualist/contextualist struggle has been waged. Twenty years ago, Quentin Skinner published a widely influential essay entitled "Meaning and Understanding in the History of Ideas,"[2] which became the manifesto of a militant contextualist movement. Significantly, however, the textualism it opposed was very different from the one that so alarms today's contextualists. In brief, the concept of the text that Skinner questioned was one that identified it with a coherent and finite set of meanings available to competent readers who could grasp its sense. In literary critical terms, it was the type of autonomous and self-enclosed text authenticated by the signature of its creator that the New Critics had tried to isolate from its conditions of production and reception—psychological, sociological, or otherwise. Attempts to transgress the text's boundaries they famously damned as "the intentional fallacy" or the "affective fallacy." All that was needed, they insisted, was an *explication de texte* in its own terms.

Comparable notions of textuality prevailed in other disciplines as well. In the realm of political philosophy, for example, texts in this sense were equated with the great, classical works whose meaning transcended their historical situation and spoke to all of humankind, a position espoused with great fervor by Leo Strauss and his antihistoricist followers. For certain intellectual historians, who could not be as explicitly hostile to history, a similar concept of the text nonetheless prevailed. It identified the text with a paraphrasable core of significant ideas, which could then be compared with similar ideas generated before or after. Although at times, this meant looking for more discrete "unit ideas" in texts, as in the case of Arthur Lovejoy and his followers, the same indifference to the specificity of their defining contexts was apparent. A disembodied history of ideas was the result.

Skinner's contextualist alternative did not advocate the wholesale reduction of the text so understood into a function of its original social context or an expression of nothing but the motives of its author, two misreadings against which he was very careful to warn. But he did argue that to understand the text *historically* meant treating it as a speech act with illocutionary or performative force, which he called its intentionality. Because texts were actions written with the purpose of affecting their readers, they could be fully understood, he argued, only by appreciating the network of relations into which they were inserted by their authors.

In several subsequent essays,[3] Skinner struggled to find the proper
formula to distinguish motives antecedent to texts from intentions em-
bodied in them and sought to strike a balance between recovering the
author's intention and reestablishing the discursive context in which the
illocutionary force of that intention was manifest. In the light of later
notions of textuality, to be discussed next, he ultimately came to concede
that because a text's significance often exceeds conscious authorial inten-
tionality, his "principal concern has not been with meaning but rather
with the performance of illocutionary acts."[4] Whether or not the refine-
ments of his position are fully persuasive is less important for our purposes
than the nature of the textualism he was initially opposing, which he
identified with the belief, shared by New Critics and Straussian political
theorists, in the text as a discretely coherent object containing an inherent
meaning that could be entirely understood without violating its self-suf-
ficiency. This approach we might call that of "integral textualism," which
seeks to avoid the contamination of a pure text by anything outside its
frontiers. The social history of ideas was designed to breach at least the
one border separating texts from their contexts of origin.

In contrast, the textualism that causes today's champions of contex-
tualism so much anxiety has expressly jettisoned the notion of an integral
text. But in so doing, it has gone one step further than the early contex-
tualists by entirely dismantling the wall between text and context, which
the social historians of ideas had only wanted to make more porous.
Moreover, the new textualism has reversed the flow of causation between
context and text or given up the search for causal priority entirely. Instead
of trying to isolate the text from the world or explain the text by the
world, it has dissolved the boundary between the two and redescribed
what was previously construed as extratextual as itself somehow textual.
What we might then call "disintegral textualism" affronts the defenders
of contextualism by seeming to deny the categorical difference between
inside and outside, thus resisting the idea that a text can be explained by
an external context evoking, englobing, or enabling it.

Disintegral textualism has, however, itself come in three general va-
rieties, which for shorthand purposes we can identify as hermeneutics I
and II and deconstruction. The first hermeneutic version of the disintegral
text calls into question the role of the reader as a neutral and objective
observer of documents revealing information about the world. Here the
border between text and context of reception rather than origin is prob-
lematized. As David Couzens Hoy puts it with reference to Hans-Georg
Gadamer's hermeneutics, "a text is not an object in itself, to be viewed
from various perspectives or in different profiles; rather, it is the product
of a dialogue directed by the expectation that something meaningful is
said *about* something."[5] What we call a text thus includes as one of its

fundamental dimensions an appreciation of what Gadamer calls its "history of effects," its subsequent series of readings and interpretations. Texts, in other words, cannot be isolated from their reception history, which allows their signifying potential to be realized. Insofar as the current reader is part of that unending process, our response is not outside the text, whose meaning exists prior to it, but is inevitably intertwined with it. In this sense, the rigid differentiation between text and context of reception, upheld by the New Critics with their warning against "the affective fallacy," breaks down.

At its most extreme, this position leads to Stanley Fish's provocative answer to the question "Is There a Text in This Class?"—that answer, being in short "no, there isn't."[6] There are instead only interpretative communities, which interpret texts according to their own standards of judgment, not according to their intrinsic qualities or their reflection of their author's intention. A similar claim is presented in Marxist terms by the English critic Tony Bennett, who contends that "the proper object for Marxist literary history consists not in the study of texts but in the study of reading formations . . . a set of discursive and inter-textual determinations which organize and animate the practice of reading. . . . This entails arguing that texts have and can have no existence independently of such reading formations."[7] Here ironically, dissolving boundaries leads not to the imperialist aggrandizement of the text, but rather its apparent disappearance.

If intellectual historians have generally been reluctant to follow literary critics in this direction, it is partly because they have been attentive to a second hermeneutic version of disintegral textualism that has the opposite implication. Here the cue has been taken from cultural anthropologists like Clifford Geertz, who famously claimed in his essay on the Balinese cock fight that "the culture of a people is an ensemble of texts, themselves ensembles, which the anthropologist strains to read over the shoulders of those to whom they properly belong."[8] This expanded notion of textualism has meant that the distinction between what the integral textualists thought of as the proper unit of inquiry and the surrounding context of irrelevant practices, structures, institutions, and so on was dissolved. Now all of culture, indeed all human action could be read as a text.

Paul Ricoeur spelled out the implications of what we might call this culturalist model of the text when he argued that all meaningful human action was like writing because of its autonomization from authorial intention, its openness to later interpretations, and its irreducibility to an immediate relation between speakers.[9] The consequences for intellectual history were drawn by William Bouwsma, who argued for a shift from "the history of ideas to the history of meaning."[10] Rather than focusing

on the allegedly "high texts" of an elite tradition, Bouwsma suggested, we should recognize the universal meaningfulness of all culture and proceed to provide what Geertz, following Gilbert Ryle, had called "thick descriptions" of it.

Both hermeneutic versions of disintegral textualism thus dissolve the boundary between text and context, but they do so in a way that could preserve certain of the implications of the earlier, more restricted model. Ricoeur, for example, claimed that "a text is a whole, a totality . . . an individual like an animal or a work of art."[11] The meaning of such texts was graspable through the circular dialectic of moving from whole to part and back again, which was characteristic of the hermeneutic method. Geertz's virtuoso interpretation of the Balinese cock fight as a kind of text was predicated on the optimistic assumption that once inside the circle, and able to "read over the natives' shoulder" in his telling metaphor, the anthropologist or historian could somehow crack the code and make sense of even the most seemingly impenetrable culture.[12]

As in the case of the integral textualism criticized by Skinner, these hermeneutic versions of disintegral textualism have shown themselves vulnerable to the criticism that by suppressing the deictic specificity of the texts they examine—their initial location in a unique time and place—they too easily efface the historical difference between the subject and object of inquiry, and do so in favor of the meaning-giving power of the former. Gadamer's dialogic fusion of horizons has often been attacked for underestimating the obstacles to a harmonious overcoming of differences. Geertz himself has been called on the carpet by other anthropologists such as Vincent Crapanzano, who complains that "despite his phenomenological-hermeneutic pretensions, there is in fact in 'Deep Play' no understanding of the native from the native's point of view. There is only the constructed understanding of the constructed native from the native's constructed point of view . . . [Geertz's] constructions of constructions appear to be little more than projections, or at least blurrings, of his point of view . . ."[13] These projections are abetted by the fiction that Balinese culture as whole is a coherent text with an identifiable meaning, which is then available to be read by the sensitive interpreter privy to its secrets. Similarly, Bouwsma's ecumenical history of meaning has been criticized for smoothing over the hierarchical differentiations based on power and status, which prevent cultures from being readable as unified texts and all their products from being homogenized into instances of the same process of signification.[14] Fish's granting of wholesale power to interpretive communities can be said to commit the same mistake, if in displaced form, by locating the source of meaning-constitution *entirely* in the reception of texts. What remains is the assumption of a coherent meaning, this time produced by the institutions of reading.

The third current variant of disintegral textualism, which we have iden-
tified with deconstruction, has seemed no less insistent than the first two
on dissolving boundaries, or at least showing how porous they are, and
thus textualizing contexts. The most notable expression of this intention,
now so incessantly trotted out by scandalized contextualists who decry
pantextualist homogenization, is surely Jacques Derrida's "there is noth-
ing outside a text," which can also be rendered as "there is no absolute
extra-text."[15]

However one translates and interprets this claim, and a lot of energy
has been expended trying to get it right, it does *not* imply the same version
of disintegral textualism represented by the hermeneutic and cultural an-
thropological theorists. For rather than retaining the idea of a text as a
meaningful and coherent whole and then extrapolating this model to
culture in the larger sense or displacing it onto an interpretive community,
deconstruction stresses instead the ways in which texts complicate, thwart,
and resist meaning. If a hermeneutics at all, which is by no means certain,
it is one of suspicion rather than recollected meaning, to cite Ricoeur's
familiar opposition. Whether we interpret meaning as an expression of
authorial intention, an instantiation of the more anonymous signifying
practices of the culture as a whole, or an effect of a historical process of
reception, deconstruction contends that the very textual mediation of that
meaning prevents it from ever being self-sufficient, transparent even to
its originators and open to harmonious fusion with the horizons of later
readers.

That is, once meaning is recognized as entangled in the linguistic web
of rhetorical devices that necessarily mediate it, it is impossible to posit
its full historical recovery as a hermeneutic goal. The very citability of
texts and a fortiori fragments from them, which Derrida calls their iter-
ability, means that they constantly escape from their moment of origin.
No amount of attention paid to reconstructing their illocutionary force,
pace Skinner, will allow us to recall their intentionality, for prior to grasp-
ing how speech acts perform, we must make sense of their constative or
locutionary meaning, which we cannot do without becoming entangled
in the web of rhetorical, that is tropological, devices affecting our reading
of them.[16]

These are, of course, by now very familiar arguments, whose complex
and in certain ways problematic implications cannot be explored now.
Let me suggest, however, several implications for intellectual history.
Whereas both the older textualist approach and the Skinnerian contex-
tualist response maintained a distinction, more or less permeable, between
text and context, differing only in their attributing explanatory pride of
place to one or the other, disintegral textualism calls into question the
boundary. In its two hermeneutic forms, it is essentially effaced in the

name of a culturalist metatextualism or a dialogic fusion of horizons, which claims everything is interpretable as signifiers of meaning. But in its deconstructionist form, fully in accord with Derrida's celebrated stress on the trace, the boundary is both erased *and* preserved. Or more precisely put, it is reinscribed within texts themselves, which become sites of internal contestation rather than integral wholes, *and* in contexts, which become contextures or intertexts rather than coherent englobing fields of meaning. In Derrida's words, a "text" is thus "no longer a finished corpus of writing, some content enclosed in a book or its margins, but a differential network, a fabric of traces referring endlessly to something other than itself, to other differentiated traces. Thus the text overruns all the limits assigned to it so far (not submerging or drowning them in an undifferentiated homogeneity, but rather making them more complex, dividing and multiplying strokes and lines)"[17]

What merits special emphasis in this passage is Derrida's insistence that texts refer endlessly to something other than themselves; they are a nontotalized system of traces that defy reduction to even the woven fabric that is sometimes assumed to be their metaphoric counterpart.[18] The implication is that a pure textualism is problematic when it fails to register the heterogeneity of a text to itself. Rather than privileging autotelic and autonomous texts in the manner of the New Criticism, deconstructionist textualism insists on the nonself-sufficiency of the texts it chooses to read. This lack can mean that other texts have to be taken into account, as is evident in the familiar insistence that a prior intertextuality can be discerned in any seemingly isolated text. But it can also mean that the "other" of textuality must be registered in our attempt to read or interpret texts. That is, rather than denying the importance of referentiality in the name of a pure interplay of diacritical sign systems, as deconstruction is sometimes alleged to be doing, it should be understood as stressing its inevitability. Even though the world to which texts refer cannot be approached directly—in this sense "there is nothing outside the text"—*that* they refer to something outside cannot be suppressed. However much we may resist reading texts in the merely documentary manner Dominick LaCapra has cautioned us against embracing,[19] we cannot avoid reacting to the traces of alterity that make texts—even the most seemingly immanent—more than merely linguistic worlds unto themselves.

Another way to express this insight is to highlight what has been called the allegorical as opposed to symbolic nature of textual signification. Restored to prominence by Walter Benjamin and Angus Fletcher, and made the basis of a theory of reading by Paul de Man, allegory has recently found its way into the methodological discussions of intellectual historians like Hans Kellner and James Clifford.[20] According to Kellner, all historical writing, wittingly or not, shares an inclination to say one thing and mean

another, which can properly be called allegorical because of the un-bridgeable distance between them. "The only semantic equivalent of a complex text," he writes, "is the text itself. What the allegorist does, and what the historian does as well, is to create a *counter*-discourse, which confronts the 'evidence' with the real meaning of the latter, a meaning that is different from or presumed to be hidden in the evidence. The counter-discourse is thus dependent upon *both* the evidence *and* the system of understanding that makes a counter-discourse necessary."[21]

Although as I have argued elsewhere,[22] the fiction of construing that counterdiscourse as a synoptic paraphrase of an original meaning pays valuable tribute to the goal of communicative rationality, an awareness of the obstacles to its achievement is useful as well. For it alerts us to the impossibility of finding plenitudinous meanings *within* the confines of a text, whether we interpret it in integral or disintegral terms. That is, the allegorical nature of cultural analysis means that we are always involved in a process of exposing traces of the nontextual even if we expand the notion of the text to include culture as a whole. Pure immanence is as utopian a model of how texts work as pure transcendence.

Clifford foregrounds one implication of this insight when he contends that "there is no way definitely, surgically, to separate the factual from the allegorical in cultural accounts. The data of ethnography [or, we might say, of intellectual history] make sense only within patterned arrange-ments and narratives, and these are conventional, political, and mean-ingful in a more than referential sense. Cultural facts are not true and cultural allegories false."[23] We must acknowledge therefore that our re-constructions are themselves figurally charged, rhetorically constructed texts, which are allegorically at a distance from the phenomena they purport to reconstruct.

This claim, whose implications have been widely discussed in the after-math of Hayden White's now classic *Metahistory*, often produces certain anxieties on the part of contextualists who fear it will produce nothing but poetic tricks played by the living on the dead. But two final consid-erations may suggest otherwise. First, it is not necessary to construe our textual reconstruction of the past only in terms of a literary narrative imposed on the raw data of "actual" events. Other allegorical relations can exist as well. For example, Jürgen Habermas has argued for a com-plicated relationship between rational reconstructions, based on socio-logical theories of evolutionary development, and historical narrative.[24] Although he doesn't draw on the theory of allegory, there is no reason not to equate what Kellner has called our inevitable counterdiscourse with such a rational reconstruction, which knows itself not to be a faithful reproduction of what "really happened."

More importantly—for this argument is not likely to satisfy contex-
tualists who worry about the imposition of the present on to the past—
allegory can be turned around to suggest that however much we may
seem to construct the past out of whole cloth, there is always something
that resists such an outcome. This something, I take it, is what Kellner
means when he says that counterdiscourses are "dependent upon *both*
the evidence *and* the system of understanding that makes a counter-
discourse necessary." It is also what I believe Derrida's concept of the
trace obliquely indicates. Indeed, we may perhaps go so far as to argue
that those paraphrasable cores of meaning that traditional intellectual
history so fervently sought might function as that "other" of a text, which
leaves traces behind that resist being absorbed entirely into their figural,
rhetorical, linguistic instantiation, their apparent web of immanent self-
referentiality. So too might what are conventionally seen as the author's
intention or the discursive field out of which the text emerges. Although
the old boundaries are not the same in the wake of this variant of dis-
integral textualism, they are not entirely wiped away either.

That is, despite the pantextualist reputation of deconstruction, it con-
tains the imperative not merely to turn contexts into texts, but also to see
in texts the shadows of contexts, understood in the broadest sense. And
it does so by making us sensitive to the impossibility of meaning fully
residing in either realm, thus forcing us to attend to the multiple tensions
between inside and outside, linguistic phenomenon and its expressive or
referential "other." Intellectual historians who follow a textualist ap-
proach in this sense need not, therefore, worry about being transformed
kicking and screaming into literary critics. If anything, it is the literary
critics these days who are in danger of becoming new historicists. Some
of the best seem already to be succumbing to the temptation.

13

Name-Dropping or Dropping
Names? Modes of Legitimation in
the Humanities

> For you apparently it makes a difference who the speaker
> is, and what country he comes from; you don't merely
> ask whether what he says is true or false.
>
> Socrates to Phaedras in *The Phaedras,* 275c

In a widely remarked letter written to Ernest Jones in 1920, Sigmund
Freud anxiously rebutted Havelock Ellis's claim that he was actually more
of an artist than a scientist. "This is all wrong," Freud contended, "I am
sure that in a few decades my name will be wiped away and our results
will last."[1] In so arguing, Freud was betraying his allegiance to an as-
sumption, widespread then as now, that artistic creation is inextricably
tied to the proper name of its creator, whereas scientific achievements are
the fruit of a collective, intersubjective process in which individual names
play only an anecdotal role.[2] Psychoanalysis, a term Freud coined in 1896,
would thus have to forget, one might even say repress, the name of its
founder and submit itself to the disinterested critical scrutiny guaranteed
by the institution of science. It would have to enter that history of science
which would be a part of what Auguste Comte had called the positivist
histoire sans noms.[3]

It takes little imagination to discern the irony in Freud's worried reply
to Ellis with its woefully misplaced confidence in the future anonymi-
zation, if we can call it that, of his theories. For despite his claims to
scientificity, claims that, to be sure, contemporary commentators like
Adolf Grünbaum continue to evaluate with utmost seriousness,[4] Freud's
ideas have remained intimately tied to his own name and its continuing
authority. Psychoanalysis is no less Freudianism today than it was when
Freud first sought to establish its scientific credentials. Its practical au-
thority as a therapeutic technique is grounded in large measure in a his-
torical chain of training analyses that can be traced back, through a kind
of apostolic succession, to the personal analytic interactions of Freud and
his first disciples. And the cogency of his theories seems defended as

167

much by a reading and rereading of his original texts as by an independent
process of experimental testing, however that might be construed in the
difficult case of the analytic cure. Thus even the most innovative Freudians
like Jacques Lacan have invited comparison with the Protestant Reformers
because of their insistence on returning to Freud's own writings, which
have been allegedly misinterpreted by intervening readers.

But contrary to Freud's own expectation that such an inability to forget
the teller and remember only the tale would mean the reduction of his
ideas to mere artistic intuitions, his influence has not suffered as a result.
Indeed, much of his still potent spell may well be due precisely to such
a "failure," at least in the humanistic disciplines that have found him so
congenial.

It would be intriguing to pursue the reasons for this historic outcome
solely with reference to Freud's theories and their reception,[5] but I want
instead to investigate their larger implications. For it is obvious that psy-
choanalysis is by no means alone in wrestling with the ambiguities of
personal versus anonymous authority. A parallel case that immediately
comes to mind is that of Marxism, which tenaciously retains the name
of its founder, even as it lays claim to objective scientificity. Marx's cel-
ebrated disclaimer, "Moi, je ne suis pas marxiste," may, among other
things, have indicated his desire not to reduce his ideas to a sectarian
doctrine based on the holy writ of a founding father. According to Max-
imilien Rubel, even after Marx's death, Engels remained deeply hostile
to the appellation Marxist, which had been coined as a term of opprobrium
by their anarchist opponents in the Second International.[6]

But, as in the case of psychoanalysis, a pattern of obsessively reading
and rereading the founder's original texts, whether literally or, as Al-
thusser would have it, symptomatically, has emerged in the history of
Marxism. And often it has served as an antidote to the uncertainties of
an experimental or practical verification that fails to verify anything very
convincingly.

Many other examples can be given of founding fathers or mothers of
theoretical discourses who retain their personal authority in spite of their
ostensible denigration of its power. Think, for example, of the aura sur-
rounding names like Friedrich Nietzsche, Martin Heidegger, Hannah Ar-
endt, Leo Strauss, and so on, all of whom figure widely in contemporary
humanist discourse as charismatic legitimaters. It might even be conjec-
tured that a clear mark of a thinker's power over posterity is the readiness
with which his or her name is given adjectival status as a convenient
label for a specific worldview. When this transformation fails to occur—
take the case of the much ballyhooed New York Intellectuals—it suggests
the weakness of their ultimate influence, although to be sure, the opposite
is no guarantee of long-term survival.

From the point of view of a scientific self-understanding, such as that espoused by Freud, this state of affairs can only be an embarrassment. For it calls into question the putative impartiality and neutrality of their verification or falsification procedures. Does it, however, create a similar dilemma for humanists who never claim a truly scientific status for their arguments? How compromised are they by the persistence of name-dropping as a mode of legitimation? To answer these questions, it is important to be clear that we are not talking about the citation of names by humanists for a variety of other purposes: as objects of inquiry, as convenient short-hand points of reference, or as honestly acknowledged sources of ideas or information. This chapter will itself provide plenty examples of such uses. What concerns us instead is the often unacknowledged function of what can be called charismatic names in legitimating arguments. Think, for example, of the innumerable essays littered with "As Benjamin said . . ." or "According to Lacan . . ." or "In the words of Althusser . . . , written by scholars who would be hard pressed to provide satisfactory justifications for their authority's controversial ideas.

These justifications need not, *pace* Freud and Marx, ape that of the natural sciences. They might, for example, be derived instead from phil-osophical models of transcendental truth, such as that implied in the words of Socrates from the *Phaedras* cited as the epigraph of this chapter. Far more likely, however, as a mode of legitimation in our era of anti-foundationalism is what sociologist Alvin Gouldner dubbed the "culture of critical discourse." For Gouldner, the "CCD," as he liked to call it,

> is an historically evolved set of rules, a grammar of discourse which (1) is concerned to *justify* its assertions, but (2) whose mode of justification does not proceed by invoking authorities, and (3) prefers to elicit *voluntary* consent solely on the basis of arguments adduced . . . the culture of critical speech forbids reliance upon the speaker's person, authority, or status in society to justify his claims.[7]

Although there are occasional exceptions such as Stanley Fish, most schol-ars, humanist or otherwise, would, I think it safe to say, accept this char-acterization of their enterprise.

And yet for all our efforts, we have not been fully successful in realizing it in practice. Whatever else it may signify, the widely trumpeted "death of the author," made famous by Foucault and Barthes,[8] has not meant the end of legitimation through charismatic names. Indeed, as the hyp-notic fascination exercised by master thinkers like Foucault and Barthes themselves makes clear, we find it very difficult to dissolve proper names into impersonal "author-functions" shorn of their affective power to sup-port the claims we derive from their work. For all our guilt at name-

dropping as a mode of legitimation, we still find it virtually impossible to drop names.

Why then the persistence of this curious practice? Why is psychoanalysis still unavoidably Freudianism and scientific socialism no less inevitably Marxism? Why do we so often fall back on the power of such resonant names as the implicit ground of our truth claims? Can we, in fact, ever free ourselves entirely from this practice and base our claims instead on the culture of critical discourse with its sole reliance on the better argument?

One commonplace answer to these questions would emphasize the traditional role of commenting on sacred texts in the religious traditions whose model is followed, consciously or not, in even the most secular of humanist discourses.[9] Canonized texts become part of the canon, it might be argued, because of a certain sacred aura clinging to or attributed to the signatures we assign to them. Insofar as sacred or pseudosacred texts are construed as the expression of a divine word or inspired prophecy, then the figures assumed to be behind them are granted an originary power, which surrounds their names with an aura of sanctity. Because the humanities so often focus on such canonical texts as objects of inquiry, a tendency often arises to transfer their authority to the tradition of commentaries that has accumulated around them. Thus a secondary critical canon emerges alongside that of its primary cultural counterpart. And so, we invest the master critics or theoreticians who precede us with some of the charisma associated with the sacred texts they study.

Arguments of this kind have, of course, often been adduced to attack psychoanalysis, Marxism, and other like traditions as displaced religions. They are not without their power, although as in the case of other secularization explanations, they tend to be somewhat reductive. Not only do they simplify the complicated modes of legitimation that have existed in the history of religion, not all of which are equally authoritarian, but they also assume too direct a transfer of substance from the sacred to the profane. As Hans Blumenberg has shown,[10] the relationship between the two is often far more complicated than the straightforward theory of secularization would suggest.

A perhaps more plausible alternative would draw on Freud's concept of transference, which Dominick LaCapra has recently foregrounded as a vital element in our intercourse with the past.[11] Insofar as we project our own emotional entanglements with figures in our personal past not merely on to those we study but also on to those whose commentaries we cite, we invest them with a power over us comparable to that of parent surrogates. According to LaCapra, this interaction often brings with it a measure of guilt, which produces a compensatory attempt to deny the affective dimension altogether in our scholarly practices. "Transference,"

he notes, "causes fear of possession by the past and loss of control over both it and oneself. It simultaneously brings the temptation to assert full control over the 'object' of study through ideologically suspect procedures that may be related to the phenomenon Freud discussed as 'narcissism'."[12] The temptation of narcissism, LaCapra warns, has its costs, for "it involves the impossible, imaginary effort to elaborate a fully unified perspective, and its self-regarding 'purity' entails the exorcistic scapegoating of the 'other' that is always to some extent within."[13]

In other words, for LaCapra, the very effort to ground our knowledge entirely in our own efforts to reach the truth smacks of a neurotic disorder. Ironically, in the light of this charge, Freud's own narcissism may well have been evident in his controversial attempt to minimize the importance of his own intellectual predecessors and present psychoanalysis as emerging from the epic journey of self-discovery described in *The Interpretation of Dreams*. His desire to legitimate psychoanalysis as a science was thus of a piece with his reluctance to acknowledge his intellectual debts which led to what has been damned as the "myth of the hero" in the historiography of Freud's thought.[14]

One might, however, wonder if the transference model, as useful as it surely is in illuminating the emotional dimension of our relations to past or even contemporary authorities, is fully sufficient to explain their abiding power over us. For Freud himself saw it as a transitional phenomenon, which could be worked through in the course of the analytic cure. Thus to allege, as LaCapra does, that all attempts to go beyond transference are neurotically narcissistic is to deny a priori the therapeutic possibility of working through transferential relationships. A similar process might at least be posited as a goal once we become aware of the emotional dimension in our appropriation of the ideas of our predecessors.

Why the goal may be extremely difficult to achieve, however, is suggested by the ruminations of Nietzsche on the interplay of debt and guilt (both translations of *Schuld*) in *The Genealogy of Morals*, which Samuel Weber has recently discussed in his study of *Institution and Interpretation*.[15] According to Nietzsche, every generation incurs a powerful debt to its forebears, which is turned into ever greater guilt as its unredeemability becomes more entrenched with the passage of time. What was once a redeemable debt through the exchange of equivalents becomes impossible to pay off as the distance between past and present increases. Magnifying their inadequacy to compensate for their guilt, later generations elevate heroes of earlier ones into Godlike figures, whose accomplishments they can only envy.

Along with this argument, Nietzsche provides a corollary account of the struggle of interpretations between past and present, which emphasizes, anticipating Harold Bloom, its agonistic dimension. Weber imagi-

natively combines the two arguments to conclude "that it is precisely the agonistic account of interpretation that necessarily transforms indebtedness into guilt, since the self-affirmation of any interpretation, as *criticism*—that is, as a discourse of *truth*—can only prevail and impose itself by denying its constitutive dependence on what it excludes, dethrones, and replaces."[16] In other words, guilt at challenging the authority of our predecessors may be converted through a kind of reaction formation into an excessive humility in the face of their putative power. Here the likelihood of working through a transferential relationship seems undermined by what Weber calls the "original sin" of all criticism, its guilty debt to the past.

One may, to be sure, wonder how universal this "original sin," like others that have been posited throughout history, actually is. Might it merely reflect a certain notion of intellectual property, which presupposes the private ownership of ideas and insights available for exchange? If instead a more cumulative notion of knowledge is posited, such as Habermas's idea of a species learning process, might it be possible to avoid this psychologistic interaction of debt and guilt and with it our dependence on name-dropping?

In his afterword to Samuel Weber's work, Wlad Godzich offers some observations that introduce an explanation on a somewhat different plane. Commenting on the deluded belief that current institutions need not acknowledge their debt because they think their own activity is the source of the meanings they dispense, he argues instead for a frank acknowledgment of universal heteronomy. This claim, he contends, is implicit in deconstruction, which "aims at nothing less than, in a first stage, the restoration of a universal indebtedness since this appears to be the only ground on which equality, as a social fact, can be thought of."[17] Rather than emphasizing the autonomous reliance on the force of the better argument in Gouldner's culture of critical discourse, "the epistemological ground favored by deconstruction permits the assertion of equality between all human beings by virtue of their dispossession from the domain of meaning. The insistence of aporia, undecidability, the fact of the dependence of our thought processes upon language and our tropological games, all convey the same sort of human powerlessness that obtained within religious thought, without any of the latter's transcendent dimension."[18]

How does this admission of universal heteronomy and dispossession from the domain of meaning help us understand the penchant for name-dropping as a mode of legitimation? Deconstruction, after all, has always been suspicious of granting any real substance to the persons behind names. Derrida, for example, insisted in *Of Grammatology* that "the names of authors or of doctrines have here no substantial value. They indicate

neither identities nor causes. It would be frivolous to think that 'Descartes,' 'Leibniz,' 'Rousseau,' 'Hegel,' etc. are names of authors, of the authors of movements or displacements that we thus designate. The indicative power that I attribute to them is first the name of a problem."[19]

What Godzich's formulation suggests, however, is that we should look to the typical deconstructionist emphasis on "the dependence of our thought processes upon language and our tropological games" for an answer. For here we will find certain tropes that provide what might be called a persistent effect of personification. In particular, we should look to the tropes of parabasis and prosopopeia, which Paul de Man and J. Hillis Miller have both considered extraordinarily important.

Parabasis, the intrusion of a narrative, authorial voice in the most apparently impersonal texts, means that we are never able to efface entirely the dual structure of writing, projecting an effect at once subjective and objective. Although most evident in such self-conscious works as Sterne's *Tristram Shandy*, parabasis, de Man liked to argue, could be found in even those works that sought to repress it completely. An example is the discussion of sense certainty in Hegel's *Phenomenology of Spirit*. According to de Man, written language

> appears in Hegel's text only in the most literal of ways: by means of the parabasis which suddenly confronts us with the actual piece of paper on which Hegel, at that very moment and in this very place, has been writing about the impossibility of ever saying the only thing one wants to say, namely the certainty of sense perception. . . . Unlike the here and now of speech, the here and now of the inscription is neither false nor misleading: because he wrote it down, the existence of a here and a now of Hegel's text is undeniable as well as totally blank. It reduces, for example, the entire text of the *Phenomenology* to the endlessly repeated stutter: *this* piece of paper, *this* piece of paper, and so on.[20]

What de Man seems to be saying is that we can never fully overcome the tropologically determined trace of the initial act of inscription by an authorial hand. As Stephen Melville has noted, de Man built his celebrated discussion of the ubiquity of irony in large measure on the parabastic moment he saw in language. "We can think of the radical ironization de Man describes," Melville writes, "as 'permanent parabasis' as if it were, in effect, the placing of every word of a given text in quotation marks, marking each word with an ironic 'I say'."[21] Thus the function of that frequent and often seemingly arbitrary tic of much deconstructionist writing, its putting certain words in quotation marks, is to signal an awareness of the parabastic presence of the author behind the text, *any* text. It is, to be sure, a tropic presence, not a literal one, but it is no less impossible to undo its effect. Arguments thus are always intertwined with names. If

the power of this trope is as great as de Man contended, then the con-
clusion is inevitable that it is very difficult indeed to avoid dropping
names, however we may try, in our interactions with the cultural legacy
of the past.

The force of another rhetorical trope, that of prosopopeia, the giving
of a face to an idea, makes it even harder. In his essay on "Autobiography
as De-facement," de Man notes that "the dominant figure of the epitaphic
or autobiographical discourse is . . . the prosopopeia, the fiction of the
voice-from-beyond-the-grave."[22] That is, the autobiographer relies on the
tropic constitution of a speaking face, which seems to come to life even
after his actual death. Elsewhere, in his critique of Michael Riffaterre's
use of the so-called hypogram, the sub- or infratext that allegedly un-
derlies texts, he extends its significance beyond autobiography narrowly
defined. How, he asks, do Riffaterre's readings "confront the trope which
threatens to dismember or to disfigure the lexicality and grammaticality
of the hypogram, namely prosopopeia which, as the trope of address, is
the very figure of the reader and of reading?"[23] In other words, the mo-
ment of apostrophe, the writers' explicit or implicit addressing his or her
audience, complicates the referential dimension of any text or even, *pace*
Riffaterre, its hypogramatic subtext. With references to a particular reading
of a Victor Hugo poem, de Man is thus able to conclude that

> the text therefore is not the mimesis of a signifier but of a specific figure,
> prosopopeia. And since mimesis is itself a figure, it is the figure of a
> figure (the prosopopeia of a prosopopeia) and not in any respect, neither
> in appearance nor in reality, a description. . . .[24]

Although every text cannot be seen as self-consciously autobiographical
or apostrophic, de Man sees prosopopeia, like parabasis, as having vir-
tually universal significance. For it "undoes the distinction between ref-
erence and signification on which all semiotic systems, including Riffa-
terre's, depend."[25] Thus in another piece dedicated to the lyric, he could
claim that "anthropomorphism seems to be the illusionary resuscitation
of the natural breath of language, frozen into stone by the semantic power
of the trope. It is a figural affirmation that claims to overcome the deadly
negative power invested in the figure."[26]

In a recent talk entitled "Face to Face: Prosopopeia in Plato's *Prota-
goras*," J. Hillis Miller has extended this argument to apply even to the
Platonic search for anonymous, transcendental truth, a search ostensibly
grounded in the rejection of personal authority we have seen expressed
in the citation from the *Phaedras* at the beginning of this paper. Miller
notes instead the subversive implications of the dialogic form in which
Plato's ideas are expressed, contending that "the whole of the *Protagoras*

is one extended multiple prosopopeia, not least in invoking the dead
Socrates himself, giving him a face and a voice once more."[27] Rather than
bemoaning this contradiction, he imaginatively claims instead that a col-
lective research program in the humanities might well proceed by a kind
of prosopopetic interchange in which positions lose their identification
with specific authors as the "faces" first attached to them are exchanged
for others.[28] Through a kind of unselving, ideas cross-fertilize chiasmically
and emerge more richly articulated for the experience. But they never
fully shed their linkage to some face, some linguistically generated au-
thorial voice, even if there is a kind of circulation of identifications. Per-
sons are fictions through which ideas become manifest, but, so Miller
implies, ideas can never escape their "face to face" personifications.
"Names" always intrude into arguments, however impersonal they may
seem. What therefore may seem a scandal to adherents of traditional
discursive notions of anonymity becomes for commentators like de Man
and Miller a necessary and perhaps even salutary feature of humanist
discourse, which cannot ever really drop names.

These are powerful observations, but there may be certain dangers as
well in too hasty an abandonment of the impersonal discursive model,
at least as a regulative ideal. De Man himself points to one of these in
his discussion of autobiography, where he talks of the "latent threat that
inhabits prosopopeia, namely that by making the dead speak, the sym-
metrical structure of the trope implies, by the same token, that the living
are struck dumb, frozen in their own death."[29] Riffaterre, in his contri-
bution to the memorial volume of essays to de Man, follows the logic of
this implication further, noting that "chiasmus, the symmetrical structure
of prosopopeia, entails that, by making the dead speak, the living are
struck dumb—they too become the monument."[30] In other words, as Sam-
uel Weber has also observed in his discussion of *The Genealogy of Morals*,
there is a life-denying implication that can be drawn from too slavish an
acknowledgment of our debts to voices from beyond the grave, real or
tropological. Put less melodramatically, when we rely too heavily on
legitimating our arguments by invoking the authority of powerful figures
from the past, we risk relinquishing our own ability to judge their validity
in the present and future. Godzich's defense of an equality of heteronomy
has rather chilling implications, if taken literally.

The weakness of too much name-dropping is, of course, shown in those
cases when something dramatic occurs to discredit the authority of the
enabling figure. Thus, many critics of movements such as psychoanalysis
and Marxism take great pains to expose the personal flaws in the char-
acters of their founding fathers. Jeffrey Masson's *The Assault on Truth* is
an obvious recent example in the case of Freud.[31] We are now witnessing
the same process in the aftermath of the scandal surrounding de Man's

early writings. From all indications, his personal charisma was a major source of what has been called de Man's "rhetoric of authority."[32] Having so willingly invoked his name to legitimate many of their arguments, deconstructionists are now in the awkward position of trying to disentangle the abiding force of his ideas from his now tainted personal authority.

It was, of course, precisely such a dilemma that Freud sought to head off by turning psychoanalysis into an anonymous science. In the humanities, such a quest, at least in the form of Gouldner's "culture of critical discourse," has often seemed worth pursuing, but it has been no less tempting to challenge. One obvious way to do so has been to point to the inevitable gap that exists between the scientific method as a norm of disinterested validity testing and the practice of science as an actual institution. Even in the natural sciences, the power of the name has remained somewhat in place. Thus, recent scandals concerning fraudulent medical papers signed by unwitting senior colleagues lending their prestige to the work of their subordinates demonstrates the residual importance of name-dropping in the verification procedures of natural science.[33] More substantial studies of scientific institutions, such as that of the Salk Institute by Bruno Latour and Steve Woolgar, cited by Samuel Weber, show even more clearly the discrepancy between the self-presentation of the scientific enterprise and its actual practice.[34] It is because of an awareness of this gap that commentators like Stanley Fish, in a spirited critique of the policy of blind submissions to journals, argue for the explicit abandonment of any pretense of disinterested neutrality in our judging work in the humanities.[35]

However tempting such a course may be, it has its own obvious drawbacks. For if we dismiss the ideal model of depersonalized, disinterested inquiry because we can easily point to deviations from it in practice, we risk collapsing all distinctions in an ultimately cynical and self-defeating manner. It is better instead to conceive of the scientific model as a counterfactual, regulative ideal, which operates as a procedural norm, a horizon of expectations, rather than a fully instantiated practice. In doing so, we avoid making the category mistake of reducing what we might call the transcendental force of validity claims to mere empirical power relations, a tendency latent in the Nietzschean or Foucaultian debunking of the will to truth as an epiphenomenon of the will to power. And we will maintain a useful tension between the tropological and nontropological impulses in language as well.

To mention validity claims reminds us once again that the humanities as well as the sciences, whether explicitly or not, make assertions that claim to be warranted. If this were not the case, the manifest embarrassment over the dogged persistence of name-dropping as a tacit mode of

legitimation would not be so deeply felt. We would simply behave like medieval theologians or Renaissance Humanists and unself-consciously cite our religious or classical authorities and try to recover their original intentions. That we resist such a course demonstrates the permeability of the boundary between the humanities today and the sciences. The value of this boundary transgression is evident if we remember what many scientists themselves mean by warranted assertability in our postpositivist, postempiricist era.[36] For rather than defending truth claims based on referential correspondences between an idea and an external object (either natural or cultural), they too fall back on discursively redeemable notions of truth by credentialed communities instead.

One recent champion of the applicability of this model outside the natural sciences is Jürgen Habermas. His notion of communicative rationality is grounded in a minimalizing of the irrational authority of names from the past and a rejection of that equality of heteronomy defended by deconstructionists like Godzich as the sole way to overcome illusions. Instead, he emphasizes as a telos of critical discourse the unconstrained, uncoerced consent of autonomous individuals in an institutionally symmetrical speech situation. Although a counterfactual, such a condition is entailed, he argues, in the very act of seeking discursive legitimation for our assertions.

As in the case of the natural scientific procedures mentioned previously, it is easy to debunk such a model by pointing to deviations from it in practice, the ways in which personal power and respect for auratic names introduce noise into the perfect speech situation. Yet, here too a useful distinction must be made between transcendental validity claims and mere description. For as Habermas has cogently demonstrated,[37] blatant performative contradictions result when those who try to persuade us of the impossibility of communicative rationality themselves resort to discursive argumentation to do so. Thus, although we may never achieve the perfect symmetrical speech situation in which the power of argument completely obliterates the force of legitimating names, the telos of striving for such an outcome cannot be brushed aside as utterly irrelevant to critical discourse in the humanities as well as the sciences.

The injunction to drop names as legitimating crutches is thus one worth trying to follow, if only as a regulative ideal that can never be fully realized. The religiously derived tradition of commenting on divinely inspired texts may be attenuated as we wean ourselves from the hermeneutics of recollected meaning. The working through of our transferential relations with the past may produce more than a narcissistic self-sufficiency, if we succeed in resolving some of our oedipal fixations. The guilt-ridden invocation of our ancestors, either to venerate them or agonistically challenge their power, may be kept under control, if we confront head-

on the sources of our seemingly unredeemable debts to them. And even the hold over us of such tropes as parabasis and prosopopeia may be shaken somewhat if we pursue what de Man himself called the ideology critique in the "linguistics of literariness."[38]

One final observation, however, may suggest how difficult it will be to overcome all of these obstacles and drop legitimating names entirely from our procedures of discursive validity testing. In *The Legitimacy of the Modern Age*, Hans Blumenberg observes that the subject of theory, the allegedly disinterested transindividual subject concerned exclusively with truth and liberated from blind obedience to the past, emerged in the early modern period only when it was uncoupled from what he calls "the subject of the successful life."[39] The former is understood as a species subject whose existence extends beyond the life spans of individuals. It is a collective immortal participant, driven by insatiable curiosity, in an ongoing and endless research project. The latter is the particular, finite, contingent subject, worried about his or her own personal salvation in heaven or happiness on earth.

The split between the two subjects occurred, Blumenberg claims, because of two prior conditions. "The first was that the concern for salvation was largely removed from the sphere over which man has disposition, the sphere of his free decision and just desserts. This alienation of the certainty of salvation from self-consciousness and self-realization was accomplished by a theology that traced justification and grace exclusively to the unfathomable divine decree of election, which is no longer bound to man's 'works'."[40] In other words, there was an elective affinity between the Protestant Ethic and the spirit of science as much as with that of capitalism, famously argued by Max Weber. Ironically, heteronomy in the case of salvation facilitated autonomy in the case of species subjective intellectual curiosity.

The second precondition was what Schiller, in a phrase later made famous by Weber, called "the disenchantment of the world." According to Blumenberg,

> The world as the creation could no longer be related to man as the expression of divine providence, nor could he understand it as the first and natural revelation. It was hermeneutically inaccessible, as though it had become speechless. Thus one's attitude towards the world was no longer preformed by the object.[41]

Along with this loss of the divinely inspired meaningfulness of the world went a new collectively human self-assertion, which abandoned a passive, contemplative, and respectful attitude toward the authority of the past.

But, as we have had ample opportunity to remark, this attitude has been retained, at least in part, in the dogged persistence of legitimation

through name-dropping in the humanities, which betokens the contin-
uation of heteronomous rather than fully autonomous habits of mind. For
all the triumph of self-assertion in Western modernity, there is still the
inclination to legitimate by dropping names. With Blumenberg's argument
to help us understand the stakes involved, might it be possible to con-
jecture that the lingering concern for personal salvation and happiness,
or at least the acquisition of some personal meaning, prevents us from
adopting without reservation the point of view of the universal, imper-
sonal species subject, the metasubject of theory? Might not our openness
to the voices and faces of the dead, which the tropes of parabasis and
prosopopeia introduce even in our most seemingly impersonal prose,
suggest a deeply rooted intuition that such meaning can only be gained
through coming to terms in one way or another with our cultural fore-
bears? Might our inability to drop names entirely and merely argue about
the warranted assertability of "our" ideas imply a sober recognition of
the limitations of ungrounded self-assertion and the insufficiency of the
characteristic modern gesture, best exemplified by Descartes, of sweeping
away the past and starting ex nihilo? Might, in other words, our embar-
rassing weakness for legitimating our ideas by acknowledging their prove-
nance with prior authors, even as we truculently proclaim the death of
the author, express the inevitably personal dimension of our stake in
humanist understanding, which prevents us from identifying totally with
the species subject of theory? In short, might not a major truth of psy-
choanalysis ironically be its inability to assume the scientific status its
founder so fervently yearned for and thus escape being the Freudianism
it has so irrevocably become?

Notes

Introduction

1. Walter Benjamin, "N [Re the Theory of Knowledge, Theory of Practice]," in *Benjamin: Philosophy, History, Aesthetics*, ed. Gary Smith (Chicago, 1989), p. 60.

2. See, for example, Dominick LaCapra, "Canons and Their Discontents," *Intellectual History Newsletter* 13 (1991), where he also invokes Benjamin as a critic of contextualist reconstruction. On the issue of dialogue in general, see Tullio Maranhão, ed., *The Interpretation of Dialogue* (Chicago, 1990).

3. For a bold attempt to do so, see the final sections of Susan Buck-Morss, *The Dialectics of Seeing: Walter Benjamin and the Arcades Project* (Cambridge, Mass., 1989).

4. Benjamin, pp. 63–64.

5. For an analysis, see the title essay in my *Fin-de-siècle Socialism and Other Essays* (New York, 1988).

6. For an analysis of this issue in his work, see my *Adorno* (Cambridge, Mass., 1984), pp. 14–15.

7. Richard J. Bernstein, *The New Constellation: The Ethical/Political Horizons of Modernity/Postmodernity* (Cambridge, 1991), p. 9.

8. Martin Jay, "Positive and Negative Totalities: Implicit Tensions in Critical Theory's Vision of Interdisciplinary Research," reprinted in *Permanent Exiles: Essays on the Intellectual Migration from Germany to America* (New York, 1985).

9. It is for this reason that I would distance myself a bit from the use to which some historians have put Pierre Bourdieu's suggestive ideas about intellectual fields. See my "Fieldwork and Theorizing in Intellectual History: A Reply to Fritz Ringer," *Theory and Society* 19, 3 (June, 1990), as well as Ringer's original article (which has reappeared as the introduction to *Fields of Knowledge: French Academic Culture in Comparative Perspective, 1890–1920* [Cambridge, 1992]), and his response in the same issue.

10. The proceedings of the conference, which took place at New York University, are published in Thomas Bender, ed., *The University and the City: From Medieval Origins to the Present* (Oxford, 1988). The conference was so stimulating that Jordi Llovet of the University of Barcelona arranged to have much of it simply repeated in Catalonia two years later! My essay also appeared in the proceedings of another conference

organized in Rotterdam in 1988, Ph. v. Engeldorp Gastellars, Sl. Magala and O. Preuss, eds., *Critical Theory Today: The Frankfurt School: How Relevant Is It Today?* (The Hague, 1990).

11. Axel Honneth et al., eds., *Zwischenbetrachtungen: Im Prozess der Aufklärung* (Frankfurt, 1989), in English as *Philosophical Interventions in the Unfinished Project of Enlightenment* (Cambridge, Mass., 1992).

12. It was published in volume I of the conference proceedings, *The Subject in Postmodernism*, ed. Aleš Erjavec (Ljubljana, 1989), and in somewhat abridged form in *The Cambridge Review* 110 (June, 1989), thanks to Ruth Morse and Stefan Collini.

13. Hans-Ulrich Wehler had asked me to reply to Ellen Kennedy's claim that Schmitt had an important role in the genesis of certain Frankfurt School theorists. My essay first appeared as "Les extrêmes ne se touchent pas. Eine Ewiderung auf Ellen Kennedy: Carl Schmitt und die Frankfurter Schule," *Geschichte und Gesellschaft* 13, 4 (1987), then as "Reconciling the Irreconcilable? A Rejoinder to Kennedy" in *Telos* 71 (Spring, 1987), along with her original essay and other replies by Alfons Söllner and Ulrich K. Preuss. Kennedy's rebuttal can be found in *Telos* 73 (Fall 1987).

14. It has since appeared as "The Disenchantment of the Eye: Surrealism and the Crisis of Ocularcentrism," *Visual Anthropology Review* VII, 1 (Spring, 1991).

15. The conference was organized at the New School for Social Research by Andrew Arato; a conference volume is forthcoming.

16. John Burnheim, ed., *Agnes Heller, Poznan Studies in the Philosophy of the Sciences and Humanities* (Amsterdam, forthcoming); Martin Jay, "The Political Existentialism of Hannah Arendt," first published in *Partisan Review* LXV, 3 (1978) under the title "Hannah Arendt: Opposing Views," and reprinted in *Permanent Exiles: Essays on the Intellectual Migration from Germany to America* (New York, 1985).

17. Hannah Arendt, *Lectures on Kant's Political Philosophy*, ed. Ronald Beiner (Chicago, 1982).

18. Once again, it turned out to be too elaborate for a column and was published instead in *Cultural Critique*, 21, (Spring, 1992).

19. Jay, "The Political Existentialism of Hannah Arendt," p. 252. This contention has recently been criticized by Maurizio Passerin d'Entrèves, *Modernity, Justice and Community* (Milan, 1990), p. 117. He acknowledges the expressive dimension of Arendt's early work, as opposed to the intersubjective, communicative dimension most apparent in her analysis of judgment, but claims that it has no linkage with the violence that often accompanies aestheticized politics. I would now want to argue that however one evaluates the aesthetic impulse in her early work, it becomes more attractive when it is presented in the terms of Kant's Third Critique in her later writings. Here I would contest the imputation of inevitable violence to aesthetics by critics of "the aesthetic ideology."

20. The conference was organized by Victor Brombert of the Christian Gauss Seminar at Princeton. I also gave the paper to a second meeting in Melbourne later that year on "Reason and Imagination in Modern Culture," sponsored by the Australian journal *Thesis Eleven*, which will publish the proceedings.

21. The conference was organized by Mark Kline Taylor of the Princeton Theological Seminary. The paper was also presented to the Interpretive Studies Colloquium at the University of California, Santa Barbara, later that year, and published in a collection edited by Paul Hernadi, first as an issue of *Poetics Today* IX, 2 (1988) and then as *The Rhetoric of Interpretation and the Interpretation of Rhetoric* (Durham, 1989). Shortly

thereafter it was given again to a conference on contemporary theory organized by Prafulla C. Kar at the American Studies Research Seminar in Hyderabad, India, and appeared in the *Journal of Contemporary Thought* (Baroda, India, 1991).

22. Hal Foster, *Vision and Visuality, Dia Art Foundation Discussions in Contemporary Culture*, vol. 2 (Seattle, 1988).

23. Its proceedings have been published as Scott Lash and Jonathan Friedman, eds., *Modernity and Identity* (London, 1992).

24. David Bennet, "Postmodernism and Vision: Ways of Seeing (at) the End of History," *Restant* XVIII, 3 (1990), p. 274.

25. The conference was at the European Institute for Literary and Cultural Studies of the University of Leuven, Belgium and organized by Peter Steiner and José Lambert. Also given at the American Sociological Association Meetings in 1989, the talk was published in Charles Lemert, ed., *Intellectuals and Politics: Social Theory in a Changing World* (Newbury Park, 1991).

26. Tony Green, review of Hal Foster, ed., *Vision and Visuality* and Steve Benson, *Blue Book*, in *M/E/A/N/I/N/G* 5 (May, 1989), p. 37.

27. It took place under the auspices of the Slovenian Society for Aesthetics in Ljubljana, and was organized by Aleš Erjavec. The proceedings have appeared in *Filozofski Vestnik* XII, 1 (1991).

28. It was published in Gisela Brude-Firnau and Karin J. MacHardy, eds., *Fact and Fiction: German History and Literature, 1848–1924* (Tübingen, 1990), and a special issue of *Strategies* on "Critical Histories," 4/5 (1991).

29. LaCapra, "Canons and Their Discontents," p. 9.

30. Derrida, "But Beyond (Open Letter to Anne McClintock and Rob Nixon)," *Critical Inquiry* 13 (Autumn, 1986), p. 168.

31. It was the inaugural conference at the Centre for the Study of Theory and Criticism at the University of Western Ontario in Canada. The proceedings were published as Martin Kreiswirth and Mark A. Cheetham, eds., *Theory Between the Disciplines: Authority/Vision/Politics* (Ann Arbor, Michigan, 1990).

32. See Michael Jennings, *Dialectical Images: Walter Benjamin's Theory of Literary Criticism* (Ithaca, 1987), p. 204.

33. For a useful critique of these tendencies, see Lutz Niethammer, "Afterthoughts on Posthistoire," *History and Memory* I, 1 (Spring, Summer, 1989).

1. Urban Flights: The Institute of Social Research between Frankfurt and New York

1. Theodor W. Adorno, *Negative Dialectics*, trans. E. B. Ashton (New York, 1973), p. 41.

2. Jürgen Habermas, *Autonomy and Solidarity: Interviews*, ed. Peter Dews (London, 1986), p. 49.

3. Martin, Jay, *Adorno* (Cambridge, Mass., 1984).

4. Habermas's departures from classical Critical Theory have sometimes seemed sufficiently extensive to justify excluding him from the Frankfurt School in favor of his own "Starnberg School." See, for example, Gerhard Brandt, "Ansichten kritischer Sozialforschung 1930-1980," *Leviathan*, Sonderheft 4 (1981), p. 25. For an overview

of the continuities that nonetheless exist, see David Held, *Introduction to Critical Theory: Horkheimer to Habermas* (Berkeley, 1980).

5. Benjamin's work on the modern metropolis included studies of Berlin, Paris, Marseilles, Moscow, and Naples. See, in particular, *Charles Baudelaire: A Lyric Poet in the Era of High Capitalism*, trans. Harry Zohn (London, 1973); *Reflections: Essays, Aphorisms, Autobiographical Writings*, ed. Peter Demetz, trans. Edmund Jephcott (New York, 1978); and *One-Way Street and Other Writings*, trans. Edmund Jephcott and Kingsley Shorter (London, 1979). For a discussion of his work on the city, see Henning Günther, *Walter Benjamin: Zwischen Marxismus und Theologie* (Olten, 1973), p. 165f.

6. Leo Lowenthal, *Literature and the Image of Man: Studies of the European Drama and Novel, 1600–1900* (Boston, 1957), p. 212f.

7. *Gemeindestudie des Instituts für sozialwissenschaftliche Forschung* (Darmstadt, 1952–54). The Institute consulted on this project. See the discussion of it in *Aspects of Sociology* by the Frankfurt Institute of Social Research, preface by Max Horkheimer and Theodor W. Adorno, trans. John Viertel (Boston, 1972), 156f.

8. *Aspects of Sociology*, p. 163.

9. Max Horkheimer, *Gesammelte Schriften, Band 8: Vorträge und Aufzeichnungen 1949–1973*, ed. Gunzenlin Schmid–Noerr (Frankfurt, 1985), pp. 361–453. See also the draft of his 1944/45 memorandum for an international academy to be set up after the war, which is included in volume 12 of the *Gesammelte Schriften: Nachgelassen Schriften*, ed. Gunzelin Schmid–Noerr (Frankfurt, 1985). It was also Horkheimer who urged Paul Kluke to write his massive history of the University of Frankfurt. See Kluke, *Die Stiftungsuniversität Frankfurt am Main 1914–1932* (Frankfurt, 1972), p. 7.

10. Max Horkheimer, *Dawn and Decline: Notes 1926–1931 and 1950–1969*, trans. Michael Shaw (New York, 1978), p. 75.

11. Perry Anderson, *Considerations on Western Marxism* (London, 1976), p. 32.

12. Fritz Ringer, *The Decline of the German Mandarins: The German Academic Community 1890–1933* (Cambridge, Mass., 1969).

13. For a history of Frankfurt in the early modern period, see Gerald Lyman Soliday, *A Community in Conflict: Frankfurt Society in the Seventeenth and Early Eighteenth Centuries* (Hanover, N.H., 1974). For an account of Frankfurt in the 1920s, see Madlen Lorei and Richard Kirn, *Frankfurt und die goldenen Zwanziger Jahre* (Frankfurt, 1966).

14. The classic study of Frankfurt Jewry is Isidor Kracauer, *Geschichte der Juden in Frankfurt*, 2 vols. (Frankfurt, 1927). He was Siegfried Kracauer's uncle.

15. The assimilation of Frankfurt Jews is shown by the comparatively low attendance figures for High Holy Day services in the 1920s: Breslau, 58 percent, Berlin, 49 percent, and Frankfurt, 41 percent, cited in Donald L. Niewyk, *The Jews in Weimar Germany* (Baton Rouge, 1980), p. 102. For a discussion of the creative response of Frankfurt Jews to modernization, see Jakob J. Petuchowski, "Frankfurt Jewry—A Model of Transition to Modernity," *Leo Baeck Yearbook XXIX* (London, 1984), pp. 405–417.

16. It was one of three new universities founded in this era, along with Hamburg and Cologne. In 1932, it was officially named the Johan-Wolfgang-Goethe Universität, in honor of Frankfurt's most illustrious citizen. For a full account, see Kluke.

17. Kluke, p. 53.

18. For a history of the decline of the German university from its Humboldtian origins, see Charles E. McClelland, *State, Society and University in Germany 1700–1914* (Cam-

bridge, 1980); for a study of the growing nationalism of students, see Konrad Jarausch, *Students, Society, and Politics in Imperial Germany* (Princeton, 1982).

19. Wolfgang Schivelbusch, *Intellektuellendämmerung: Zur Lage der Frankfurter Intelligenz in den zwanziger Jahren* (Frankfurt, 1982), p. 18.

20. Ulrike Migdal, *Die Frühgeschichte des Frankfurter Instituts für Sozialforschung* (Frankfurt, 1981).

21. McClelland, p. 280f.

21. For a discussion of the Institute's holistic inclinations, see Martin Jay, *Marxism and Totality: The Adventures of a Concept from Lukács to Habermas* (Berkeley, 1984); for a different account of Horkheimer's initial attitude toward totality, see Michiel Korthals, "Die kritische Gesellschaftstheorie des frühen Horkheimer: Misverständnisse über das Verhältnis von Horkheimer, Lukács und dem Positivismus," *Zeitschrift für Soziologie* XIV, 4 (August, 1985).

23. McClelland, chapter 8.

24. Brecht's scornful discussion of the relationship appeared in his account of "Tui-intellectuals" in his *Arbeitsjournal*, vol. I, ed. Werner Hecht (Frankfurt, 1973).

25. Lewis S. Feuer, "The Frankfurt Marxists and the Columbia Liberals," *Survey* XXV, 3 (Summer, 1980), p. 167. Richard Sorge was later unmasked as a Soviet spy, but there is no evidence he recruited anyone else during his brief Institute stay.

26. Among the acknowledged Communists were Karl August Wittfogel, Julien Gumperz, and Richard Sorge. There has also been some speculation about the possible allegiance of others in the early 1920s. See Migdal, p. 102.

27. One important precedent was the so-called "Austro-Marxist School," which has been compared to the Frankfurt School in the introduction to *Austro-Marxism*, ed. Tom Bottomore and Patrick Goode (Oxford, 1978), p. 2. The link between the two was Carl Grünberg, who was known as the father of Austro-Marxism before he became the Institute's director. Another possible model was the "Kathedersozialisten" (socialists of the chair) around the Verein für Sozialpolitik during the Wilhelmian era, although they were very distant from Marxism per se.

28. Migdal claims that the Institute during its Grünberg phase was more open, pluralistic, and undogmatic than later. She chides my account in *The Dialectical Imagination: The Frankfurt School and the Institute of Social Research, 1923–1950* (Boston, 1973), for failing to appreciate the virtues of Grünberg's lack of firm direction. She refers to a letter by Oscar Swede to Max Eastman (which she inadvertently attributes to "Oscar Eastman"), which I cite to make the case that Grünberg's leadership was dogmatic, but she doesn't really refute it. For a critique of her tendentious comparison between the two eras, see the review of her book by Hauke Brunkhorst in the *Soziologische Revue* 3 (1982), p. 81.

29. Helmut Dubiel, *Theory and Politics: Studies in the Development of Critical Theory*, trans. Benjamin Gregg (Cambridge, Mass., 1985).

30. Max Horkheimer, "Traditional and Critical Theory," *Critical Theory: Selected Essays*, trans. Matthew J. O'Connell et al. (New York, 1972).

31. On prewar Munich, see Peter Jelavich, *Munich and Theatrical Modernism: Politics, Play-writing, and Performance, 1890–1914* (Cambridge, Mass., 1985). Berlin's preeminence during the Weimar Republic is discussed in such works as Peter Gay, *Weimar Culture: The Outsider as Insider* (New York, 1968); John Willett, *Art and Politics in the Weimar*

Period: The New Sobriety 1917–1933 (New York, 1978) and Henry Pachter, *Weimar Etudes* (New York, 1982).

32. Willett, p. 124. For more on Frankfurt's role in modern architecture, see Kenneth Frampton, *Modern Architecture: A Critical History* (London, 1985), p. 136f.

33. For an account of Radio Frankfurt, see Schivelbusch, chapter 4.

34. *Ibid.*, p. 68.

35. For an account of the decision to grant the prize, see Schivelbusch, chapter 5.

36. Ernst Erich Noth, *Errinerungen eines Deutschen* (Hamburg, 1971), p. 194.

37. For discussions of the Lehrhaus, see Schivelbusch, chapter 2, Nahum N. Glatzer, "The Frankfort (sic) Lehrhaus," *Leo Baeck Yearbook* I (1956) and Erich Ahrens, "Reminiscences of the Men of the Frankfurt Lehrhaus," *Leo Baeck Yearbook* XIX (1974).

38. Leo Lowenthal, *Mitmachen wollte ich nie: Ein autobiographisches Gespräch mit Helmut Dubiel* (Frankfurt, 1980), p. 61.

39. Max Horkheimer, *Dawn and Decline*, p. 96f.

40. Benjamin's failure to earn his *Habilitation* in 1925 ended his hopes for an academic career. Kracauer, thwarted by a speech defect, never pursued a teaching career, moving instead from architecture to journalism.

41. For a comparison of Simmel with Kracauer and Benjamin, see David Frisby, *Fragments of Modernity: Theories of Modernity in the Work of Simmel, Kracauer and Benjamin* (Cambridge, Mass., 1986).

42. Siegfried Kracauer, "Uber den Schriftsteller," *Die Neue Rundschau* 42 (June, 1931), pp. 860–862; Walter Benjamin, "The Author as Producer," in *Reflections*. The proletarianization of intellectual life had been a preoccupation of German thinkers well before this period. See the discussion of it among the Naturalists of the 1890s in Peter Jelavich, "Popular Dimensions of Modernist Elite Culture: The Case of Theater in Fin-de-Siècle Munich," in *Modern European Intellectual History: Reappraisals and New Perspectives*, ed. Dominick LaCapra and Steven L. Kaplan (Ithaca, 1982), p. 230.

43. Schivelbusch, chapters 3 and 4.

44. See note 25. The debate continued in *Survey* XXVI, 2 (Spring, 1982) with Martin Jay, "Misrepresentations of the Frankfurt School," G. L. Ulmen, "Heresy? Yes! Conspiracy? No!" and Lewis S. Feuer, "The Social Role of the Frankfurt Marxists."

45. During the seven years the *Zeitschrift für Sozialforschung* was published while the Institute was in New York, only eight major articles were contributed by Americans, and three of those were in the 1941 volume. As for the audience at the Institute's Extension Course lectures, a letter of Karl Korsch, written on November 20, 1938, may be indicative of its limits. Horkheimer's "circle of hearers," he wrote, "was for the most part the people in the Institute and their wives, and a few confused students. . . . See Douglas Kellner, ed., *Karl Korsch: Revolutionary Theory* (Austin, 1977), p. 284.

46. The connections between Finley, Gouldner, and Mills and the Institute have been widely remarked in the literature on them and in their own writings. Bell's has been ignored. His essay, "The Grass Roots of American Jew Hatred," *Jewish Frontier* XI (June, 1944), pp. 15–20, clearly displays the influence of the Institute's work on anti-Semitism. Although Bell has become very critical of the Frankfurt School, he circulated this piece forty years later among his friends to warn against the neoconservative weakness for populist bedfellows.

47. See, for example, the account of an unsuccessful meeting with the editors of *The Marxist Quarterly* during the late 1930s by Sidney Hook, "The Institute for Social Research—

Addendum," *Survey* XXV, 3 (1980), pp. 177–78. Korsch's letter, cited in note 45, also testifies to the Institute's aloofness from political movements of any kind.

48. Theodor W. Adorno, *Minima Moralia: Reflections from Damaged Life*, trans. E. F. N. Jephcott (London, 1974). For an account of the general problems of life in southern California for refugees, see Anthony Heilbut, *Exiled in Paradise: German Refugee Artists and Intellectuals in America From the 1930's to the Present* (New York, 1983).

49. For an account of the Institute contribution to the war effort, see Alfons Söllner, ed., *Zur Archäologie der Demokratie in Deutschland*, 2 vols. (Frankfurt, 1986). Marcuse's role is discussed in Barry Katz, *Herbert Marcuse and the Art of Liberation* (London, 1982), p. 109f.

50. See, for example, Mark Krupnick, *Lionel Trilling and the Fate of Cultural Criticism* (Evanston, 1986), in which potential comparisons with Adorno are mentioned several times (e.g., p. 110). See also James Gilbert, *Writers and Partisans: A History of Literary Radicals in America* (New York, 1968); William Barrett, *The Truants: Adventures Among the Intellectuals* (Garden City, N.Y., 1982); Irving Howe, *A Margin of Hope: An Intellectual Autobiography* (San Diego, 1982). Only the last of these mentions a Frankfurt School figure, Marcuse, and then with contempt (p. 309).

51. Dwight MacDonald, "A Theory of Popular Culture," *Politics* 1 (February, 1944).

52. On the reception of the Frankfurt School, see Martin Jay, "The Frankfurt School in Exile" and "Adorno and America," in *Permanent Exiles: Essays on the Intellectual Migration from Germany to America* (New York, 1985).

53. Schivelbusch, chapter 6.

54. Horkheimer's lectures, interviews, and articles of these years are available in the seventh and eighth volumes of his *Gesammelte Schriften*.

55. Susan Handelman, *The Slayers of Moses: The Emergence of Rabbinic Interpretation in Modern Literary Theory* (Albany, 1982).

56. Heinrich Levy, *Die Hegel-Renaissance in der Deutschen Philosophie* (Charlottenberg, 1927).

57. In *Mitmachen wollte ich nie* (p. 156), Lowenthal has recently acknowledged the importance of his experience at the Lehrhaus for the development of Critical Theory.

58. For a good account of the Frankfurt School position on aesthetic modernism, see Eugene Lunn, *Marxism and Modernism: An Historical Study of Lukács, Brecht, Benjamin and Adorno* (Berkeley, 1982).

59. Carl E. Schorske, "The Idea of the City in European Thought: Voltaire to Spengler," in Oscar Handlin and John Burchard, eds., *The Historian and the City* (Cambridge, Mass., 1963), p. 60.

60. George Steiner, "The City Under Attack," *Salmagundi* 24 (Fall, 1973).

61. The most important expression of this hope appeared in Friedrich Engels, "The Housing Question," in Karl Marx and Friedrich Engels, *Selected Works*, 2 vols. (Moscow, 1958), vol. I, pp. 546–635. See also Raymond Williams, *The Country and the City* (New York, 1973).

62. Thomas Bender, "The Cultures of Intellectual Life: The City and the Professions," in John Higham and Paul K. Conkin, eds., *New Directions in American Intellectual History* (Baltimore, 1979), p. 63.

63. Martin Jay, *Marxism and Totality: The Adventures of a Concept from Lukács to Habermas* (Berkeley, 1984).

64. Jürgen Habermas, "Modern and Postmodern Architecture," in John Forester, ed., *Critical Theory and Public Life* (Cambridge, Mass., 1985), pp. 326–327.

65. Dominick LaCapra, *Rethinking Intellectual History: Texts, Contexts, Language* (Ithaca, 1983), chapter 3.

2. The Debate over Performative Contradiction: Habermas versus the Poststructuralists

1. Most notably, John B. Thompson and David Held, eds., *Habermas: Critical Debates* (Cambridge, Mass., 1982), and Richard J. Bernstein, ed., *Habermas and Modernity* (Cambridge, Mass., 1985).

2. Cited in Michael St. John Packe, *The Life of John Stuart Mill* (New York, 1970), p. 455.

3. A salient exception to this rule is the Italian Marxist Lucio Colletti. See, for example, his "Contraddizione dialettica e non-contraddizione," in *Tramonto dell'ideologia* (Rome, 1980).

4. Herbert Marcuse, *One-Dimensional Man: Studies in the Ideology of Advanced Industrial Society* (Boston, 1964), p. 142.

5. Theodor W. Adorno, "Introduction," *The Positivist Dispute in German Sociology*, trans. Glyn Adey and David Frisby (London, 1976), p. 26.

6. Karl Popper, "What Is Dialectic?" *Conjectures and Refutations* (London, 1962).

7. Adorno, "Introduction," p. 66.

8. Theodor W. Adorno, *Negative Dialectics*, trans. E. B. Ashton (New York, 1973), pp. 142–143. Translation emended.

9. Ibid., p. 153.

10. For a critical analysis of his argument, see Michael Rosen, *Hegel's Dialectic and Its Criticism*, (Cambridge, 1982), p. 160f.

11. Jürgen Habermas, *The Philosophical Discourse of Modernity: Twelve Lectures*, trans. Frederick Lawrence (Cambridge, Mass., 1987), p. 119.

12. Jürgen Habermas, "A Philosophico-political Profile," in *Habermas: Autonomy and Solidarity*, ed. Peter Dews (London, 1986), p. 155.

13. Jürgen Habermas, *Legitimation Crisis*, trans. Thomas McCarthy (Boston, 1973), pp. 26–27.

14. Ibid., p. 27.

15. Habermas, *The Philosophical Discourse of Modernity*, p. 188.

16. Karl-Otto Apel, "The Problem of Philosophical Foundations in Light of a Transcendental Pragmatics of Language," in *After Philosophy: End or Transformation?*, ed. Kenneth Baynes, James Bohman, and Thomas McCarthy (Cambridge, Mass., 1987), p. 281. This argument attempts to avoid the decisionist underpinnings of Apel's earlier position criticized by Thomas McCarthy in *The Critical Theory of Jürgen Habermas* (Cambridge, Mass., 1978), p. 321.

17. Ibid., p. 185.

18. We might have also pursued a similar critique in the hermeneutic tradition. See, for example, Hans-Georg Gadamer, *Truth and Method* (New York, 1986), p. 308, where he concludes that "however clearly one demonstrates the inner contradictions of all relativist views, it is as Heidegger has said: all these victorious arguments have some-

thing about them that suggests they are attempting to bowl one over. However cogent they may seem, they finally still miss the main point. In making use of them one is proved right, and yet they do not express any superior insight of any value." I am indebted to Joel Whitebook for drawing my attention to this passage.

19. Michel Foucault, *Maurice Blanchot: The Thought from Outside*, trans. Brian Massumi; Maurice Blanchot, *Michel Foucault as I Imagine Him*, trans. Jeffrey Mehlman (New York, 1987).

20. Ibid., pp. 9–10. Foucault is perhaps drawing here on Bertrand Russell's theory of types, as Thomas McCarthy has suggested to me, or possibly on the distinction he would later make in *The Archaeology of Knowledge* between *énoncé* and *énonciation* (usually translated as "statement" and "enunciation"). In any event, Foucault's acceptance of this answer to the liar's paradox is not shared by all poststructuralist thinkers. See, for example, Jean-François Lyotard, *Rudiments paiens* (Paris, 1977), pp. 229–230. He claims the paradox is not refutable. In fact, in his later work, *The Postmodern Condition: A Report on Knowledge*, trans. Geoff Bennington and Brian Massumi, foreword by Fredric Jameson (Minneapolis, 1984), Lyotard defines postmodern science by its willing embrace of paradox and its disdain for consensus. Thus, although he uses speech act theory to introduce the notion of "performativity," he never takes the issue of performative contradiction seriously.

21. Ibid., p. 10.

22. Ibid., p. 11.

23. Foucault does, to be sure, have a discussion of contradictions in discursive formations in *The Archaeology of Knowledge*, trans. A. M. Sheridan Smith (New York, 1972), p. 149f. He concludes that archaeological analysis "erects the primacy of a contradiction that has its model in the simultaneous affirmation and negation of a single proposition" (p. 155).

24. Rodolphe Gasché, *The Tain of the Mirror: Derrida and the Philosophy of Reflection* (Cambridge, Mass., 1986), p. 135.

25. Ibid., p. 142.

26. Ibid., p. 76.

27. Gasché, to be sure, acknowledges that Habermas, along with Herbert Schnädelbach, has provided the best defense of a reflection philosophy by jettisoning vain attempts to distinguish metacommunicative from communicative versions of the argument. But he clearly thinks that the deconstructionist rejection of all versions of it is superior. See his discussion on p. 78.

28. Paul de Man, *Allegories of Reading: Figural Language in Rousseau, Nietzsche, Rilke, and Proust* (New Haven, 1979).

29. Ibid., p. 86.

30. Cited from *The Birth of Tragedy* in Ibid., p. 86.

31. Ibid., p. 94.

32. Ibid., p. 98.

33. Nietzsche cited in Ibid., p. 119.

34. Nietzsche cited in Ibid., p. 121.

35. Ibid., p. 124.

36. Ibid., pp. 124–125.

37. Ibid., p. 125.
38. Ibid., p. 130.
39. Ibid., p. 131.
40. Jürgen Habermas, *Communication and the Evolution of Society*, p. 6.
41. Habermas, *The Philosophical Discourse of Modernity*, p. 198.
42. That Habermas tacitly holds on to the existence of a sovereign subject, despite his critique of consciousness philosophy, might be discerned from his own rhetorical style, which certainly projects a powerful authorial presence behind it.
43. For a recent attempt to draw such a distinction, see Paul Smith, *Discerning the Subject* (Minneapolis, 1987).
44. Habermas, *Legitimation Crisis*, p. 28.

3. The Morals of Genealogy: Or Is There a Poststructuralist Ethics?

1. See, for example, Gillian Rose, *Dialectic of Nihilism: Poststructuralism and Law* (London, 1984).
2. Alasdair MacIntyre, *After Virtue: A Study in Moral Theory* (Notre Dame, Ind., 1981); Bernard Williams, *Ethics and the Limits of Philosophy* (London, 1985). MacIntyre, to be sure, does consider Nietzsche, whom he sees as *the* moral philosopher of our day, but he does so only to contrast him invidiously with Aristotle.
3. Michel Foucault, *The Use of Pleasure*, trans. Robert Hurley (New York, 1985); *The Care of the Self*, trans. Robert Hurley (New York, 1986). See also, the interviews collected in *Michel Foucault: Politics, Philosophy, Culture*, ed. Lawrence D. Kritzman (New York, 1988).
4. Jean-François Lyotard and Jean-Loup Thébaud, *Just Gaming*, trans. Wlad Godzich, Afterword by Samuel Weber (Minneapolis, 1985). The original title, *Au Juste*, is less successful at capturing the Wittgensteinian notion of language games underlying Lyotard's discussion of prescriptive versus descriptive gaming.
5. Jacques Lacan, *L'Éthique de la psychanalyse* (Paris, 1986). See also *Encore* (Paris, Seuil, 1975).
6. Luce Irigaray, *Éthique de la différence sexuelle* (Paris, 1984).
7. Jacques Derrida, *Writing and Difference*, trans. Alan Bass (Chicago, 1978).
8. J. Hillis Miller, *The Ethics of Reading* (New York, 1987).
9. Maurice Blanchot, *The Unavowable Community*, trans. Pierre Joris (Barrytown, N.Y., 1988), p. 18.
10. Michel de Certeau, "Lacan: An Ethics of Speech," in *Heterologies: Discourse on the Other*, trans. Brian Massumi, foreword by Wlad Godzich (Minneapolis, 1986); John Rajchman, *Michel Foucault: The Freedom of Philosophy* (New York, 1985); "Ethics After Foucault," *Socialtext* (Winter, 1985); "Lacan and the Ethics of Modernity," *Representations* 15 (Summer, 1986); James Bernauer, "Michel Foucault's Ecstatic Thinking," *Philosophy and Social Criticism* 12, 2–3 (1987); Arnold I. Davidson, "Archaeology, Genealogy, Ethics," in David Couzens Hoy, ed., *Foucault: A Critical Reader* (New York, 1986); Christopher Norris, *Derrida* (Cambridge, Mass., 1987), chapter 8; Richard Shusterman, "Postmodernist Aestheticism: A New Moral Philosophy?" *Theory, Culture and Society* V, 2–3 (June, 1988); Tobin Siebers, *The Ethics of Criticism* (Ithaca, 1988).

11. Foucault, "On the Genealogy of Ethics: An Overview of Work in Progress," in Paul Rabinow, ed., *The Foucault Reader* (New York, 1984), p. 343.

12. Foucault, "The Ethic of Care for the Self as a Practice of Freedom," interview with Raul Fornet-Betancourt, Helmut Becker, and Alfredo Gomez-Müller (January 20, 1984) in *Philosophy and Social Criticism* 12, 2–3 (Summer, 1987), p. 115.

13. Foucault, "Power, Moral Values, and the Intellectual," interview with Michael Bess (November 3, 1980) in *History of the Present Newsletter* 4 (Spring, 1988), p. 1.

14. Rajchman, *Michel Foucault and the Freedom of Philosophy*, p. 37.

15. Lyotard, *Just Gaming*, p. 14.

16. Lacan, *The Four Fundamental Concepts of Psycho-analysis*, ed. Jacques-Alain Miller, trans. Alan Sheridan (New York, 1978), p. 33. It would be interesting to compare this contention with the well-known argument of Philip Rieff in *Freud: The Mind of a Moralist* (Garden City, N.Y., 1961) that Freud's "ethics of honesty" values conscious deliberation about the impulses of the unconscious. Rieff, however, acknowledges that psychoanalysis provides no new public morality to replace the discredited moral command systems of the past and worries as a result about its possibly nihilistic implications (p. 352).

17. de Certeau, "Lacan: An Ethics of Speech," p. 61.

18. Siebers, *The Ethics of Criticism*, p. 179.

19. Jacques Lacan, *Télévision* (Paris, 1974), p. 65.

20. As Anthony Wilden has remarked, this similarity may well derive from a common source in the famous lectures of Alexandre Kojève on Hegel's *Phenomenology* at the École des Hautes Études in the 1930s. See his commentary in Jacques Lacan, *The Language of the Self: The Function of Language in Psychoanalysis* (New York, 1968), p. 192f.

21. For a discussion of these differences, see Christopher Norris, *The Deconstructive Turn: Essays in the Rhetoric of Philosophy* (New York, 1984), chapter 4.

22. For Lyotard's thoughts on the motif of obedience in Levinas, see his "Levinas' Logic," in Richard A. Cohen, ed., *Face to Face with Levinas* (Albany, N.Y., 1986), p. 147f.

23. Lyotard, *Just Gaming*, p. 37.

24. Ibid., p. 72.

25. Miller, *The Ethics of Reading*, p. 3.

26. Ibid., p. 59.

27. Ibid., p. 58. Only a literary critic could conceive of all human activity as a variation of reading!

28. Ibid., p. 8.

29. Ibid., p. 76.

30. Ibid., p. 98.

31. Siebers, *The Ethics of Criticism*, p. 39.

32. MacIntyre, *After Virtue*, p. 22.

33. Although Foucault was careful to claim that he was not simply endorsing Greek ethics as a norm for our age, there were aspects of it he clearly found attractive.

34. For a good account of this dimension of Nietzsche's work, see Alexander Nehamas, *Nietzsche: Life as Literature* (Cambridge, Mass., 1985). For a more critical account of

Nietzschean morality, see John Andrew Bernstein, *Nietzsche's Moral Philosophy* (Rutherford, N.J., 1987).

35. Foucault, "On the Genealogy of Ethics," p. 351.

36. Not surprisingly, Foucault's stress on ethics as the care of the self has aroused the opposition of those who worry about intersubjective relations. See, for example, Stephen K. White, *The Recent Work of Jürgen Habermas: Reason, Justice and Modernity* (Cambridge, 1988), p. 150f.

37. Rajchman, "Lacan and the Ethics of Modernity," p. 55.

38. See David Carroll, *Paraesthetics: Foucault, Lyotard, Derrida* (New York, 1987).

39. I have attempted a short answer in a review essay on Jürgen Habermas's *The Philosophical Discourse of Modernity*, in *History and Theory* XXVIII, 1 (1988), pp. 94–111.

40. See note 9.

41. Jean-Luc Nancy, *La Communauté désoeuvrée* (Paris, 1986). The word *désoeuvrément*, which Blanchot coined, carries connotations of uneventfulness, inertia, and idleness as well, according to one of his translators, Ann Smock.

42. For an indictment of the violence of the constructed character and a defense of unleashing its counterviolence, see Leo Bersani, *A Future for Astynax: Character and Desire in Literature* (Boston, 1976). Bersani has applied much of the same reasoning in a recent exploration of a theme with more than literary significance. See his discussion of the AIDS crisis in "Is the Rectum a Grave?" *October* 43 (Winter, 1988).

 For a very different discussion of the implications of violence for ethics, see Paul Ricoeur, "The Teleological and Deontological Structures of Action: Aristotle and/or Kant," in A. Phillips Griffiths, ed., *Contemporary French Philosophy* (Cambridge, 1987). Ricoeur contends that an Aristotelian teleological pluralism, allowing a qualitatively defined variety of virtues leading to the "good life," needs to be supplemented by a Kantian deontology of obligation because of violence. "Morality," he insists, "has to be prescriptive and not merely evaluative, because our moral judgment about violence implies more than saying that it is not desirable, less preferable, less advisable; because violence is evil, and evil is what *is* and what *ought not* to be. Furthermore, because there is violence, the *other* is projected to the forefront of the ethical consideration either as victim, as executioner, as witness, or as judge" (p. 106). There is much in this argument that would be shared by poststructuralist thinkers like Bersani, but the difference is in their conception of the "other" involved; whereas for Ricoeur it is a moral agent, a narratively defined self, for them, it is a more fluid reality that is violently victimized by the creation of that every self.

43. See his chapter 5, "Why the Enlightenment Project of Justifying Morality Had to Fail."

44. Williams, *Ethics and the Limits of Philosophy*, p. 169.

45. Ibid., p. 117.

46. Perhaps his fullest account is in *Moralbewusstsein und kommunikative Handeln* (Frankfurt, 1983). There is a helpful summary of his argument in White, *The Recent Work of Jürgen Habermas*.

47. See, for example, Alessandro Ferrara, "A Critique of Habermas' *Diskursethik*," *Telos* 64 (Summer, 1985), pp. 45–74; Seyla Benhabib, "The Utopian Dimension in Communicative Ethics," *New German Critique* 35 (Spring/Summer, 1985), pp. 83–96; and Niels Thomassen, "Habermas' Discourse Ethics," *Danish Yearbook of Philosophy* 24 (1987), pp. 77–96.

48. Interestingly, the type of discourse that may be most helpful is not as far from aesthetics as might seem the case at first glance. Insofar as aesthetic judgment eschews a priori general principles, but tries to get beyond individual preference, it suggests a model for ethical discourse. For a brief consideration of its implications, see Shusterman, "Postmodernist Aestheticism," pp. 353–4.

49. For a penetrating meditation on the ethical implications of asceticism, which contains a subtle analysis of Foucault's relationship to it, see Geoffrey Galt Harpham, *The Ascetic Imperative in Culture and Criticism* (Chicago, 1987).

4. The Reassertion of Sovereignty in a Time of Crisis: Carl Schmitt and Georges Bataille

1. Georges Bataille, "Nietzsche and the Fascists," *Visions of Excess: Selected Political Writings, 1927–1939*, ed. Allan Stoekl, trans. Allan Stoekl with Carl R. Lovitt and Donald M. Leslie, Jr. (Minneapolis, 1985). Rosenberg had attempted to fit Nietzsche into the Nazi pantheon by linking him with Wagner and Lagarde, a move that Bataille found repugnant.

2. Rita Bischoff, *Souveränität und Subversion: Georges Batailles Theorie der Moderne* (Munich, 1984), pp. 220–222, and Jürgen Habermas, *The Philosophical Discourse of Modernity: Twelve Lectures*, trans. Frederick Lawrence (Cambridge, Mass., 1987), p. 219.

3. Niklaus Sombart has noted certain references to Bataille in Schmitt's unpublished correspondence. Personal communication in New York, February 16, 1990.

4. According to one of the most distinguished students of the history of the concept, F. H. Hinsley, "it has been the source of greatest preoccupation and contention when conditions have been producing rapid changes in the scope of government or in the nature of society or in both. It has been resisted or reviled—it could not be overlooked— when conditions, by producing a close integration between society and government or else by producing a gap between society and government, have inclined men to assume that government and community are identical or else to insist that they ought to be." (*Sovereignty*, 2nd ed. [Cambridge, 1986], p. 2). Weimar Germany and the French Third Republic after the war were both periods of rapid changes of the kind that were conducive to this preoccupation.

5. Schmitt, *Political Theology: Four Chapters on the Concept of Sovereignty*, trans. George Schwab (Cambridge, Mass., 1985). A previous allusion to this work in my essay "Reconciling the Irreconcilable? A Rejoinder to Kennedy," *Telos* 71 (Spring 1987), has been subjected to a splenetic critique by Ellen Kennedy, "Carl Schmitt and the Frankfurt School: A Rejoinder," *Telos* 73 (Fall, 1987). She concludes that "Jay simply gets it wrong. Schmitt does not argue that 'the sovereign is like God.' His view is precisely the opposite: there is no 'sovereign' in the modern world which functions as the creator and guarantor of the state. For Schmitt this is the whole problem of modernity and the Achilles heel of contemporary state theory" (p. 105).
I'm afraid that a second reading of *Political Theology* leaves me unrepentant. Schmitt may not have believed that modern state theory acknowledges the real nature of the sovereign, but his version of that real nature is impossible to understand without grasping its roots in theology. As Schwab says in his introduction, "although Schmitt was prepared to accept modern constitutional developments he was determined to reinstate the personal element in sovereignty and make it indivisible once more" (p. xvi).

6. Schmitt, *Die Diktatur: Von Anfänge des modernen Soveränitätsgedankens bis zum proletarischen Klassenkampf* (Munich, 1921), 2nd ed., 1928; *Legalität und Legitimität* (Munich,

1932); *The Concept of the Political,* trans. with intro. George Schwab (New Brunswick, N.J., 1976). For accounts of the ways in which these theoretical works were linked with Schmitt's political decisions, see George Schwab, *The Challenge of the Exception: An Introduction to the Political Ideas of Carl Schmitt between 1921 and 1936* (Berlin, 1970); and Joseph W. Bendersky, *Carl Schmitt: Theorist for the Reich* (Princeton, 1983). Both of these studies have to be read with some caution because of their subtly apologetic inclinations. See my review of Bendersky in *The Journal of Modern History* 53, 3 (September, 1984).

7. This term has sometimes been translated as "state of emergency," but the other rendering seems to have won out in the more recent literature.

8. Although Schmitt's position was aimed at liberals like Kelsen, its origins can be traced in German liberal theory itself. For a discussion of the increasing importance of decisionism from Rudolph von Ihering to Gustav Radbruch and Max Weber, see Stephen Turner and Regis Factor, "Decisionism and Politics: Max Weber as Constitutional Theorist," in Sam Whimster and Scott Lash, eds., *Max Weber, Rationality and Modernity* (London, 1987).

9. Such homogeneity was predicated, however, on the friend/foe opposition; the hated other was needed to create the solidarity of the homogeneous self. As he wrote in *The Crisis of Parliamentary Democracy,* "Every actual democracy rests on the principle that not only are equals equal but unequals will not be treated equally. Democracy requires, therefore, first homogeneity and second—if the need arises—elimination or eradication of heterogeneity. . . . one has to say that a democracy—because inequality always belongs to equality—can exclude one part of those governed without ceasing to be a democracy. . . ." (p. 9). Schmitt's apologists, who want to deny any link between his Weimar politics and his cynical embrace of Nazism, have some difficulty dealing with the implications of these sinister remarks, made in 1926, which so presciently foreshadow the Third Reich's attitudes.

10. Schmitt, *Political Theology,* p. 36. Schmitt acknowledged that Kelsen had already noted the relationship between theology and jurisprudence but questioned his belief in the lawfulness of God's order as the basis for the lawfulness of man's. See p. 40f. Interestingly, many years later, Kelsen would return to this issue in a book he never published entitled *Secular Religion: A Polemic Against the Misinterpretation of Modern Social Philosophy, Science, and Politics as 'New Religions',* which was set to appear with the University of California Press in 1964, but was withdrawn by Kelsen at the last moment. In a long footnote to what would have been p. 5, he acknowledges that his 1922 *Der soziologische und der juristische Staatsbegriff* pointed to a certain parallel between the relationship of the state and law, on one hand, and the theological problem of the relation between God and the world, on the other. But he added, "the demonstration of this parallelism is meant only as an epistemological criticism of the dualistic theory of state and law. It does not imply the assumption that this dualism is a disguise of the theological dualism of God and world. I am far from turning the analogy into an identity. . . . A characteristic example of misinterpreting analogy as identity is Carl Schmitt, *Politische Theologie.* . . . From the fact that the so-called sovereign is competent to establish a state of emergency does not follow that 'sovereignty' is nothing else but this competence. . . . Every scientific and not politically determined definition of the so-called omnipotence of the legislator stresses the difference between this concept and the omnipotence of God. The omnipotence of God is unlimited; the so-called omnipotence of the legislator means only his competence to make and unmake positive laws," Schmitt's reading of Bodin, Kelsen concluded, tendentiously fails to acknowledge this distinction.

I am indebted to Professor Richard Buxbaum of the Boalt Hall Law School for making
the proofs of Kelsen's book available to me.

11. In the Christian tradition, it should be noted, the precise balance between God's will
and His reason or intellect was a point of frequent dispute. For a helpful overview,
see Hannah Arendt, *Willing*, in *The Life of the Mind* (New York, 1978). Schmitt's God
was more in the tradition associated with Augustine and Duns Scotus than Aquinas.
Arendt herself, it might be noted, was deeply suspicious of a politics based on the
primacy of the will. See her remarks on p. 200.

12. In *Political Theology*, Schmitt writes of the sovereign, "although he stands outside the
normally valid legal system, he nevertheless belongs to it, for it is he who must decide
whether the constitution needs to be suspended in its entirety" (p. 7). This paradox
has allowed one observer, Bendersky, to conclude that for Schmitt the sovereign "still
works within the legal framework. His authority emanates solely from the existing
legal system" (p. 38). If this were so, the sovereign would need all of the gymnastic
skills of Baron von Münchausen.

13. Schmitt did not, however, turn the legitimacy/legality distinction into a theory of
resistance against unjust laws or illegitimate, "merely" legal authority. As Bendersky
correctly notes, "Obedience to the legally constituted authority was always a funda-
mental maxim of Schmitt's political and legal philosophy" (*Carl Schmitt: Theorist for
the Reich*, p. 28). His authoritarian penchant for obeying all positive laws, just as long
as their source could be construed as legitimated by the current decision-making sov-
ereign, helps explain his relatively painless transition from a resigned supporter of
Weimar to a defender of Nazism. No right of civil disobedience to unjust laws could
come from a theory in which justice is a function of the sovereign's commands and
nothing else. Even Schwab, who is prone to find ways to excuse Schmitt, concedes
that "the unfortunate consequences of this approach to justice [based only on the
friend/foe distinction] in a totalitarian state became apparent all too soon" (*The Chal-
lenge of the Exception*, p. 116).

14. For Blumenberg's critique, see *The Legitimacy of the Modern Age*, trans. Robert M.
Wallace (Cambridge, Mass. 1983). For an attempted defense of Schmitt, see Richard
Faber, "The Rejection of Political Theology: A Critique of Hans Blumenberg," *Telos*
72 (Summer, 1987), pp. 173–186.

15. See Alfons Söllner, "German Conservativism in America: Morgenthau's Political Re-
alism," *Telos* 72 (Summer, 1987), pp. 161–172.

16. In *The Concept of the Political*, he followed a repetition of his secularization argument
with the claim that "the nineteenth-century German doctrine of the personality of the
state is important here because it was in part a polemical antithesis to the personality
of the absolute prince, and in part to a state considered as a higher third (vis-à-vis all
other social groups) with the aim of evading the dilemma of monarchical or popular
sovereignty" (pp. 42–43).

17. Hinsley, *Sovereignty*, p. 127.

18. Paul Hirst, one of Schmitt's recent Leftist defenders, notes that "Schmitt insists that
all legal orders have an outside. Politics and the state are not in fact bound by law
and political necessity knows no law, in the last instance it seeks political order by
means that are without law" ("Carl Schmitt—Decisionism and Politics," *Economy and
Society* 17,2 [May, 1988], p. 273). This type of realism may seem attractive to Marxists
who also point to the "outside" of laws in class struggle. But the question for Schmitt
and his leftist devotees then must be, what is the "outside" of politics? Why must the
process of unmasking end with a political sphere that is protected from any pollution

by its other? Although the reduction of the political to the social or economic was a mistake Schmitt and many others in the twentieth century were right to challenge, the absolute quarantining of politics from everything else is no less problematic. For a critique of a similar failing in Hannah Arendt, see my essay "The Political Existentialism of Hannah Arendt," *Permanent Exiles: Essays on the Intellectual Migration from Germany to America* (New York, 1985).

19. Bataille, "The Notion of Expenditure," in *Visions of Excess*, first published in *La Critique Sociale* 7 (January, 1933); "The Psychological Structure of Fascism," in Ibid., first published in *La Critique Sociale* 10 (November, 1933) and 11 (March, 1933); *La Souveraineté*, ed. Thadée Klossowski in *Oeuvres Complètes*, vol. VIII (Paris, 1976). For a helpful overview, see Michele H. Richman, *Reading Georges Bataille: Beyond The Gift* (Baltimore, 1982), chapter 3.

20. Bataille's thoughts on decision can be found in *Inner Experience*, trans. Leslie Anne Boldt (Albany, N.Y., 1988), where he writes, "*The entire morality of laughter, of risk, of the exaltation of virtues and of strengths is* spirit of decision. . . . Decision is what is born before the worst and rises above. It is the essence of courage, of the heart, of being itself. And it is the inverse of project (it demands that one reject delay, that one decide on the spot, with everything at stake: what follows matters second)" (pp. 25–26).

21. Marramao, *Macht und Säkularisierung: Die Kategorie der Zeit*, trans. Max Looser (Frankfurt, 1989), chapter 4.

22. Ibid., p. 202.

23. Schmitt, *Political Romanticism*, trans. Guy Oakes (Cambridge, Mass., 1986).

24. Annette Michelson, "Heterology and the Critique of Reason," *October* 36 (Spring, 1986), p. 124.

25. Bataille, "The Psychological Structure of Fascism," *Visions of Excess*, originally in *La Critique Sociale* 10 (November, 1933) and 11 (March, 1934).

26. It is important to note that the concept of mastery was Nietzschean rather than Hegelian. In *Inner Experience*, first written in 1943, Bataille was careful to distinguish sovereignty from the Hegelian dialectic of master and slave, which was based on work and knowledge (p. 108f).

27. Bataille, "The Psychological Structure of Fascism," p. 148.

28. Ibid., p. 145.

29. The term atheological appears in the title of a three-volume work called *La Somme athéologique*, vols. V and VI of the *Oeuvres Complètes*.

30. Bataille, "The Psychological Structure of Fascism," p. 153. In this somewhat cryptic passage, Bataille opposes lived heterogeneity to the "limitative value of reality," by which I take him to mean that reality which imposes limits, the reality of the restricted economy.

31. Bataille, "Propositions," *Visions of Excess*, p. 197. *Acéphale* was the name of a review that Bataille and his friends at the Collège de Sociologie published for four issues in 1939. It also was the name of the secret society to which they belonged, dedicated to resurrecting a kind of Nietschean society of myth and sacrifice. Its program of April 4, 1936, is reprinted in *October* 36 (Spring, 1936), p. 79. Its last, rather sinister plank reads "Affirm the value of violence and the will to aggression insofar as they are the foundation of all power."

32. Maurice Blanchot, *The Unavowable Community*, trans. Pierre Joris (Barrytown, N.Y., 1988).

33. Jacques Derrida, "From Restricted to General Economy: A Hegelianism without Reserve," in *Writing and Difference*, trans. Alan Bass (Chicago, 1978), p. 269.

34. As Allen S. Weiss puts it, "because of its propensity to excess, to ecstasy (that going beyond oneself common to both the formation of community and that special community known as mysticism), sovereignty is essentially groundless, without a true foundation or origin. Only by making chance its necessity can the sovereign subject escape becoming just one more moment within universal reason and history" ("Impossible Sovereignty: Between *The Will to Power* and *The Will to Chance*," October 36 [Spring, 1986], p. 141).

35. Habermas's formulation in *The Philosophical Discourse of Modernity* that "With the help of the same idea [elemental violence] he [Bataille] also justifies in fascism that element (so characteristic of Carl Schmitt) of groundless or 'pure' leadership, against which Horkheimer and Adorno most clearly set the force of the mimetic" (p. 86) seems problematic on two accounts. First, Schmitt's notion of sovereignty was groundless only in the sense of its antinormativity; it had another ground in the criterionless decisions of the lawgiving surrogate of God. Second, although Bataille's alternative was more consistently antifoundational, his sovereign leader was anything but pure. It was instead the violation of purity that paradoxically constituted the sacred as he understood it.

36. *Informe* was one of Bataille's central concepts. "For academic men to be happy," he wrote, "the universe would have to take shape. All of philosophy has no other goal: it is a matter of giving a frock coat to what is, a mathematical frock coat. On the other hand, affirming that the universe resembles nothing and is only *formless* amounts to staying that the universe is something like a spider or spit." "Formless," in *Visions of Excess*, p. 31.

37. Bataille, *Literature and Evil*, trans. Alisdair Hamilton (New York, 1973), p. 173.

38. For a discussion of Bataille's concept of communication, see Richman, *Reading Georges Bataille*, chapter 5.

39. For a suggestive interpretation of the links between political power in primitive societies without strong states, the repudiation of reciprocity and exchange, and the prophetic, anticommunicative function of language (in the normal sense of communication), see Pierre Clastres, *Society Against the State: The Leader as Servant and the Humane Uses of Power Among the Indians of the Americas*, trans. Robert Hurley (New York, 1977), p. 182f.

40. The linkages are perhaps most evident in his celebrated pornographic novel, *The Story of the Eye*, trans. Joachim Neugroschel (New York, 1977).

41. In a perspicacious critique of Bataille's essay, Anthony Stephens writes, "he shows the same willingness to accept the Nazis as much nobler than all the facts suggested that determined, for varying lengths of time, the attitudes of Ernst Jünger, Gottfried Benn and Martin Heidegger" ("Georges Bataille's Diagnosis of Fascism and Some Second Thoughts," *Thesis Eleven* 24 [1989], p. 77).

42. Ernst Bloch, *Erbschaft dieser Zeit* (Zurich, 1935).

43. Bataille, "The Psychological Structure of Fascism," p. 154.

44. Ibid., p. 159. Later, to be sure, he would try to distinguish between genuinely sacred violence and the Nazi perversion of it. See his "La Morale du malheur: La Peste," *Critique* 13/14 (June-July, 1947).

45. Victor Turner, *The Ritual Process: Structure and Anti-Structure* (Ithaca, N.Y., 1977).

46. The most important difference is that Turner identifies homogeneity with communitas and heterogeneity with status structure. That is, because he notes the breakdown of clear-cut hierarchical differentiations in liminal situations, he thinks they produce a kind of communal homogeneity. From Bataille's point of view, rigid hierarchical structure is precisely the essence of homogeneity, as we have seen in his discussion of the military dimension of fascism. Its overcoming, therefore, leads to a more profound type of heterogeneity than before.

47. Turner, *The Ritual Process*, p. 128.

48. Bataille, *Inner Experience*, pp. 90, 132. His colleague at the Collège de Sociologie, Roger Caillois, also lectured on the sacred status of carnival. See his 1939 essay "Festival" in *The College of Sociology, 1937–1939*, ed. Denis Hollier, trans. Betsy Wing (Minneapolis, 1988).

49. Turner, *The Ritual Process*, p. 132.

50. Ibid., p. 129.

51. Michel Foucault, *Power/Knowledge: Selected Interviews and Other Writings*, ed. Colin Gordin, trans. Colin Gordon et al. (New York, 1980), p. 105.

5. Women in Dark Times: Agnes Heller and Hannah Arendt

1. I owe this observation and the knowledge of other details to a conversation with Agnes Heller in New York on February 16, 1990.

2. The classic account of Arendt's life is Elisabeth Young-Bruehl, *Hannah Arendt: For Love of the World* (New Haven, 1982). No sustained account of Heller's still thriving career has yet appeared, although some information about her years as a member of the Budapest School can be found in Serge Frankel and Daniel Martin, "The Budapest School," *Telos* 17 (Fall, 1973), pp. 122–133; and Joseph Gabel, "Hungarian Marxism," *Telos* 25 (Fall, 1975), pp. 185–191.

3. For a recent account of this milieu, which emphasizes the elective affinity between its residual messianic inclinations and political utopianism, see Michael Löwy, *Rédemption et Utopie: le judaïsme libertaire en Europe centrale* (Paris, 1988). Interestingly, Heller would attempt to include Arendt, along with that other notable citizen of Königsberg, Kant, in a distinctly East-Elbian tradition of "Great Republican" political theory, which also included Rosa Luxemburg. See the essay "The Great Republic," in Ferenc Fehér and Agnes Heller, *Eastern Left, Western Left: Totalitarianism, Freedom and Democracy* (Oxford, 1986), p. 188.

4. Arendt's use of the pariah/parvenu distinction in her 1944 essay "The Jew as Pariah: a Hidden Tradition," reprinted in *The Jew as Pariah: Jewish Identity and Politics in the Modern Age*, ed. Ron H. Feldman (New York, 1978) is discussed by Fehér in "The Pariah and the Citizen (On Arendt's Political Theory)," in Heller and Fehér, *The Postmodern Political Condition* (New York, 1988). He attributes the category more to Max Weber's famous analysis of the Jews as a "pariah people" than to Lazare, who is not mentioned.

5. Arendt was also strongly indebted to Karl Jaspers, but was deeper in Heidegger's thrall. She perhaps wrote less about Heidegger than Heller did about Lukács, but was more intimately involved on a personal level with her teacher, as the Young-Bruehl biography makes clear. But that Heller also knew something of the importance of emotional and intellectual entanglement is suggested by her sensitive essay on "Georg Lukács

and Irma Seidler," in Agnes Heller, ed., *Lukács Revalued* (Oxford, 1983), as well as such works as *A Theory of Feelings* (The Hague, 1979). Although this is not the place to attempt a biographical reconstruction of their lives, it may be worth recalling in this context that both women lost their fathers at a young age. Paul Arendt died in 1913, when his daughter was only seven; Pal Heller perished in Auschwitz in 1944, when his daughter was fifteen.

6. The struggle, to be sure, was not always easily won. Arendt's widely remarked essay of 1971 on "Martin Heidegger at Eighty," in Michael Murray, ed., *Heidegger and Modern Philosophy* (New Haven, 1978), pp. 293–303, has a defensive treatment of his "error" that seemed woefully inadequate even before the recent research of Hugo Ott, Victor Farias, and Richard Wolin. Heller's repudiation of her teacher's politics has been more forthright. See, for example, the remarks in the Introduction to Agnes Heller and Ferenc Fehér, *Eastern Left, Western Left*, p. 20, and the critique of Lukács's notorious distinction between imputed and empirical class consciousness (p. 216.).

7. Alfred Kazin's description of Arendt's marriage to Héinrich Blücher as "the most passionate seminar I would ever witness between a man and a woman living together" (cited in Young-Bruehl, p. 267) could easily be applied to Heller's relation to Ferenc Fehér. In their case, unlike that of Arendt and Blücher, the seminar was often conducted in public through jointly authored and edited works. As a result, it is sometimes difficult to distinguish between their attitudes toward Arendt, which will allow us to cite certain essays written under Fehér's name but then published in joint works as indicative of Heller's position as well. It should be noted that in both cases, these were second marriages.

8. Although Arendt was generally less sympathetic to Marxism than Heller, she avidly embraced Luxemburg's analysis of imperialism in *The Origins of Totalitarianism* (Cleveland, 1958), p. 148 and wrote glowingly of her career in "Rosa Luxemburg, 1871–1919," *Men in Dark Times* (New York, 1968). In the essay by Fehér entitled "Redemptive and Democratic Paradigms," published in the joint work *Eastern Left, Western Left*, Arendt's piece is called "magnificent" (p. 74). For a typical example of Heller's admiration, see her discussion in *The Power of Shame: A Rational Perspective* (London, 1985), pp. 242–243, where she praises Luxemburg's Stoic-Epicurean ethics and the exemplary conduct of her life.

9. Arendt's explicit distaste for feminism is cautiously and thoughtfully defended by Heller's Budapest School colleague Maria Markus, "The 'Anti-Feminism' of Hannah Arendt," *Thesis Eleven* 17 (1987), pp. 76–87. In her own most recent work, Heller has come to defend feminism in general terms, for example, in *A Theory of History* (London, 1982), p. 305, and *The Postmodern Political Condition*, pp. 35–36 and 144–145. But it would be mistaken to say that gender issues have ever really been at the center of her philosophy in the manner of, say, Simone de Beauvoir, Luce Irigaray, or Michèle Le Doeuff.

10. In the midst of the controversy over her Eichmann book, Arendt wrote to Gershom Scholem, "I have great confidence in Lessing's *Selbstdenken* for which, I think, no ideology, no public opinion, and no 'convictions' can ever be a substitute" (Arendt, *The Jew as Pariah: Jewish Identity and Politics in the Modern World* (New York, 1978), p. 250). Later, in her posthumously published *Lectures on Kant's Political Philosophy*, ed. Ronald Beiner (Chicago, 1982), she would attribute the same idea of Enlightenment as *Selbstdenken* to Kant (p. 43).

11. Arendt, "On Humanity in Dark Times: Thoughts about Lessing," in *Men in Dark Times*; Heller, "Enlightenment Against Fundamentalism: the Example of Lessing," *New Ger-*

man Critique 23 (Spring/Summer, 1981), pp. 13–26. In earlier treatments of Lessing, Arendt had been more critical of Lessing as an Enlightenment foe of historical truths, but she reversed herself in her 1959 essay. See the discussion in Young-Bruehl, pp. 93–94.

12. Heller, to be sure, demurred from Arendt's "splendid essay," as she called it, to the extent that it set off friendship too radically from the pursuit of truth. Whereas for Arendt, "Nathan's wisdom consists solely in his readiness to sacrifice truth to friendship" (p. 16), for Heller, "friendship belongs to truth, because it belongs to that which is good" (p. 16).

13. In *Between Past and Future: Six Exercises in Political Thought* (Cleveland, 1961), she contended that Engels, "contrary to an opinion current among some Marx scholars, usually rendered Marx's thought adequately and succinctly" (p. 21).

14. Arendt, *The Origins of Totalitarianism*, p. 482.

15. Ibid., p. 501. She would repeat this praise in such later works as *On Revolution* (New York, 1963) and *Crises of the Republic* (New York, 1972).

16. Heller and Fehér, *Hungary 1956 Revisited: the Message of a Revolution—A Quarter Century After* (London, 1983).

17. Ibid., p. 114. However, unlike Arendt, or Castoriadis, the other great celebrant of the councils they discussed, they did think the revolutionaries wanted to make the entire society over into a council system.

18. As late as *The Postmodern Political Condition*, Heller and Fehér attacked Arendt's reading of Marx as obsessed with the social question, claiming instead that his real interest was in the anthropological issue of human freedom (pp. 108, 118).

19. Arendt continued to hold this view throughout her career; it reappeared as late as *The Life of the Mind*, vol. II, *Willing* (New York, 1978), p. 216. For Heller, in contrast, "Marx's theory was a philosophy of freedom" (*Eastern Left, Western Left*, p. 128).

20. Heller, *General Ethics* (Oxford, 1988), chapter 1, where she explicitly acknowledges her debt to Arendt (p. 17).

21. Heller, *A Theory of History* (London, 1982), especially chapter 18 on "The Philosophy of History and the Idea of Socialism."

22. Heller, "A Socialist in Exile: Patrick Wright talks to Agnes Heller," *New Socialist* (July, 1985), p. 12. The same sentiment reappears almost word for word in Fehér's essay "The Pariah and the Citizen (On Arendt's Political Theory)," p. 97. The difference, of course, between Marx and Arendt concerns their respective attitudes toward the split.

23. Heller works out the differences in *The Power of Shame*, chapters 2 and 3. It should be noted that the paradigms of work and production are not equivalent to Arendt's distinction between labor and work.

24. Heller, *The Power of Shame*, p. 282.

25. Ibid., pp. viii and 283. For Arendt's critique of *techné* as inherently instrumental, see *The Human Condition* (Garden City, N.Y., 1959), p. 126f. Heller also criticized Habermas for the same impoverished understanding of labor and *techné*. See her remarks in "Habermas and Marxism" in *Habermas: Critical Debates*, ed. John E. Thompson and David Held (Cambridge, Mass., 1982), pp. 34–35. For his response, see "A Reply to My Critics," Ibid., p. 223f.

26. Heller, *A Philosophy of Morals* (Oxford, 1990), pp. 153–154.

27. Fehér and Heller, *The Postmodern Political Condition*, p. 103. See also their critique of Arendt's exclusion of economics from state concerns in *Eastern Left, Western Left*, p. 226.

28. Heller, "The Concept of the Political Revisited," in *Can Modernity Survive?* (forthcoming). I am indebted to Agnes Heller for an advance copy of this manuscript.

29. Ibid., p. 12 in manuscript.

30. See *Eastern Left, Western Left*, pp. 134–135, where Castoriadis is accused of being a "partisan of an absolute equality, obviously without thinking of its implications for freedom, which—as 'autonomy'—is a central category for him as well, to the end. Precisely for that same reason, he is a zealot of the absolute predominance of the political over all other social activities and an admirer of the egalitarianism of *sans-culotte* masses in the Great Revolution." Interestingly, in her more militantly Marxist phase, Heller had denied that Marx himself was an egalitarian, claiming that equality was an abstract term still within bourgeois discourse. Marx, she implied, had sought a society in which the tension between equality and liberty would be fully overcome. See Heller, *The Theory of Need in Marx* (London, 1976), p. 122.

31. See, in particular, *Eastern Left, Western Left*, p. 74.

32. *Eastern Left, Western Left*, p. 137. This was a tradition, she followed Andrzej Walicki in claiming, that was specific to Eastern Europe, where Western-style liberalism was weak.

33. Ibid., pp. 188–189. For more on the value of maintaining a certain tension between the social and the political, see "The Pariah and the Citizen (On Arendt's Political Theory)," p. 101f.

34. The distinction between democratic and republican ideals is drawn more sharply here than elsewhere in Heller and Fehér's work, where democracy is normally an honorific term. It should also be noted that elsewhere, Fehér took issue with Arendt on her treatment of the French Revolution. In *The Frozen Revolution: an Essay on Jacobinism* (Cambridge, 1987), he accepted her contention that the Revolution in its Jacobin phase embarked on a "liberticidal course," but disagreed with her blaming it on the Revolutionaries' stress on social rather than political issues (p. 16). It was rather the way in which the social was raised that was the problem: the 'social' ought to have been 'politicized,' but in a different, democratic and pragmatic manner which would have stood in stark contrast to the haughty rationalism of revolutionaries of all kinds who continued to believe that appropriate solutions could simply be deduced from the 'rules of reason' " (p. 44). He also criticized her categorical banishment of compassion from the political sphere, contending that it was dangerous only when it led to redemptive-absolutist rather than pragmatic solutions (p. 66).

35. Distancing themselves from Habermas, Heller and Fehér contend that consensus, although important, is "not the organizing center of our political inquiry and philosophy. This is so, firstly, because we heed Arendt's warning about the potentially totalitarian and oppressive character of consensus politics" (p. 12). But they do recognize that the basic law of all democratic politics is "the possibility of a *consensus omnium*, not a consensus in all political decisions but a consensus about the political principles of such decisions" (p. 70).

36. This sinister version of democratic sovereignty was, in fact, defended by Carl Schmitt in such works as *The Crisis of Parliamentary Democracy*, trans. Ellen Kennedy (Cambridge, Mass., 1985).

37. Ibid., p. 94. Heller and Fehér, it should be noted included representative democratic institutions in their version of the republican tradition of radical democracy, whereas

Arendt was much more critical of representative democracy. For a critique of her position on this issue, see George Kateb, *Hannah Arendt: Politics, Conscience, Evil* (Totowa, N.J., 1983); for a defense, see James Bernauer, "On Reading and Mis-reading Hannah Arendt," *Philosophy and Social Criticism* 11, 1 (Summer, 1985), pp. 1–34.

38. Heller and Fehér, *Eastern Left, Western Left*, chapter 10. The concept of totalitarianism was also defended in Heller's contribution to Heller, Fehér, and György Markus, *Dictatorship over Needs* (New York, 1983).

39. Ibid., p. 259. This essay was written during the period when Heller and Fehér were engaged in a spirited dispute over the threat of a new Rapallo agreement between the Soviet Union and an increasingly neutral Germany, an agreement that would be at the cost of the freedom of the peoples of Eastern Europe. See their "Eastern Europe under the Shadow of a New Rapallo," and the six essays that followed along with their rebuttal in *New German Critique* 37 (Winter, 1986). In their response to one of their critics, Walter Süss, they in fact invoked *The Origins of Totalitarianism* to make a point concerning the relation between racism and nationalism ("A New Rapallo: Fiction, Threat or Capitulation-in-progress? A Reply to Our Critics," p. 154). Happily, this was another prognosis that seems to have been proved wrong.

40. Heller, *The Power of Shame*, pp. 204–205. She then added that it was Castoriadis who was responsible for restoring interest in the theme of the imagination. Arendt, it should be noted, was also interested in the link between imagination and judgment, as the last of her *Lectures on Kant's Political Philosophy* makes clear.

41. Heller, "Hannah Arendt on the Vita Contemplativa," *Philosophy and Social Criticism* 12 (1987), pp. 281–296.

42. Ibid., p. 286.

43. Ibid., p. 287.

44. According to Heller (p. 282) Arendt's distinction between thinking and knowing parallels the old Idealist opposition of *Vernunft* and *Verstand*, Reason and Understanding. My own reading of the Heideggerian residue in Arendt suggests that although she does cite the distinction (*The Life of the Mind*, p. 57f.), thinking is less ratiocination than a reflective process of openness to what is revealed to it. Unlike *Vernunft*, thinking lacks the telos of a higher unity overcoming antinomies.

45. Ibid., p. 292.

46. Ibid., p. 294.

47. Heller, *General Ethics*, chapter 3. It would be very interesting to compare this argument with the moral theory of another insightful critic of moral autonomy, Emmanuel Levinas. Although both Heller and Levinas reject the possibility of complete moral self-legislation, she emphasizes the complicating factor of knowledge, whereas he stresses the heteronomous origin of prescriptive commands.

48. Ibid., p. 296.

49. Heller credits Arendt, along with Lyotard, for restoring interest in Kant on this issue, but cautions that it "deserves close scrutiny, given that both the identification of the aesthetic and the ethical dimensions, and their strict and complete division, arouse feeling of discomfort in everyday actors and philosophers alike" (*A Philosophy of Morals*, p. 240).

50. Unlike many other contemporary thinkers, however, Heller has not become truculently antihumanist. For a nuanced defense of what she calls "modern humanism," see *The Postmodern Political Condition*, p. 52f. Interestingly, she enlists some familiar names

in her cause: "the idea that moral universalism can be achieved not by surpassing contingency, particularity, and individuality, but rather by changing our attitude within one and the same form of life, goes back to Lessing, and has been recycled by Hannah Arendt" (p. 59). See also her discussion of humanism and Heidegger's notion of "care of the world" in *A Philosophy of Morals*, p. 164f.

51. Heller and Fehér, *The Postmodern Political Condition*, p. 12.

52. Bernauer, "On Reading and Mis-reading Hannah Arendt," p. 21.

53. Heller and Fehér, *Eastern Left, Western Left*, p. 244.

54. Heller and Fehér, *The Postmodern Political Condition*, p. 151.

6. "The Aesthetic Ideology" as Ideology: Or What Does It Mean to Aestheticize Politics?

1. Walter Benjamin, "Theories of German Fascism: On the Collection of Essays *War and Warrior*, ed. Ernst Jünger," *New German Critique* 17 (Spring, 1979), prefaced by Ansgar Hillach, "The Aesthetics of Politics: Walter Benjamin's 'Theories of German Fascism'."

2. Ibid., p. 122.

3. Walter Benjamin, *Illuminations*, ed. with intro. Hannah Arendt, trans. Harry Zohn (New York, 1968), p. 244.

4. In the original version of the essay, which appeared in the *Zeitschrift für Sozialforschung* V, 1 (1936), the word "Communism" was replaced by the euphemism "les forces constructives de l'humanité" (p. 66). When the essay was republished in the 1960s, the original word was restored and appears in the English translation.

5. Bill Kinser and Neil Kleinman, *The Dream That Was No More a Dream: A Search for Aesthetic Reality in Germany, 1890–1945* (New York, 1969), p. 7.

6. J. P. Stern, *Hitler: The Führer and the People* (Berkeley, 1976), p. 45. For another account of Nietzsche's influence on aestheticized politics in the milieu that spawned Hitler, see William J. McGrath, *Dionysian Art and Populist Politics in Austria* (New Haven, 1974).

7. Susan Sontag, "Fascinating Fascism," *Under the Sign of Saturn* (New York, 1980).

8. Alice Yaeger Kaplan, *Reproductions of Banality: Fascism, Literature and French Intellectual Life*, foreword Russell Berman (Minneapolis, 1986), p. 184.

9. Saul Friedländer, *Reflections of Nazism: An Essay on Kitsch and Death*, trans. Thomas Weyr (New York, 1984).

10. Paul de Man, *The Resistance to Theory*, foreword Wlad Godzich (Minneapolis, 1986). This volume includes one of de Man's last essays, which dealt with Benjamin's "The Task of the Translator." In his foreword, Godzich notes the forthcoming appearance of another collection to be called *The Aesthetic Ideology*, edited by Andrzej Warminski. The concept's importance for de Man has been underlined in Christopher Norris, *Paul de Man: Deconstruction and the Critique of the Aesthetic Ideology* (New York, 1988).

11. See, for example, Jonathan Culler, "'Paul de Man's War' and the Aesthetic Ideology," *Critical Inquiry* 15, 4 (Summer, 1989), and J. Hillis Miller, "An Open Letter to Professor Jon Weiner," in *Responses: On Paul de Man's Wartime Journalism*, ed. Werner Hamacher, Neil Hertz, and Thomas Keenen (Lincoln, Neb., 1989).

12. David Lloyd, "Arnold, Ferguson, Schiller: Aesthetic Culture and the Politics of Aesthetics," *Cultural Critique* 2 (Winter, 1985–86); "Kant's Examples," *Representations* 28

(Fall, 1989); Terry Eagleton, "The Ideology of the Aesthetic," *Poetics Today* 9, 2 (1988), included in *The Ideology of the Aesthetic* (London, 1990).

13. Wilde as quoted in Ernest Raynaud, *Souvenirs sur le symbolisme* (Paris, 1895), p. 397.

14. For a recent account of Tailhade and other Symbolists involved with anarchist politics, see Richard D. Sonn, *Anarchism and Cultural Politics in Fin de Siècle France* (Lincoln, Neb., 1989). The links between anarchist and fascist politics have often been made because of their shared aestheticization of violence.

15. F. T. Marinetti, "The Futurist Manifesto," reprinted in James Joll, *Three Intellectuals in Politics* (New York, 1960), p. 182.

16. Benjamin, *Illuminations*, p. 244.

17. Friedrich Nietzsche, *The Birth of Tragedy and The Genealogy of Morals*, trans. Francis Golffing (New York, 1956), p. 220.

18. Mussolini to Emil Ludwig in 1932, cited in Denis Mack Smith, "The Theory and Practice of Fascism," in *Fascism: An Anthology*, ed. Nathanael Greene (New York, 1968), p. 82.

19. Russell Berman, foreword to Kaplan, *Reproductions of Banality*, p. xix. In a subsequent piece on Ernst Jünger, Berman makes a similar charge of the fetishization of images. See his "Written Right Across Their Faces: Ernst Jünger's Fascist Modernism," in *Modernity and the Text: Revisions of German Modernism*, ed. Andreas Huyssen and David Bathrick (New York, 1989). Interestingly, the same assumption was held by a very different figure, the logical positivist and avid socialist Otto Neurath, who claimed that *"Words divide, pictures unite"* (*Empiricism and Sociology*, trans. Paul Foulkes and Marie Neurath, ed. Marie Neurath and Robert S. Cohen [Dordrecht, 1973], p. 217).

20. Ibid., p. xxi.

21. Philippe Lacoue-Labarthe and Jean-Luc Nancy, *The Literary Absolute: The Theory of Literature in German Romanticism*, trans. Philip Barnard and Cheryl Lester (Albany, N.Y., 1988). In a later work on Heidegger and Nazism, Lacoue-Labarthe returned to the issue of "the aestheticization of politics." See his *Heidegger, Art and Politics: The Fiction of the Political*, trans. Chris Turner (Cambridge, Mass., 1990), chapter 7.

22. Ibid., pp. 44–45.

23. Paul de Man, "Aesthetic Formalization: Kleist's *Über das Marionettentheater*," in *The Rhetoric of Romanticism* (New York, 1984), p. 264. The fairness of de Man's reading of Schiller has been powerfully challenged by Stanley Corngold in "Potential Violence in Paul de Man," *Critical Review* 3, 1 (Winter, 1989).

24. Ibid., p. 289.

25. Paul de Man, "Kant and Schiller," forthcoming in *The Aesthetic Ideology*. The following quotations are from the unpublished manuscript.

26. It should be noted that misreading was not simply a pejorative term in de Man's vocabulary, for all interpretations were inevitably misreadings in the sense that no reading could claim to be the only correct one. The adjective "grievous," however, indicates that he wanted to distinguish between misreadings, perhaps in terms of their pragmatic implications.

27. Culler, "'Paul de Man's War' and The Aesthetic Ideology," p. 780.

28. Ibid., p. 783.

29. De Man, "Reading and History," in *The Resistance to Theory*, p. 64. See also his remark in "Phenomenality and Materiality in Kant," in Gary Shapiro and Alan Sica, eds.,

Hermeneutics: Questions and Prospects (Amherst, Mass., 1984): "morality and the aesthetic are both disinterested, but this disinterestedness becomes necessarily polluted in aesthetic representation: the persuasion that [such] judgments are capable of achieving is linked, in the case of the aesthetic, with positively valorized sensual experiences" (pp. 137–138). I will leave de Man's more psychoanalytically inclined interpreters to muse on the implications of his anxiety about sensual pollution.

30. Norris, *Paul de Man*, p. xii.

31. Although this is not the place to launch yet another analysis of the links between de Man's wartime writing and his later work, it may be conjectured that the ascetic, anti-eudamonistic rigor of the latter was in some sense a reaction to—perhaps even a self-punishment for—his having fallen for the seductions of an organic ideology of aesthetic redemption.

32. Eagleton, "The Ideology of the Aesthetic," p. 328. David Lloyd also claims that it functioned in the transition from coercion to hegemony; see "Arnold, Ferguson, Schiller," p. 155.

33. Ibid., p. 329.

34. Herbert Marcuse, "The Affirmative Character of Culture," *Negations: Essays in Critical Theory*, trans. Jeremy J. Shapiro (Boston, 1968).

35. Ibid., p. 337.

36. Ibid., p. 338.

37. Lloyd's greater hostility is perhaps explained by his interest in the way that the ideology of the aesthetic functions in the relations between hegemonic and marginal cultures, such as the English and Irish. He notes its role in establishing the canon of great texts, which works to exclude "minor works" that fail to fit the hegemonic model.

38. Josef Chytry, *The Aesthetic State: A Quest in Modern German Thought* (Berkeley, 1989). See also Luc Ferry, *Homo Aestheticus: L'invention du goût a l'âge démocratique* (Paris, 1990).

39. Clifford Geertz, *Negara: The Theatre State in Nineteenth-century Bali* (Princeton, 1980).

40. Chytry, *The Aesthetic State*, p. 90. For a similar analysis of Schiller, see Jürgen Habermas, *The Philosophical Discourse of Modernity: Twelve Lectures*, trans. Frederick Lawrence (Cambridge, Mass., 1987), p. 45f.

41. Ibid., p. 86.

42. For a less generous interpretation of this withdrawal, see Lloyd, "Arnold, Ferguson, Schiller," p. 167, where he writes "since the realization of the aesthetic state is perpetually deferred and can be found in only a few representative individuals, the aesthetic education of individuals towards participation in the ethical State is likewise deferred in a process which requires the order guaranteed by the dynamic State of rights, that is, by the force of the natural State once again."

43. For a recent and very thorough consideration of the issue, see Howard Caygill, *Art of Judgement* (London, 1989).

44. Jacques Derrida, *The Truth in Painting*, trans. Geoff Bennington and Ian McLeod (Chicago, 1987), p. 117. In *Paul de Man*, Norris also spells out the problematic implications of analogy in Kant's discussion of both the beautiful and the sublime. The former analogizes between the realm of sensual experience and the faculty of the Understanding, the latter between sensual experience and Reason (p. 56f). For a subtle response to Derrida's analysis, see Caygill, *The Art of Judgement*, p. 395.

45. De Man, *The Resistance to Theory*, p. 11.

46. Jean-François Lyotard and Jean-Loup Thébaud, *Just Gaming*, trans. Wlad Godzich (Minneapolis, 1985). See also Lyotard, *The Differend: Phrases in Dispute*, trans. George Van Den Abbeele (Minneapolis, 1988), p. 140f; and "Lessons in Paganism," *The Lyotard Reader*, ed. Andrew Benjamin (Oxford, 1989). For sympathetic accounts of Lyotard's political thought and its relation to aesthetics, see David Carroll, *Paraesthetics: Foucault, Lyotard, Derrida* (New York, 1987), chapter 7; and Bill Readings, *Introducing Lyotard: Art and Politics* (London, 1991).

47. In his April, 1987, interview with Willem van Reijen and Dick Vreeman, Lyotard explicitly draws on Lacoue-Labarthe and Nancy's rejection of politics as a work of art. The interview appears in *Theory, Culture and Society* V (1988), with the critique of this version of aesthetic politics on p. 296f.

48. Carroll, *Paraesthetics*, p. 182.

49. Eagleton, *The Ideology of the Aesthetic*, p. 396f.

50. Arendt's discussion of judgment was unfortunately cut short by her sudden death in 1975, which prevented her from adding a volume on it to the planned trilogy that began with "Thinking" and "Willing." These are included in *The Life of the Mind* (New York, 1978). Her most extensive early discussion can be found at the end of her essay "The Crisis in Culture," in *Between Past and Future: Six Exercises in Political Thought* (Cleveland, 1961). Her last thoughts on the subject are collected as *Lectures on Kant's Political Philosophy*, ed. with an Interpretive Essay by Ronald Beiner (Chicago, 1982). For analyses of Arendt on judgment, see Michael Denneny, "The Privilege of Ourselves: Hannah Arendt on Judgment," in *Hannah Arendt: The Recovery of the Public World*, ed. Melvyn A. Hill (New York, 1979); and Richard J. Bernstein, "Judging—the Actor and the Spectator," *Philosophical Profiles: Essays in a Pragmatic Mode* (Philadelphia, 1986). Despite the clear similarities in their work, Lyotard never acknowledges Arendt's earlier use of Kant's Third Critique as a model for politics. For a comparison of Arendt and Lyotard, see David Ingram, "The Postmodern Kantianism of Arendt & Lyotard," *The Review of Metaphysics*, 42, 1 (1988), pp. 51–77.

51. According to Lyotard, even if aesthetic judgments contain a pretension of universality, they are still "exempt from the domain of conversation. Even if my taste for a work or for a landscape leads me to discuss it with others (taking that last term in the sense, this time, of an empirical group), it is no less true that any assent that I can obtain from them has nothing to do with the validity of my aesthetic judgment. For the conditions of validity of this judgment are transcendental and are clearly not subject to the opinions of any others whatsoever. The communicability, and even, to speak rigorously, the communion of aesthetic sentiments, cannot be obtained *de facto*, empirically, and much less by means of conversation. . . . Aesthetic judgment does not proceed through concepts, it cannot be validated by argumentative consensus" (Interview with van Reijen and Veerman, p. 306).

52. Arendt, *Between Past and Future*, p. 221.

53. Arendt, *Lectures on Kant's Political Philosophy*, p. 42f.

54. Bernstein, *Philosophical Profiles*, p. 237. Beiner too wrestles with this tension. See, in particular, p. 135f. One example of the difficulties of her position appears in her citation of Kant's treatment of war, in which he claims that it expresses something sublime that is lost in a long peace. "This is the judgment," she writes, "of the spectator (i.e., it is aesthetical)" (*Lectures on Kant's Political Philosophy*, p. 53). Here we are not that far from Ciano admiring the formal beauty of bombing Ethiopians. What needs to be

done to make the political implications of aesthetic judgment attractive is to close the gap between the actors and the spectators of action, and thus reverse Arendt's curious claim that "the public realm is constituted by the critics and the spectators, not by the actors or the makers" (p. 63).

55. Still another possible version might be sought in an unexpected place, the work of Jürgen Habermas. Although the role of the aesthetic is less central in his system than in Lyotard's and Arendt's, it might be argued that his recent interest in aesthetic rationality suggests interesting avenues of inquiry. For an account that stresses their importance, see David Ingram, *Habermas and the Dialectic of Reason* (New Haven, 1987).

7. The Apocalyptic Imagination and the Inability to Mourn

1. Blanchot, *The Writing of the Disaster*, trans. Ann Smock (Lincoln, Nebr., 1986), p. 42.

2. According to Henri Focillon, the relationship between the two is not, however, intrinsic or inevitable. See his *The Year 1000*, trans. Fred D. Wieck (New York, 1969), p. 50.

3. For a very technical explication of the linguistic workings of this text, see David Hellholm, "The Problem of Apocalyptic Genre and the Apocalypse of John," *Semeia* 36 (1986).

4. Hillel Schwartz, *Century's End: A Cultural History of the Fin de Siècle from the 990s to the 1990s* (New York, 1990), p. 31.

5. A number of articles in the popular press have commented on the upsurge of apocalyptic thinking, e.g., Bill Lawren, "Apocalypse Now," *Psychology Today* (October, 1989); Jeffrey L. Scheler, "Will Armageddon Start in Iraq?" *The San Francisco Chronicle*, December 16, 1990, p. 13.

6. Schwartz, *Century's End*, p. 201.

7. See, e.g., C.A. Patrides and Joseph Wittreich, eds., *The Apocalypse in English Renaissance Thought and Literature: Patterns, Antecedents and Repercussions* (Ithaca, 1984); Louise M. Kawada, ed., *The Apocalypse Anthology* (Boston, 1985) or Saul Friedländer et al., eds., *Visions of Apocalypse: End or Rebirth?* (New York, 1985).

8. Amos Funkenstein notes that "it is very clear that the apocalyptic tradition does not exclude eternal return, at times even alludes to it under the influence, perhaps, of Iranian tradition." See his "A Schedule for the End of the World: The Origins and Persistence of the Apocalyptic Mentality," in Friedländer, *Visions of Apocalypse*, p. 50.

9. M. H. Abrams, *Natural Supernaturalism: Tradition and Revolution in Romantic Literature* (New York, 1971), p. 37f. Dominick LaCapra has recently noted that for all his celebration of the symbolic overcoming of differences in a wide variety of forms, which valorize the consummation of the marriage, Abrams himself "tends to repeat the apocalyptic paradigm in an almost obsessive way, in wave upon wave of plangent high seriousness, until the hallowed story he tells becomes almost hollow—eroded and made a bit tedious and even senseless." See his *Soundings in Critical Theory* (Ithaca, 1989), p. 100.

10. Michael Barkun, "Divided Apocalypse: Thinking About the End in Contemporary America," *Soundings* LXVI, 3 (Fall, 1983), pp. 257–280.

11. Norman Cohn, *The Pursuit of the Millennium* (London, 1957).

12. See Spencer R. Weart, *Nuclear Fear: A History of Images* (Cambridge, Mass., 1988), p. 397.

13. Ibid., p. 260.

14. For a discussion of such books, see John Elson, "Apocalypse Now?" *Time* (February 11, 1991), p. 88.

15. Barry Commoner, *The Closing Circle: Nature, Man and Technology* (New York, 1971); Robert L. Heilbronner, *An Inquiry into the Human Prospect* (New York, 1974); Jonathan Schell, *The Fate of the Earth* (New York, 1982).

16. Elaine Showalter, *Sexual Anarchy: Gender and Culture at the Fin de Siècle* (New York, 1990), p. 176.

17. Barkun, "Divided Apocalypse," p. 278.

18. Derrida, to be sure, has resisted incorporation into the discourse of postmodernism. See his remarks recorded by Ingeborg Hoesterey in her introduction to *Zeitgeist in Babel: The Postmodernist Controversy*, ed. Ingeborg Hoesterey (Bloomington, Ind., 1991), p. xii. What he apparently dislikes about it is its implied notion of linear historical periodization. But Derrida's work has certainly figured prominently in the discourse of postmodernism, which cannot be fully grasped without taking it into account.

19. For an account of the linkage in eighteenth-century Britain, see Morton D. Paley, *The Apocalyptic Sublime* (New Haven, 1986).

20. Frank Kermode, "Apocalypse and the Modern," in Friedländer et al., eds. *Visions of Apocalypse*. A similar apocalyptic current ran through certain Western Marxist theorists of the same era, such as Ernst Bloch and Walter Benjamin. For an account, see Anson Rabinbach, "Between Enlightenment and Apocalypse: Benjamin, Bloch and Modern Jewish Messianism," *New German Critique* 34 (Winter, 1985); and Michael Löwy, *Rédemption et Utopie: Le judaïsme libertaire en Europe centrale* (Paris, 1988). In fact, apocalyptic fantasies were common coin among many German intellectuals during the Weimer era. See Ivo Frenzel, "Utopia and Apocalypse in German Literature," *Social Research* 39, 2 (Summer, 1972).

21. Yve-Alain Bois, "Painting: The Task of Mourning," *Endgame* (Boston, 1990), p. 30. Bois is referring to the belief that abstraction was the final reduction of painting to its essence, after which nothing more could be done. There were, to be sure, more literal modernist attempts to depict apocalypse, for example by the German Expressionist Ludwig Meidner. See Carol S. Eliel, *The Apocalyptic Landscape of Ludwig Meidner* (Los Angeles, 1989).

22. Klaus R. Scherpe, "Dramatization and De-dramatization of 'the End': The Apocalyptic Consciousness of Modernity and Post-modernity," *Cultural Critique* 5 (Winter, 1986–87), p. 122.

23. For a suggestive reading of the *posthistoire* discourse, see Lutz Niethammer, "Afterthoughts on Posthistoire," *History and Memory* I, 1 (Spring/Summer, 1989). The relation between history and apocalypse, it should be noted, is more complicated than may appear at first glance. Hans Blumenberg has contended that the "historicization of eschatology" in the early Christian era did not mean putting the moment of redemption in the historical future, but rather believing that it had occurred in the past. That is, disappointed initial hopes for a Second Coming led to the consoling belief that all that was needed for personal salvation had been already provided by the First Coming, which allowed the faithful to gain heaven by acting on the basis of Jesus's message. See *The Legitimacy of the Modern Age*, trans. Robert M. Wallace (Cambridge, Mass., 1983), chapter 4. If this is true, then the postmodernist belief in *posthistoire* should also be understood as denying past as well as future consolations.

24. Derrida, "Of an Apocalyptic Tone Recently Adopted in Philosophy," *Semeia* 23 (1982). Derrida acknowledges in this essay the prevalence of apocalyptic concerns elsewhere in his work, such as *Glas*, *La Carte postale* and the essays "Pas" and "Living On" (pp. 90–91). "The Ends of Man" is available in *Margins of Philosophy*, trans. Alan Bass (Chicago, 1982). It deals with the theme of the last man and the end of metaphysics in philosophers like Heidegger and Nietzsche. He treats the theme again in his essay on "nuclear criticism," entitled "No Apocalypse, Not Now (Full Speed Ahead, Seven Missiles, Seven Missives)," *Diacritics* 14, 2 (Summer, 1984). Here the three apocalyptic discourses—religious, scientific, and postmodern—all mingle in the shadow of the nuclear holocaust.

25. Kant, "Von einem neuerdings erhobenen vornehmen Ton in der Philosophie," in *Schriften von 1790–1796 von Immanuel Kant*, ed. A. Buchenau, E. Cassirer, B. Kellerman, vol. 6 of *Immanuel Kants Werke*, ed. E. Cassirer (Berlin, 1923), pp. 475–496.

26. The distinction between knowledge and thought is based on the crucial opposition in Kant between the synthetic a priori judgments of pure reason and the speculative ideas that metaphysics had claimed it could provide. Only in practical reason, the moral reasoning discussed in the Second Critique, are such ideas given to us, but they can never be grounded in synthetic a priori judgments.

27. Derrida, "Of an Apocalyptic Tone Recently Adopted in Philosophy," p. 80.

28. Ibid.

29. Ibid., p. 87.

30. Ibid., p. 89.

31. In so doing, Derrida curiously forgets what he has argued elsewhere: that there can be no absolutely categorical distinction between prescriptive and descriptive language games (between the Greek fascination with ontology and the Jewish obsession with ethics). See his critique of Levinas for precisely this failing: "Violence and Metaphysics: An Essay on the Thought of Emmanuel Levinas," *Writing and Difference*, trans. Alan Bass (Chicago, 1978). Instead, in this essay he sounds very much like Lyotard, who follows Levinas more rigorously in such works as *The Differend: Phrases in Dispute*, trans. George Van Den Abbeele (Minneapolis, 1988).

32. Derrida, "Of an Apocalyptic Tone Recently Adopted in Philosophy," p. 93.

33. Ibid., p. 94.

34. Ibid., p. 95.

35. John P. Leavy, Jr., "Destinerrance: The Apotropocalyptics of Translation," *Deconstruction and Philosophy: The Texts of Jacques Derrida*, ed. John Sallis (Chicago, 1987).

36. Eric L. Santner, *Stranded Objects: Mourning, Memory and Film in Postwar Germany* (Ithaca, 1990), p. 13. Santner argues that much postmodernism represents itself as a healthy mourning for the lost hopes of the modernist project, but as he notes in the complicated case of Paul de Man in particular, the mourning appears endless. That is, de Man's insistence that language itself necessitates a never-ending mourning for its inability to achieve plenitude leads to a valorization of repetition that is closer to melancholy than mourning per se. It is, to be sure, a melancholy shorn of its affective charge and abstracted from any link with actual lived experience and the human solidarity that might be its antidote.

37. Jean Baudrillard, "Sur le nihilisme," *Simulacres et simulation* (Paris, 1981), p. 234.

38. Lyotard, "A Conversation with Jean-François Lyotard," *Flash Art* (March, 1985), p. 33.

39. John Rajchman, "The Postmodern Museum," *Art in America* 73, 10 (October, 1985), p. 115.

40. For a different attempt to psychologize the apocalyptic mentality, see Robert J. Lifton, "The Image of 'The End of the World': A Psychohistorical View," in Friedländer et al., *Visions of Apocalypse*. He relates it to paranoid schizophrenia, as in the case of Schreber.

41. Sigmund Freud, "Mourning and Melancholia," *Collected Papers*, vol. 4, ed. Ernest Jones (New York, 1959). There is a vast pre-Freudian literature on the theme of melancholy, from literary, pictorial, theological, and medical points of view. For helpful overviews, see Raymond Klibansky, Erwin Panofsky, and Fritz Saxl, *Saturn and Melancholy: Studies in the History of Natural Philosophy, Religion and Art* (London, 1964); Reinhard Kuhn, *The Demon of Noontide: Ennui in Western Literature* (Princeton, 1976); Wolf Lepenies, *Melancholie und Gesellschaft* (Frankfurt, 1972).

42. Freud, "Mourning and Melancholia," p. 154.

43. Ibid., p. 153.

44. Ibid., p. 157. This essay provides one of the earliest accounts of what he would later call the superego.

45. Ibid., p. 159.

46. Ibid., p. 164.

47. Freud, *Group Psychology and the Analysis of the Ego*, trans. James Strachey (New York, 1985), p. 82f.

48. See in particular, Melanie Klein's 1940 paper, "Mourning and Its Relation to Manic-Depressive States," *Contributions to Psychoanalysis, 1921–1945* (London, 1973). For a general overview of the literature, see Lorraine D. Siggens, "Mourning: A Critical Survey of the Literature," *International Journal of Psychoanalysis* 47 (1966), pp. 14–25, and the more recent bibliography in Neal L. Tolchin, *Mourning, Gender, and Creativity in the Art of Herman Melville* (New Haven, 1988).

49. See, for example, Jonathan Schell, *The Fate of the Earth* (New York, 1982), pp. 127, 174.

50. For good account of this aspect of their work, see Michael E. Zimmerman, *Heidegger's Confrontation with Modernity: Technology, Politics, Art* (Bloomington, Ind., 1990).

51. Freud, "Mourning and Melancholia," p. 163.

52. See Alexander and Margarete Mitscherlich, *The Inability to Mourn: Principles of Collective Behavior*, trans. Beverley R. Placzek (New York, 1975) and Santner, *Stranded Objects*.

53. Mortimer Ostow, "Archetypes of Apocalypse in Dreams and Fantasies, and in Religious Scripture," *American Imago* 43, 4 (Winter, 1986), p. 308.

54. Abrams, *Natural Supernaturalism*, p. 45.

55. Jean-Joseph Goux, *Les iconoclastes* (Paris, 1978).

56. Lyotard, "Figure Foreclosed," *The Lyotard Reader*, ed. Andrew Benjamin (Oxford, 1989).

57. Julia Kristeva, *Black Sun: Depression and Melancholia*, trans. Leon S. Roudiez (New York, 1989). For a helpful analysis, see John Lechte, "Art, Love and Melancholy in the Work of Julia Kristeva," in John Fletcher and Andrew Benjamin, eds., *Abjection, Melancholy and Love: The Work of Julia Kristeva* (London, 1990).

58. Ibid., p. 13.

59. Ibid.

60. Ibid., pp. 27–28. She borrows Klein's notion of the "depressive position" to indicate the first stage of breaking with the mother. It should be noted that according to Klein, this is a normal and not pathological moment in human development, despite the seemingly pejorative label. For a suggestive application of this and other Kleinian categories to moral and social phenomena, which illuminates the issues addressed in this paper, see C. Fred Alford, *Melanie Klein and Critical Social Theory* (New Haven, 1989).

61. Ibid., p. 28.

62. Ibid., p. 22.

63. Ibid., p. 224.

64. Ibid., p. 61.

65. As Kristeva puts it, "in order to protect mother I kill myself while knowing—phantasmatic and protective knowledge—that it comes from her, the death-bearing she-Gehenna . . . Thus my hatred is safe and my matricidal guilt erased. I make of Her an image of Death so as not to be shattered through the hatred I bear against myself when I identify with Her, for that aversion is in principle meant for her as it is an individuating dam against confusional love" (Ibid., p. 28).

66. Bram Dijkstra, *Idols of Perversity: Fantasies of Feminine Evil in Fin-de-siècle Culture* (New York, 1986).

67. Evelyn Fox Keller, *Reflections on Gender and Science* (New Haven, 1985); Susan R. Bordo, *The Flight to Objectivity: Essays on Cartesianism and Culture* (Albany, N.Y., 1987).

68. For an interesting defense of this position, which uses Roland Barthes's treatment of his mother's death in *Camera Lucida* to modify Freud, see Kathleen Woodward, "Freud and Barthes: Theorizing Mourning, Sustaining Grief," *Discourse* 13, 1 (Fall-Winter, 1990–1991).

8. The Rise of Hermeneutics and the Crisis of Ocularcentrism

1. Jacques Ellul, *The Humiliation of the Word*, trans. Joyce Main Hanks (Grand Rapids, Mich., 1985).

2. Ibid., p. 119.

3. Ibid., p. 81.

4. Ibid., p. 48.

5. See, for example, Susan A. Handelman, *The Slayers of Moses: The Emergence of Rabbinic Interpretation in Modern Literary Theory* (Albany, N.Y., 1982), p. 90. It has been argued, however, by W. J. T. Mitchell that the *Imago Dei* is better understood as a "likeness" than a "picture," that is, as a spiritual similarity. See his "What Is an Image?" *New Literary History* 15, 3 (Spring, 1984), p. 521.

6. Ellul, *The Humiliation of the Word* p. 115. See Guy Debord, *Society of the Spectacle* (Detroit, 1970).

7. See, for example, Norman Bryson, *Word and Image: French Painting of the Ancien Régime* (Cambridge, 1981), p. 1f.

8. Ellul's animosity toward Goux is particularly striking. He dislikes the psychoanalytic dimension of Goux's *Les iconoclastes* (Paris, 1978), as well as his contention that Christianity has an affinity for imagistic representation. Foucault's analysis of the panopticon

is mentioned approvingly but criticized for not stressing the evils of technology sufficiently. Ricoeur is treated more kindly than the others.

9. Martin Jay, "In the Empire of the Gaze: Foucault and the Denigration of Vision in Twentieth-Century French Thought," in David Couzens Hoy, ed. *Foucault: A Critical Reader* (London, 1986).

10. See Marcel Duchamp, *Ingénieur du temps perdu: Entretiens avec Pierre Cabanne* (Paris, 1977), p. 65.

11. For an analysis of the importance of spectacle in maintaining political power, see Jean-Marie Apostolidès, *Le roi-machine: Spectacle et politique au temps de Louis XIV* (Paris, 1981).

12. Martin Heidegger, "The Age of the World Picture" in *The Question Concerning Technology and Other Essays*, trans. with intro., William Lovitt (New York, 1977).

13. Richard Rorty, *Philosophy and the Mirror of Nature* (Princeton, 1979).

14. For a discussion of this theme, see Odo Marquard, "The Question, To What Question is Hermeneutics the Answer?" in *Contemporary German Philosophy*, vol. 4, ed. Darrel E. Christensen et al. (Pennsylvania State, 1984). Marquard offers several useful answers (hermeneutics is a response to human finitude, to human derivativeness, to human transitoriness, to the civil war over the absolute text, and to the need to break codes), but he does not investigate the crisis of ocularcentrism as another source.

15. Hans-Georg Gadamer, *Truth and Method* (New York, 1975), p. 420. Gadamer credits Aristotle with this insight.

16. Ellul, p. 11.

17. Ibid., p. 12.

18. Ibid., p. 97.

19. Ibid., p. 95.

20. See *Modernes et après? Les Immatériaux*, ed. Élie Théofilakis (Paris, 1985).

21. Goux, *Les iconoclastes*, p. 101f.

22. For a recent discussion of its significance, see Tobin Siebers, *The Mirror of Medusa* (Berkeley, 1983). For a study of apotropaic reactions to the evil eye, see Albert M. Potts, *The World's Eye* (Lexington, Ky., 1982).

23. See, for example, Hans Jonas, "The Nobility of Sight," in *The Phenomenon of Life: Toward a Philosophical Biology* (Chicago, 1966). He appends, however, a short discussion of "Sight and Movement," which complicates his argument somewhat.

24. For a helpful discussion of the differences, see Norman Bryson, *Vision and Painting: The Logic of the Gaze* (New Haven, 1983), p. 87f.

25. For a treatment of Javal's work and its implication, see Paul C. Vitz and Arnold B. Glimcher, *Modern Art and Modern Science: The Parallel Analysis of Vision* (New York, 1984), p. 122f.

26. Maurice Merleau-Ponty, *The Visible and the Invisible*, ed. Claude Lefort, trans. Alphonso Lingis (Evanston, Ill., 1968).

27. Augustine develops the connection in chapter 35 of his *Confessions*.

28. Another French critic of visual primacy who has made a similar point is the Jewish phenomenologist Emmanuel Levinas. For an excellent discussion of his attitude toward the senses, see Edith Wyschograd, "Doing Before Hearing: On the Primacy of Touch,"

in François Laruelle ed., *Textes pour Emmanuel Levinas* (Paris, 1980). Levinas goes beyond the privileging of hearing over sight to emphasize the importance of the caress.

29. Paul Ricoeur, "Manifestation et proclamation," in *Le Sacré*, ed. Enrico Castelli (Paris, 1974).

30. Hans Blumenberg, *The Legitimacy of the Modern Age*, trans. Robert M. Wallace (Cambridge, Mass., 1983), part 3.

31. Freud, of course, had speculated that civilization itself had begun with the abandonment of our crawling on all fours and adoption of an erect posture. See *Civilization and Its Discontents*, trans. James Strachey (New York, 1961), pp. 46–47. On the link between the upright posture and dignity, see Ernst Bloch, *Natural Law and Human Dignity*, trans. Dennis J. Schmidt (Cambridge, Mass., 1986). A much earlier connection was drawn by Herder, who was criticized for neglecting the transcendental source of rationality by Kant. For a suggestive, psychoanalytically informed treatment of their dispute, see Mark Poster, "Kant's Crooked Stick," *The Psychoanalytic Review* 61, 3 (1974), pp. 475–480.

32. See, for example, Evelyn Fox Keller and Christine Grontowski, "The Mind's Eye," in Sandra Harding and Merrill B. Hintikka, eds., *Discovering Reality: Feminist Perspectives on Epistemology, Metaphysics, Methodology and Philosophy of Science* (Boston, 1983), and Deena Weinstein and Michael Weinstein, "On the Visual Constitution of Society: The Contributions of Georg Simmel and Jean-Paul Sartre," *History of European Ideas* 5 (1984), pp. 349–362.

33. Jean-Paul Sartre, *Being and Nothingness: An Essay on Phenomenological Ontology*, trans. with intro. Hazel E. Barnes (New York, 1966), p. 310f.

34. If we employ an elastic concept of hermeneutics, this generalization is especially true. Susan Handelman, for example, has claimed that much contemporary poststructuralist thought can be understood as a secular instantiation of the "heretic hermeneutics" she sees in the Rabbinic tradition. See *The Slayers of Moses, passim*. Although more interested in texts than dialogic interactions, this tradition is equally suspicious of the primacy of vision.

35. The origin of this term is Merleau-Ponty, *The Visible and the Invisible*, p. 75. It is the subject of an illuminating essay by Michel de Certeau, "La folie de la vision," *Esprit* 66 (June, 1982), pp. 89–99. De Certeau is the figure to whom Christine Buci-Glucksmann dedicates *La folie du voir: De l'esthétique baroque* (Paris, 1986).

36. Mary Ann Caws, *The Eye in the Text: Essays on Perception, Mannerist to Modern* (Princeton, 1981).

37. Vasco Ronchi, *Optics: The Science of Vision*, trans. Edward Rosen (New York, 1957). See also David C. Lindberg, *Theories of Vision from Al-Kindi to Kepler* (Chicago, 1976).

38. See Stephen H. Daniel, "The Nature of Light in Descartes' Physics," *The Philosophical Forum* 7 (1976), pp. 323–344.

39. See Benjamin Goldberg, *The Mirror and Man* (Virginia, 1985), p. 112f.

40. For a discussion of this conflict, see Bryson, *Word and Image*, p. 60f.

41. For a subtle discussion of the differences between Greek *theoria* and modern, post-Cartesian science, see Gadamer, *Truth and Method*, p. 412f.

42. Ellul discusses its importance on p. 233.

43. Ibid.

44. Merleau-Ponty, *The Visible and the Invisible*. For a psychoanalytic use of Merleau-Ponty's argument, see Jacques Lacan, *The Four Fundamental Concepts of Psycho-analysis*,

ed. Jacques-Alain Miller, trans. Alan Sheridan (New York, 1978), p. 67f. Neither of them explicitly draws on the *lux/lumen* distinction, but it would be easy to interpret it in their terms.

45. It is, of course, Ricoeur who posits the distinction between a hermeneutics of recollected meaning and a hermeneutics of suspicion. See his *Freud and Philosophy: An Essay on Interpretation*, trans. Denis Savage (New Haven, 1970), p. 28f. Ellul would clearly be in the former camp; the heretic hermeneuticians discussed by Handelman would belong to the latter.

46. Rodolphe Gasché, *The Tain of the Mirror: Derrida and the Philosophy of Reflection* (Cambridge, Mass., 1986), pp. 16–17.

47. Thorlieff Boman, *Hebrew Thought Compared with Greek* (Philadelphia, 1954); Handelman, *The Slayers of Moses*.

48. Gadamer, *Truth and Method*, p. 423.

49. Heinz Kohut, "Forms and Transformations of Narcissism," *Journal of the American Psychoanalytic Association* 14 (1966), pp. 243–276. For a creative use of this argument with reference to the theme of vision, see Kathleen Woodward, "The Look and the Gaze: Narcissism, Aggression and Aging," Working Paper #7 of the Center for Twentieth Century Studies, Fall, 1986.

50. For a discussion, see Goldberg, *The Mirror and Man*, p. 122.

51. Gasché, *The Tain of the Mirror*, p. 102.

52. Paul Ricoeur, *The Rule of Metaphor* (Toronto, 1978), p. 7.

53. Gadamer, *Truth and Method*, p. 308.

54. Christine Buci-Glucksmann, *La raison baroque: De Baudelaire à Benjamin* (Paris, 1984) and *La folie du voir*.

55. Buci-Glucksmann, *La folie du voir*, p. 70f.

56. The French fascination for anamorphosis was stimulated in part by Jurgen Baltrušaitis. See his *Anamorphoses: Les perspectives dépravées* (Paris, 1984). The first edition appeared in 1955 and one can find references to it in Lyotard, Lacan, and others interested in visual themes.

57. Buci-Glucksmann, *La folie du voir*, p. 84. The term conjures up Merleau-Ponty's critique of "high-altitude thinking."

58. Walter Benjamin, *Origin of German Tragic Drama*, trans. John Osborne, intro. George Steiner (London, 1977).

59. Goux in *Les iconoclastes* makes a strong case for the pervasive hostility to images in modern art, economics, religion and psychoanalysis.

60. Mitchell, "What Is an Image?" p. 529.

61. For a discussion of Heidegger's use of aural metaphors, see John D. Caputo, "The Thought of Being and the Conversation of Mankind: The Case of Heidegger and Rorty," in Robert Hollinger, ed., *Hermeneutics and Praxis* (Notre Dame, Ind., 1985), p. 255.

62. For an interesting comparison of Heidegger's use of *Umsicht* with Wittgenstein's notion of *Übersicht*, see Nicholas F. Gier, *Wittgenstein and Phenomenology: A Comparative Study of the Later Wittgenstein, Husserl, Heidegger, and Merleau-Ponty* (Albany, N.Y., 1981), p. 80f.

63. Gadamer, *Truth and Method*, p. 269.

64. Ibid., p. 12.

65. For an account of the debate, see Martin Jay, "Should Intellectual History Take a Linguistic Turn? Reflections on the Habermas-Gadamer Debate," in Dominick LaCapra and Steven L. Kaplan eds., *Modern European Intellectual History: Reappraisals and New Perspectives* (Ithaca, 1982).

66. Habermas's most sustained discussion of the need to use both interpretative and explanatory models can be found in *Zur Logik der Sozialwissenschaften* (Frankfurt, 1970). The term "second nature" is, of course, Hegel's and is revived in the Hegelian Marxist tradition begun by Lukács.

67. Gadamer, *Truth and Method*, p. 426.

68. Ibid., p. 432.

69. Kathleen Wright, "Gadamer: The Speculative Structure of Language," in Brice R. Wachterhauser, *Hermeneutics and Modern Philosophy* (Albany, N.Y., 1986), p. 211.

70. To be fair to Ellul, he does talk of dialogue, but it would be difficult to call it symmetrical.

71. Buci-Glucksmann, *La folie du voir*, p. 134. For another consideration of the interpenetration of words and images in language, which comes to similar conclusions, see Jean-François Lyotard, *Discours. Figure* (Paris, 1971). In a very different way, the importance of the visual in rhetoric is suggested by Frances A. Yates in her classic study of *The Art of Memory* (Chicago, 1966).

72. Buci-Glucksmann, *La folie du voir*, p. 197.

9. Scopic Regimes of Modernity

1. See, for example, Lucien Febvre, *The Problem of Unbelief in the Sixteenth Century: The Religion of Rabelais*, trans. Beatrice Gottlieb, (Cambridge, Mass., 1982) and Robert Mandrou, *Introduction to Modern France, 1500–1640: An Essay on Historical Psychology*, trans. R. B. Hallmark (New York, 1976).

2. Marshall McLuhan, *Understanding Media: The Extensions of Man* (London, 1964); Walter J. Ong, *The Presence of the Word* (New Haven, 1967); see also Elizabeth Eisenstein, *The Printing Press as an Agent of Change* (Cambridge, 1979).

3. Donald M. Lowe, *History of Bourgeois Perception* (Chicago, 1982), p. 26.

4. For an account of the positive attitude toward vision in the medieval church, see Margaret R. Miles, *Image as Insight: Visual Understanding in Western Christianity and Secular Culture* (Boston, 1985). Contrary to the argument of Febvre and Mandrou, which has been very influential, she shows the extent to which sight was by no means widely demeaned in the Middle Ages.

5. Richard Rorty, *Philosophy and the Mirror of Nature* (Princeton, 1979), Michael Foucault, *Discipline and Punish: The Birth of the Prison*, trans. Alan Sheridan (New York, 1979); Guy Debord, *Society of the Spectacle* (Detroit, 1983).

6. Christian Metz, *The Imaginary Signifier: Psychoanalysis and Cinema* trans. Celia Britton et al., (Bloomington, Ind., 1982), p. 61.

7. Jacqueline Rose, *Sexuality in the Field of Vision* (London, 1986), pp. 232–233.

8. William M. Ivins, Jr., *Art and Geometry: A Study in Space Intuitions* (Cambridge, Mass., 1946), p. 81.

9. Rorty, p. 45.

10. Erwin Panofsky, "Die Perspektive als 'symbolischen Form'," *Vorträge der Bibliothek Warburg*, 1924/5, 4, pp. 258–331.

11. William M. Ivins, Jr., *On the Rationalization of Sight* (New York, 1973); Panofsky, "Die Perspektive als 'symbolischen Form' "; Richard Krautheimer, "Brunelleschi and Linear Perspective," in I. Hyman, ed., *Brunelleschi in Perspective* (Englewood Cliffs, N.J., 1974); Samuel Y. Edgerton, Jr., *The Renaissance Rediscovery of Linear Perspective* (New York, 1975); John White, *The Birth and Rebirth of Pictorial Space* (Cambridge, Mass., 1987); Michael Kubovy, *The Psychology of Perspective and Renaissance Art* (Cambridge, 1986).

12. Rosalind E. Krauss, *The Originality of the Avant-Garde and Other Modernist Myths* (Cambridge, Mass., 1985), p. 10.

13. Norman Bryson, *Vision and Painting: The Logic of the Gaze* (New Haven, 1983), p. 94.

14. Augustine discusses ocular desire in chapter 35 of the *Confessions*.

15. For discussion of the gender implications of this work, see Svetlana Alpers, "Art History and its Exclusions," in Norma Broude and Mary D. Garrard, eds., *Feminism and Art History* (New York, 1982), p. 187.

16. Norman Bryson, *Word and Image: French Painting of the Ancien Régime* (Cambridge, 1981), chapter 1.

17. Edgerton, p. 39.

18. John Berger, *Ways of Seeing* (London, 1972), p. 109.

19. Martin Heidegger, "The Question Concerning Technology," *The Question Concerning Technology and Other Essays*, trans. William Lovitt (New York, 1977), p. 17. Heidegger's most extensive critique of Cartesian perspectivalism can be found in his essay, "The Age of the World Picture," in the same volume.

20. White, p. 208.

21. Kubovy, chapter 4.

22. Sarah Kofman, *Camera Obscura: de l'idéologie* (Paris, 1973) treats this theme in Nietzsche.

23. Bryson, *Vision and Painting*, p. 112.

24. Svetlana Alpers, *The Art of Describing: Dutch Art in the Seventeenth Century* (Chicago, 1983).

25. Ibid., p. xix.

26. Ibid., p. 44.

27. Ibid., p. 138.

28. Ibid., p. 43.

29. Aaron Scharf, *Art and Photography* (New York, 1986), chapter 8.

30. Peter Galassi, *Before Photography: Painting and the Invention of Photography* (New York, 1981).

31. Heinrich Wölfflin, *Renaissance and Baroque*, trans. K. Simon (London, 1964). See also the systematic development of the contrast in *Principles of Art History: The Problem of the Development of Style in Later Art*, trans. M. D. Hottinger (New York, 1932).

32. José Antonio Maravall, *Culture of the Baroque: Analysis of a Historical Structure*, trans. Terry Cochran (Minneapolis, 1986).

33. Christine Buci-Glucksmann, *La raison baroque: de Baudelaire à Benjamin* (Paris, 1984) and *La folie du voir* (Paris, 1986).

34. Rodolphe Gasché, *The Tain of the Mirror: Derrida and the Philosophy of Reflection* (Cambridge, Mass., 1986).

35. As Buci-Glucksmann recognizes, Leibnizian pluralism retains a faith in the harmonizing of perspective that is absent from the more radically Nietzschean impulse in the Baroque. See *La folie du voir*, p. 80, where she identifies that impulse with Gracián and Pascal.

36. See Irit Rogoff, "Mapping Out Strategies of Dislocation," in the catalogue for Neustein's October 24–November 26, 1987, show at the Exit Art gallery in New York.

37. Krauss, "The Photographic Conditions of Surrealism," in *The Originality of the Avant-garde*. See also her work with Jane Livingstone, *L'Amour Fou: Photography and Surrealism* (New York, 1986).

38. Buci-Glucksmann, *La folie du voir*, chapter 6.

39. It was first given at the Dia Art Foundation in New York in April, 1988 and published in *Vision and Visuality*, ed. Hal Foster (Seattle, 1988).

40. Another potentially interesting application would be to varieties of landscape architecture, the interface between "nature" and "culture," which might get beyond the time-honored dichotomies of the garden versus the wilderness, or the French and English gardens.

41. For an account of the city, see Philippe Boudon, *Richelieu, ville nouvelle* (Paris, 1978).

42. Alpers, *The Art of Describing*, p. 152.

43. Germain Bazin, *The Baroque: Principles, Styles, Modes, Themes* (London, 1968), p. 311.

44. Bazin, *The Baroque*, p. 312.

10. Ideology and Ocularcentrism: Is There Anything Behind the Mirror's Tain?

1. Karl Marx and Friedrich Engels, *The German Ideology*, ed. with intro. C. J. Arthur (London, 1970), p. 47; for a recent consideration of the metaphor, see W. J. T. Mitchell, *Iconology: Image, Text, Ideology* (Chicago, 1986), chapter 6.

2. For useful discussions of these and other visual metaphors in Western epistemologies, see Hans Jonas, "The Nobility of Sight" in *The Phenomenon of Life: Toward a Philosophical Biology* (Chicago, 1982); and Evelyn Fox Keller and Christine R. Grontowski, "The Mind's Eye," in *Discovering Reality: Feminist Perspectives on Epistemology, Metaphysics, Methodology, and Philosophy of Science*, ed. Sandra Harding and Merrill B. Hintikka (Dordrecht, 1983).

3. Hans Blumenberg, "Licht als Metaphor der Wahrheit," *Studium Generale* 10 (1957), pp. 432–447.

4. This was the title of an essay by Carlyle printed in James Anthony Froude, *Thomas Carlyle 1795–1835*, 2 vols. (New York, 1882), II, pp. 7–12. For a discussion of the Romantic attitude toward vision, see M. H. Abrams, *Natural Supernaturalism: Tradition and Revolution in Romantic Literature* (New York, 1973), p. 373f.

5. For a critique of the disembodied eye, see Maurice Merleau-Ponty, "Eye and Mind" in *The Primacy of Perception*, ed. with intro. James M. Edie (Evanston, 1964). It might be noted that Descartes, for all his hostility to the imperfections of the actual human

eyes, did advocate the usage of the newly discovered telescope in his *Dioptrique* of 1637.

6. Augustine discusses ocular desire in chapter 35 of his *Confessions,* where he links it to the temptations of idle curiosity.

7. G. M. Stratton performed an experiment wearing an inverted lens for eight days and discovered that he was able to reacquire normal, straightforward vision. See his "Vision without Inversion of the Retinal Image," *Psychological Review* IV, 5 (September, 1897).

8. Martin Jay, "In the Empire of the Gaze: Foucault and the Denigration of Vision in Twentieth-century French Thought," in David Couzens Hoy, ed., *Foucault: A Critical Reader* (London, 1986).

9. Claude Lefort, *The Political Forms of Modern Society: Bureaucracy, Democracy, Totalitarianism,* ed. with intro. John B. Thompson (London, 1986), pp. 196–202.

10. Louis Althusser, *Lenin and Philosophy and Other Essays,* trans. Ben Brewster (New York, 1971), p. 153.

11. See especially, Luce Irigaray, *Speculum of the Other Woman,* trans. Gillian C. Gill (Ithaca, 1985).

12. Sarah Kofman, *Camera Obscura—de l'idéologie* (Paris, 1973).

13. Ibid., p. 33.

14. Ibid., pp. 59–60.

15. Rodolphe Gasché, *The Tain of the Mirror: Derrida and the Philosophy of Reflection* (Cambridge, Mass., 1986), p. 238.

16. A classic example is the use of the term in Daniel Bell, *The End of Ideology* (Glencoe, Ill., 1960). Other proponents of this view included Edward Shils, Raymond Aron, and Seymour Martin Lipset.

17. Richard Rorty, *Philosophy and the Mirror of Nature* (Princeton, 1979), p. 37. The phrase is taken from Shakespeare's *Measure for Measure.*

18. Paul de Man, *The Resistance to Theory* (Minneapolis, 1986), p. 11. See also his remarks on the need for "critique of ideology" and the relevance of Adorno and Heidegger to such a project on p. 121.

19. De Man, p. 11. See also the discussion of ideology in Michael Ryan, *Marxism and Deconstruction* (Baltimore, 1982), p. 39. Ryan contends that a belief in an ideal meaning prior to its textual expression is the equivalent of the idealism Marx was attacking in *The German Ideology.*

20. For an account of the crisis of the traditional aesthetic assumptions before the actual emergence of modernism, see Catherine Gallagher, *The Industrial Reformation of English Fiction 1832–1867* (Chicago, 1985). She demonstrates how the nineteenth-century realist novel also experienced a breakdown of formal consistency as it tried to incorporate new material from nonliterary discourses.

21. Jürgen Habermas, "Technology and Science as 'Ideology'," in *Toward a Rational Society: Student Protest, Science and Politics,* trans. Jeremy J. Shapiro (Boston, 1970).

22. John B. Thompson, *Studies in the Theory of Ideology* (Cambridge, 1984), p. 194.

23. Conference on The States of "Theory," University of California, Irvine, May, 1987.

24. Guy Debord, *Society of the Spectacle* (Detroit, 1970).

25. Cornelius Castoriadis, *L'Institution imaginaire de la société* (Paris, 1975); Paul Ricoeur, "Ideology and Utopia as Cultural Imagination," *Philosophic Exchange* 2 (Summer, 1976), pp. 17–28.

26. Recognizing the ambivalent quality of ideology as containing both a yearning for
 something better and a consolation for its unattainability under present circumstances
 may be seen as derived from the deconstructionist critique of either/or formulations.
 It may, however, also be understood as evidence of a dialectical concept of ideology,
 which can be traced back to Marx's usage itself.

11. Modernism and the Retreat from Form

1. See, for example, Peter Bürger, *Theory of the Avant-Garde*, trans. Michael Shaw (Min-
 neapolis, 1984), p. 19; or Suzi Gablik, *Progress in Art* (New York, 1976), p. 85.

2. See the essays collected in *Aesthetics and Politics; Debates Between Bloch, Lukács, Brecht,
 Benjamin, Adorno*, ed. New Left Review, afterword Fredric Jameson (London, 1977).

3. Bataille, "Formless," in *Visions of Excess; Selected Writings, 1927–1939*, ed. Allan Stoekl,
 trans. Allan Stoekl et al. (Minneapolis, 1985). The article first appeared as an entry in
 the *Dictionnaire critique* in *Documents* 7 (December, 1929).

4. Martin Jay, "In the Empire of the Gaze: Foucault and the Denigration of Vision in
 20th-century French Thought," in *Foucault: A Critical Reader*, ed. David Couzens Hoy
 (London, 1986); see also chapter 8.

5. Here I am drawing on the excellent essay by W. Tatarkiewicz on "Form in the History
 of Aesthetics" in *Dictionary of the History of Ideas*, vol. II, ed. Philip P. Weiner (New
 York, 1973).

6. For a subtle account of its implications, see Geoffrey Galt Harpham, *On the Grotesque:
 Strategies of Contradiction in Art and Literature* (Princeton, 1982).

7. Jacques Derrida, "Form and Meaning: A Note on the Phenomenology of Language,"
 Margins of Philosophy, trans. Alan Bass (Chicago, 1972), p. 158.

8. David Carroll, *The Subject in Question: The Languages of Theory and the Strategies of
 Fiction* (Chicago, 1982), p. 191.

9. On the relation between vision and form, see Hans Jonas, "The Nobility of Sight,"
 The Phenomenon of Life: Towards a Philosophical Biology (Chicago, 1982).

10. Clement Greenberg, *Art and Culture: Critical Essays* (Boston, 1965), p. 171.

11. See, for example, Frank, "Spatial Form in Modern Literature," in *The Avant-Garde
 Tradition in Literature*, ed. Richard Kostelanetz (Buffalo, N.Y., 1982).

12. Fredric Jameson, *The Prison-House of Language: A Critical Account of Structuralism and
 Russian Formalism* (Princeton, 1972), p. 52.

13. See, for example, Robert Goldwater, *Primitivism in Modern Art* (Cambridge, Mass.,
 1986).

14. For recent discussions of this issue, see Hal Foster, "The 'Primitive' Unconscious of
 Modern Art," *October* 34 (Fall, 1985), pp. 45–70; and James Clifford, *The Predicament
 of Culture: Twentieth-Century Ethnography, Literature and Art* (Cambridge, Mass., 1988).

15. See Clifford, *The Predicament of Culture*, chapter 4. It should also be noted that the
 Surrealists were keenly aware of the context of reception of primitive art, as they were
 among the most vociferous critics of French imperialism in the 1920s.

16. Bataille, "Formless," p. 31.

17. Ibid.

18. Although this is not the place to pursue the relation between visuality and concep-
 tuality, it should be mentioned that not all theorists have found them synonymous.

Theodor Adorno, for example, places visuality on the side of sensuality and juxtaposes it to the conceptual dimension of art. See his discussion in *Aesthetic Theory*, ed. Gretel Adorno and Rolf Tiedemann, trans. C. Lenhardt (London, 1984), p. 139f. He notes that the term "visuality" was used in epistemology to mean a content that was then formed.

19. Bataille, "Rotten Sun," in *Visions of Excess* p. 58.

20. Ibid. For Bataille's appreciation of Van Gogh in these terms, see his "Sacrificial Mutilation and the Severed Ear of Vincent Van Gogh," in *Visions of Excess*.

21. According to Rosalind Krauss, *informe* meant the undoing of the Aristotelian distinction between form and matter, not the privileging of one over the other. See her *The Originality of the Avant-Garde and Other Modernist Myths* (Cambridge, Mass., 1985), p. 53. This undoing, however, was more in the nature of a deconstruction than dialectical sublation.

22. Ibid., p. 64.

23. Bataille, "Base Materialism and Gnosticism," *Visions of Excess*, p. 47.

24. Bataille, *The Accursed Share*, vol. I, *Consumption*, trans. Robert Hurley (New York, 1988), p. 63f.

25. For a helpful account of the varieties of sovereignty—erotic, poetic, and political—in Bataille, see Michele H. Richman, *Reading Georges Bataille: Beyond the Gift* (Baltimore, 1982), chapter 3.

26. Acéphale was the name of the group Bataille helped form at the Collège de Sociologie in the late 1930s, which published a review with the same name. It referred to the headless body he found so attractive. For a sympathetic analysis of Bataille's notion of community, see Maurice Blanchot, *The Unavowable Community*, trans. Pierre Joris (Barrytown, N.Y., 1988).

27. Denis Hollier, *Against Architecture: The Writings of Georges Bataille*, trans. Betsy Wing (Cambridge, Mass., 1989), p. 24.

28. Kristin Ross, *The Emergence of Social Space: Rimbaud and the Paris Commune* (Minneapolis, 1988), p. 102.

29. The obvious influence of Gilles Deleuze and Félix Guattari on Ross's celebration of force over form is explicitly acknowledged (p. 67).

30. Ibid., p. 123.

31. Rosalind Krauss, "Corpus Delicti," *October* 33 (Summer, 1985), p. 34.

32. Ibid., p. 37.

33. Ibid., p. 72.

34. Jean-François Lyotard, *The Postmodern Condition: A Report on Knowledge*, trans. Geoff Bennington and Brian Massumi (Minneapolis, 1984), p. 77.

35. For Lyotard on Newman and the sublime, see his "Newman: The Instant," in *The Lyotard Reader*, ed. Andrew Benjamin (Oxford, 1989).

36. Lyotard, *The Postmodern Condition*, p. 78.

37. For a brief account, see H. H. Stuckenschmidt, *Twentieth-Century Music*, trans. Richard Deveson (New York, 1970), chapter 3.

38. See, for instance, Victor Burgin, *The End of Art Theory: Criticism and Postmodernity* (London, 1986); or the essays in *Art After Modernism: Rethinking Representation*, ed. Brian Wallis (New York, 1984). In Mary Kelly's contribution to the latter, "ReViewing

Modernist Criticism," she discusses the importance of performance art in terms that recall Bataille: "The art of the 'real body' does not pertain to the truth of visible form, but refers back to its essential content: the irreducible, irrefutable experience of *pain*" (p. 96).

39. According to Harpham, "most grotesques are marked by such an affinity/antagonism, by the co-presence of the normative, fully formed 'high' or ideal, and the abnormal, unformed, degenerate, 'low' or material" (*On the Grotesque*, p. 9).

40. Georg Lukács, *Soul and Form*, trans. Anna Bostock (Cambridge, Mass., 1971).

41. Ibid., p. 172.

42. Jacques Lacan, *The Four Fundamental Concepts of Psycho-analysis*, ed. Jacques Alain Miller, trans. Alan Sheridan (New York, 1981).

43. Philosophically, perhaps the most important defender of this position was Maurice Merleau-Ponty in such essays as "Cézanne's Doubt," *Sense and Non-Sense*, trans. Hubert L. Dreyfus and Patricia N. Dreyfus (Evanston, 1964). Not surprisingly, he was frequently criticized by those like Lyotard hostile to the high modernist fetish of pure opticality.

44. For an exploration of Lacan's debts to the Surrealist movement in the 1930s, see David Macey, *Lacan in Contexts* (London, 1988).

45. Slavoj Žižek, *The Sublime Object of Ideology* (London, 1989).

46. Jurgis Baltrušaitis, *Anamorphoses ou magie artificielle des effects merveilleux* (Paris, 1969), on which Lacan draws in *The Four Fundamental Concepts of Psycho-analysis*, p. 79f.

47. Joan Copjec, "The Orthopsychic Subject: Film Theory and the Reception of Lacan," *October* 49 (Summer, 1989), p. 69.

48. Bürger, *Theory of the Avant-Garde*.

12. The Textual Approach to Intellectual History

1. See, for example, Dominick LaCapra, *Rethinking Intellectual History: Texts, Contexts, Language* (Ithaca, 1983); and *History and Criticism* (Ithaca, 1985); Hans Kellner, "Triangular Anxieties: The Present State of Intellectual History," in *Modern European Intellectual History: Reappraisals and New Perspectives*, ed. Dominick LaCapra and Steven L. Kaplan (Ithaca, 1982), Robert F. Berkhofer, Jr., "The Challenge of Poetics to (Normal) Historical Practice," in *The Rhetoric of Interpretation and the Interpretation of Rhetoric*, ed. Paul Hernadi (Durham, 1989); David Harlan, "Intellectual History and the Return of Literature," *American Historical Review* 94, 3 (June, 1989); John Toews, "Intellectual History After the Linguistic Turn: The Autonomy of Meaning and the Irreducibility of Experience," *American Historical Review* 92, 4 (October, 1987); David Hollinger, "The Return of the Prodigal: The Persistence of Historical Knowing," *American Historical Review* 94, 3 (June, 1989); Anthony Pagden, Review Essay on LaCapra, *Journal of History of Ideas* 48 (1987), with LaCapra's replay, "A Review of a Review," *Journal of the History of Ideas* 49 (1986); James T. Kloppenberg, "Deconstruction and Hermeneutics as Strategies for Intellectual History: The Recent Work of Dominick LaCapra and David Hollinger," *Intellectual History Newsletter* 9 (1987), and "Objectivity and Historicism: A Century of American Historical Writing," *American Historical Review* 94, 4 (1989). See also the interesting exchange between LaCapra and Nancy Fraser in *Enclitic* 9, 1–2 (1987).

2. Reprinted in *Meaning and Context: Quentin Skinner and His Critics*, ed. James Tully (Cambridge, 1988).

3. These are conveniently collected in *Meaning and Context*.

4. Skinner, "A Reply to My Critics," *Meaning and Context*, p. 270. Compare this statement with his earlier remark that "the recovery of the historical meaning of any given text is a necessary condition of understanding it." ("Some Problems in the Analysis of Political Thought and Action," *Meaning and Context*, p. 104.)

5. David Couzens Hoy, *The Critical Circle: Literature and History in Contemporary Hermeneutics* (Berkeley, 1978), p. 145.

6. Stanley Fish, *Is There a Text in This Class?* (Cambridge, Mass., 1980).

7. Tony Bennett, "Texts in History: The Determination of Readings in Texts," in *Poststructuralism and the Question of History*, ed. Derek Attridge, Geoff Bennington, and Robert Young (Cambridge, 1987), p. 70.

8. Clifford Geertz, "Deep Play: Notes on the Balinese Cockfight," *The Interpretation of Cultures* (New York, 1973), p. 452.

9. Ricoeur, "The Model of the Text: Meaningful Action Considered as a Text," in *Interpretative Social Science: A Reader*, ed. Paul Rabinow and William M. Sullivan (Berkeley, 1979).

10. Bouwsma, "Intellectual History in the 1980's: From History of Ideas to the History of Meaning," *Journal of Interdisciplinary History*, XII, 2 (Autumn, 1981). I have discussed the implications of this essay in *Fin-de-siècle Socialism and Other Essays* (New York, 1988), chapter 3.

11. Ricoeur, p. 89.

12. To be sure, he warns that "there are enormous difficulties in such an enterprise, methodological pitfalls to make a Freudian quake, and some moral perplexities as well" (pp. 452–453). But the example of his own performance suggests a great deal of confidence in being able to surmount these difficulties.

13. Crapanzano, "Hermes' Dilemma: The Masking of Subversion in Ethnographic Description," in *Writing Culture: The Poetics and Politics of Ethnography*, ed. James Clifford and George E. Marcus (Berkeley, 1986), p. 74.

14. See my *Fin-de-siècle Socialism*, p. 43.

15. This translation is suggested by Gayatri Chakravorty Spivak in "Speculations on Reading Marx: After Reading Derrida," in *Post-structuralism and the Question of History*, p. 30. The other most notorious deconstructionist expression of a similar idea is Paul de Man's claim in his essay on "Literary History and Literary Modernity," *Blindness and Insight: Essays in the Rhetoric of Contemporary Criticism* (Oxford, 1971) that "the bases for historical knowledge are not empirical facts but written texts, even if these texts masquerade in the guise of wars or revolutions" (p. 165). Interestingly, one of the first critics of deconstructionist pantextualism was Michel Foucault, who charged in his reply to Derrida's critique of *Madness and Civilization* that his was "a pedagogy which teaches the pupil that there is nothing outside the text." See Foucault, "My Body, This Paper, This Fire," *Oxford Literary Review* 4, 1 (1979), p. 27.

16. De Man contends that "speech act theories of reading in fact repeat, in a much more effective way, the grammatization of the *trivium* at the expense of rhetoric. For the characterization of the performative as sheer convention reduces it in effect to a grammatical code among others. . . . Speech act oriented theories of reading read only to the extent that they prepare the way for the rhetorical reading they avoid" (*The Resistance to Theory*, foreword Wlad Godzich [Minneapolis, 1986], p. 19).

17. Derrida, "Living on: *Border Lines*," in *Deconstruction and Criticism*, ed. Harold Bloom et al. (New York, 1979), pp. 83–84.

18. The weaving metaphor is invoked by Alison Lurie in "A Dictionary for Deconstructors," *The New York Review of Books* XXVI, 18 (November 23, 1989), p. 49. Its deficiencies from a deconstructionist point of view are elaborated in Rodolphe Gasché, *The Tain of the Mirror: Derrida and the Philosophy of Reflection* (Cambridge, Mass., 1986), p. 289.

19. See especially, "Rethinking Intellectual History and Reading Texts," in *Rethinking Intellectual History* and "Rhetoric and History," in *History and Criticism*.

20. Kellner, "Triangular Anxieties: The Present State of European Intellectual History," in *Modern European Intellectual History*; Clifford, "On Ethnographic Allegory," in *Writing Culture: The Poetics and Politics of Ethnography*, ed. James Clifford and George E. Marcus (Berkeley, 1986).

21. Kellner, "Triangular Anxieties: The Present State of European Intellectual History," p. 132.

22. Jay, "Two Cheers for Paraphrase: The Confessions of a Synoptic Intellectual Historian," in *Fin-de-siècle Socialism and Other Essays*.

23. Clifford, "On Ethnographic Allegory," p. 119.

24. Habermas, "History and Evolution," *Telos* 39 (Spring, 1979).

13. Name-Dropping or Dropping Names?
Modes of Legitimation in the Humanities

1. Letter from Freud to Jones, February 12, 1920, cited in Ernest Jones, *Sigmund Freud; Life and Work*, vol. III (London, 1977), p. 20. This letter has occasioned widespread commentary. See, for example John Forrester, "Who Is in Analysis with Whom? Freud, Lacan, Derrida," *Economy and Society* 13 (1984), p. 165.

2. There are, to be sure, historians of art who contest this assumption. Heinrich Wölfflin, for example, explicitly championed an "art history without names," which meant the alternation of anonymous visual forms. See Wölfflin, *Kunstgeschichtliche Grundbegriffe*, 5th ed. (Munich, 1943).

3. Auguste Comte, *Cours de philosophie positive*, Lecon LII, ed. Emile Littré (Paris, 1877), V., p. 14. This model of science is, however, only a modern one. According to Michel Foucault, "there was a time when those texts which we call 'literary' (stories, folk tales, epics and tragedies) were accepted, circulated, and valorized without any question about the identity of their author. Their anonymity was ignored because their real or supposed age was a sufficient guarantee of their authenticity. Texts, however, that we now call 'scientific' (dealing with cosmology and the heavens, medicine or illness, the natural sciences or geography) were only considered truthful during the Middle Ages if the name of the author was indicated." *Language, Counter-Memory, Practice: Selected Essays and Interviews*, ed. with intro., Donald F. Bouchard, trans. Donald F. Bouchard and Sherry Simon (Ithaca, N.Y., 1977), pp. 125–126.

4. Adolf Grünbaum, *The Foundations of Psychoanalysis: A Philosophical Critique* (Berkeley, 1985).

5. For an interesting examination of this question in reference to Freud, see Samuel Weber, *The Legend of Freud* (Minneapolis, 1982), especially the final section on "Speculation— the Way to Utter Difference."

6. Maximilien Rubel, *Marx Critique du Marxisme: Essais* (Paris, 1974), p. 22.

7. Alvin W. Gouldner, *The Future of Intellectuals and the Rise of the New Class* (New York, 1979), pp. 28–29.

8. Michel Foucault, "What Is an Author?" in *Language, Counter-Memory, Practice;* Roland Barthes, "The Death of the Author," in *Image—Music—Text,* trans. Stephen Heath (New York, 1977).

9. Paul Ricoeur, *Freud and Philosophy: An Essay on Interpretation,* trans. Denis Savage (New Haven, 1979), p. 28f.; Jürgen Habermas, "Consciousness-raising or Redemptive Criticism: The Contemporaneity of Walter Benjamin," *New German Critique* 17 (Spring, 1979), pp. 30–59.

10. Hans Blumenberg, *The Legitimacy of the Modern Age,* trans. Robert M. Wallace (Cambridge, Mass., 1983).

11. Dominick LaCapra, "Is Everyone a Mentalité Case? Transference and the 'Culture' Concept," *History and Criticism* (Ithaca, N.Y., 1985).

12. Ibid., p. 72.

13. Ibid.

14. Frank J. Sulloway, *Freud: Biologist of the Mind* (New York, 1979), p. 5.

15. Samuel Weber, *Institution and Interpretation,* afterword by Wlad Godzich (Minneapolis, 1987), p. 38.

16. Ibid.

17. Wlad Godzich in Ibid., p. 162.

18. Ibid.

19. Jacques Derrida, *Of Grammatology,* trans. Gayatri Chakravorty Spivak (Baltimore, 1976), p. 99.

20. Paul de Man, "Hypogram and Inscription," in *The Resistance to Theory,* foreword by Wlad Godzich (Minneapolis, 1986), p. 42.

21. Stephen W. Melville, *Philosophy Beside Itself: On Deconstruction and Modernism,* foreword by Donald Marshall (Minneapolis, 1986), p. 151.

22. Paul de Man, "Autobiography as De-facement," in *The Rhetoric of Romanticism* (New York, 1984), p. 77.

23. Paul de Man, "Hypogram and Inscription," p. 45.

24. Ibid., p. 48.

25. Ibid., p. 50.

26. Paul de Man, "Anthropomorphism and Trope in the Lyric," in *The Rhetoric of Romanticism,* p. 247.

27. J. Hillis Miller, "Face to Face: Prosopopeia in Plato's *Protagoras,*" unpublished manuscript, p. 28. I am very grateful to Professor Miller for showing me a copy of this paper.

28. This conclusion is actually drawn in another essay which grew out of the argument of "Face to Face." It is called "Face to Face: Plato's *Protagoras* as a Model for Collective Research in the Humanities" and was delivered at the inaugural conference for the University of California, Irvine Humanities Center in May, 1987.

29. Paul de Man, "Autobiography as De-facement," p. 78.

30. Michael Riffaterre, "Prosopopeia," in *Yale French Studies*, "The Lesson of Paul de Man," 69 (New Haven, 1985), p. 112.

31. Jeffrey Moussaieff Masson, *The Assault on Truth: Freud's Suppression of the Seduction Theory* (New York, 1984).

32. Frank Lentricchia, *After the New Criticism* (Chicago, 1980), chapter 8. For more on the implications of the scandal, see Martin Jay, "The Descent of de Man," *Salmagundi*, 78, 79 (Spring–Summer, 1988).

33. Philip M. Boffey, "Major Study Points to Faulty Research at Two Universities," *New York Times*, April 22, 1986.

34. Bruno Latour and Steve Woolgar, *Laboratory Life* (Beverly Hills, 1979), cited in Weber, p. 168.

35. Stanley Fish, "No Bias, No Merit: The Case Against Blind Submission," *Doing What Comes Naturally: Change, Rhetoric and the Practice of Theory in Literary and Legal Studies* (Durham, N.C., 1989).

36. For an account of the recent turns in the philosophy of science, which relates them to current thinking in the humanities, see Richard J. Bernstein, *Beyond Objectivism and Relativism: Science, Hermeneutics, and Praxis* (Philadelphia, 1983).

37. See Chapter 2.

38. Paul de Man, "The Resistance to Theory," in *The Resistance to Theory*, p. 11.

39. Hans Blumenberg, *The Legitimacy of the Modern Age*, p. 240.

40. Ibid., p. 345.

41. Ibid.

Index